Martin Creed
Works

Martin Creed
Works

Front cover image: Martin Creed, Work No. 397, 2005
Back cover image: Martin Creed, Work No. 516, 2006

Martin Creed: Works © 2010 Martin Creed

Foreword Copyright © 2010 Martin Creed
'Interview' Copyright © 2010 Martin Creed and Tom Eccles
'Questionnaire' Copyright © 2008 Martin Creed and Novello & Co. Limited
'The System of Objects' Copyright © 2010 Massimiliano Gioni
'When Nothing is More than Enough' Copyright © 2010 Germaine Greer
'Martin Creed 20 Questions' Copyright © 1999 Matthew Higgs
'The Lights Off' Copyright © 2010 Barry Humphries
'Somethings' Copyright © 2010 Tess Jaray
'Forms of Attachment' Copyright © 2010 Darian Leader
'The Title + The Text =' Copyright © 2010 John O'Reilly
'What Are You Looking At?' Copyright © 2010 Colm Tóibín

All works by Martin Creed Copyright © 2010 Martin Creed
Martin Creed has asserted his right to be identified as the author of this
work, subject to the contributions of third parties.

Music Copyright © Martin Creed – exclusive licensee, Novello & Co.
Limited, reprinted with permission

Design by Martin Creed, Catherine Lutman, David Southard and
Thames & Hudson
Design based on Work No. 157 by Martin Creed

Thames & Hudson thanks Hauser & Wirth for their assistance in the
preparation of this publication.

First published in 2010 in hardcover in the United States of America by
Thames & Hudson Inc., 500 Fifth Avenue, New York, New York 10110

thamesandhudsonusa.com

First paperback edition 2014

Library of Congress Catalog Card Number 2009936621
ISBN 978-0-500-29081-1

Printed and bound in China by Toppan Leefung Printing Limited

Contents

vi Foreword
Martin Creed

ix Editorial Note

3 WORKS

x *Interview*
Tom Eccles and Martin Creed

xviii *Questionnaire*
The Full Score and Martin Creed

xx *The System of Objects*
Massimiliano Gioni

xxv *When Nothing is More than Enough*
Germaine Greer

xxviii *Martin Creed 20 Questions*
Matthew Higgs

xxxiv *The Lights Off*
Barry Humphries

xxxv *Somethings*
Tess Jaray

xxxvi *Forms of Attachment*
Darian Leader

xlii *The Title + The Text =*
John O'Reilly

xliii *What Are You Looking At?*
Colm Tóibín

l Biography
l Exhibition History
liv Public Collections
lv Selected Bibliography
lviii Picture Credits
lix Acknowledgments
lx Index

Foreword

Martin Creed

I fear this book
I dare not look
As bit by bit
I trawl my shit

I don't think I want to make a book of my work. I am scared to look
at what I have done in case I don't like it, and I'm scared to show it to
others in case they don't like it. The world is tricky and looking is sticky.
I was taught it is bad to look in the mirror. My dad painted over the
mirror in the hall, and that is why I grew up staring at the wall.

My advice to me is:

Shelve things
Kid yourself
Just enough to like yourself
Just enough to let yourself
Think that what you are doing is not a load of wank

This book has taken me years to complete. It must be the slowest
wank ever. To fill each rectangle of the book, to portray each thing,
sometimes took longer than making the thing in the first place. It's like
what people say about love and relationships: that it takes the same
amount of time, or more, to get over someone after you split up as
the length of time you spent together. Who am I to know what I do or
what I am like? I am probably the last to see me clearly. I imagine I am
obvious to everyone else — just like when a couple are splitting up, and
it's obvious to everyone around them that it's going wrong, but not to
the people themselves. Maybe I am splitting up with my own work
and I don't even realize it? I don't know.

Working on this book has been like trying to refold a map after
a long journey. It is softened and crumpled and torn, and I could not
fold it back into its original shape. While making this book I bought
a SatNav.

The more I work, the more I think I don't know what I am doing.
I have absolutely no idea what I am doing. It is like sweat or shit. It
comes out as I go along. As you do one thing over here, something else
comes out over there. It is not what you think you are doing. It is like
scum on top of things or like sediment at the bottom. It builds up while
you are doing other things.

Working feels like trying to face up to what comes out of you.

Art is shit. Art galleries are toilets. Curators are toilet attendants.
Artists are bullshitters.

Working on this book I have felt like a cat having its nose rubbed in its own shit to housetrain it.

I was walking along on a beach years ago and I threw a stone in the water. It made a little splash and a nice noise, and it was good to watch. But now, years later, do I have to dive in to the water and scrabble around in the mud to find the stone, drag it up onto the beach, clean it up, photograph it and put it in a book? I fear I might drown. I feel like I am swimming through mud. I feel mired in myself.

I am inside me. It is warm in here. I don't want to go out. I am scared that I will congeal, shrivel up and die on the cold, white pages of this book.

It's easy to start, but it's hard to go on, and it's very difficult to finish. I hate endings. That is a start.

It's easy to say it's easy to start, but it's difficult to start too. It means choosing and feeling your way, being careful, worrying and guessing, creeping and peeping, and after interminable humming and haaing, plumping and dumping. I want to move in all directions at once: like a sound, or like a wave from a thrown stone.

At the start there is potential in all directions, 360 degrees of hope. You are free, and so maybe it is best to stay at the start. Stay still, stand there and throw things. Keep starting again and again, and never go on. Just keep making starts. Not false starts, but true starts that stop and start. Keep your options open. If you only ever start and never finish you can always hope and you can never lose.

But one thing leads to another, and a sequence of starts starts to form a pattern which clearly has a beginning and a bit after that and a bit after that, and by that time you have moved on from the start and things have developed, and before you know it you are entangled and involved, and there is no going back, not easily. The more you do, the more you have to contend with, and the more you have to do to cope. Everything has consequences and ramifications that multiply and fly off in all directions like sparks from a grinder. It is a can of worms on a stormy sea in a hall of mirrors on a slippery slope to a bottomless pit.

If you try to stay still on the ocean, after a while you will find yourself in a different place anyway, carried on the currents and blown by the wind. You move and the world moves and you can't stop it.

I feel like a plant or a flower growing stupidly towards the light. As much as you try to control yourself your body moves on without you and your nature gives itself away. You cannot stay still because being alive you move.

What have I done? I can say I have moved. What have I made? I have made movements.

To do or make something, whether a phone call or a painting, is a matter of making or choreographing movements, of moving your body.

I move, I flap around and make a commotion, but the wake I make is hard to shape. It fades, drifts and loses power, receding into the distance, dissipating and disappearing into the ocean. You can control the shape of a work but not the effect of it. To see how a work works you have to throw it into the sea and see.

I try my best to hold back skill and craft and let my natural talent come through.

When you make something inside in the warm, and put it outside in the cold, there is a danger that it will die unless it is given warmth by others. It needs to be fed and kept alive. You cannot stand there feeding it and keeping it warm. That would take your whole life. That is why I do not decide what my work is. Everyone else does.

I think I need to exhibit my work in public to find out what it is like. I feel like a goldfish, with no memory. I forget what it's like outside. I have to keep going out to remember.

I feel like I am only scratching the surface; but I am shallow, so I get to the bottom.

I feel bad. I want to feel better. Wanting makes me feel better. If I take away the things I want there is a hole where they were. That is why it's better not to get what you want. Emptiness is like coffee in an American diner: it has an infinite refill.

You have to get used to being a loser, because every moment is lost. Every work is a desperate attempt to stem the flow of loss, to grab onto a floater amongst the dross. Everything is work, because doing everything involves work and trying and action and movement from stillness.

I work on this, and then I have lunch, and it all feels different.

The more I write to make things clear, the more difficult it becomes to see. The words form a curtain obscuring my view. The blobby world of thoughts and feelings is not defined, but the world in words is too defined: they are a certain shape. I don't want to be pinned down. I'm not running out of things to say, but running into things to say. They are obstacles. Words are hard, but the world is soft.

This foreword is going backwards. As I write things occur to me, but I can't write them all down, because you can think much faster than you can write. I want something to say that feels okay. It's a shame you can't have a book without edges.

I want to feel better, better than I do
I want to feel better, better than you

You cannot win. Life is a fight against yourself that you can never win. You're your own worst enemy. I fight against my competitive nature, but I try not to beat myself up about it. I'm a loser in the fight with myself. My heart beats me, pounding me senseless, not stopping until I am dead.

London / Alicudi, 2008–2010

Editorial Note

Martin Creed assigns each of his works a unique number, usually at the point when the work is first exhibited. (A work may or may not be given a title in addition to its number.) He started numbering the works in 1991–1992, at which point he began the sequence by assigning Work No. 3 to a work created in 1986. Occasionally a number is not allocated and that number in the sequence is skipped over. Additionally, works are sometimes assigned numbers retroactively, so that an early work might be formally given the status of a numbered work later than the date of its production.

The page numbers within the works section of this book correspond to the work numbers and are sequential, but interrupted: the pagination is discontinuous, skipping a number if it has not been assigned to a specific work or if the corresponding work is not included in this book.

In some cases works are illustrated at actual size; in these instances the caption indicates this. Some two-dimensional works are shown framed, when the frame is part of the work or the work is seen in an installation shot, but most are illustrated unframed. For most of the neon works, the only dimension given is the height. This is because Creed specifies the height and the proportions of the letters when the neon is fabricated, and this determines the length of the work.

Most of the works that consist of text on paper are re-created as text directly on the pages of the book. Musical and theatrical works are represented through various means such as reproductions of the scores, lyrics, or photographs of the work in performance, and the captions reflect what is represented. The captions for film and video works give the medium in which the work was originally shot.

Multiple-part works on paper, which Creed generally exhibits in one continuous horizontal row, are presented on a single page of this book in rows that allow the largest illustrations of the individual pieces of the composite work, arranged from top left to bottom right.

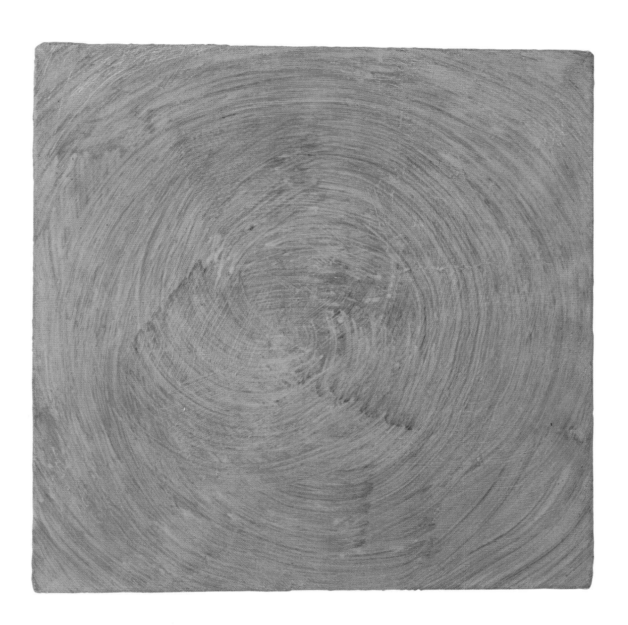

Work No. 3
Yellow painting, 1986
Acrylic on canvas
12 × 12 in / 30.5 × 30.5 cm

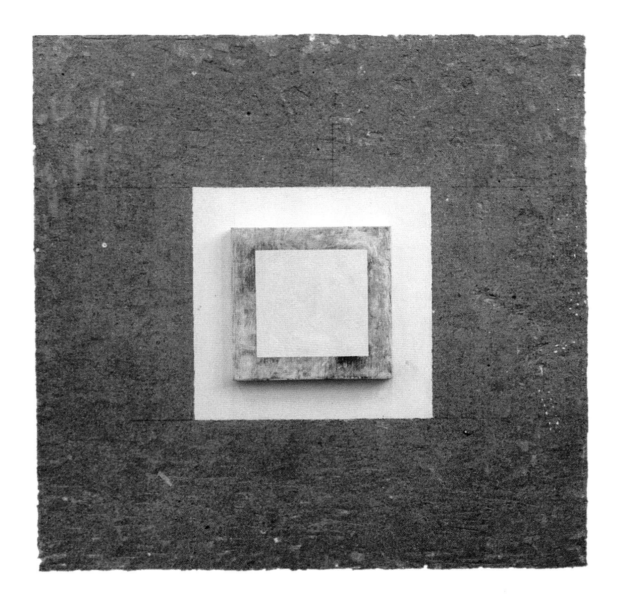

Work No. 4
1987
Wood and paint on chipboard screen
Approximately 24 × 24 in / 61 × 61 cm

Work No. 5
1987
Paint, wood, brass, steel
9.8 × 9.8 in / 25 × 25 cm

6

Work No. 6
1987
Enamel, canvas, brass
6 × 6 in / 15.2 × 15.2 cm

Work No. 7
1988
Size, canvas, brass
6 × 6 in / 15.2 × 15.2 cm

Work No. 8
1988
Linen
2 parts, dimensions variable
Installation at Slade School of Fine Art, London, UK, 1988
(Details)

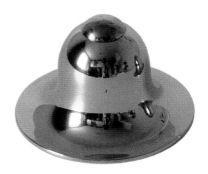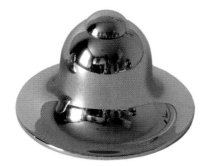

Work No. 9
Two objects, 1989
Brass, chrome-plated brass
2 parts, each 2 in / 5.1 cm diameter
Edition of 3 + 1 AP
(Shown actual size)

11

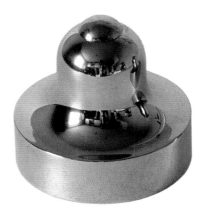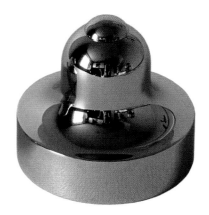

Work No. 11
Two objects, 1989
Brass, chrome-plated brass
2 parts, each 2 in / 5.1 cm diameter
Edition of 1 + 1 AP
(Shown actual size)

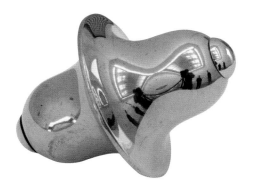

Work No. 12
1989
Brass, chrome-plated brass
2 in / 5.1 cm diameter
Edition of 1 + 1 AP
(Shown actual size)

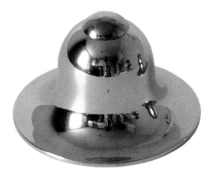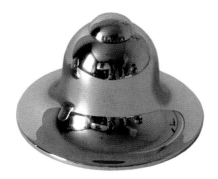

Work No. 14
Two objects, 1989
Brass, chrome-plated brass
2 parts, each 2 in / 5.1 cm diameter
Edition of 3 + 1 AP
(Shown actual size)

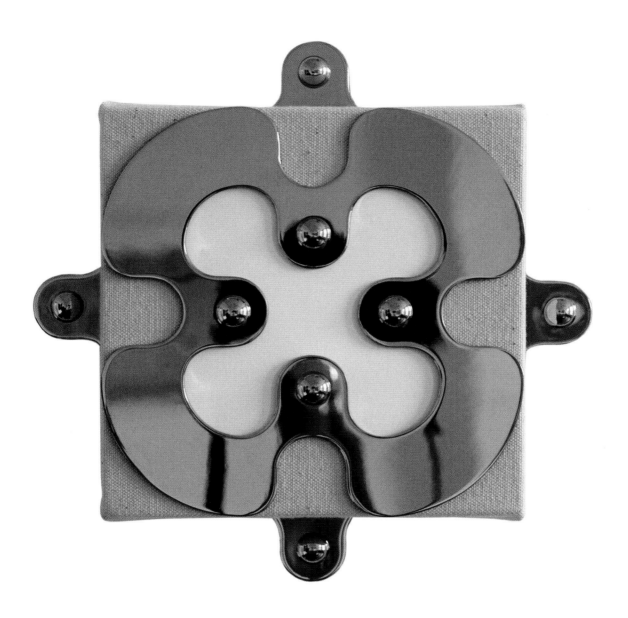

Work No. 18
1989
Primer, canvas, chrome-plated brass
6 × 6 in / 15.2 × 15.2 cm

Work No. 19
An intrusion and a protrusion from a wall, 1989
Brass in / brass out; both sides of a wall
2 parts, each 2 in / 5.1 cm diameter
Installation at Slade School of Fine Art, London, UK, 1989

Work No. 20
1988–1989
Brass
2 in / 5.1 cm diameter
(Shown actual size)

Work No. 21
An intrusion and a protrusion from a wall, 1989
Brass in / brass out; opposite walls
2 parts, each 2 in / 5.1 cm diameter
Edition of 1 + 1 AP
Installation at Slade School of Fine Art, London, UK, 1990

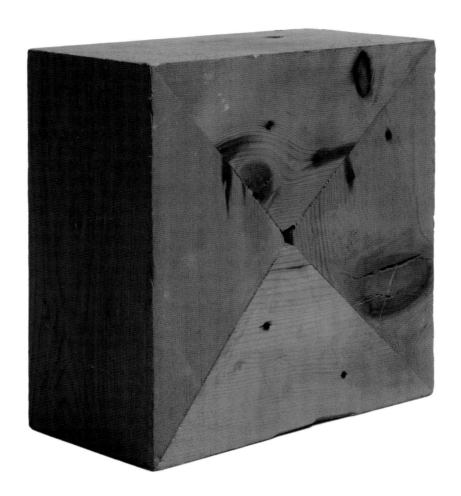

Work No. 22
c. 1987
Wood, glue
7.2 × 7.2 × 3.5 in / 18.5 × 18.5 × 9 cm

Work No. 23
Four objects, 1989
Brass, chrome-plated brass
4 parts, each 2 in / 5.1 cm diameter
Edition of 3 + 1 AP
Installation at The Black Bull, London, UK, 1989

Work No. 24
1989
Brass
2 in / 5.1 cm diameter
Edition of 3 + 1 AP
Installation at Slade School of Fine Art, London, UK, 1989

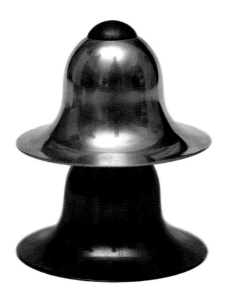

Work No. 28
c. 1988
Brass, aluminium
2 in / 5.1 cm diameter
(Shown actual size)

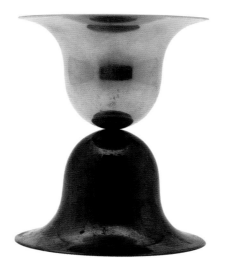

Work No. 29
1988–1989
Brass, aluminium
2 in / 5.1 cm diameter
(Shown actual size)

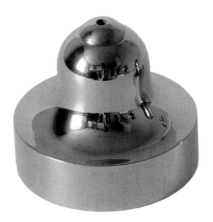 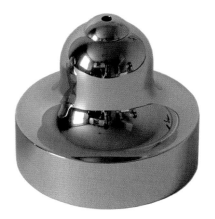

Work No. 33
Salt and pepper set, 1990–1999
Brass, chrome-plated brass
2 parts, each 2 in / 5.1 cm diameter
Edition of 2 + 1 AP
(Shown actual size)

Work No. 36
An object on a door, 1990
Photographic print
8 × 10 in / 20.3 × 25.4 cm
Edition of 1 + 1 AP

37

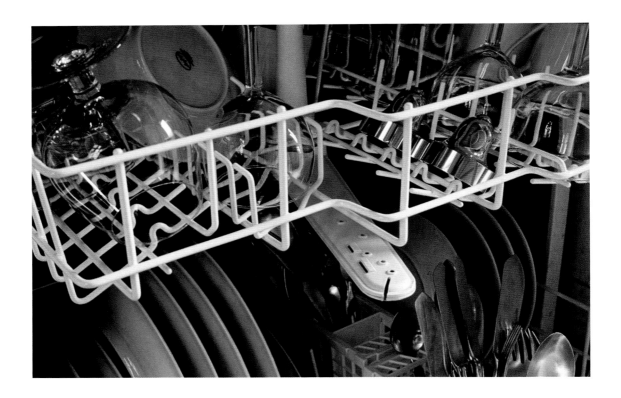

Work No. 37
Two objects in the dishwasher, 1990
Photographic print
8 × 10 in / 20.3 × 25.4 cm
Edition of 1 + 1 AP

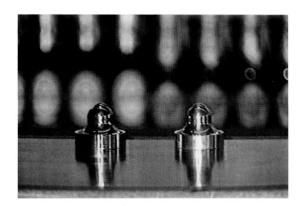

Work No. 42
Chrome and brass, 1990–1997
U-matic video, colour, sound
18 minutes

an object on a door

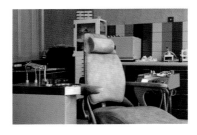

two objects at the dentist

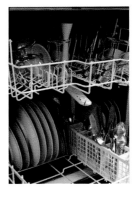

two objects in the dishwasher

four objects on a bar

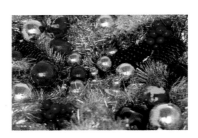

two objects at christmas

Work No. 43
Objects in different places, 1990–1996
Photographic prints, ink on paper
5 parts, each 4 × 6 in / 10.1 × 15.2 cm
Edition of 5 + 1 AP

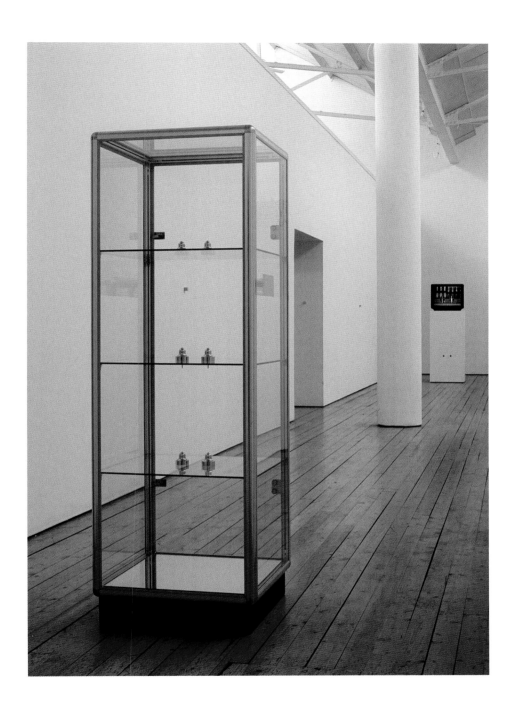

Work No. 47
1990
Chrome-plated brass, U-matic video
Dimensions variable
Edition of 1 + 1 AP
Installation at Starkmann Ltd, London, UK, 1992

52

Work No. 52
Two paintings, 1988–1991
Size, primer, canvas, brass, chrome-plated brass
2 parts, each 6 × 6 in / 15.2 × 15.2 cm

Work No. 53
Two paintings, 1991
Metal polish, canvas, brass, chrome-plated brass
2 parts, each 6 × 6 in / 15.2 × 15.2 cm

58

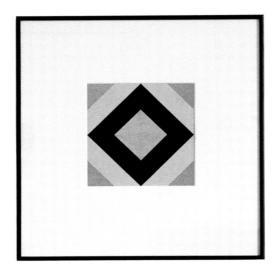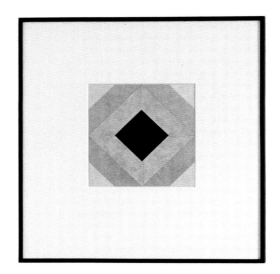

Work No. 58
Two drawings, 1991
Masking tape, blue-print, window-mount, frame
2 parts, each window 5.5 × 5.5 in / 14 × 14 cm

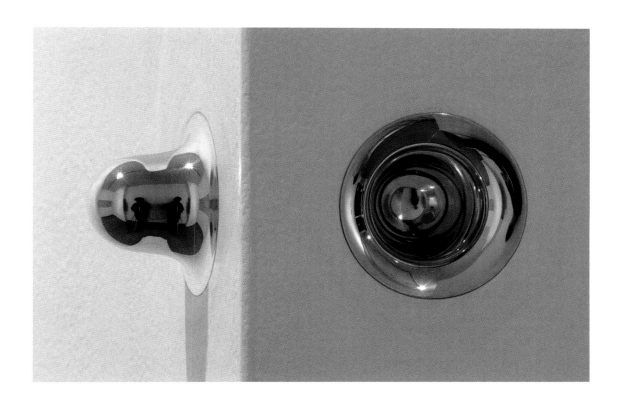

Work No. 61
An intrusion and a protrusion from a wall, 1991
Brass in / brass out; external corner
2 parts, each 2 in / 5.1 cm diameter
Edition of 1 + 1 AP

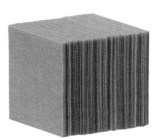

Work No. 67
As many 1" squares as are necessary cut from 1" masking tape and piled up,
adhesive sides down, to form a 1" cubic stack, 1992
Masking tape
1 × 1 × 1 in / 2.5 × 2.5 × 2.5 cm
(Shown actual size)

Work No. 69
1992
Chrome-plated brass
2 in / 5.1 cm diameter
Edition of 1 + 1 AP
Installation at Transmission Gallery, Glasgow, UK, 1992

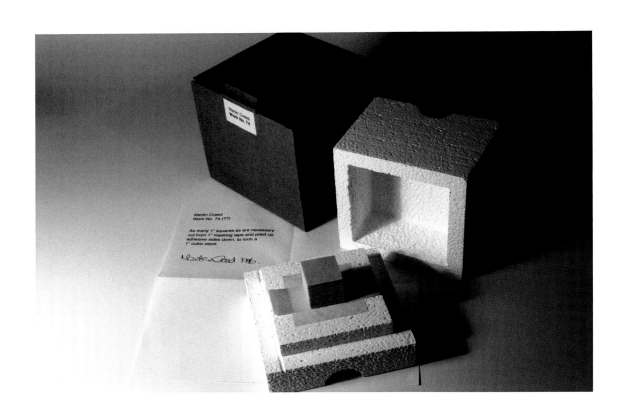

Work No. 74
As many 1" squares as are necessary cut from 1" masking tape and piled up,
adhesive sides down, to form a 1" cubic stack, 1992
Masking tape, polystyrene, ink on paper, cardboard
Box 4 × 4 × 4 in / 10.1 × 10.1 × 10.1 cm
Originally made as an unlimited edition and later limited to 100 + 5 AP

Work No. 75
A 1" cubic stack of masking tape in the middle of every wall in a room, 1992
Masking tape
Multiple parts, each 1 × 1 × 1 in / 2.5 × 2.5 × 2.5 cm; overall dimensions variable
Installation at Laure Genillard, London, UK, 1997
(Details)

Work No. 74
An unlimited edition
Martin Creed 1992

If anything, this work begins as an attempt to make something, if not nothing.

If that, the problem was to attempt to establish, amongst other things, what material something could be, what shape something could be, what size something could be, how something could be constructed, how something could be situated, how something could be attached, how something could be positioned, how something could be displayed, how something could be portable, how something could be packaged, how something could be stored, how something could be certified, how something could be presented, how something could be for sale, what price something could be, and how many of something there could be, or should be, if any, if at all.

Work No. 76
1992
Text written about Work No. 74

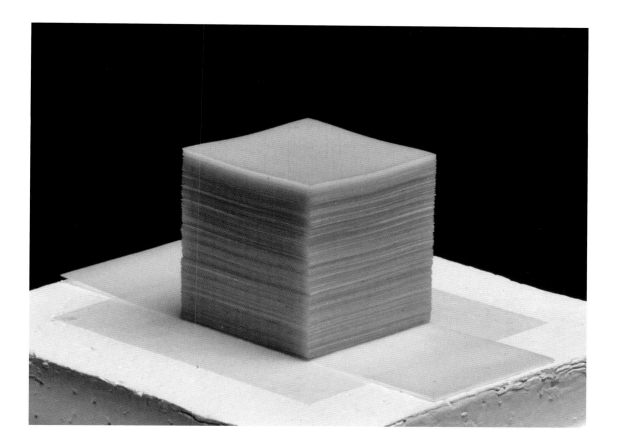

Work No. 77
As many 2.5 cm squares as are necessary cut from 2.5 cm Magic tape and piled up,
adhesive sides down, to form a 2.5 cm cubic stack, 1993
Magic tape, polystyrene, paper, cardboard
Box 4 × 4 × 4 in / 10.1 × 10.1 × 10.1 cm
(Detail)

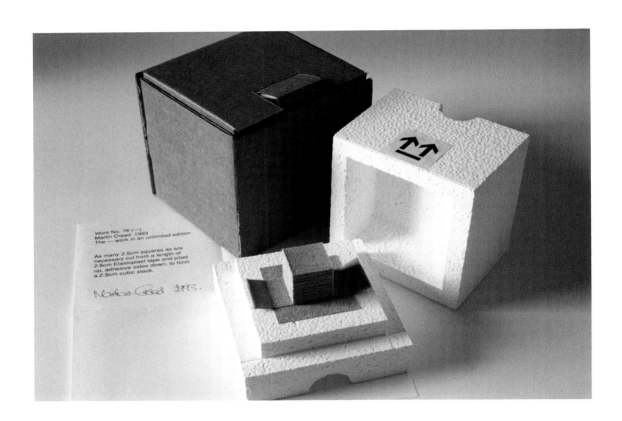

Work No. 78
As many 2.5 cm squares as are necessary cut from 2.5 cm Elastoplast tape and piled up,
adhesive sides down, to form a 2.5 cm cubic stack, 1993
Elastoplast tape, polystyrene, paper, cardboard
Box 4 × 4 × 4 in / 10.1 × 10.1 × 10.1 cm
Originally made as an unlimited edition and later limited to 50 + 5 AP

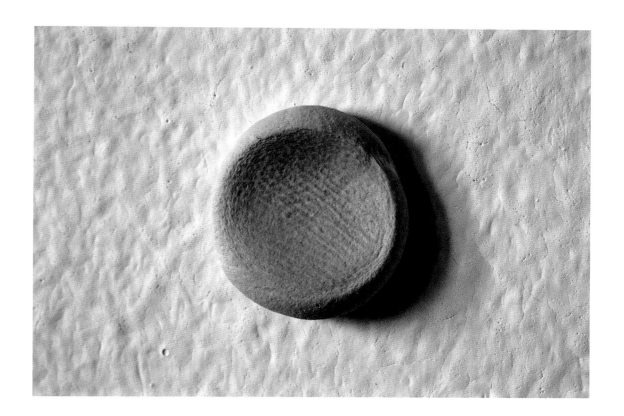

Work No. 79
Some Blu-Tack kneaded, rolled into a ball, and depressed against a wall, 1993
Blu-Tack
Approximately 1 in / 2.5 cm diameter
Edition of 3 + 1 AP

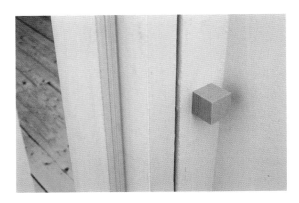

Work No. 81
A 1" cubic stack of masking tape in the middle of every wall in a building, 1993
Masking tape
Multiple parts, each 1 × 1 × 1 in / 2.5 × 2.5 × 2.5 cm; overall dimensions variable
Installation at Starkmann Ltd, London, UK, 1993
(Details)

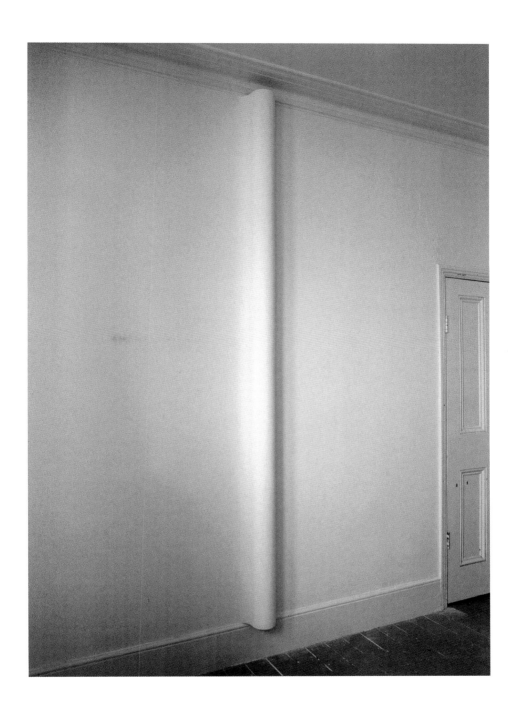

Work No. 83
A protrusion from a wall, 1993
Plaster, paint
9 × 4.5 in / 22.9 × 11.4 cm
Edition of 3 + 1 AP
Installation at the artist's studio, London, UK, 1993

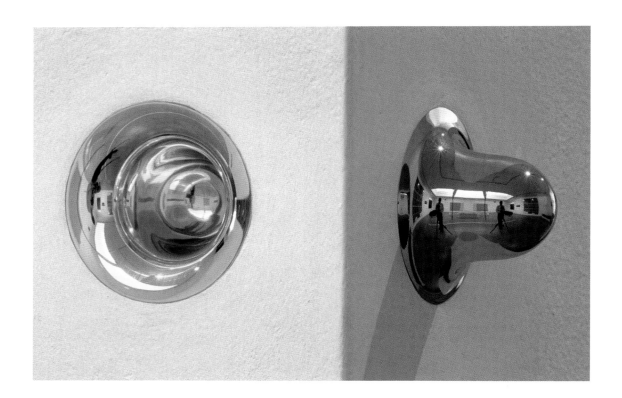

Work No. 84
An intrusion and a protrusion from a wall, 1993
Brass in / chrome-plated brass out; external corner
2 parts, each 2 in / 5.1 cm diameter
Edition of 2 + 1 AP

Work No. 86
An Elastoplast cube in the middle of every empty wall in a gallery, filling the gaps in an exhibition, 1993
Elastoplast tape
Multiple parts, each 1 × 1 × 1 in / 2.5 × 2.5 × 2.5 cm; overall dimensions variable
(Detail)

88

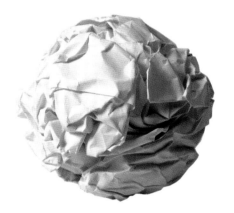

Work No. 88
A sheet of A4 paper crumpled into a ball, 1995
A4 paper
Approximately 2 in / 5.1 cm diameter
Unlimited edition
(Shown actual size)

One packet of Blu-Tack

<u>Instructions</u>

Using the packet of Blu-Tack provided, stick blobs of
Blu-Tack to walls and surfaces throughout the space.

Method: tear off some Blu-Tack, knead until supple,
roll into a ball approximately 1cm* in diameter, and
depress against a surface using your thumb. Repeat
until the packet has been used up.

Locate blobs wherever you like, ensuring only that
there is at least one in each room (including toilets,
office etc).

*less rather than more

Work No. 91
One packet of Blu-Tack, 1994–2001
Blu-Tack
Multiple parts; dimensions variable
Edition of 3 + 1 AP
(Instructions shown)

Work No. 92
A doorbell amplified, 1994
Microphone, amplifier
Dimensions variable
Edition of 3 + 1 AP
Installation at Cabinet Gallery, London, UK, 1994

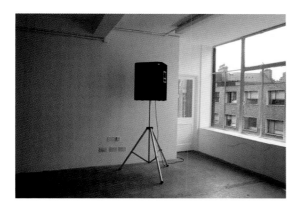

Work No. 95
All the sounds amplified, 1994
Microphones, mixer, amplifier, speaker
Dimensions variable
Edition of 3 + 1 AP
Installation at Marc Jancou Gallery, London, UK, 1994

Just imagine, for the sake of it, you were going to write about an artist who specialises in nothing in particular. Someone who has got a name like Martin Creed for example. You would look at some of his work. You pick a number, any number, let's say number 95. So you walk into the gallery **and** scan the space. You're puzzled because you see nothing. You look around but there's nothing there. Although you try to ignore it, the thought takes hold that someone might see that you see nothing. As you ease with sweaty embarrassment out the door you suddenly hear it. The rush **and** gurgle of a toilet flushing water, the rat-a-tat-tat of the fax machine printing, **and** in the time lag of this double-take you laugh because this slice of ambient minimalism, this sliver of nano-art is Work No. 95 "all the sounds in a gallery amplified."

When you receive in the post Work No. 140 "a sheet of A4 paper torn up" or the instructions for a piece of music, a one-note song, to be played Moderato **and** either mezzopiano or mezzoforte, you realise that this is a self-negating art that amounts to...well...nothing exactly. It's a pilgrimage in pursuit of the pointless. You remember Frank Stella saying what you see is what you see **and** you recall that there is a whole genealogy of writers debating nothing in particular. Like the medieval philosophers contemplating the question "what is the difference between something **and** nothing?" They worried desperately that it can't be something because then there would be no difference at all. Then again it can't be nothing.

There was Leibniz whose life's work was a reflection on the question "Why is there something rather than nothing?" But the most touching of all was the Greek philosopher Gorgias, a man dedicated to the poignantly self-defeating exercise of proving that nothing exists. He tried to cover all possible objections by asserting that even if something did exist we couldn't know it. **And** if something did exist we couldn't communicate it. When Gorgias died in Thessaly he was 105 years old. But longevity is proof of nothing.

You realise that this genealogy tells you nothing so you decide to ask the artist. He confesses that he is trying not to make anything in particular. His work is what it is. He talks about Work No. 102 "a protrusion from a wall." Formally it is the simplest way of making something happen on the wall. It's a perfect shape for coming in **and** out of a wall. Because it all happens in a circle it's equal in all directions. He says he tries to make work that is as much a part of everything else. He doesn't know what to make so he is trying to make something **and** trying not to make something at the same time. Trying to make nothing. He says in order to make zero or nothing you have to make an equation that adds up to nothing. The equation is the work, because the equation is visible. It's what's left over although you get back to zero again.

Of course that is the double-bind of this heroic minimalism. No matter how many times the work is repeated, no matter how invisibly discreet it is, the fact that this conjunction of nothing ends up luring you in is a kind of defeat. It's like the chess game in Beckett's Murphy. After what seems like an interminable series of bizarre moves Murphy realises that the schizophrenic Mr Endon has contrived to produce a game in which all the pieces have returned to their original squares. Something has happened. But what exactly?

Then it dawns on you that writing something about nothing might be a labour in futility. **And** you remember Beckett's advice to himself in Texts for Nothing "**And** it's still the same old road I'm trudging, up yes **and** down no, towards one yet to be named, so that he may leave me in peace, be no more, have never been. Name, no, nothing is namable, tell, no, nothing can be told, what then, I don't know, I shouldn't have begun."

And so you imagine not writing about an artist who specializes in nothing in particular because it is too pointless for words.

John O'Reilly 1996

Work No. 96
Every 'and' set in bold type, 1994
Typographic design

Work No. 97
A metronome working at moderate speed, 1994
Metronome, amplifier
Dimensions variable
Installation at Peter Doig's studio, London, UK, 1994

Work No. 99
An intrusion and a protrusion from a wall, 1994
Silver-plated brass in / gold-plated brass out; external corner
2 parts, each 3 in / 7.6 cm diameter
Edition of 2 + 1 AP
Installation at Rhizome, Amsterdam, the Netherlands, 1994

Work No. 100
On a tiled floor, in an awkward place, a cubic stack of tiles built on top of one of the existing tiles, 1994
Floor tiles, adhesive
Dimensions variable
Edition of 10 + 1 AP
Installation at Rhizome, Amsterdam, the Netherlands, 1994

Moderato

mp or *mf*

Work No. 101
For pianoforte, 1994
Ink on paper
11.7 × 8.2 in / 29.7 × 21 cm
Unlimited edition

Work No. 102
A protrusion from a wall, 1994
Plaster, paint
9 × 18 in / 22.8 × 45.7 cm
Edition of 2 + 1 AP
Installation at Marc Jancou Gallery, London, UK, 1994

The ascending and descending chromatic scales
played over the whole piano keyboard, each note
being played for one second and being followed
by a one second rest.

Work No. 105
1994
Piece for piano
(Instructions shown)

Work No. 106
An intrusion and a protrusion from a wall, 1994
Gold-plated silver in / gold-plated silver out; opposite walls
2 parts, each 3 in / 7.6 cm diameter
Edition of 2 + 1 AP
Installation at Todd Gallery, London, UK, 1994

Up and Down

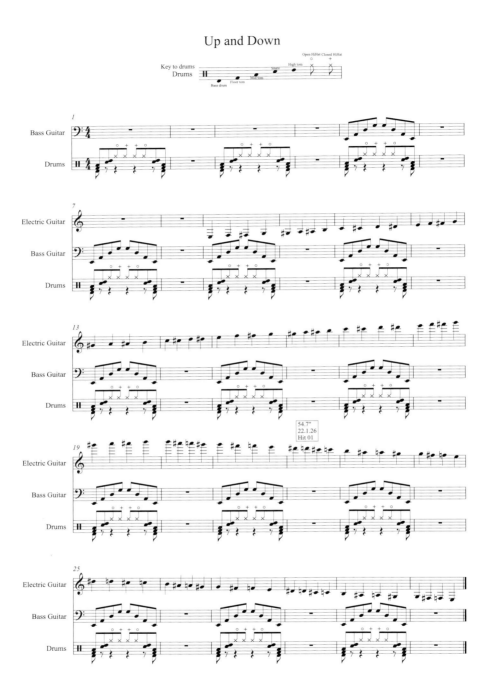

Work No. 107
Up and down, 1994
Piece for guitar, bass and drums
(Score shown)

Work No. 108
The usual first one, 1994
Piece for guitar, bass and drums

Work No. 109
1994
Piece for guitar, bass and drums

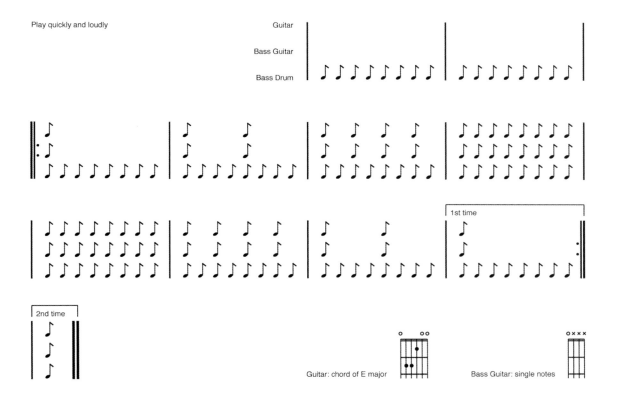

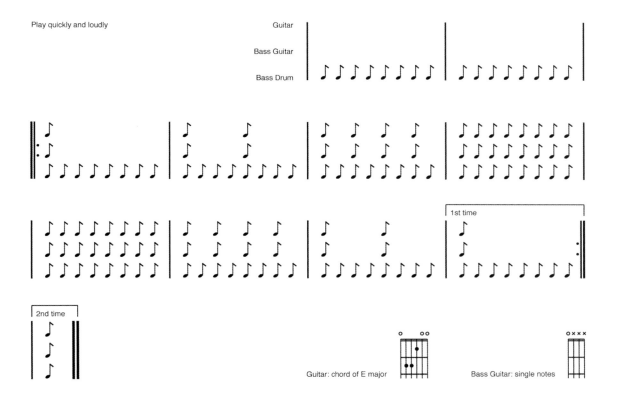

Work No. 110
Low, 1994
Piece for guitar, bass and drums
(Score shown)

Play quickly

Guitar

Bass Guitar

Bass Drum

1st time

2nd time

Guitar plays its highest note

Bass Guitar plays its highest note

Work No. 111

High, 1995

Piece for guitar, bass and drums

(Score shown)

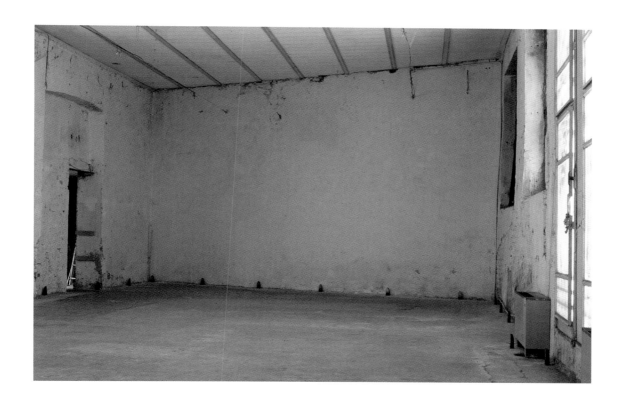

Work No. 112
Thirty-nine metronomes beating time, one at every speed, 1995–1998
Metronomes
39 parts; dimensions variable
Edition of 3 + 1 AP
Installation at Viafarini, Milan, Italy, 1995
(Detail)

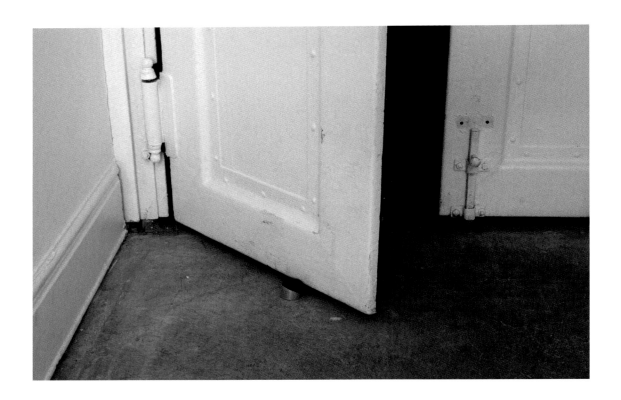

Work No. 115
A doorstop fixed to a floor to let a door open only 45 degrees, 1995
Doorstop
Dimensions variable
Edition of 15 + 1 AP
Installation at Javier Lopez Gallery, London, UK, 1995

Work No. 116
Short G
Piece for guitar, bass and drums

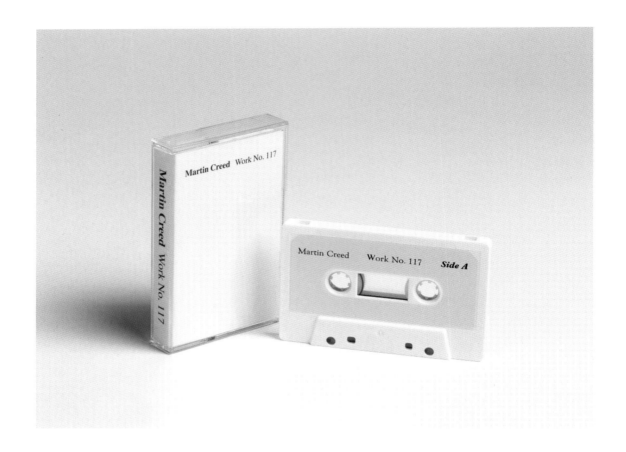

Work No. 117
All the sounds on a drum machine, 1995
Audio cassette
4.6 × 2.7 in / 11.9 × 6.9 cm; each side 1 minute

Work No. 118
Martin Creed 1995

Time: 4/4
Speed: fast
Lead Guitar: chord of open strings
Bass Guitar: chord of open strings
Repeat chorus four times

Introduction
Voice 1: One Two Three Four

Chorus
Voice 1: One Two Three Four
Voice 2: One Two Three Four
Lead Guitar: - - - - - - - -
Bass Guitar: - - - - - - - -
Hi-Hat: - - - - - - - -
Snare Drum: - - - - - - - -
Bass Drum: - - - -

Work No. 118
1234, 1995
Piece for voices, guitar, bass and drums

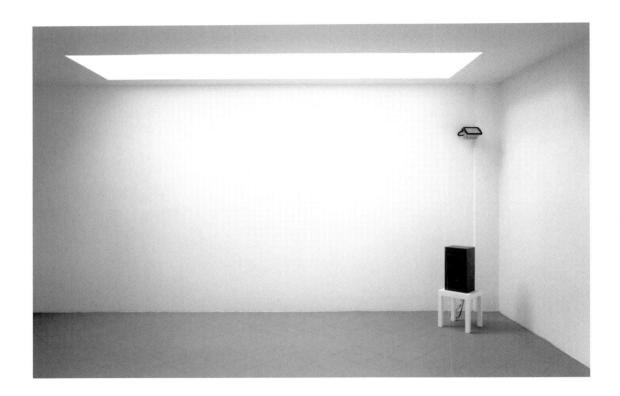

Work No. 120
All the sounds on a drum machine played one after the other, in their given order,
at a speed of one per second, in a continuous loop, 1995
Drum machine, amplifier, speaker
Dimensions variable
Edition of 1 + 1 AP
Installation at Galleria Paolo Vitolo, Milan, Italy, 1995

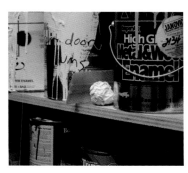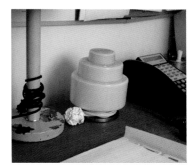
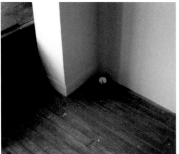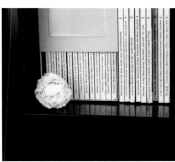

Work No. 121
A crumpled ball of paper in every room in a house, 1995
A4 paper
Multiple parts, each part approximately 1.7 in / 4.5 cm diameter; overall dimensions variable
Edition of 10 + 1 AP
Installation at Swiss Institute Contemporary Art, New York, USA, 2004

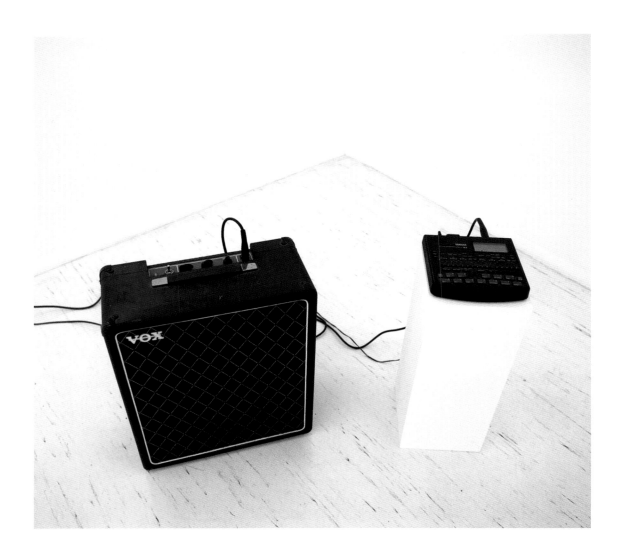

Work No. 122
Drum machine, 1995–2000
Drum machine, amplifier
Dimensions variable
Edition of 3 + 1 AP
Installation at Camden Arts Centre, London, UK, 2000

Start
Middle
End

Work No. 124
Start middle end, 1995
Piece for voice, guitar, bass and drums
(Lyrics shown)

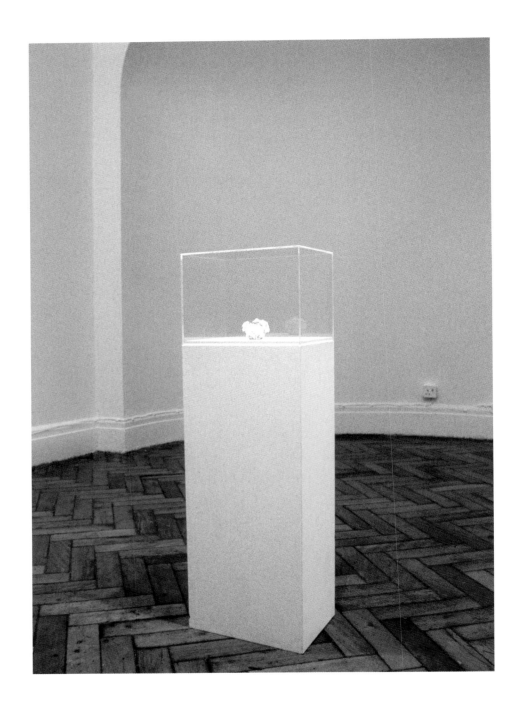

Work No. 126
A sheet of paper crumpled into a ball, 1995
A4 paper, lid, plinth
Lid 11.7 × 8.2 × 8.2 in / 29.7 × 21 × 21 cm; plinth height variable
Edition of 4 + 1 AP
Installation at Centre for Contemporary Art, Ujazdowski Castle, Warsaw, Poland, 2004

Work No. 127
The lights going on and off, 1995
Dimensions variable; 30 seconds on / 30 seconds off
Edition of 2 + 1 AP
Installation at Cubitt Gallery, London, UK, 1995

Turn all the lights off for 30 seconds.

When the lights go off play as hard, fast and loud as you can.

Stop when the lights come on.

Work No. 128
30 seconds with the lights off, 1995
Piece for guitar, bass and drums
(Instructions shown)

Work No. 129
A door opening and closing, 1995
Materials and dimensions variable
Edition of 3 + 1 AP
Installation at the Armory Show, New York, USA, 2008

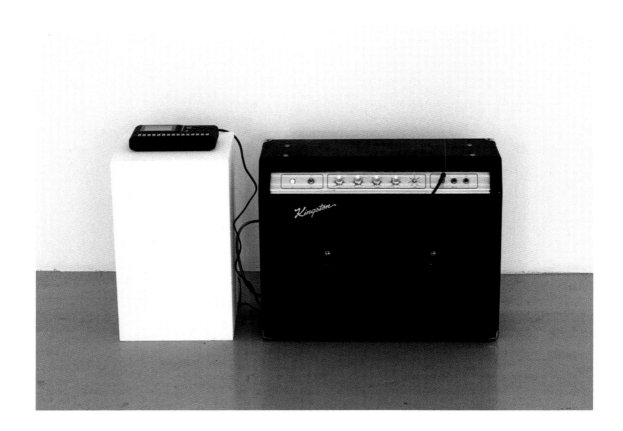

Work No. 130
All the sounds on a synthesizer, 1995
Synthesizer, amplifier
Dimensions variable
Edition of 1 + 1 AP

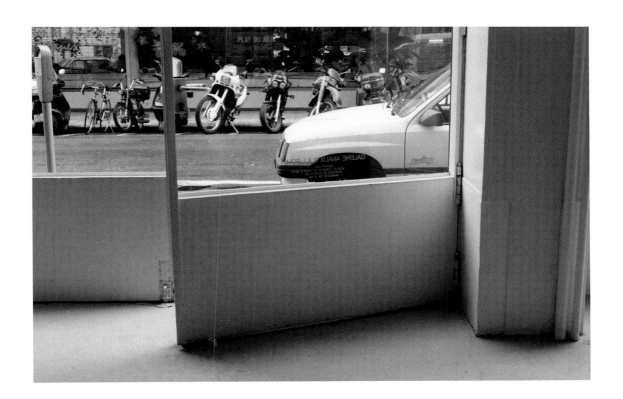

Work No. 131
A doorstop fixed to a floor to let a door open only 30 degrees, 1995
Doorstop
Dimensions variable
Edition of 4 + 1 AP
Installation at Galerie Analix B & L Polla, Geneva, Switzerland, 1995

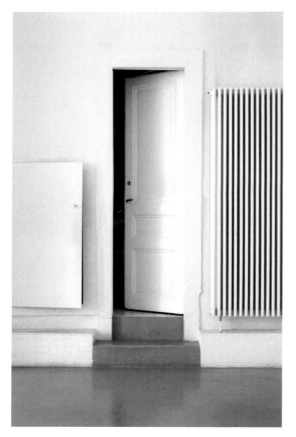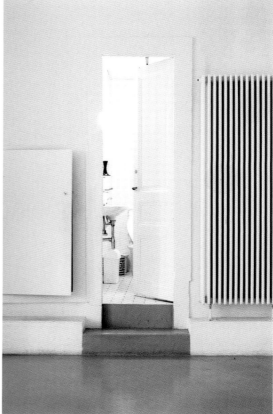

Work No. 132
A door opening and closing and a light going on and off, 1995
Materials and dimensions variable
Edition of 3 + 2 AP
Installation at Galerie Analix B & L Polla, Geneva, Switzerland, 1995

Work No. 134
Largo, larghetto, adagio, andante, moderato, allegro, presto e prestissimo, 1995
Electronic metronomes
8 parts, each 9.3 × 9.3 × 4.3 in / 23.6 × 23.6 × 11 cm; overall dimensions variable
Edition of 1 + 1 AP

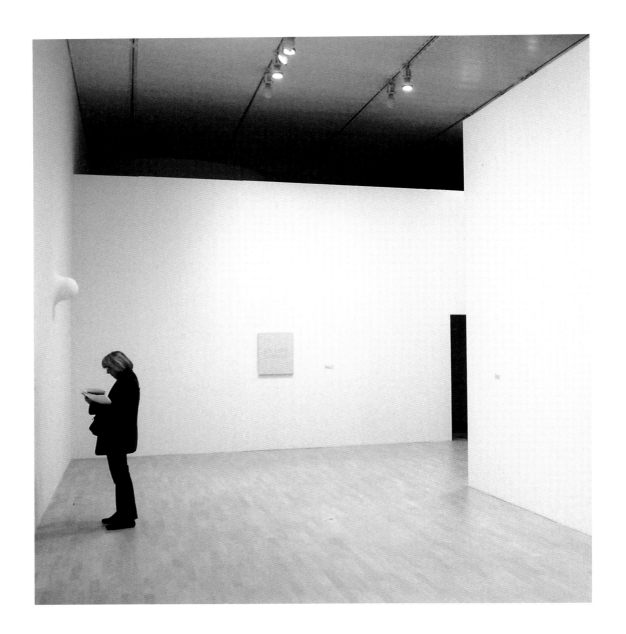

Work No. 135
A protrusion from a wall, 1996
Aluminium, paint
10 × 20 in / 25.4 × 50.8 cm
Edition of 3 + 1 AP
Installation at Kunstammlung Nordrhein-Westfalen, Düsseldorf, Germany, 2005

Appassionato

ff

Work No. 138
A love duet, 1996
Ink on paper
11.7 × 8.2 in / 29.7 × 21 cm
Unlimited edition

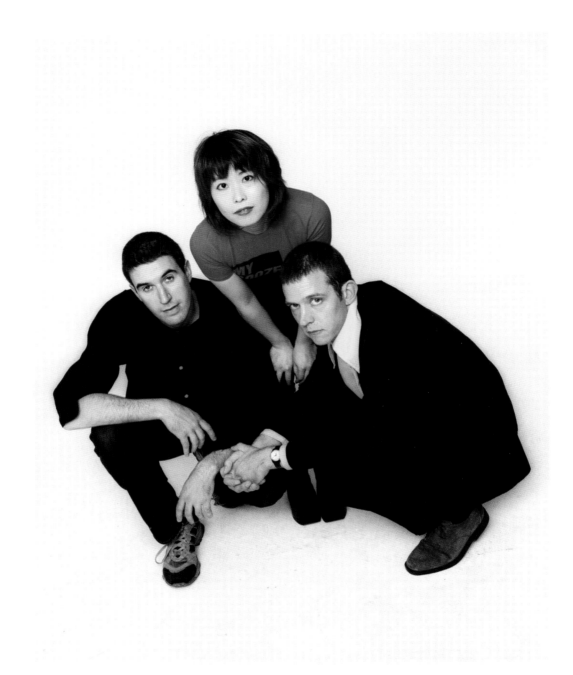

Work No. 139
1995
Piece for guitar, bass and drums
(Picture of the band Owada shown, from left to right, Adam McEwen on drums,
Keiko Owada on bass and Martin Creed on guitar and voice)

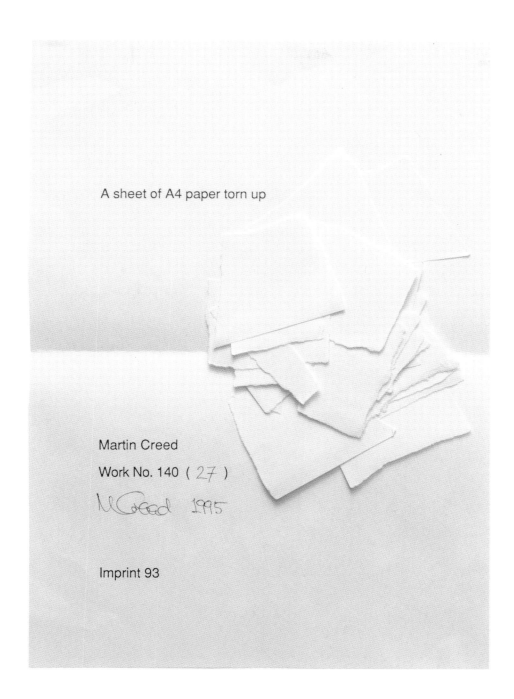

A sheet of A4 paper torn up

Martin Creed

Work No. 140 (27)

M Creed 1995

Imprint 93

Work No. 140
A sheet of A4 paper torn up, 1995
A4 paper
Dimensions variable
Unlimited edition

from none
take one
add one
make none

Work No. 141
From none take one add one make none, 1995–1999
Ink on paper
11.7 × 8.2 in / 29.7 × 21 cm
Edition of 10 + 2 AP

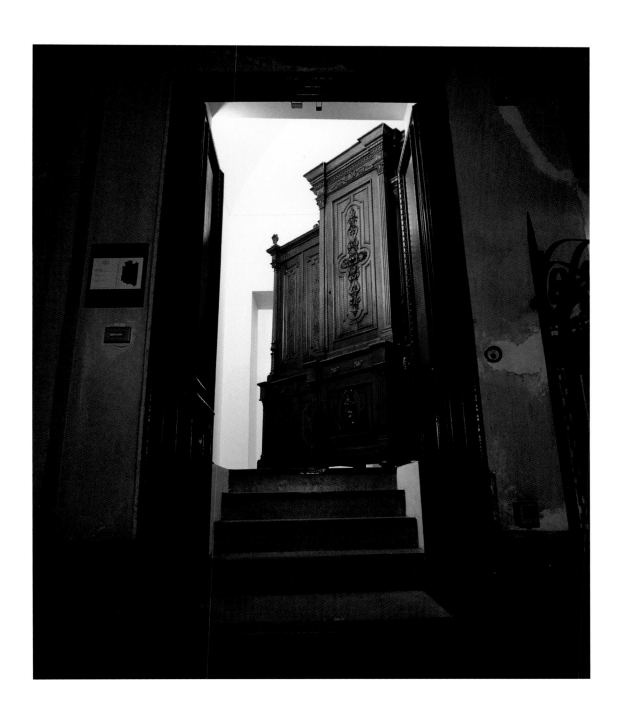

Work No. 142
A large piece of furniture partially obstructing a door, 1996–2002
Materials and dimensions variable
Edition of 10 + 1 AP
Installation at Alberto Peola Arte Contemporanea, Turin, Italy, 2002

the whole world + the work = the whole world

Work No. 143
the whole world + the work = the whole world, 1996
Ink on paper
11.7 × 8.2 in / 29.7 × 21 cm
Unlimited edition

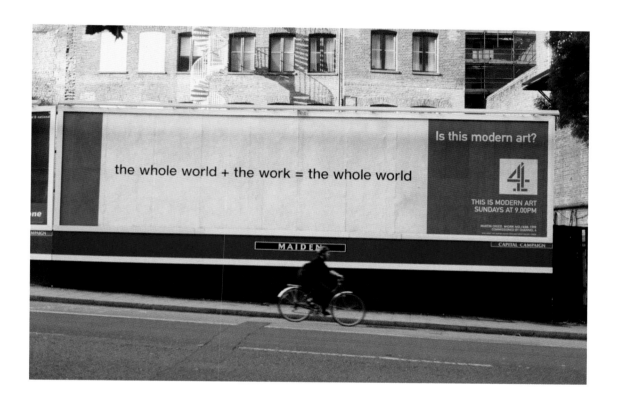

Work No. 143b
the whole world + the work = the whole world, 1998
Billboard
Approximately 10 × 30 ft / 3 × 6 m
Installation at Farringdon Road, London, UK, 1998

Hello

hello

hello

hello

hello

hello

hello

hello

hello

Work No. 148

Hello, 1996

Song lyrics

half of anything multiplied by two

Work No. 152
1996
Masking tape, blue-print, window-mount, frame
Window 5.5 × 5.5 in / 14 × 14 cm

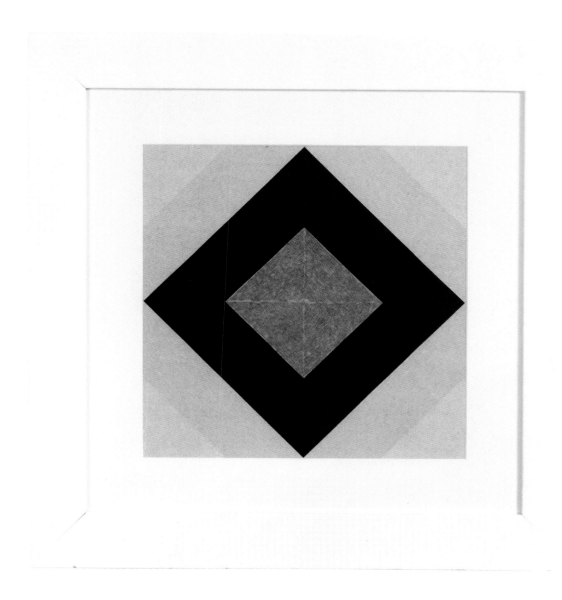

Work No. 153
1996
Masking tape, blue-print, window-mount, frame
Window 5.5 × 5.5 in / 14 × 14 cm

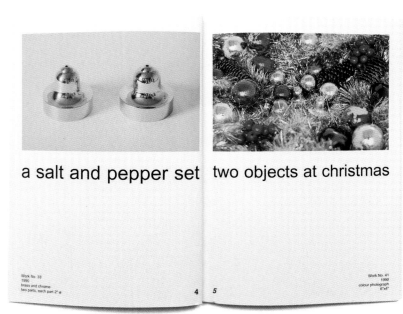

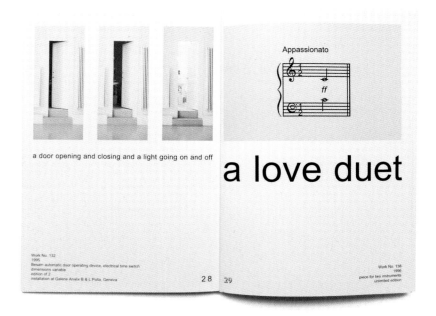

Work No. 157
the whole world + the work = the whole world, 1996
Catalogue
Published by Galerie Analix B & L Polla, and Karsten Schubert
5.8 × 8.2 in / 14.8 × 21 cm
(Two spreads shown)

something on the left, just as you come in, not too high or low

Work No. 158
Something on the left, just as you come in, not too high or low, 1996
Ink on paper
11.7 × 8.2 in / 29.7 × 21 cm
Edition of 10 + 1 AP

something in the middle of a wall

Work No. 160
The lights going on and off, 1996
Dimensions variable; 1 second on / 1 second off
Edition of 3 + 1 AP
Installation at Palazzo dell'Arengario, Milan, Italy, 2006

oh no

Work No. 161
Oh no, 1996
Ink on paper
11.7 × 8.2 in / 29.7 × 21 cm
Edition of 10 + 1 AP

ach nein

Work No. 162
Ach nein, 1996
Ink on paper
11.7 × 8.2 in / 29.7 × 21 cm
Edition of 10 + 1 AP

Tutti i suoni prodotti da una batteria elettronica suonati uno dopo l'altro nell'ordine dato, alla velocità di uno al secondo in una sequenza continua e ripetuta.

Work No. 163
1995
Announcement card
3.9 × 5.9 in / 10 × 15 cm
(Italian to English: All the sounds on a drum machine played one after the other,
in their given order, at a speed of one per second, in a continuous loop)

a doorstop fixed to a floor to let a door open only 45 degrees

Work No. 167
A doorstop fixed to a floor to let a door open only 45 degrees, 1996
Photographic print, ink, paper
6.6 × 8 in / 16.9 × 20.3 cm

on a tiled floor, in an awkward place, a cubic stack of tiles built on top of one of the existing tiles

Work No. 168
On a tiled floor, in an awkward place, a cubic stack of tiles built on top of the existing tiles, 1996
Photographic print, ink, paper
6.5 × 8 in / 16.7 × 20.3 cm
Edition of 10 + 1 AP

lights on lights off

Work No. 170
Lights on / lights off, 1996
Photographic prints, ink, paper
2 parts, each 4 × 6 in / 10.1 × 15.2 cm
Edition of 2 + 1 AP

a doorstop fixed to a floor to let a door open only 30 degrees

Work No. 171
A doorstop fixed to a floor to let a door open only 30 degrees, 1996
Photographic print, ink, paper
6.6 × 8 in / 16.9 × 20.3 cm

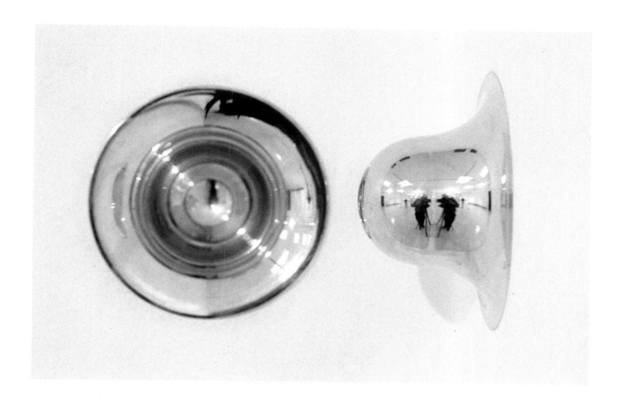

Work No. 172
An intrusion and a protrusion from a wall, 1997–2000
Silver in / silver out; internal corner
2 parts, each 4 in / 10.1 cm diameter
Edition of 2 + 1 AP

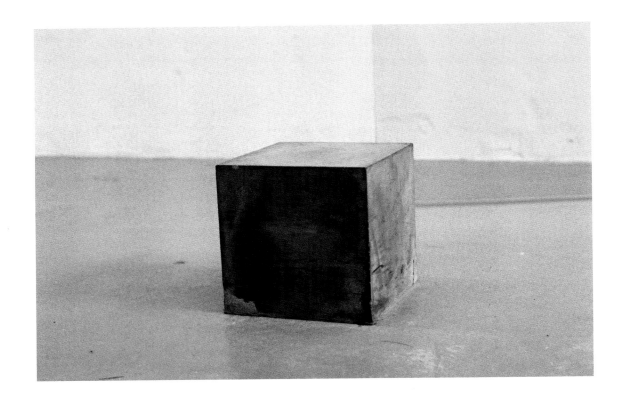

Work No. 173
1997
Concrete
3.9 × 3.9 × 3.9 in / 10 × 10 × 10 cm
Edition of 10 + 2 AP

extra bit

Work No. 174
Extra bit, 1997
Ink on paper
11.7 × 8.2 in / 29.7 × 21 cm
Edition of 10 + 1 AP

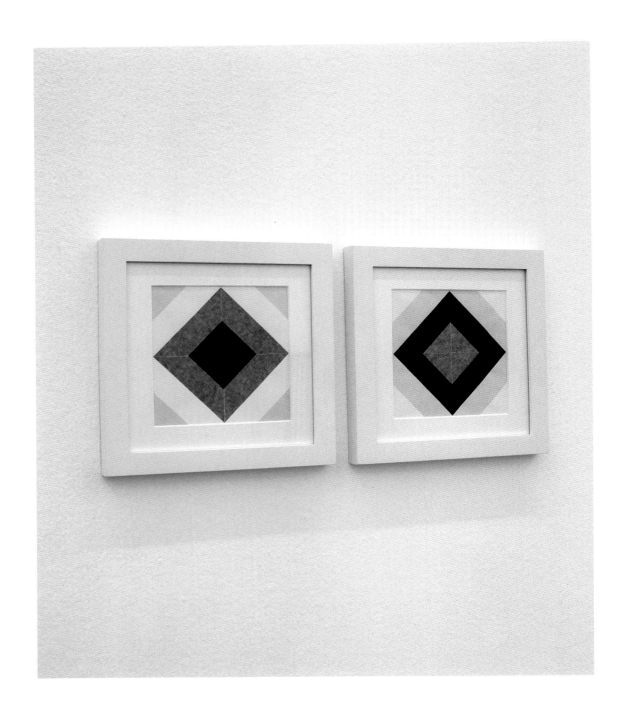

Work No. 175
Two drawings, 1997
Ink, masking tape, paper, window-mount, frame
2 parts, each window 5.5 × 5.5 in / 14 × 14 cm

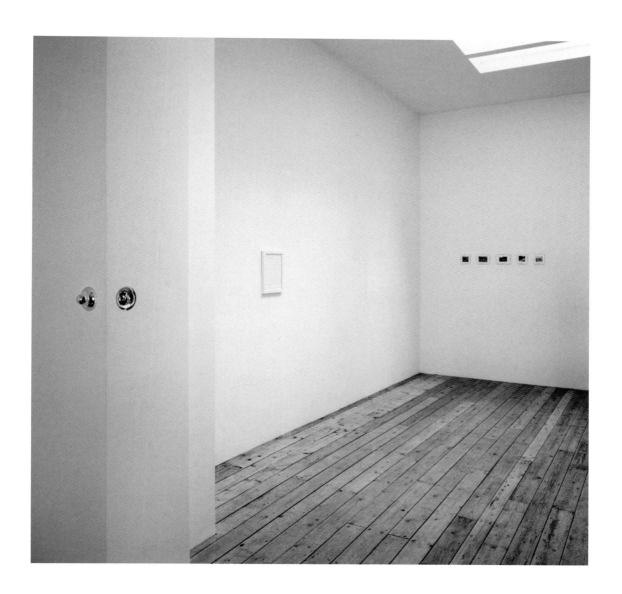

Work No. 177
An intrusion and a protrusion from a wall, 1997
Silver in / silver out; external corner
2 parts, each 4 in / 10.1 cm diameter
Edition of 2 + 1 AP
Installation at Galerie Mot & Van den Boogaard, Brussels, Belgium, 1997

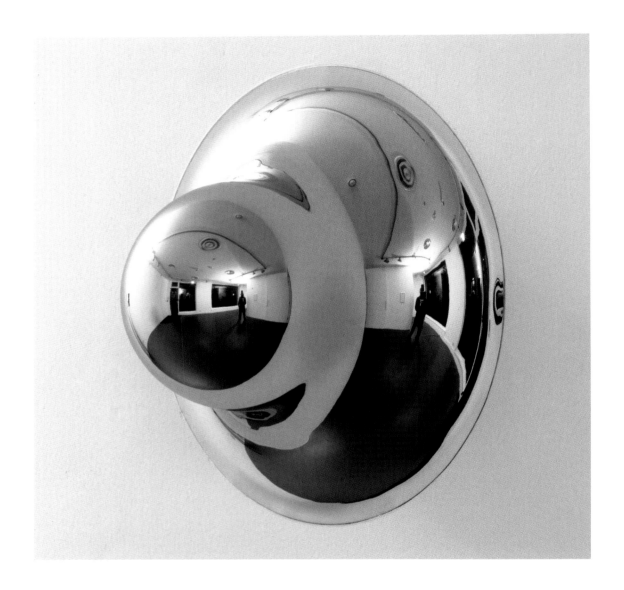

Work No. 178
A protrusion from a wall, 1997
Chrome-plated copper
10 × 20 in / 25.4 × 50.8 cm
Edition of 3 + 1 AP

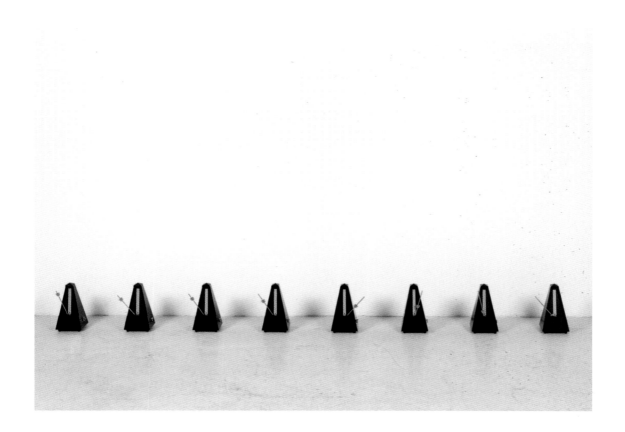

Work No. 180
Largo, larghetto, adagio, andante, moderato, allegro, presto, e prestissimo, 1995–2004
Mechanical metronomes
8 parts, each 4.5 in / 11.5 cm high; overall dimensions variable
Edition of 3 + 1 AP

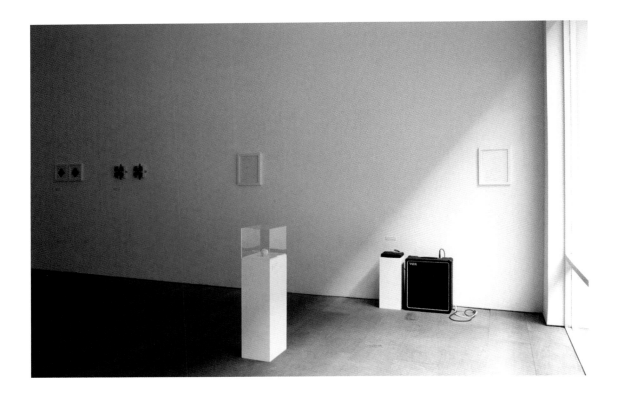

Work No. 182
All the sounds on a drum machine, 1997
Drum machine, amplifier
1 sound every 30 seconds
Installation at Victoria Miro Gallery, London, UK, 1997

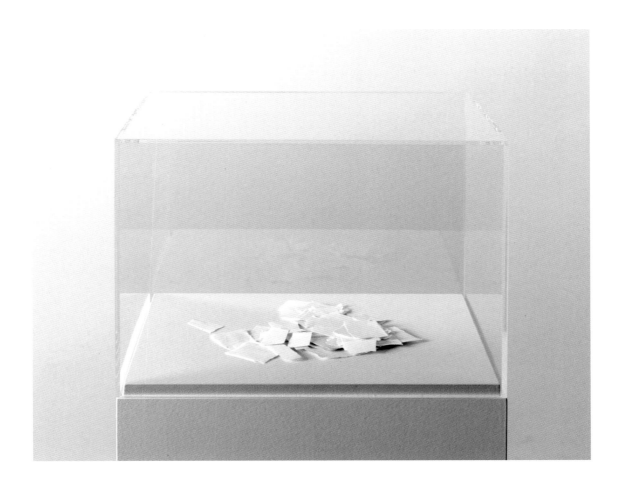

Work No. 183
A sheet of paper torn up, 1997
A4 paper, lid, plinth
Lid 11.7 × 8.2 × 8.2 in / 29.7 × 21 × 21 cm; plinth height variable
Edition of 4 + 1 AP

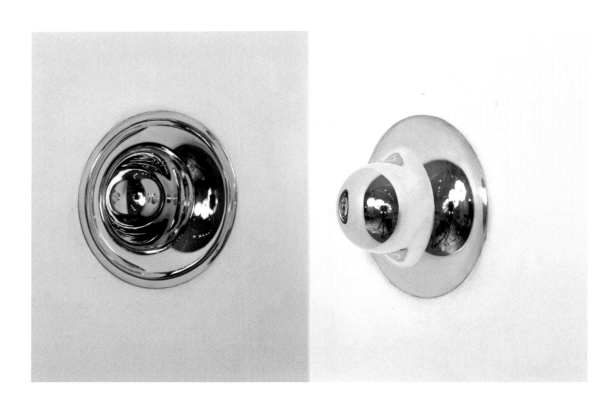

Work No. 184
An intrusion and a protrusion from a wall, 1997
Gold-plated silver in / silver out; internal corner
2 parts, each 4 in / 10.1 cm diameter
Edition of 2 + 1 AP

All dimensions inches
R = radius
R'= 5
R"=10

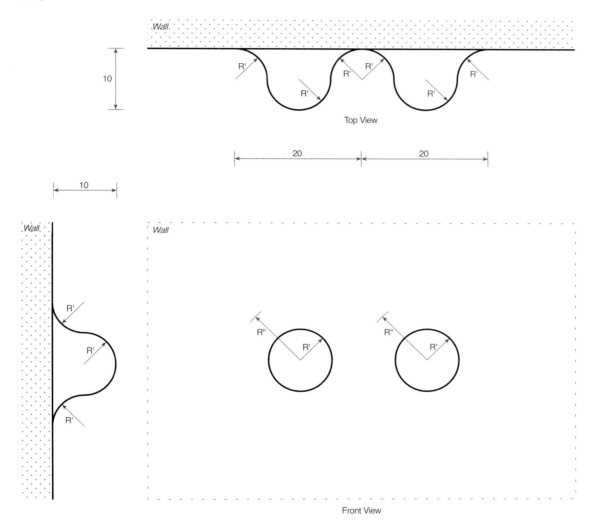

Top View

Front View

The finish of the protrusions should be identical to the finish of the wall. The joins between the protrusions and the wall should be seamless.

Work No. 188
Two protrusions from a wall, 1998
Aluminium, plaster, paint
2 parts, each 10 × 20 in / 25.4 × 50.8 cm
Edition of 3 + 1 AP
(Drawing shown)

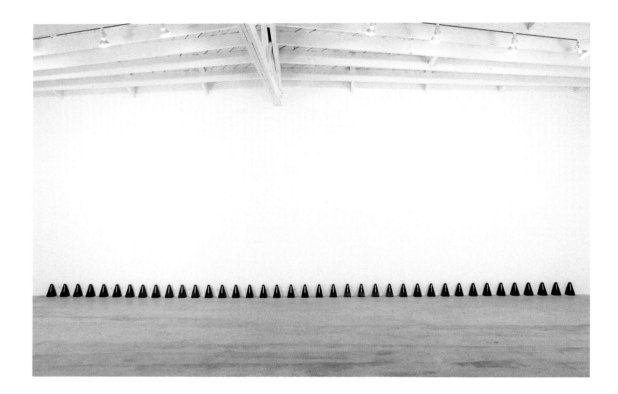

Work No. 189
Thirty-nine metronomes beating time, one at every speed, 1998
Mechanical metronomes
39 parts, each 4.5 in / 11.5 cm high; overall dimensions variable
Edition of 3 + 1 AP
Installation at Marc Foxx, Los Angeles, USA, 1999

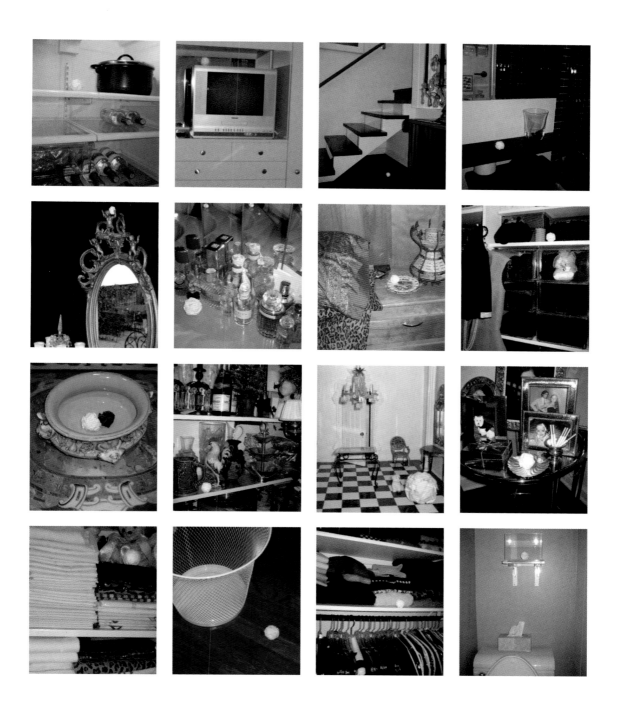

Work No. 190
A crumpled ball of paper in every room in a house, 1999–2002
White US letter paper
Multiple parts, each approximately 1.7 in / 4.5 cm diameter; overall dimensions variable
Edition of 10 + 1 AP
Installation in a private residence, Cincinnati, USA, 2002

Feeling Blue

I'm feeling low
I'm feeling down
I'm feeling blue
I'm feeling brown

I'm feeling orange
I'm feeling green
I'm feeling purple
I'm feeling cream

I'm feeling scarlet
I'm feeling loose
I'm feeling maroon
I'm feeling puce

I'm feeling black
I'm feeling dead
I'm feeling yellow
I'm feeling red

I'm feeling pink
I'm feeling light
I'm feeling buff
I'm feeling white

I'm feeling up
I'm feeling bright
I'm feeling clear
I'm feeling alright

I'm feeling off-white
I'm feeling grey
I'm feeling mixed-up
I'm feeling okay

Work No. 191
Feeling blue, 1994–1996
Song lyrics

thirty thirty

one two three four five six seven
eight nine ten eleven twelve thir-
teen fourteen fifteen sixteen se-
venteen eighteen nineteen twenty
twenty-one twenty-two twenty-
three twenty-four twenty-five twen-
ty-six twenty-seven twenty-
eight twenty-nine thirty thirty

three four eight nine leven twelve thir
one twen three twen twenty-five twen
twenty eight twen thirty thirty
teen fif venteen nineteen twenty

one twen three twen twenty-five twen
three four eight nine leven twelve thir
teen fif venteen nineteen twenty
twenty eight twen thirty thirty

one two three four five six seven
eight nine ten eleven twelve thir-
teen fourteen fifteen sixteen se-
venteen eighteen nineteen twenty
twenty-one twenty-two twenty-
three twenty-four twenty-five twen-
ty-six twenty-seven twenty-
eight twenty-nine thirty thirty

Work No. 192
Thirty thirty, 1994–1996
Song lyrics

One Whole Song

One whole to go
Seven-eighths to go
Three-quarters to go
Five-eighths to go
One half to go
Three-eighths to go
One quarter to go
One-eighth to go
Nothing to go

Work No. 193
One whole song, 1995–1996
Song lyrics

Nothing

Nothing
Nothing
Nothing
Nothing
Nothing
Nothing
Nothing
Nothing
Nothing
Nothing
Nothing
Nothing
Nothing
Nothing
Nothing
Nothing
Nothing
Nothing
Nothing
Nothing
Nothing
Nothing
Nothing
Nothing
Nothing
Nothing

Work No. 194
Nothing, 1995–1996
Song lyrics

1–100

one	twenty-six	fifty-one	seventy-six
two	twenty-seven	fifty-two	seventy-seven
three	twenty-eight	fifty-three	seventy-eight
four	twenty-nine	fifty-four	seventy-nine
five	thirty	fifty-five	eighty
six	thirty-one	fifty-six	eighty-one
seven	thirty-two	fifty-seven	eighty-two
eight	thirty-three	fifty-eight	eighty-three
nine	thirty-four	fifty-nine	eighty-four
ten	thirty-five	sixty	eighty-five
eleven	thirty-six	sixty-one	eighty-six
twelve	thirty-seven	sixty-two	eighty-seven
thirteen	thirty-eight	sixty-three	eighty-eight
fourteen	thirty-nine	sixty-four	eighty-nine
fifteen	forty	sixty-five	ninety
sixteen	forty-one	sixty-six	ninety-one
seventeen	forty-two	sixty-seven	ninety-two
eighteen	forty-three	sixty-eight	ninety-three
nineteen	forty-four	sixty-nine	ninety-four
twenty	forty-five	seventy	ninety-five
twenty-one	forty-six	seventy-one	ninety-six
twenty-two	forty-seven	seventy-two	ninety-seven
twenty-three	forty-eight	seventy-three	ninety-eight
twenty-four	forty-nine	seventy-four	ninety-nine
twenty-five	fifty	seventy-five	one hundred

Work No. 195
1–100, 1994–1995
Song lyrics

101–200

one hundred and one

one hundred and two

one hundred and three

one hundred and four

one hundred and five

one hundred and six

one hundred and seven

one hundred and eight

one hundred and nine

one hundred and ten

one hundred and eleven

one hundred and twelve

one hundred and thirteen

one hundred and fourteen

one hundred and fifteen

one hundred and sixteen

one hundred and seventeen

one hundred and eighteen

one hundred and nineteen

one hundred and twenty

one hundred and twenty-one

one hundred and twenty-two

one hundred and twenty-three

one hundred and twenty-four

one hundred and twenty-five

one hundred and twenty-six

one hundred and twenty-seven

one hundred and twenty-eight

one hundred and twenty-nine

one hundred and thirty

one hundred and thirty-one

one hundred and thirty-two

one hundred and thirty-three

one hundred and thirty-four

one hundred and thirty-five

one hundred and thirty-six

one hundred and thirty-seven

one hundred and thirty-eight

one hundred and thirty-nine

one hundred and forty

one hundred and forty-one

one hundred and forty-two

one hundred and forty-three

one hundred and forty-four

one hundred and forty-five

one hundred and forty-six

one hundred and forty-seven

one hundred and forty-eight

one hundred and forty-nine

one hundred and fifty

one hundred and fifty-one

one hundred and fifty-two

one hundred and fifty-three

one hundred and fifty-four

one hundred and fifty-five

one hundred and fifty-six

one hundred and fifty-seven

one hundred and fifty-eight

one hundred and fifty-nine

one hundred and sixty

one hundred and sixty-one

one hundred and sixty-two

one hundred and sixty-three

one hundred and sixty-four

one hundred and sixty-five

one hundred and sixty-six

one hundred and sixty-seven

one hundred and sixty-eight

one hundred and sixty-nine

one hundred and seventy

one hundred and seventy-one

one hundred and seventy-two

one hundred and seventy-three

one hundred and seventy-four

one hundred and seventy-five

one hundred and seventy-six

one hundred and seventy-seven

one hundred and seventy-eight

one hundred and seventy-nine

one hundred and eighty

one hundred and eighty-one

one hundred and eighty-two

one hundred and eighty-three

one hundred and eighty-four

one hundred and eighty-five

one hundred and eighty-six

one hundred and eighty-seven

one hundred and eighty-eight

one hundred and eighty-nine

one hundred and ninety

one hundred and ninety-one

one hundred and ninety-two

one hundred and ninety-three

one hundred and ninety-four

one hundred and ninety-five

one hundred and ninety-six

one hundred and ninety-seven

one hundred and ninety-eight

one hundred and ninety-nine

two hundred

Work No. 196
101–200, 1994–1995
Song lyrics

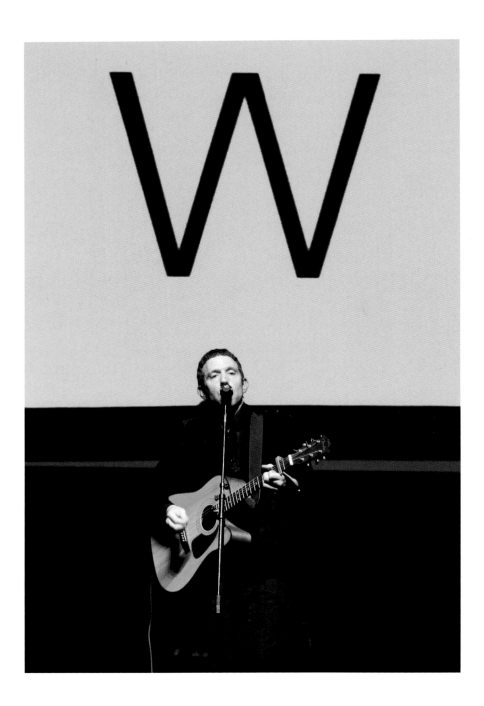

Work No. 197
A–Z, 1994–1996
Song lyrics
Shown in performance at The New Athenaeum Theatre, Royal Scottish Academy of Music and Drama,
Glasgow, UK, 2007

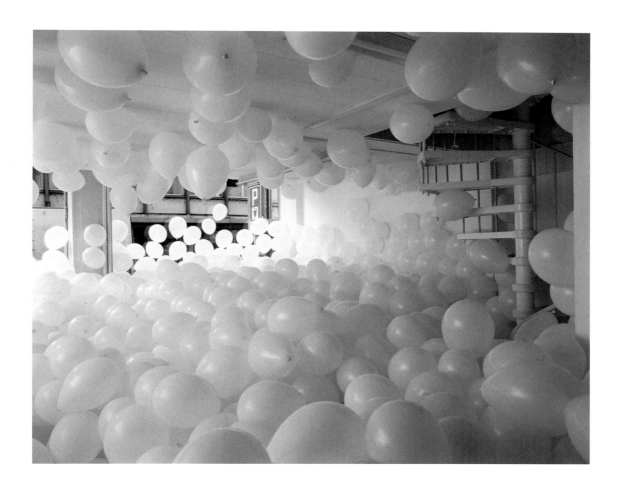

Work No. 200
Half the air in a given space, 1998
White balloons
Multiple parts, each balloon 12 in / 30.5 cm diameter; overall dimensions variable
Installation at Galerie Analix B & L Polla, Geneva, Switzerland, 1998
(Detail)

201

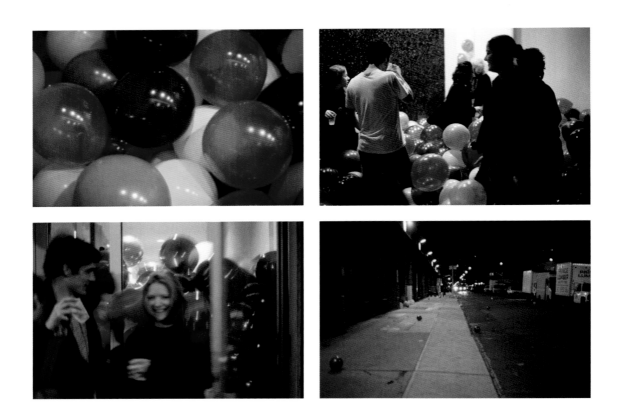

Work No. 201
Half the air in a given space, 1998
Multicoloured balloons
Multiple parts, each balloon 11 in / 28 cm; overall dimensions variable
Installation at Gavin Brown's enterprise, New York, USA, 1998
(Details)

Work No. 202
Half the air in a given space, 1998
Black balloons
Multiple parts, each balloon 12 in / 30.5 cm diameter; overall dimensions variable
Installation at Titanik, Turku, Finland, 1998

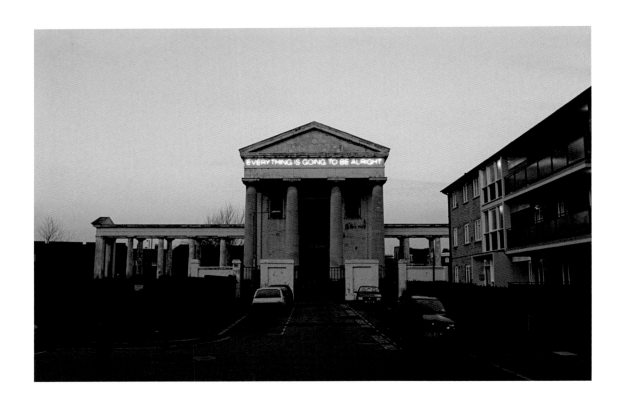

Work No. 203
EVERYTHING IS GOING TO BE ALRIGHT, 1999
White neon
1.6 × 42.6 ft / 0.5 × 13 m
Installation at The Portico, Linscott Road, London, UK, 1999
Commissioned by Ingrid Swenson

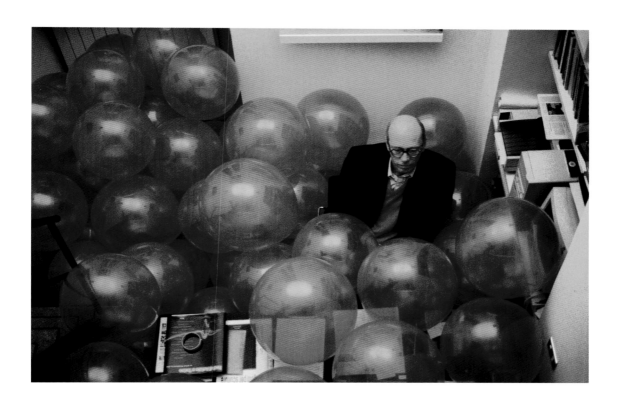

Work No. 204
Half the air in a given space, 1999
Red balloons
Multiple parts, each balloon 16 in / 40.6 cm diameter; overall dimensions variable
Installation at Alberto Peola Arte Contemporanea, Turin, Italy, 1999
(Detail)

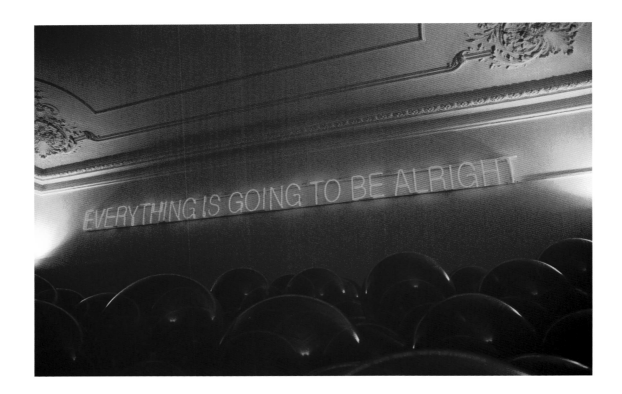

Work No. 205
EVERYTHING IS GOING TO BE ALRIGHT, 1999
Red neon
0.75 × 16.4 ft / 0.25 × 5 m
Installation at Alberto Peola Arte Contemporanea, Turin, Italy, 1999

I Like Things

I like things a lot	I like things a lot
I like things a lot	I like things a lot
I feel very well	I feel very well
I feel very well	I feel very well
I feel positive	I feel positive
I like things a lot	I like things a lot
I like things	I like things
I like things	I like things
I like things	I like things
I like things	I like things
I like things	I like things
I like things	I like things
I like things	I like things
I'm happy	I'm happy
Happy	Happy
Happy	Happy
Liking	Liking
Liking	Liking
Things	Things
Things	Things
Yeah	No
Yeah	No

Work No. 207
I like things, 1994–1999
Piece for voice, guitar, bass and drums
(Lyrics shown)

Nothing Is Something / Blow And Suck

From none	No
Take one	More
Add one	Less
Make one	Yes
To none	From none
Add three	To some
Take two	To none
Make one	
	Add up
From one	Get up
Take N	Take up
Add S	Make up
And M	Keep up
	Keep up
Make some	Keep up
From none	Keep up
Take some	Stay up
Make none	Grow up
	Give up
From none	Let up
To some	
From some	And blow
To none	And suck
	And blow
None	And suck
Some	And blow
More	And suck
Less	And blow
	And suck
Blow	
Suck	
Blow	
Suck	

Work No. 208
Nothing is something / Blow and suck, c. 1997–1999
Piece for voice, guitar, bass and drums
(Lyrics shown)

I Can't Move

I can't move

I can't move

I can't move

I can't move

I can't move (move)

I can't move

I can't move

I can't move

I can't move

I can't do things

I want things to happen to me

I want to let go of things

I want to be free

I want you to leave me

I want you to see me

I want you to be with me

AEIOU

AEIOU

Work No. 209
I can't move, c. 1997–1999
Piece for voice, guitar, bass and drums
(Lyrics shown)

Work No. 210
Half the air in a given space, 1999
White balloons
Multiple parts, each balloon 16 in / 40.6 cm diameter; overall dimensions variable
Installation at Cabinet Gallery, London, UK, 1999
(Detail)

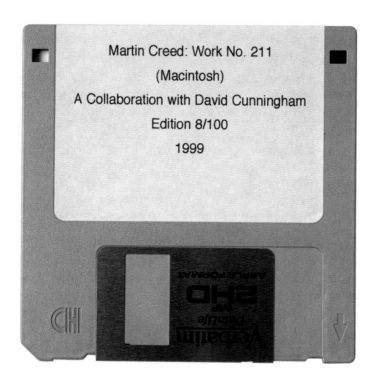

Work No. 211
Fuck off, 1999
Floppy disk containing alert sound for Macintosh or Windows
In collaboration with David Cunningham
3.6 × 3.5 in / 9.3 × 9 cm
Edition of 100 + 10 AP

Give Me Something To Say

Numbers instead of words
Letters instead of other letters
2 instead of too
4 instead of four
Z instead of S
U instead of you

Give me something to say
Give me coffee all day
Give me tea
Give me three
Give me five
Give me ten
Give me high
Give me low
Give me up
Give me down
Give me length
Give me breadth
Give me height
Give me depth

Give me other things as well
Give me other things too
Give me different things for free
Give me a wide variety of things, for

Things,
Things are like other things
And it doesn't matter very much
Cos they're all the same

And things are going well
And other things as well
Things are going well
And other things as well

Work No. 212
Give me something to say, 1997–1999
Piece for voice, guitar, bass and drums
(Lyrics shown)

S.O.N.G.

I.N.T.R.O.D.U.C.T.I.O.N
F.I.R.S.T.V.E.R.S.E
C.H.O.R.U.S
S.E.C.O.N.D.V.E.R.S.E
C.H.O.R.U.S
R.E.P.E.A.T.C.H.O.R.U.S
E.T.C.E.T.E.R.A
E.T.C.E.T.E.R.A.E.T.C.E.T.E.R.A

Work No. 214
S.O.N.G., 1997–1999
Piece for voice, guitar, bass and drums
(Lyrics shown)

You're The One For Me

One two three four

One, two, three, four,
Five

I'm the one for you
I'm your two
You're the one for me
You're my three

We make

One, two, three, four,
Five

You make me laugh
You make me cry
You make me try
You make me high

You're my sign
You're my time
You're my rhyme
You're my nine

One, two, three, four,
Five, six, seven, eight,
Nine

You make me talk
You make me think
You make me smoke
You make me drink

You're like depth
You're like height
You're like light
You're like sight

You help me see
You make me free
You let me be
You make me me

I'm the one for you
I'm your two
You're the one for me
You're my three

I love the way you do things
And I love the way you don't

Work No. 215
You're the one for me, 1998–1999
Piece for voice, guitar, bass and drums
(Lyrics shown)

Be Natural

B

B
B sharp
B flat
B natural

B
B sharp
B flat
B natural

B
B sharp
B flat
B natural

B
B sharp
B flat
B natural

Work No. 216
Be natural, 1998–1999
Piece for voice, guitar, bass and drums
(Lyrics shown)

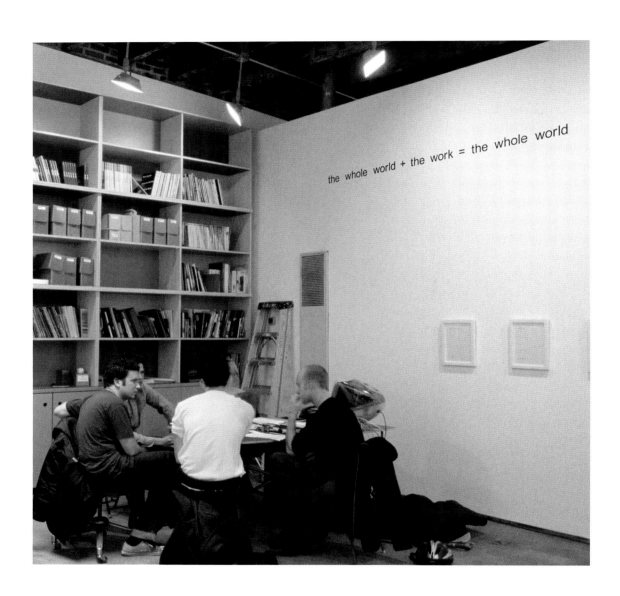

Work No. 217
the whole world + the work = the whole world, 1999
Vinyl letters
3 in / 7.5 cm high
Edition of 10 + 1 AP
Installation at Gavin Brown's enterprise, New York, USA, 2000

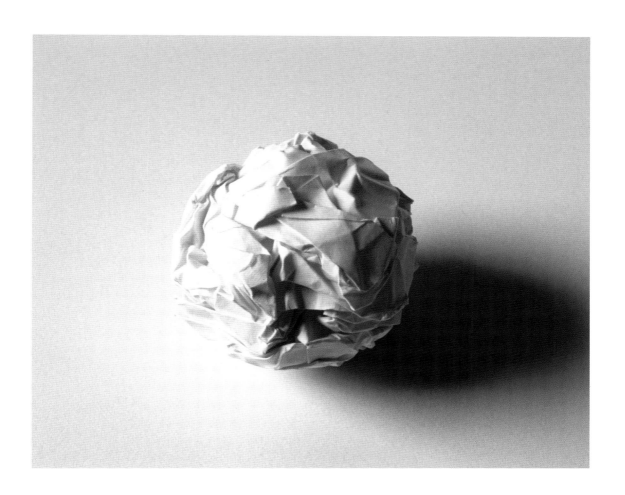

Work No. 218
A sheet of paper crumpled into a ball, 1999
US letter paper
Approximately 2 in / 5 cm diameter
Edition of 100 + 10 AP

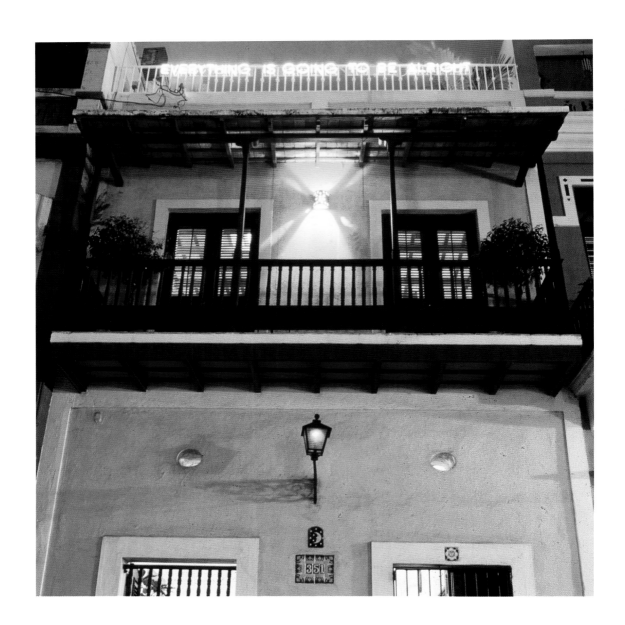

Work No. 219
EVERYTHING IS GOING TO BE ALRIGHT, 1999
Blue neon
Approximately 0.8 × 20 ft / 0.25 × 6.5 m
Installation at a private residence, San Juan, Puerto Rico, 1999

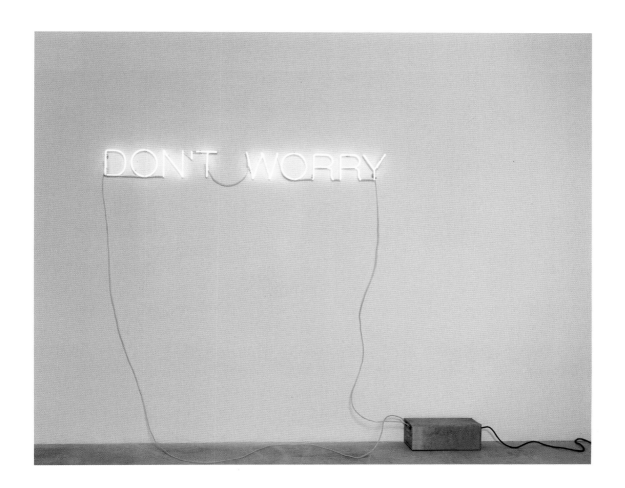

Work No. 220
DON'T WORRY, 1999–2002
White neon
7.9 in / 20 cm high
Edition of 3 + 1 AP
Installation at Marc Foxx, Los Angeles, USA, 1999

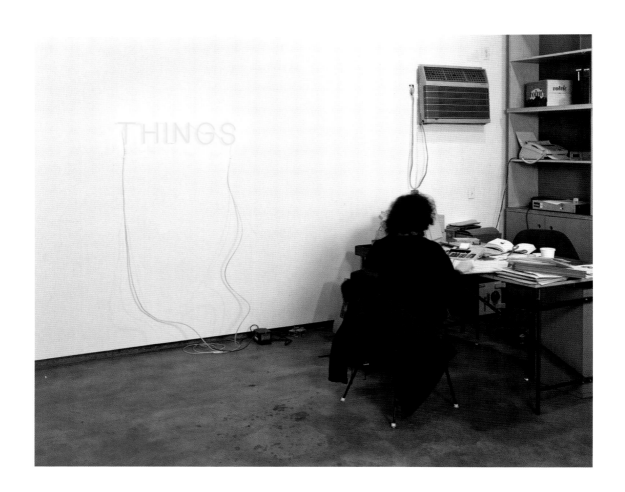

Work No. 221
THINGS, 1999
Yellow neon
6 in / 15.2 cm high; 1 second on / 1 second off
Installation at Gavin Brown's enterprise, New York, USA, 1999

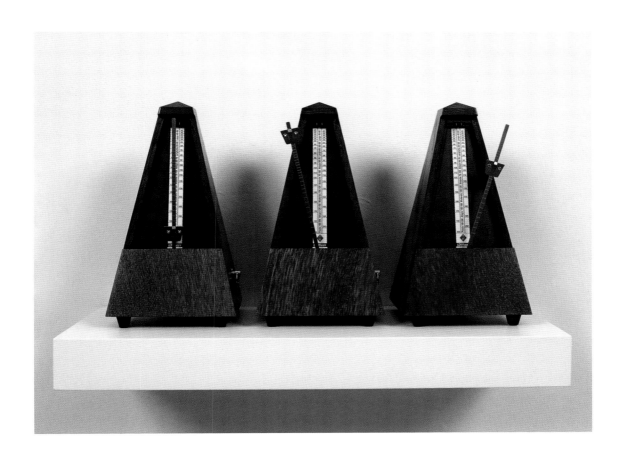

Work No. 223
Three metronomes beating time, one quickly, one slowly, and one neither quickly nor slowly, 1999
Mechanical metronomes
3 parts, each 4.5 in / 11.5 cm high; overall dimensions variable
Edition of 9 + 1 AP

big things in small rooms

Work No. 224
Big things in small rooms, 2000
Ink on paper
11.7 × 8.2 in / 29.7 × 21 cm
Edition of 10 + 2 AP

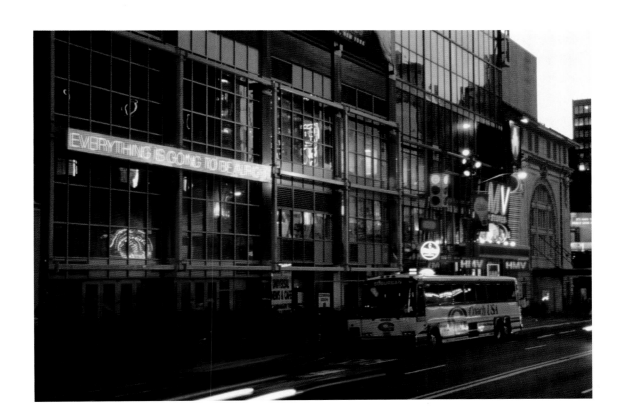

Work No. 225
EVERYTHING IS GOING TO BE ALRIGHT, 1999
Red neon
7 ft / 2.13 m high
Installation at 42nd Street, Times Square, New York, USA, 1999
Commissioned by Public Art Fund, New York

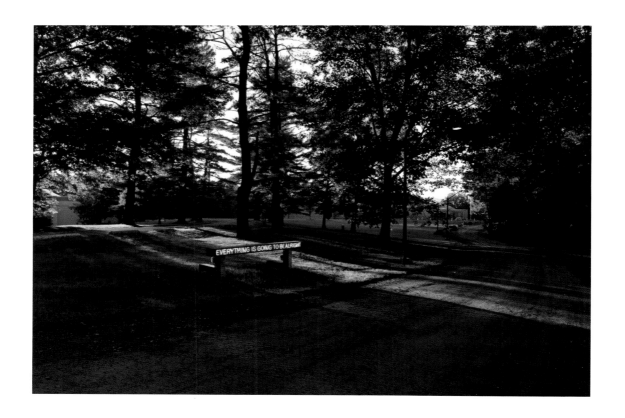

Work No. 226
EVERYTHING IS GOING TO BE ALRIGHT, 2000
White neon
4 in / 10.1 cm high
Installation at CCS Bard Hessel Museum, Annandale-on-Hudson, USA, 2007

Work No. 227
The lights going on and off, 2000
Dimensions variable; 5 seconds on / 5 seconds off
Edition of 3 + 1 AP
Installation at The Museum of Modern Art, New York, USA, 2007

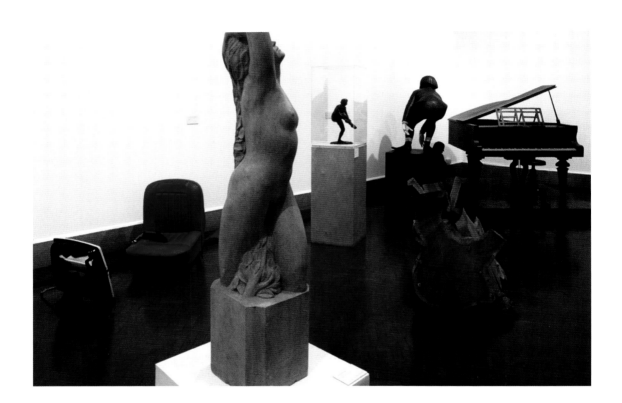

Work No. 228
All of the sculpture in a collection, 2000
Materials and dimensions variable
Edition of 3 + 1 AP
Installation at Southampton City Art Gallery, UK, 2000
(Detail)

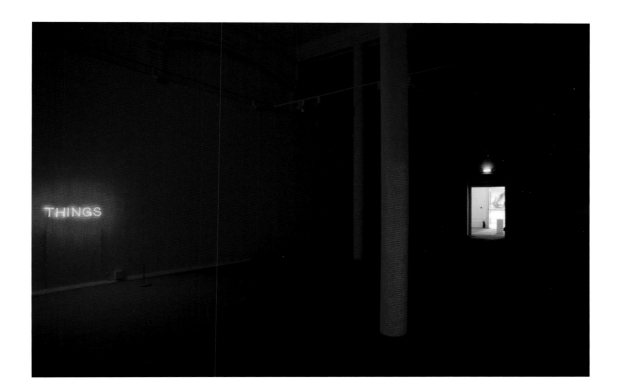

Work No. 231
THINGS, 2000
Red neon
6 in / 15.2 cm high; 5 seconds on / 5 seconds off
Edition of 3 + 1 AP

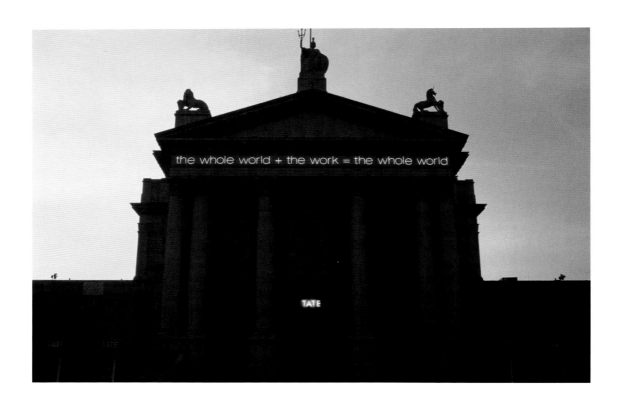

Work No. 232
the whole world + the work = the whole world, 2000
White neon
1.6 × 51 ft / 0.5 × 15.5 m
Installation at Tate Britain, London, UK, 2000

fuck off

Work No. 235
Fuck off, 2000
Ink on paper
11.7 × 8.2 in / 29.7 × 21 cm
Edition of 10 + 1 AP

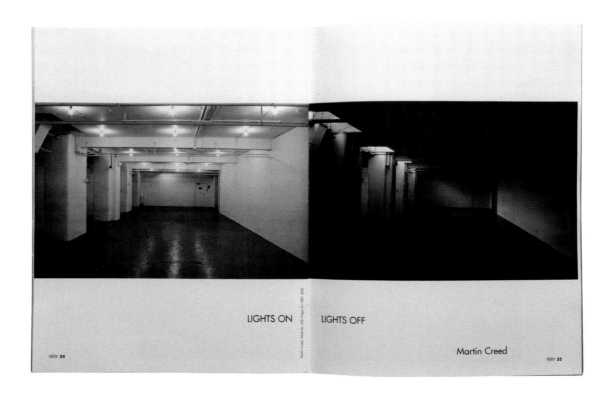

LIGHTS ON LIGHTS OFF

Martin Creed

VERY **34** VERY **35**

Work No. 236
LIGHTS ON / LIGHTS OFF, 2000
Spread for *VERY* magazine
11 × 18.5 in / 28 × 47 cm

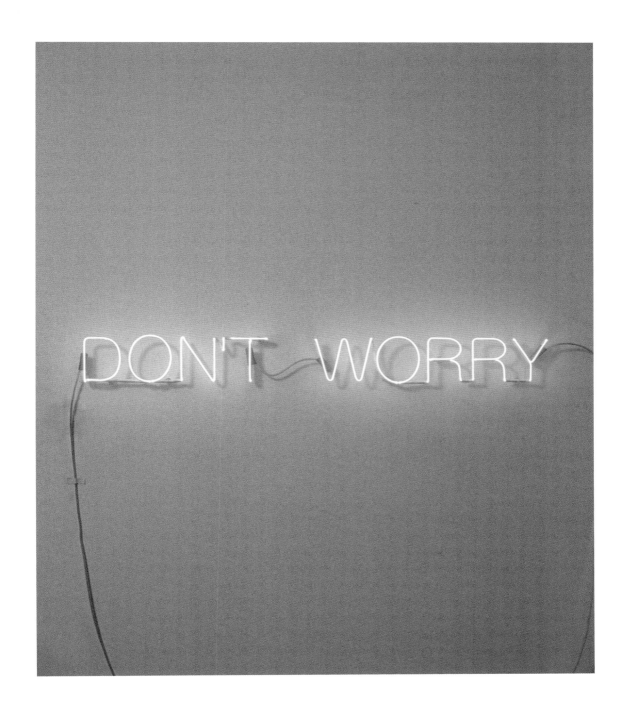

Work No. 239
DON'T WORRY, 2000
Blue neon
6 in / 15.2 cm high
Edition of 3 + 1 AP

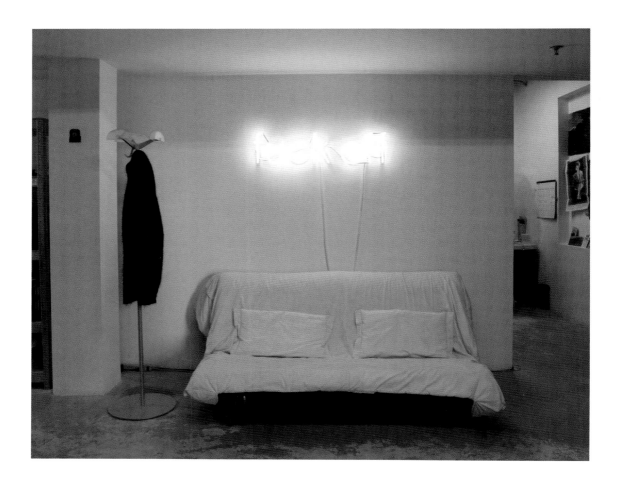

Work No. 240
Fuck off, 2000
White neon
8.5 in / 21.5 cm high
Edition of 3 + 1 AP
Installation in a private residence, Miami, USA, 2007

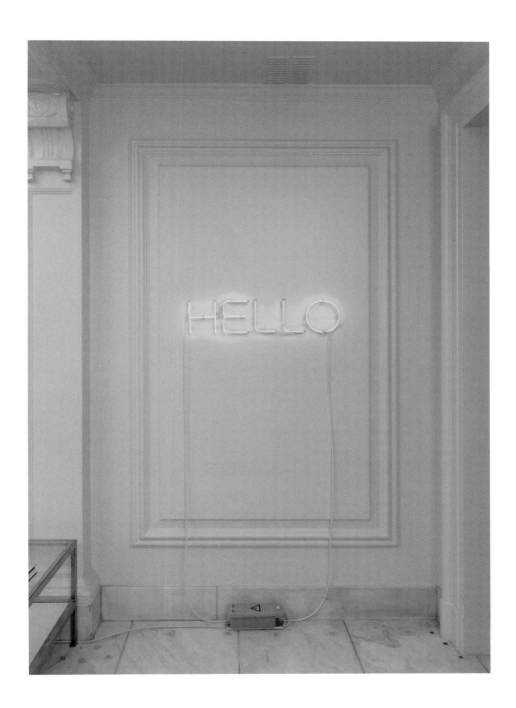

Work No. 243
HELLO, 2000
Red neon
6 in / 15.2 cm high
Edition of 3 + 1 AP
Installation at Hauser & Wirth London, London, UK, 2008

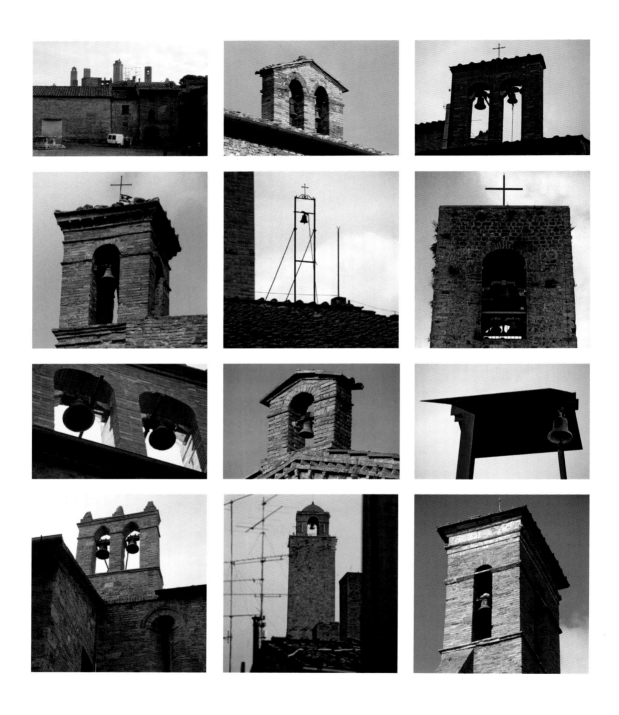

Work No. 245
All of the bells in a city or town rung as quickly and as loudly as possible for three minutes, 2000
Installation in San Gimignano, Italy, 2000

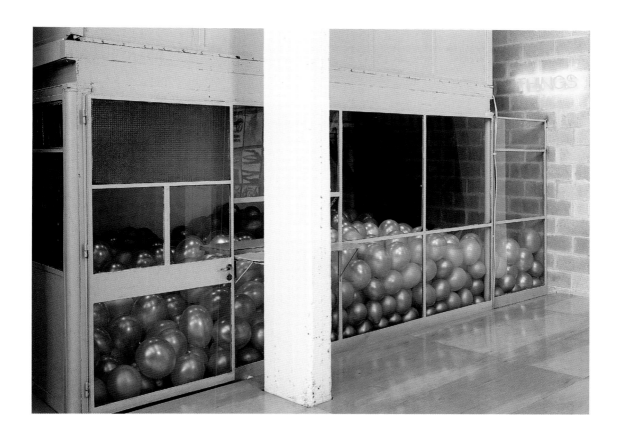

Work No. 247
Half the air in a given space, 2000
Light-blue balloons
Multiple parts, each balloon 16 in / 40.6 cm diameter; overall dimensions variable
Installation at the Pat and Juan Vergez Collection, Buenos Aires, Argentina

Work No. 248
2000
Poster
Approximately 6 × 2 ft / 1.8 × 0.6 m
Installation in San Gimignano, Italy, 2000

Work No. 251
THINGS, 2000
Blue neon
6 in / 15.2 cm high; 1 second on / 1 second off
Edition of 3 + 1 AP
Installation at Cologne Art Fair, Cologne, Germany, 2000

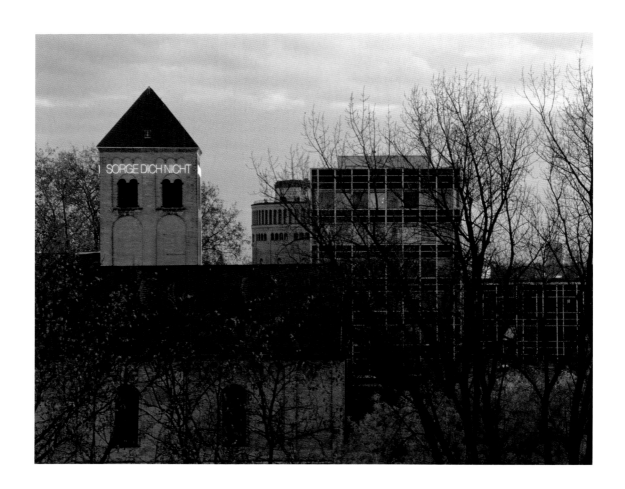

Work No. 252
NOLI SOLICITUS ESSE / SORGE DICH NICHT / DON'T WORRY / MH MEPIMNA, 2000
White neon
4 parts, each 4.2 × 19.7 ft / 1.3 × 6 m
Installation at St Peter's Church, Cologne, Germany, 2000
(Detail)

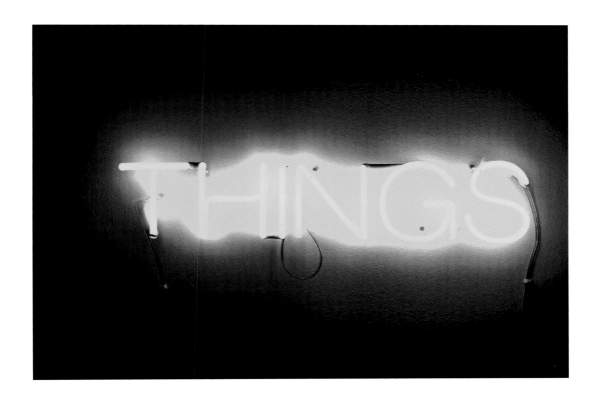

Work No. 253
THINGS, 2000
Yellow neon
6 in / 15.2 cm high
Edition of 3 + 1 AP

Work No. 254
The lights in a building going on and off, 2000
Materials and dimensions variable; 1 second on / 1 second off
Edition of 3 + 1 AP
Installation at Camden Arts Centre, London, UK, 2000

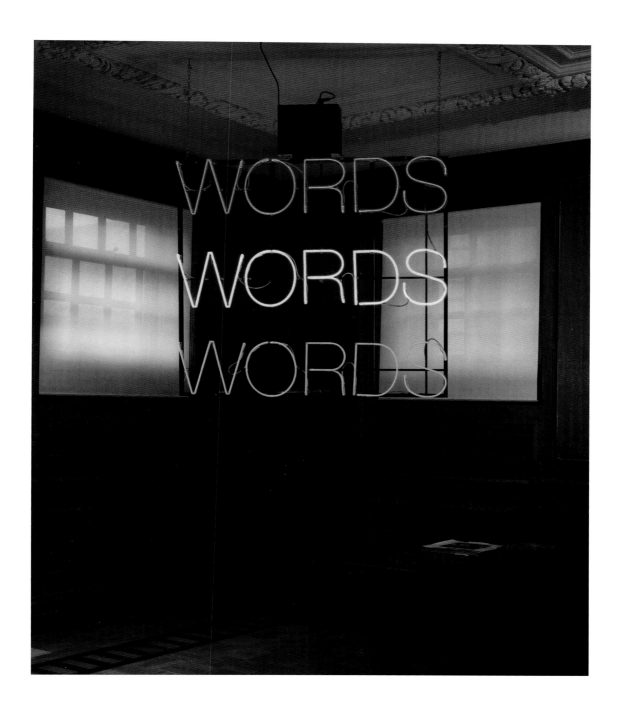

Work No. 259
WORDS WORDS WORDS, 2001
Red, yellow, blue neon
4.5 × 5.25 × 0.8 ft / 1.3 × 1.6 × 0.25 m; flashing
Edition of 3 + 1 AP
Installation at Hauser & Wirth London, London, UK, 2008

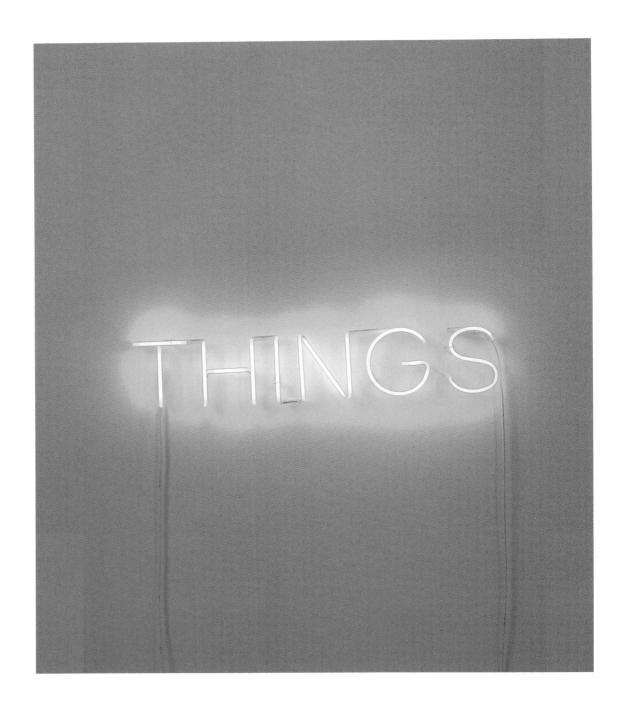

Work No. 260
THINGS, 2001
Green neon
6 in / 15.2 cm high
Edition of 3 + 1 AP

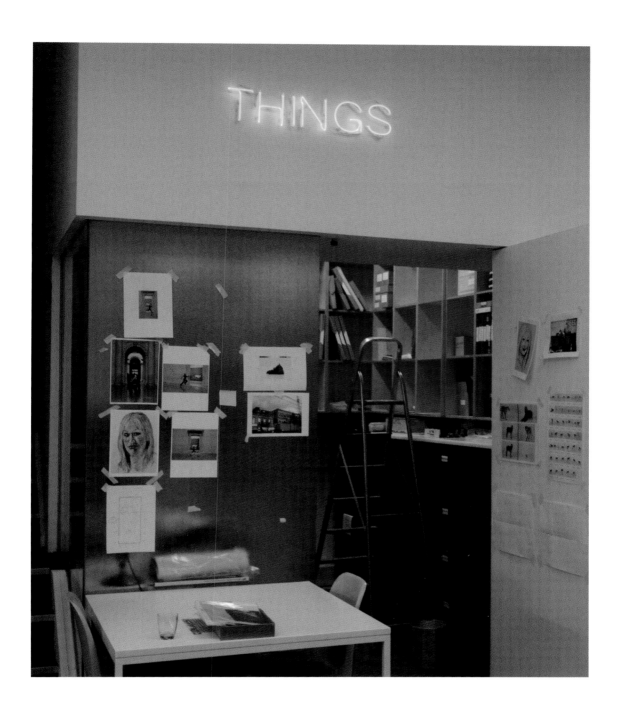

Work No. 261
THINGS, 2001
Blue neon
6 in / 15.2 cm high
Edition of 3 + 1 AP
Installation at the artist's studio, London, UK, 2009

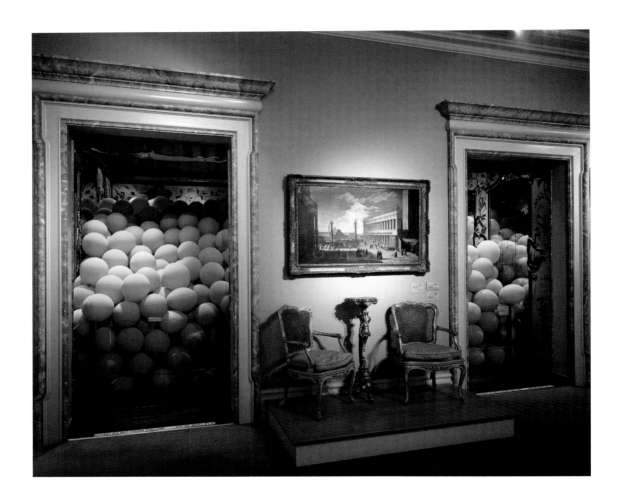

Work No. 262
2001
Green balloons
Multiple parts, each balloon 16 in / 40.6 cm diameter; overall dimensions variable
Installation at The Israel Museum, Jerusalem, Israel, 2006

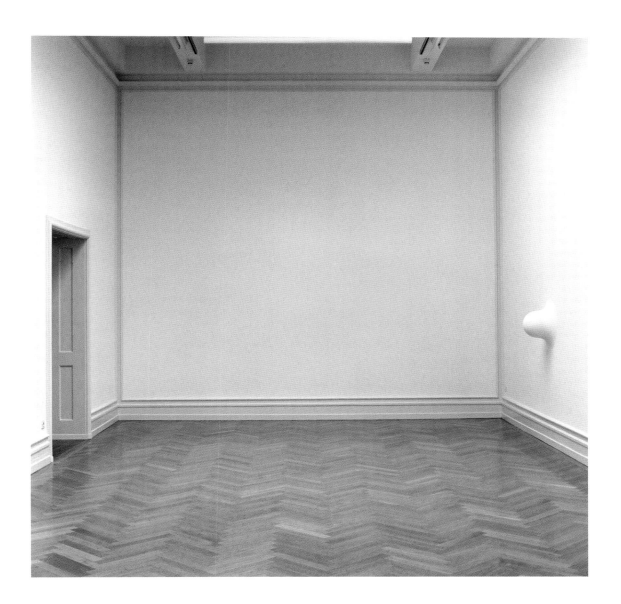

Work No. 263
A protrusion from a wall, 2001
Aluminium, plaster, paint
12 × 24 in / 30.5 × 61 cm
Edition of 9 + 1 AP
Installation at Kunsthalle Bern, Switzerland, 2003

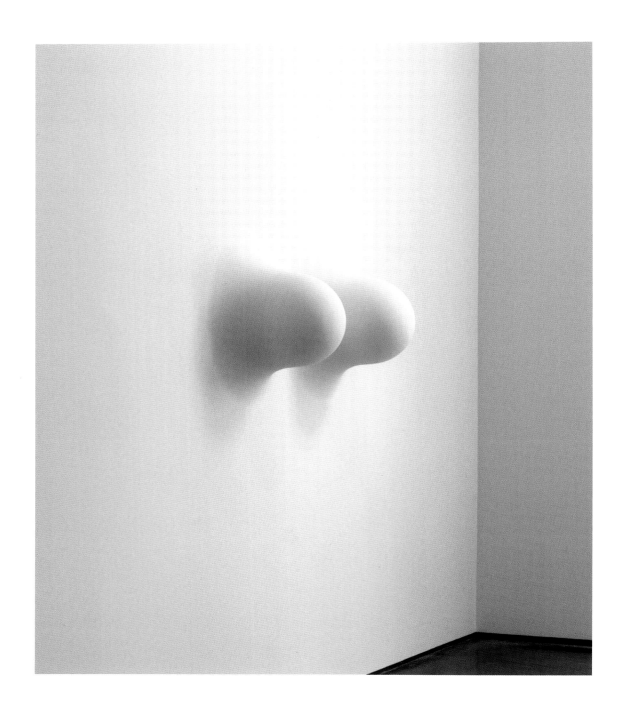

Work No. 264
Two protrusions from a wall, 2001
Aluminium, plaster, paint
2 parts, each 12 × 24 in / 30.5 × 61 cm
Installation at CCS Bard Hessel Museum, Annandale-on-Hudson, USA, 2007

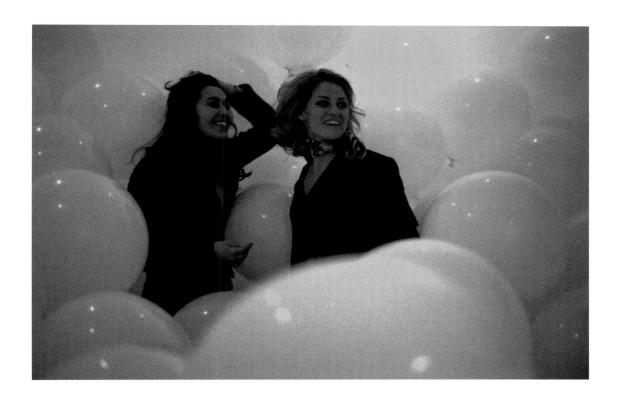

Work No. 265
2001
Yellow balloons
Multiple parts, each balloon 16 in / 40.6 cm diameter; overall dimensions variable
Installation at Micromuseum, Palermo, Italy, 2001
(Detail)

I don't know what I want to say

I don't know what I want to say, but, to try to say
something, I think I want to try to think.
I want to try to see what I think. I think trying is a
big part of it, I think thinking is a big part
of it, and I think wanting is a big part of it, but
saying it is difficult, and I find saying trying and
nearly always wanting. I want what I want to say
to go without saying.

Work No. 267
I don't know what I want to say, 2001
Text

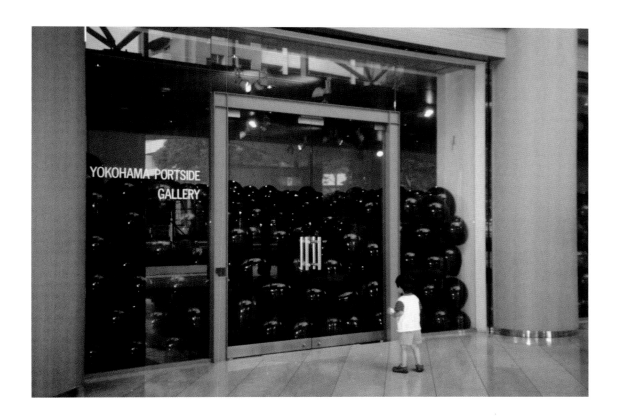

Work No. 268
2001
Black balloons
Multiple parts, each balloon 16 in / 40.6 cm diameter; overall dimensions variable
Installation at Yokohama Portside Gallery, Yokohama, Japan, 2001

270

Work No. 270
The lights off, 2001
Materials and dimensions variable
Edition of 3 + 1 AP
Installation at Galerie Johnen & Schöttle, Cologne, Germany, 2001

Work No. 271
On a tiled wall, in a useful place, a cubic stack of tiles built on top of one of the existing tiles, 2001
Tiles
Dimensions variable
Edition of 10 + 1 AP
Installation at Galerie Johnen & Schöttle, Cologne, Germany, 2001

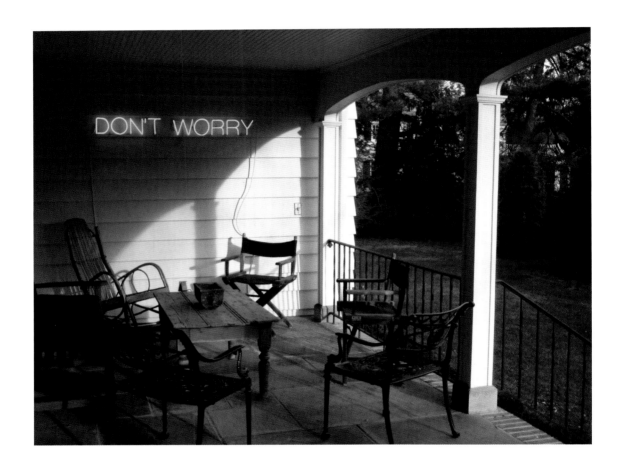

Work No. 273
DON'T WORRY, 2001
Yellow neon
6 in / 15.2 cm high
Edition of 3 + 1 AP
Installation at a private residence in New York, USA, 2006

Martin Creed Work No. 274: A–Z

Work No. 274
A–Z, 2002
Pages for *The Independent* newspaper
22.4 × 14.5 in / 57 × 37 cm
(Detail)

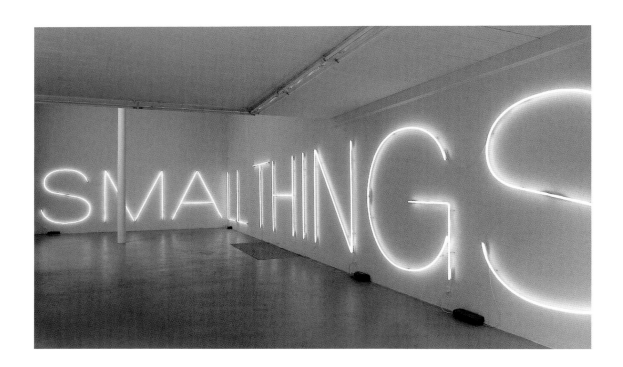

Work No. 275
SMALL THINGS, 2003
White neon
Approximately 5.5 × 65 ft / 1.7 × 20 m
Installation at Galerie Analix B & L Polla, Geneva, Switzerland, 2003

Work No. 276
The lights in a street going on and off, 2002
Dimensions variable; 1 second on / 1 second off
Installation in Bolzano, Italy, 2002

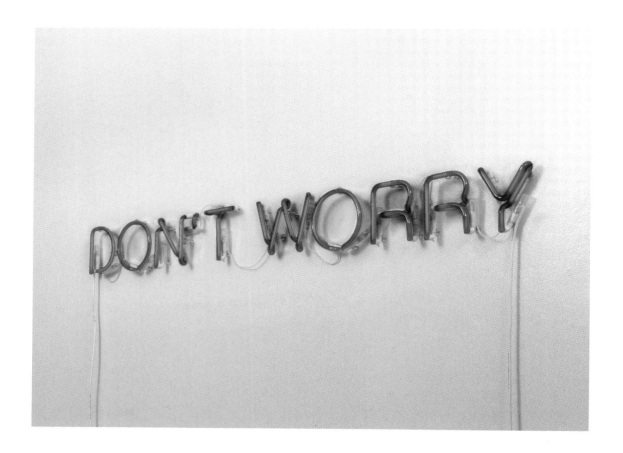

Work No. 277
DON'T WORRY, 2002–2003
Green neon
6 in / 15.2 cm high
Edition of 3 + 1 AP

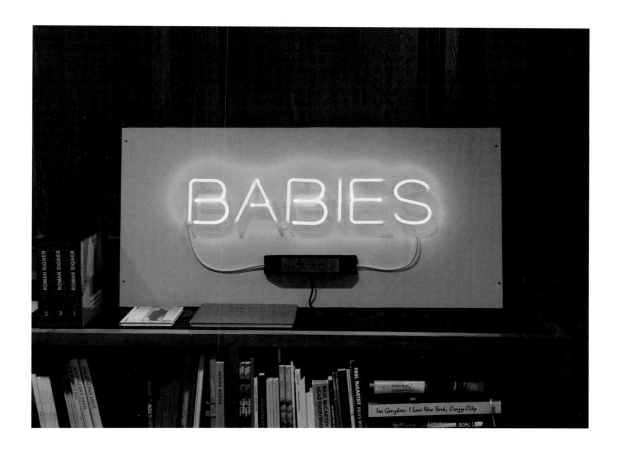

Work No. 279
BABIES, 2002
Orange neon
6 in / 15.2 cm high
Edition of 3 + 1 AP
Installation at Hauser & Wirth London, London, UK, 2008

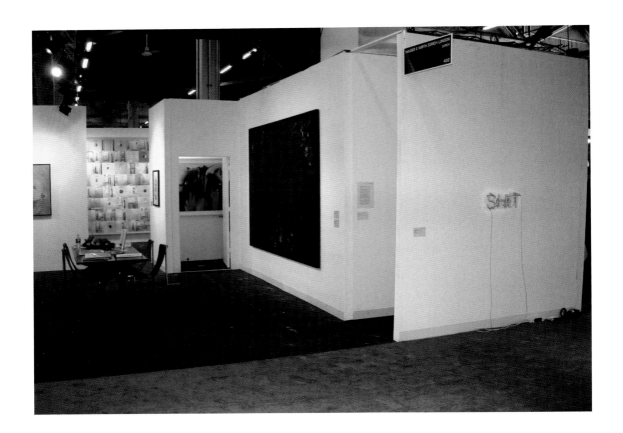

Work No. 281
SHIT, 2002
Purple neon
6 in / 15.2 cm high
Edition of 3 + 1 AP
Installation at the Armory Show, New York, USA, 2007

Work No. 282
An intrusion and a protrusion from a wall, 2002
Gold-plated silver in / gold-plated silver out; opposite walls
2 parts, each 4 in / 10.1 cm diameter
Edition of 2 + 1 AP
Installation at a private residence, Kortrijk, Belgium

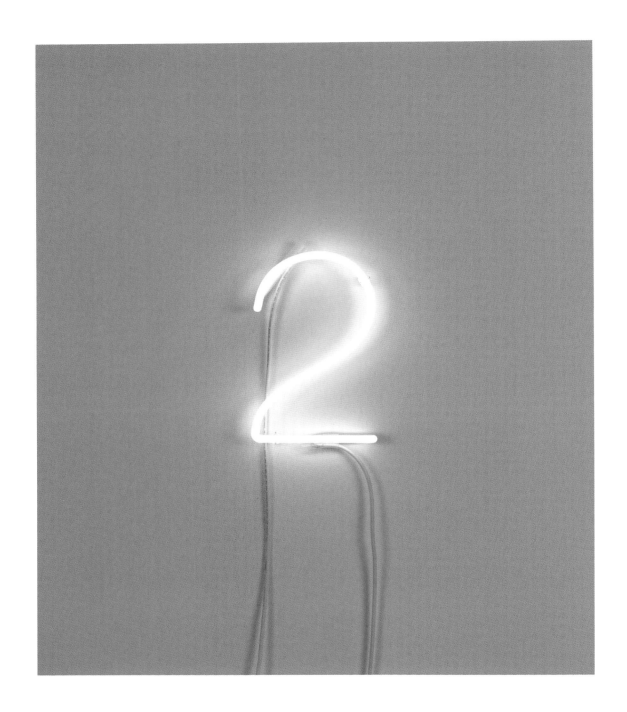

Work No. 283
2, 2002
White neon
12 in / 30.5 cm high
Edition of 3 + 2 AP

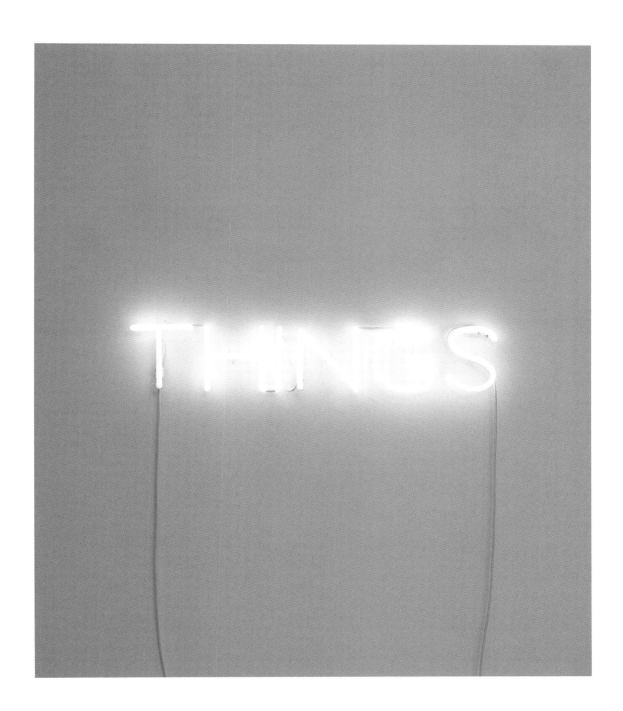

Work No. 285
THINGS, 2002
White neon
6 in / 15.2 cm high
Edition of 3 + 1 AP

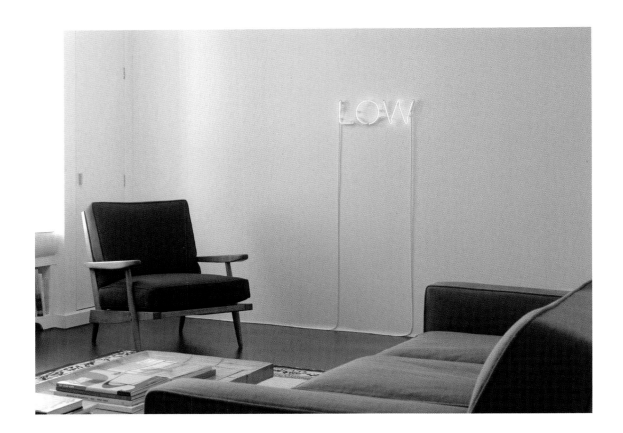

Work No. 286
LOW, 2002
Blue neon
6 in / 15.2 cm high
Edition of 3 + 1 AP
Installation at Hauser & Wirth London, London, UK, 2008

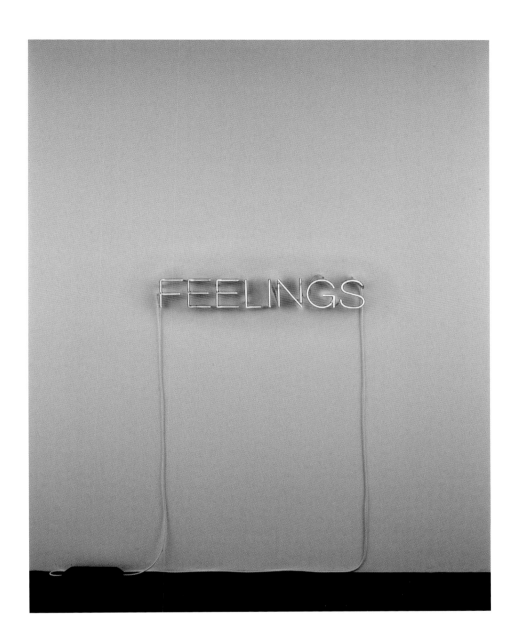

Work No. 287
FEELINGS, 2003
Purple neon
6 in / 15.2 cm high
Edition of 3 + 1 AP

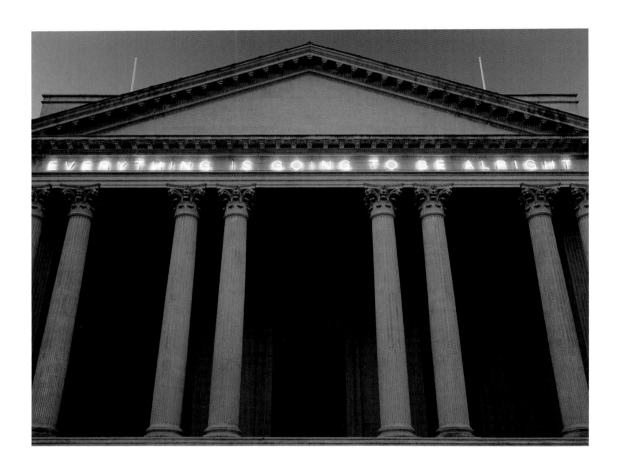

Work No. 289
EVERYTHING IS GOING TO BE ALRIGHT, 2003
White neon
Approximately 1 × 52 ft / 0.3 × 16 m
Installation at British School at Rome, Italy, 2003

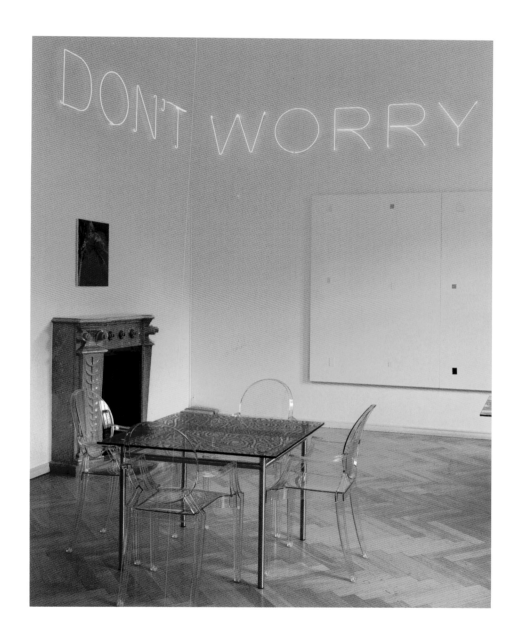

Work No. 291
DON'T WORRY, 2003
Red neon
19.7 in / 50 cm high
Installation at Galerie Thaddaeus Ropac, Salzburg, Austria, 2003

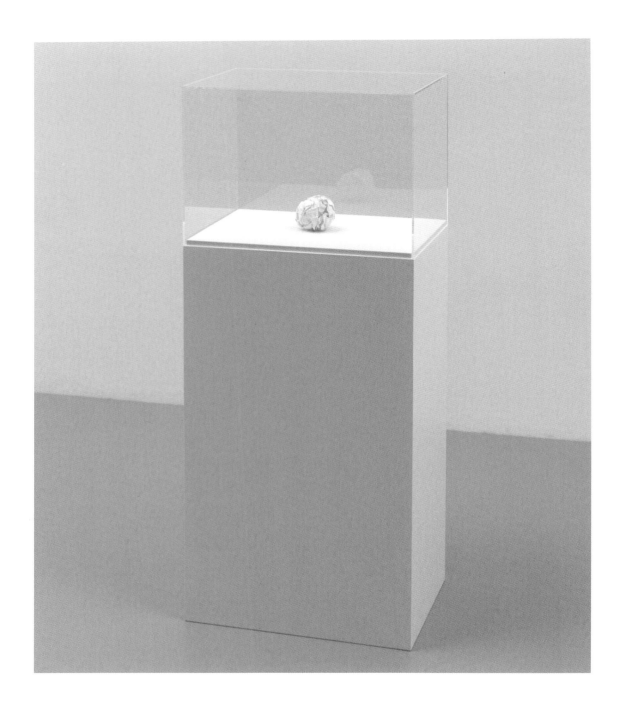

Work No. 293
A sheet of paper crumpled into a ball, 2003
A3 paper, lid, plinth
Lid 16.5 × 11.6 × 11.6 in / 42 × 29.7 × 29.7 cm; plinth height variable
Edition of 3 + 1 AP

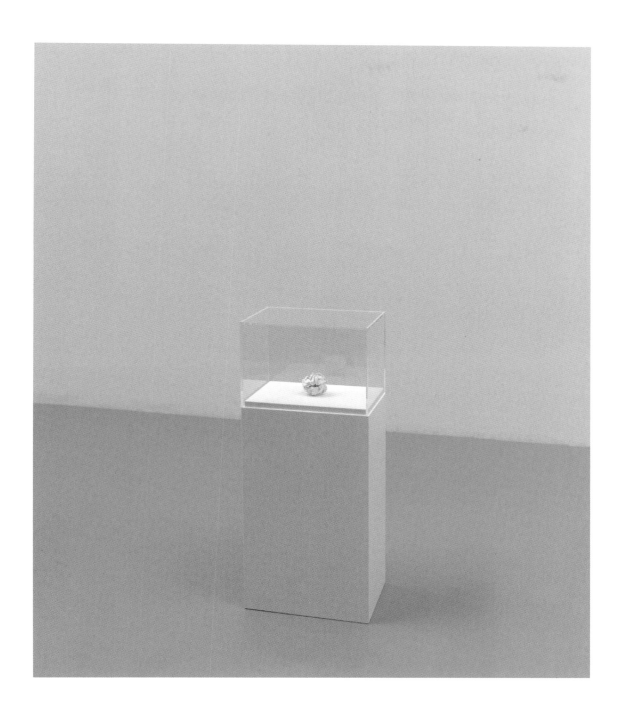

Work No. 294
A sheet of paper crumpled into a ball, 2003
A5 paper, lid, plinth
Lid 8.2 × 5.8 × 5.8 in / 21 × 14.8 × 14.8 cm; plinth height variable
Edition of 3 + 1 AP

Work No. 295
Smiling people, 2003
Photographic prints
4 parts, each 15.7 × 15.7 in / 40 × 40 cm

What's the point of it?

What's the point of it?
What's the point of it?
What's the point of it?
What's the point of it?
What's the point of it?
What's the point of it?
What's the point of it?
What's the point of it?
What's the point of it?
What's the point of it?
What's the point of it?
What's the point of it?
What's the point of it?
What's the point of it?
What's the point of it?
What's the point of it?
What's the point of it?

What's the point of it?
What's the point of it?
What's the point of it?
What's the point of it?
What's the point of it?
What's the point of it?
What's the point of it?
What's the point of it?
What's the point of it?
What's the point of it?
What's the point of it?
What's the point of it?
What's the point of it?
What's the point of it?
What's the point of it?
What's the point of it?

Some people I like
I like because they talk a lot
Some people I like
I like because they don't talk a lot

I want to go away
I want to stay at home

Work No. 296
What's the point of it?, 2002–2004
Song for voice, guitar, base and drums
(Lyrics shown)

Work No. 299
Self portrait smiling, 2003
Photographic print
30.3 × 41.4 in / 77 × 105.5 cm
Edition of 10 + 1 AP

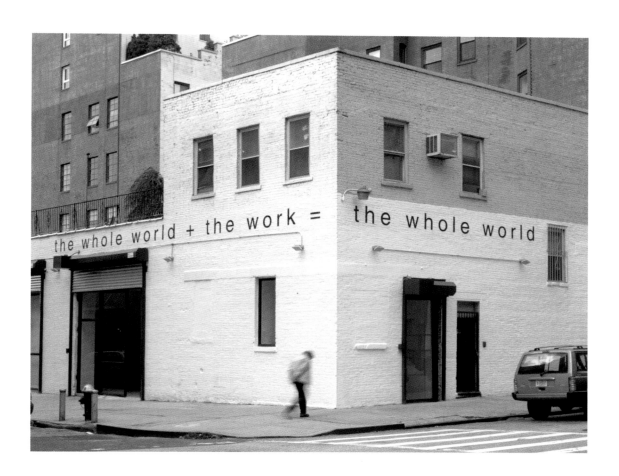

Work No. 300
the whole world + the work = the whole world, 2003
Materials variable
1.5 × 77.5 ft / 0.5 × 23.5 m
Installation at Gavin Brown's enterprise, New York, USA, 2003

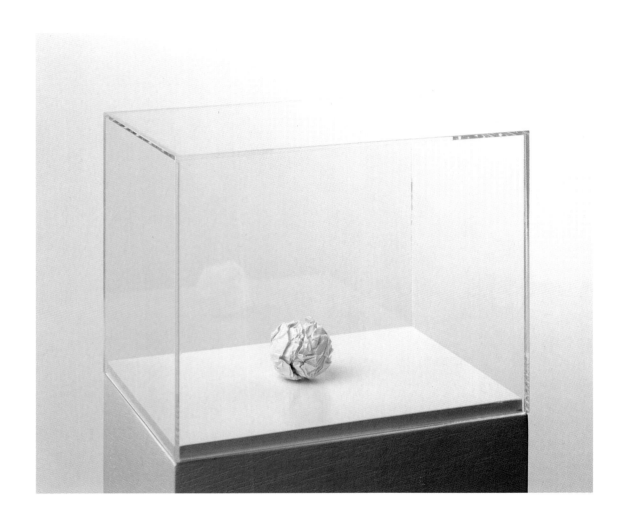

Work No. 301
A sheet of paper crumpled into a ball, 2003
US letter paper, lid, plinth
Lid 11 × 8.5 × 8.5 in / 27.9 × 21.6 × 21.6 cm; plinth height variable

304

Work No. 304
Smiling people, 2003
Photographic prints
6 parts, each 4 × 6 in / 10.1 × 15.2 cm

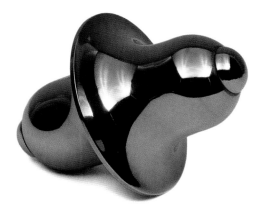

Work No. 305
1989–2003
Brass
2 in / 5.1 cm diameter
Edition of 3 + 1 AP
(Shown actual size)

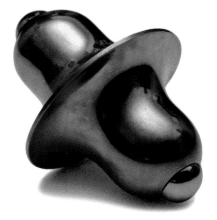

Work No. 306
1989–2003
Brass, chrome-plated brass
2 in / 5.1 cm diameter
Edition of 3 + 1 AP
(Shown actual size)

308

Work No. 308
An intrusion and a protrusion from a wall, 1997–2003
Silver in / gold-plated silver out; external corner
2 parts, each 4 in / 10.1 cm diameter
Edition of 2 + 1 AP
Installation at Kunsthalle Bern, Bern, Switzerland, 2003

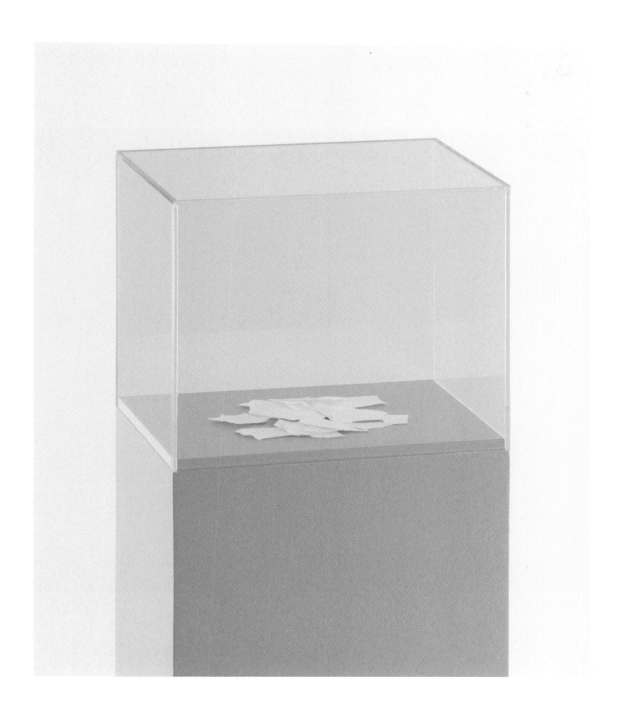

Work No. 309
A sheet of paper torn up, 2003
US letter paper, lid, plinth
Lid 11 × 8.5 × 8.5 in / 27.9 × 21.6 × 21.6 cm; plinth height variable
Edition of 3 + 1 AP

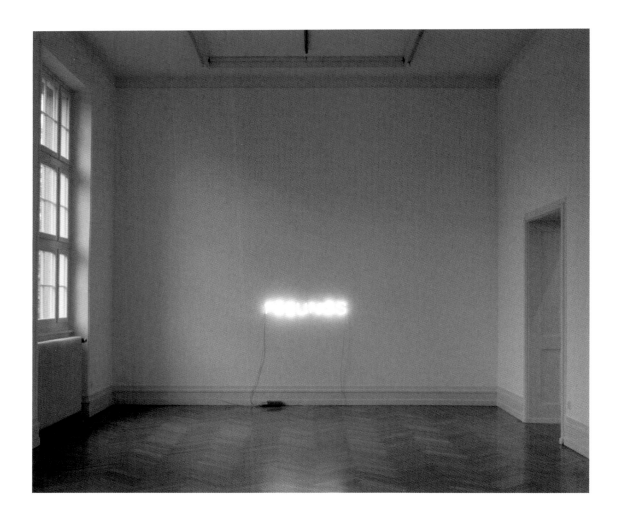

Work No. 311
FEELINGS, 2003
White neon
6 in / 15.2 cm high
Edition of 3 + 1 AP
Installation at Kunsthalle Bern, Bern, Switzerland, 2003

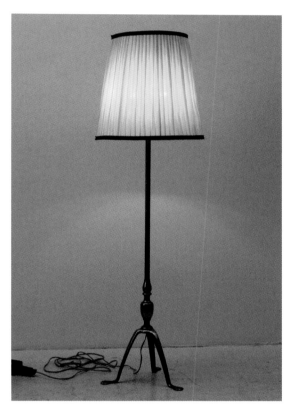 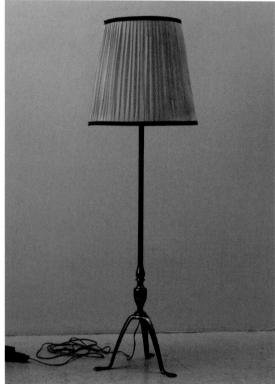

Work No. 312
A lamp going on and off, 2003
Materials and dimensions variable; 1 second on / 1 second off
Edition of 10 + 1 AP

Work No. 316
Self portrait thinking, 2004
Photographic print
4 × 5.3 in / 10.16 × 13.55 cm
Edition of 10 + 1 AP

Work No. 318
Self portrait smiling, 2004
Photographic print
6.6 × 10 in / 16.8 × 25.5 cm
Edition of 25 + 5 AP

Work No. 319
A sheet of paper crumpled up and flattened out, 2004
Paper
11.7 × 8.2 in / 29.7 × 21 cm

I don't know what I want
I don't know what I think
I don't know what I see
I don't know what I feel
You know?

Work No. 320
I don't know what I want, 2003–2004
Piece for voice, guitar, bass and drums
(Lyrics shown)

Work No. 321
2005
Marker pen on paper
11.7 × 8.2 in / 29.7 × 21 cm

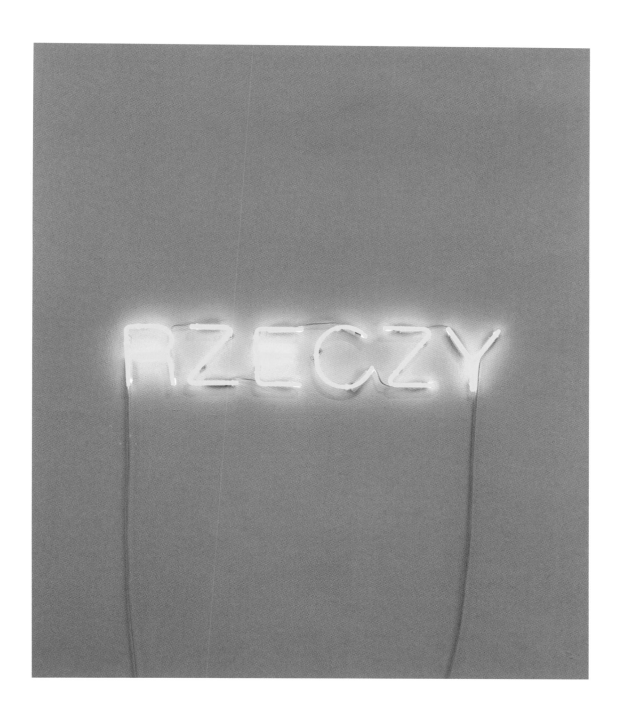

Work No. 325
RZECZY, 2004
Yellow neon
6 in / 15.2 cm high; 1 second on / 1 second off
Edition of 3 + 1 AP
(Polish to English: THINGS)

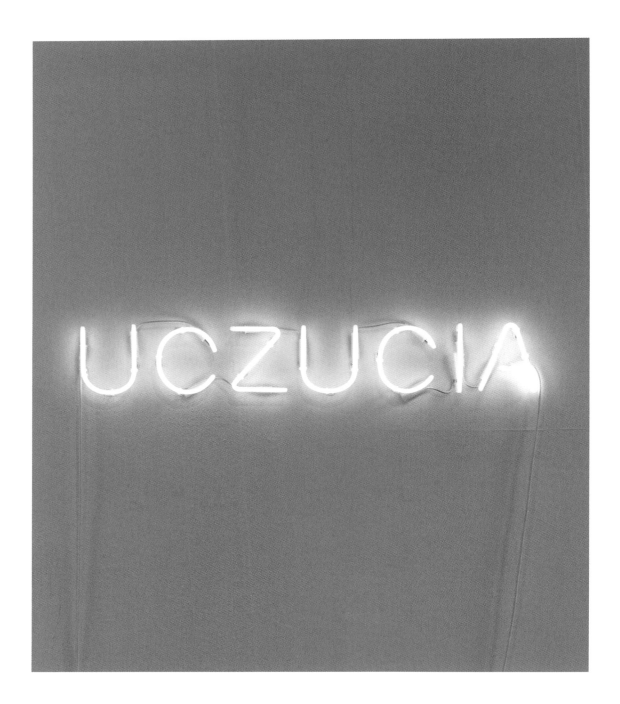

Work No. 326
UCZUCIA, 2004
White neon
6 in / 15.2 cm high
Edition of 3 + 1 AP
(Polish to English: FEELINGS)

Work No. 327
A sheet of paper crumpled up and flattened out, 2004
Paper
11.7 × 8.2 in / 29.7 × 21 cm

Work No. 328
A sheet of paper folded up and unfolded, 2004
Paper
11.7 × 8.2 in / 29.7 × 21 cm

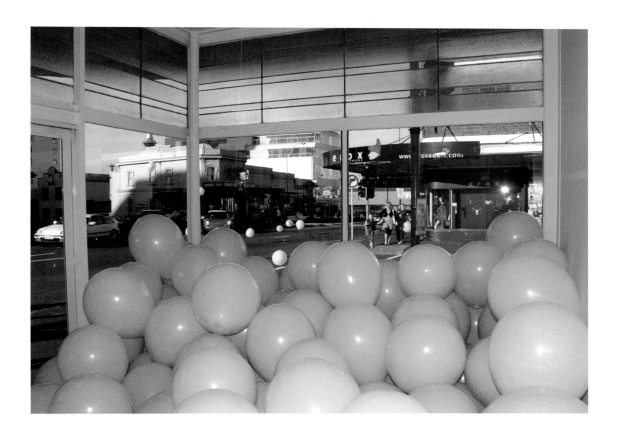

Work No. 329
2004
Pink balloons
Multiple parts, each balloon 16 in / 40.6 cm diameter; overall dimensions variable
Installation at Michael Lett, Auckland, New Zealand, 2006
(Detail)

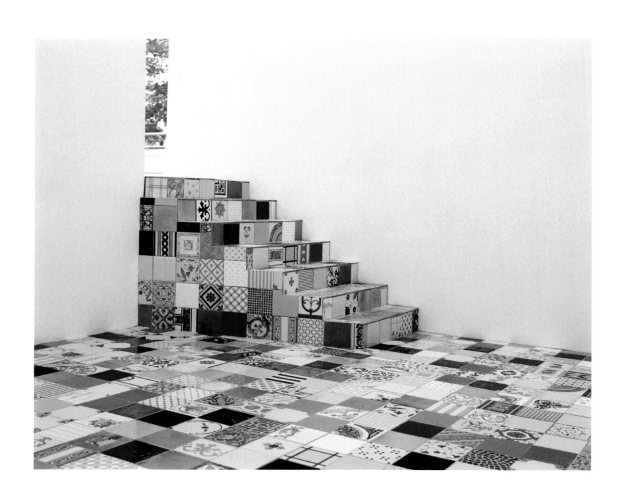

Work No. 330
2004
Tiles
Multiple parts, each 8 × 8 in / 20 × 20 cm; overall dimensions variable
Installation at Galerie Emmanuel Perrotin, Paris, France, 2004
(Detail)

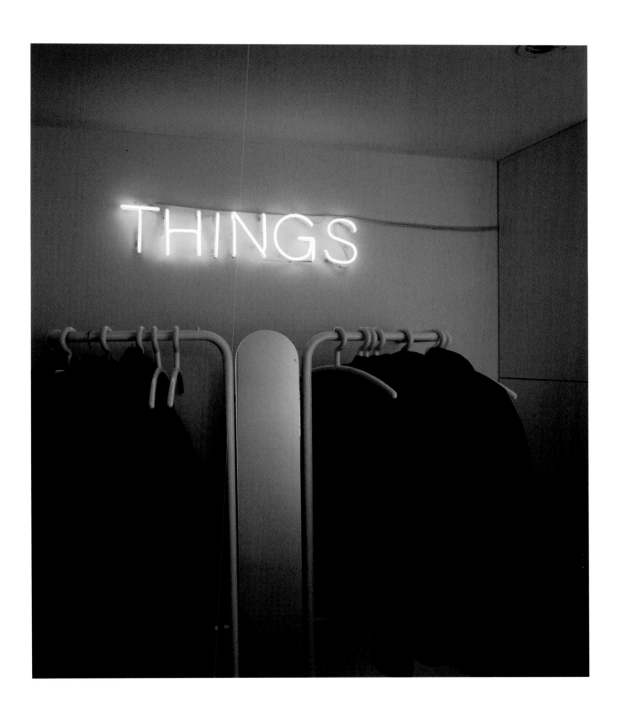

Work No. 331
THINGS, 2004
Pink neon
6 in / 15.2 cm high
Edition of 3 + 1 AP
Installation at a private residence, Switzerland

Words

Words
Words
Words
Words
Words
Words
Words
Words
Words
Words
Words
Words
Words
Words
Words
Words
Words
Words
Words
Words
Words
Words
Words
Words
Words
Words
Words
Words
Words
Words
Words
Words

Work No. 332
Words, 2004
Piece for voices, guitar, bass and drums
(Lyrics shown)

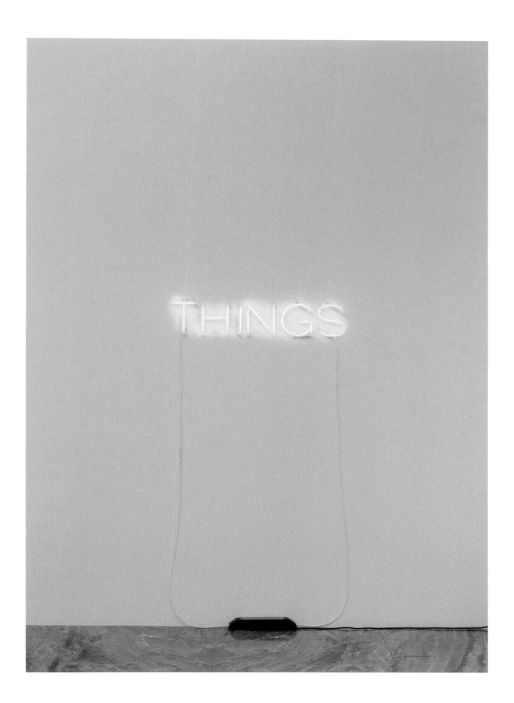

Work No. 335
THINGS, 2004
Pink neon
1 second on / 1 second off
6 in / 15.2 cm
Edition of 3 + 1 AP

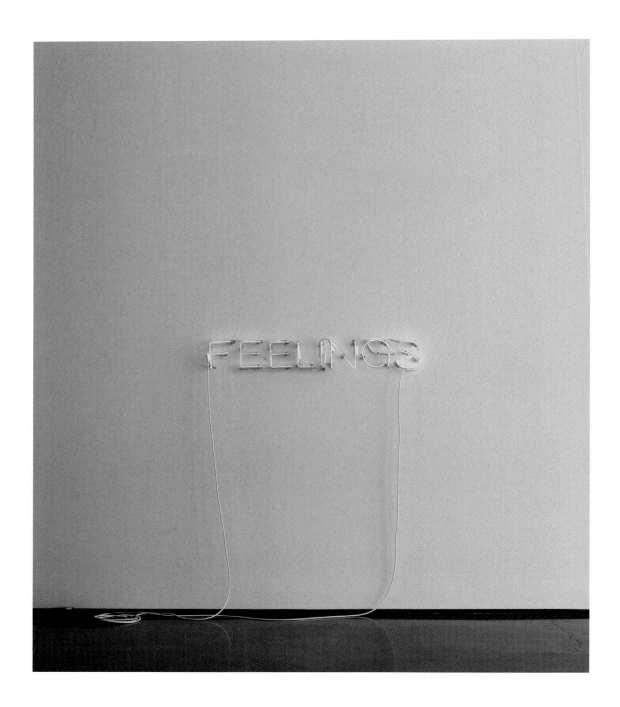

Work No. 336
FEELINGS, 2004
Blue neon
6 in / 15.2 cm high
Edition of 3 + 1 AP

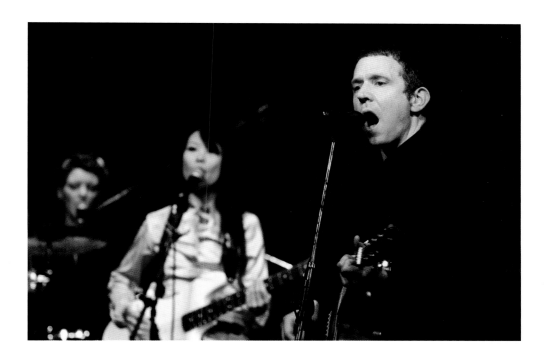

Fuck Off

fuck off

fuck off

fuck fuck fuck fuck fuck fuck fuck fuck fuck fuck

fuck fuck

off off off off off off off off

fuck off

fuck off

fuck off

fuck off

fuck fuck fuck fuck fuck fuck fuck fuck fuck fuck

off off off off off off off off

fuck off

fuck off

fuck off

fuck off

fuck fuck fuck fuck fuck fuck fuck fuck fuck fuck

off off off off off off off off

fuck off fuck off fuck off fuck off

fuck fuck fuck fuck fuck fuck fuck fuck fuck fuck

off off off off off off off off

fuck off

fuck off

fuck off

fuck off

fuck fuck fuck fuck fuck fuck fuck fuck fuck fuck

off off off off off off off off

off

Work No. 337
Fuck off, 2004
Piece for voices, guitar, bass and drums
Top Shown in performance in Glasgow by Martin Creed and band with, left to right, Karen Hutt on drums and vocals,
Keiko Owada on bass and vocals, and Martin Creed on guitar and vocals
Bottom Lyrics shown

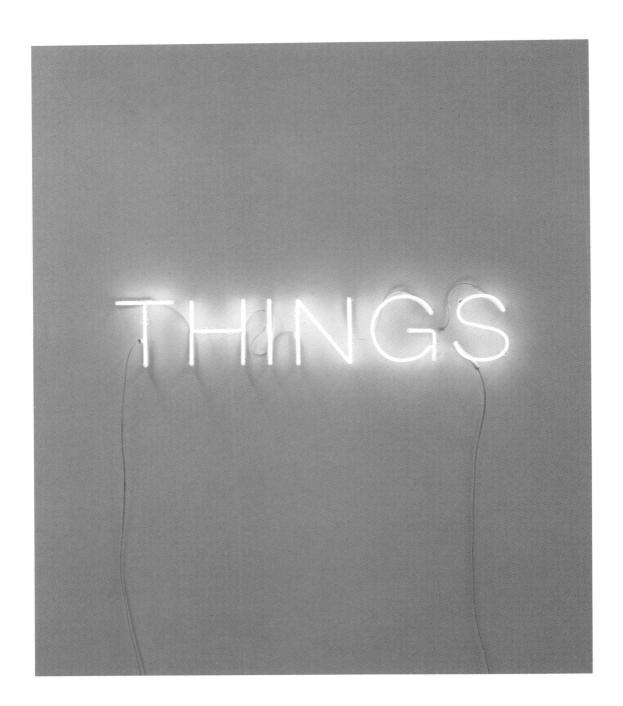

Work No. 338
THINGS, 2004
White neon
6 in / 15.2 cm high; 1 second on / 1 second off
Edition of 3 + 1 AP

Work No. 339
A sheet of paper crumpled up and flattened out, 2004
Paper
11.7 × 8.2 in / 29.7 × 21 cm

Work No. 340
A sheet of paper folded up and unfolded, 2004
Paper
11.7 × 8.2 in / 29.7 × 21 cm

Work No. 341
2004
Pen on paper
7 parts, each 11.7 × 8.2 in / 29.7 × 21 cm

Work No. 343
A sheet of paper folded up and unfolded, 2004
Paper
11.7 × 8.2 in / 29.7 × 21 cm

Work No. 344
Four drawings, 2004
Paper, pen on paper
4 parts, each 11.7 × 8.2 in / 29.7 × 21 cm

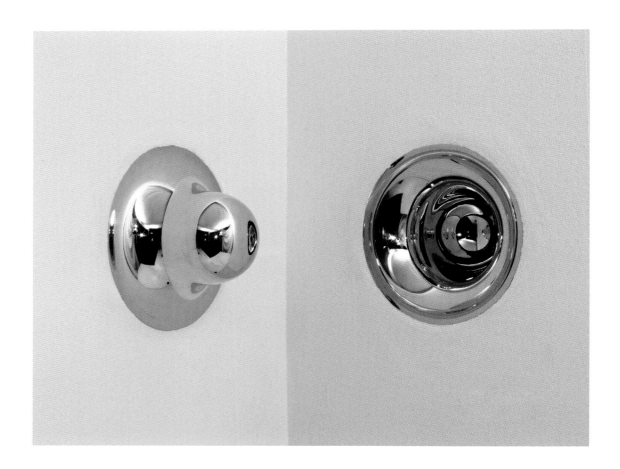

Work No. 348
An intrusion and a protrusion from a wall, 2004
Gold-plated silver in / gold-plated silver out; internal corner
2 parts, each 4 in / 10.1 cm diameter
Edition of 2 + 1 AP

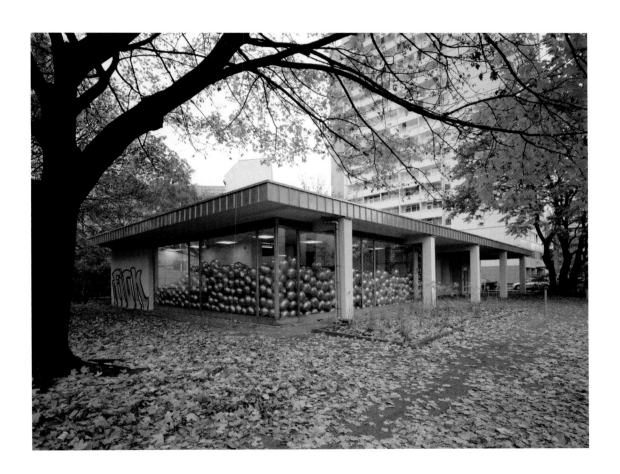

Work No. 360
Half the air in a given space, 2004
Silver balloons
Multiple parts, each balloon 16 in / 40.6 cm diameter; overall dimensions variable
Installation at Johnen Galerie, Berlin, Germany, 2004

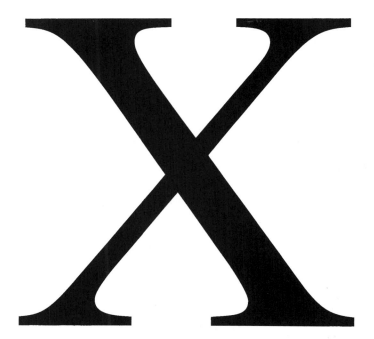

Work No. 361
X, 2004
Postcard
3.9 × 5.9 in / 10 × 15 cm

Work No. 367
2004
Poster
32 × 23.2 in / 81 × 59 cm
Edition of 100

Work No. 368
2004
Poster
32 × 23.2 in / 81 × 59 cm
Edition of 100

MARTIN CREED
OCTOBER 8 TO OCTOBER 30, 2004

HAUSER & WIRTH LONDON
196 A PICCADILLY LONDON W1 +44 (0) 20 7287 2300
www.hauserwirth.com Tuesday – Saturday 10 am – 6 pm

Work No. 369
2004
Poster
32 × 23.2 in / 81 × 59 cm
Edition of 100

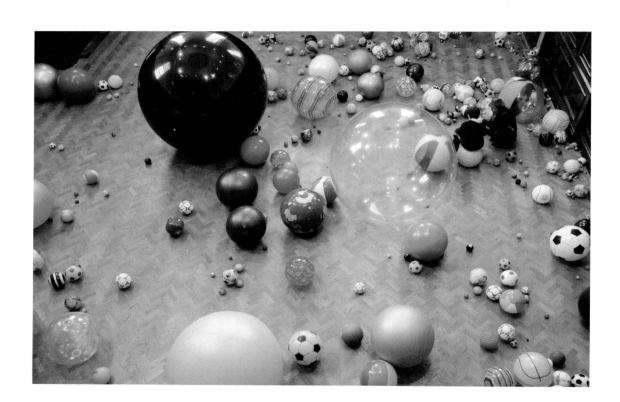

Work No. 370
Balls, 2004
Balls
Multiple parts; overall dimensions variable
Installation at Hauser & Wirth London, London, UK, 2004

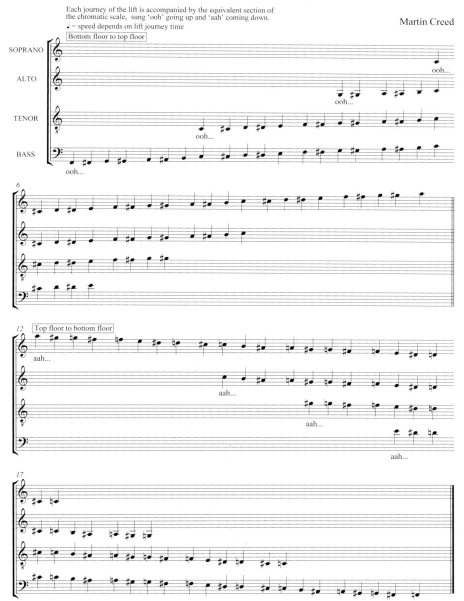

Work No. 371

Elevator ooh/aah up/down, 2004
Piece for bass, tenor, alto and soprano voices, and elevator
Dimensions variable
Edition of 3 + 1 AP
(Score shown)

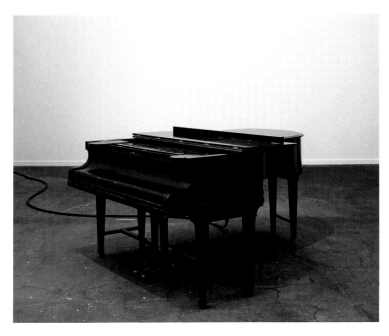

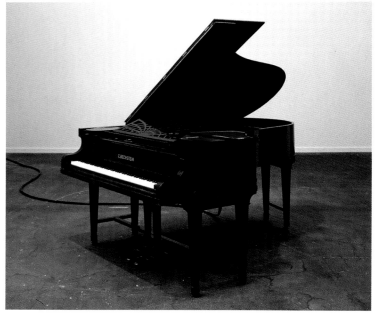

Work No. 372
2004–2005
Automated slamming piano
58.3 × 61.2 × 78.7 in / 148 × 155.5 × 200 cm
Installation at Basel Art Fair, Basel, Switzerland, 2005

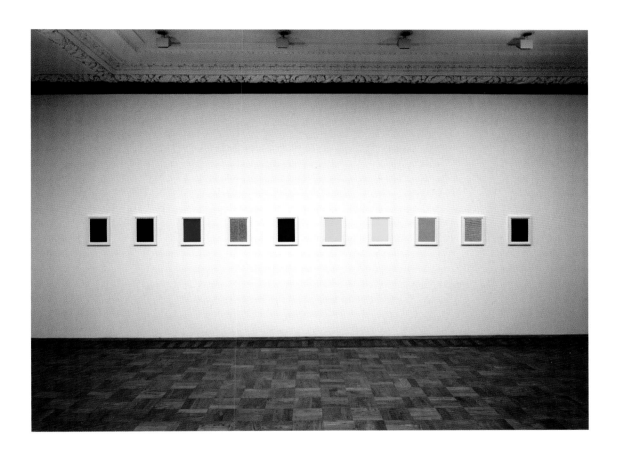

Work No. 373
2004
Pen on paper
10 parts, each 11.7 × 8.2 in / 29.7 × 21 cm
Installation at Hauser & Wirth London, London, UK, 2004

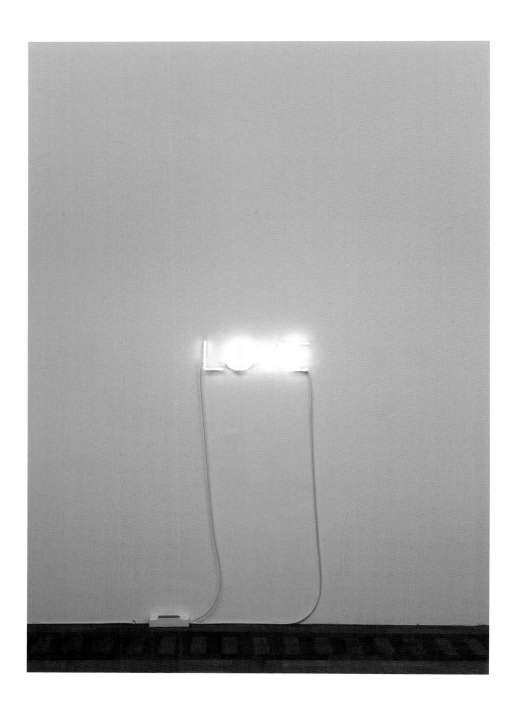

Work No. 374
LOVE, 2004
White neon
6 in / 15.2 cm high
Edition of 3 + 1 AP
Installation at Hauser & Wirth London, London, UK, 2004

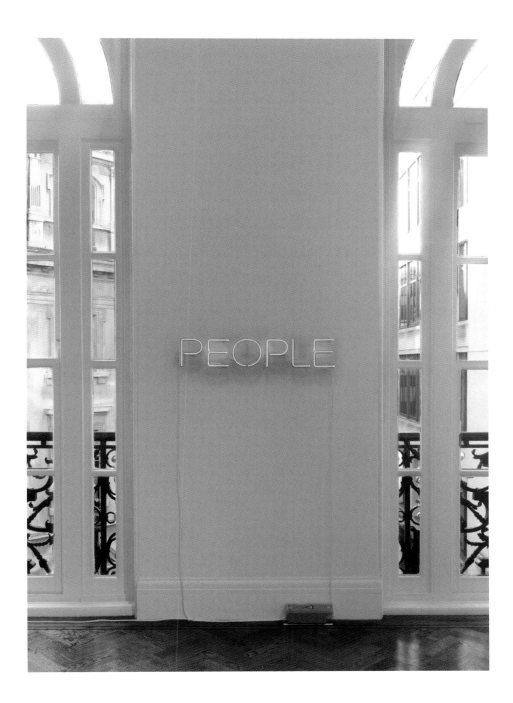

Work No. 376
PEOPLE, 2004
Green neon
6 in / 15.2 cm high
Edition of 3 + 1 AP
Installation at Hauser & Wirth London, London, UK, 2007

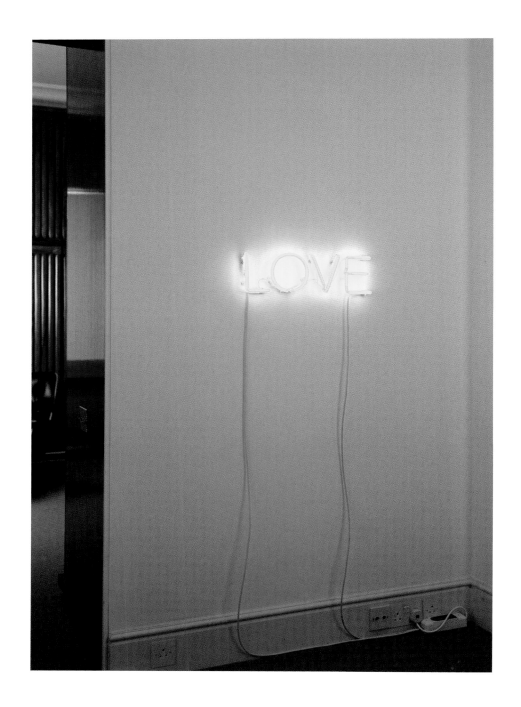

Work No. 379
LOVE, 2004
Yellow neon
6 in / 15.2 cm high
Edition of 3 + 1 AP
Installation at Hauser & Wirth London, London, UK, 2007

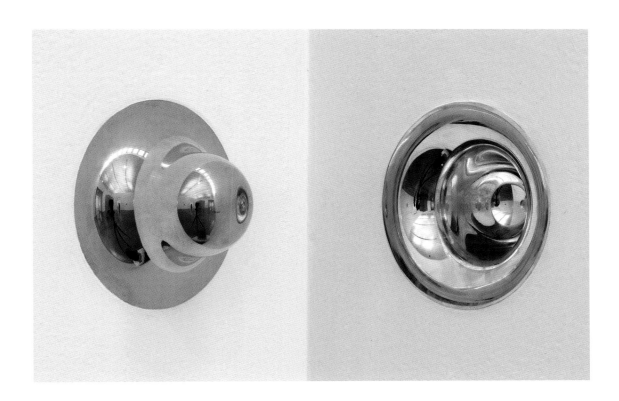

Work No. 380
An intrusion and a protrusion from a wall, 2004–2005
Silver in / gold-plated silver out; internal corner
2 parts, each 4 in / 10.1 cm diameter
Edition of 2 + 1 AP

All dimensions inches
R = radius, R' = 2, R" = 1

0.064

0.064

4

0.064

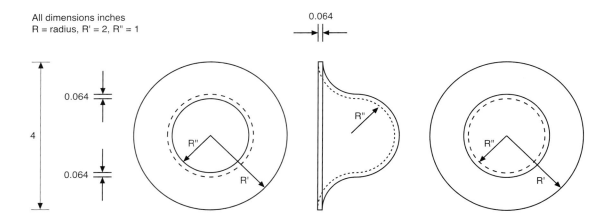

Two of the object represented in the diagram above.
Material: silver.
One polished to a mirror finish on its external surface.
The other gold-plated and polished to a mirror finish on its internal surface.
The objects situated as shown in the plan view below, at the corner of two walls.

2

2

The positions of the intrusion and protrusion swappable. The surface of each object meeting the surface of the wall at an absolute tangent. Both objects at the same height, their polished surfaces facing outwards.

Work No. 381
An intrusion and a protrusion from a wall, 2004
Gold-plated silver in / silver out; external corner
2 parts, each 4 in / 10.1 cm diameter
Edition of 2 + 1 AP
(Drawing shown)

Work No. 382
2004
Highlighter pen on paper
5 parts, each 11.7 × 8.2 in / 29.7 × 21 cm

Work No. 383
A sheet of paper folded up and unfolded, 2004
Paper
11.7 × 8.2 in / 29.7 × 21 cm

384

Work No. 384
A sheet of paper folded up and unfolded, 2004
Paper
11.7 × 8.2 in / 29.7 × 21 cm

Work No. 386
Two objects, 1986–2004
Silver-plated, gold-plated and chrome-plated brass
2 parts, each 2 in / 5.1 cm diameter
Edition of 3 + 1 AP
(Shown actual size)

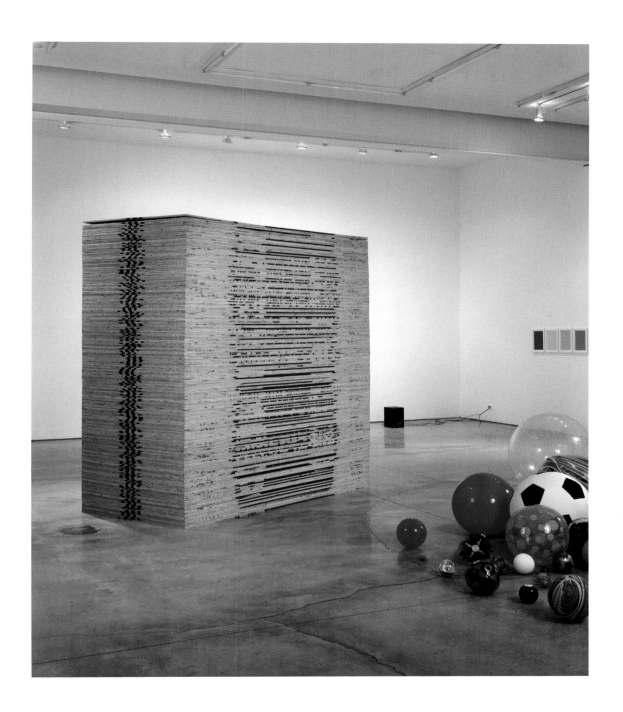

Work No. 387
2004
1/2-inch shuttering plywood
8 × 8 × 4 ft / 2.4 × 2.4 × 1.2 m
Installation at Gavin Brown's enterprise, New York, USA, 2005

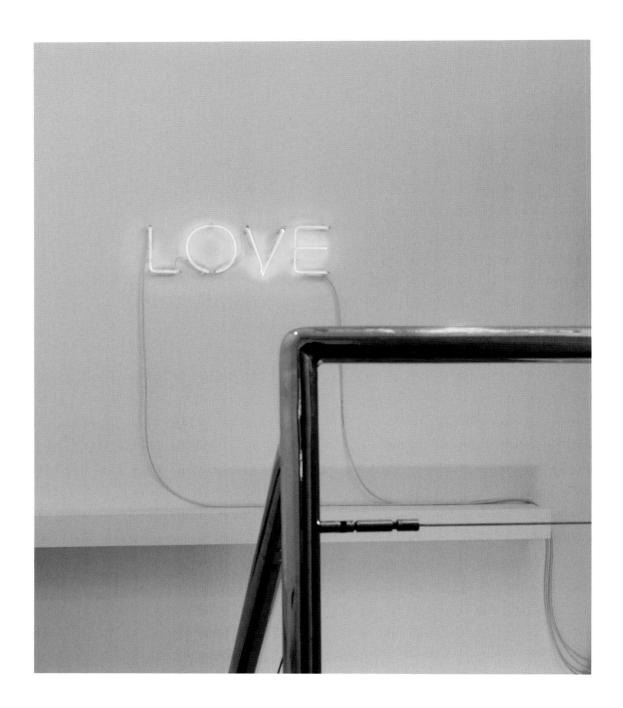

Work No. 389
LOVE, 2004
Blue neon
6 in / 15.2 cm high
Edition of 3 + 1 AP
Installation at Hauser & Wirth London, London, UK, 2008

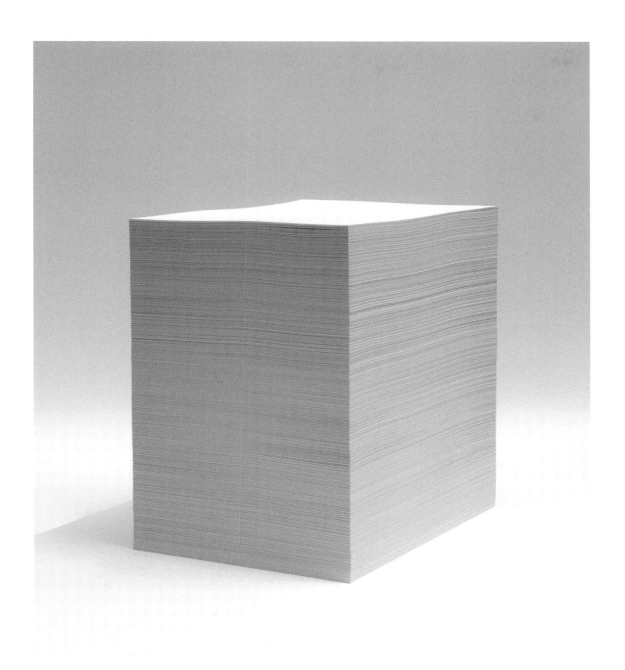

Work No. 391
2004
Paper
11.7 × 8.2 × 11.7 in / 29.7 × 21 × 29.7 cm
Edition of 3 + 1 AP

Work No. 392
2005
Spread for *.Cent* magazine
8.2 × 22 in / 21 × 56 cm

DOWN

UP

Martin Creed

March 12 to April 9, 2005
Opening March 12 from 6 to 8pm

Gavin Brown's enterprise
620 Greenwich Street New York, NY
t: 212 627 5258 f: 212 627 5261
gallery@gavinbrown.biz
www.gavinbrown.biz

Down over up © Martin Creed 2005 (Work No. 394)

Work No. 394
Down over up, 2005
Announcement card
8.6 × 5.7 in / 22.2 × 14.6 cm

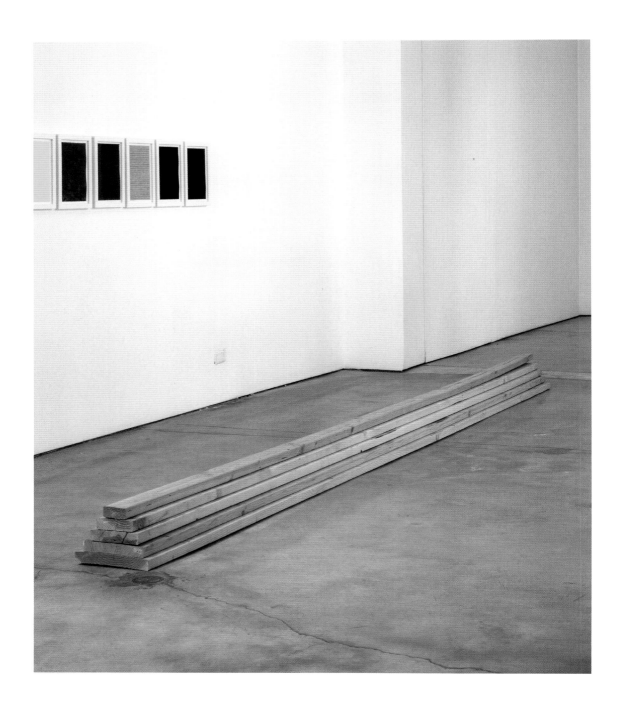

Work No. 395
2005
Planks of wood
9.8 × 192.9 in / 25 × 490 cm
Installation at Gavin Brown's enterprise, New York, USA, 2005

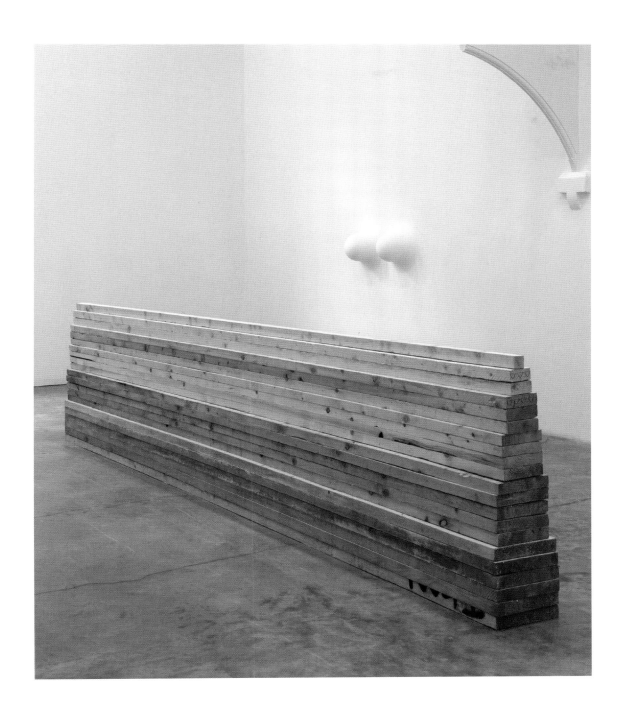

Work No. 396
2005
Planks of wood
40.2 × 189.8 × 11.6 in / 102 × 482 × 29.5 cm
Installation at Ikon Gallery, Birmingham, UK, 2008

Work No. 397
2005
Marker pen on paper
11.7 × 8.2 in / 29.7 × 21 cm

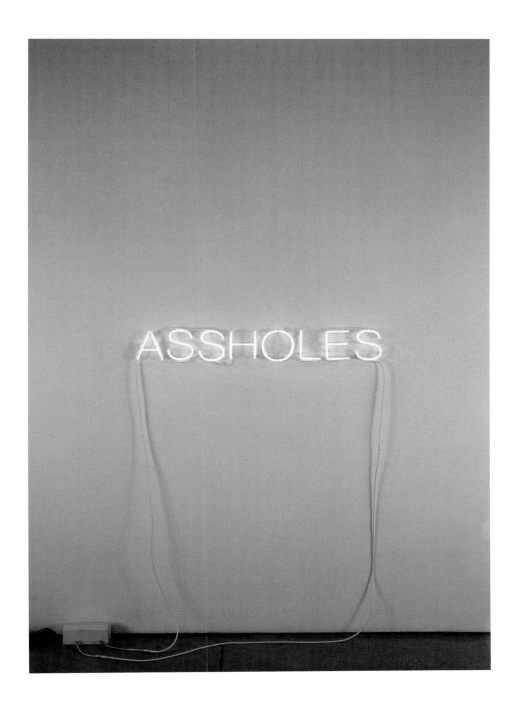

Work No. 398
ASSHOLES, 2005
White neon
6 in / 15.2 cm high
Edition of 3 + 1 AP

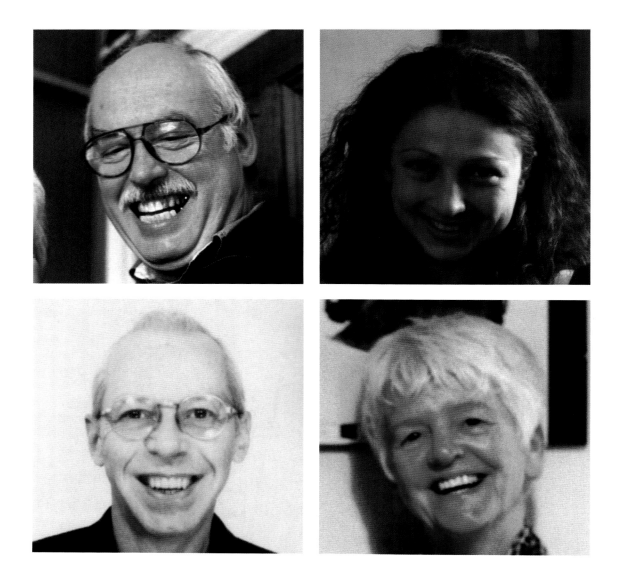

399

Work No. 399
Smiling people, 2005
Photographic prints
4 parts, each 12 × 12 in / 30.5 × 30.5 cm
Edition of 1 + 1 AP

Work No. 401
Blowing a raspberry, 2005
Audio recording, speaker
Dimensions variable
Edition of 3 + 1 AP

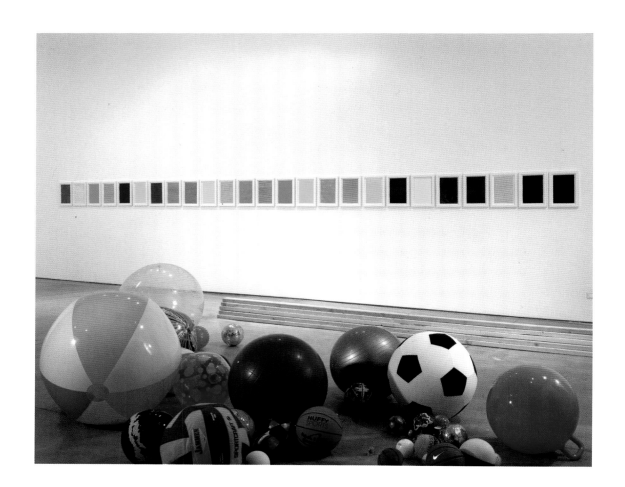

Work No. 403
2005
Pen on paper
25 parts, each 11.7 × 8.2 in / 29.7 × 21 cm
Installation at Gavin Brown's enterprise, New York, USA, 2005

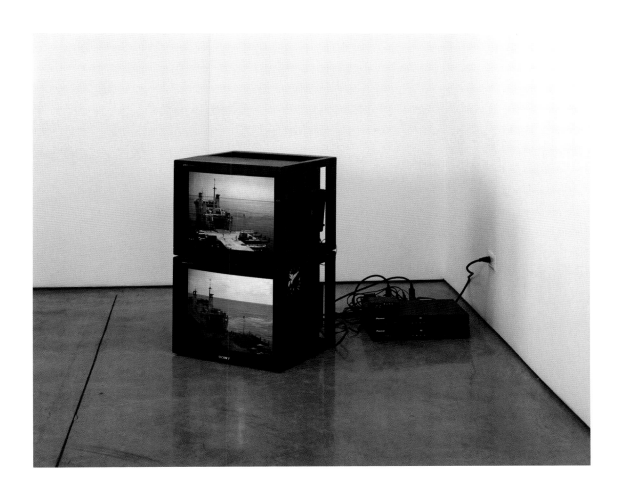

Work No. 405
Ships coming in, 2005
2 synchronized videos; Mini DV, colour, sound
8 minutes, 30 seconds
Dimensions variable
Edition of 1 + 1 AP
Installation at Gavin Brown's enterprise, New York, USA, 2005

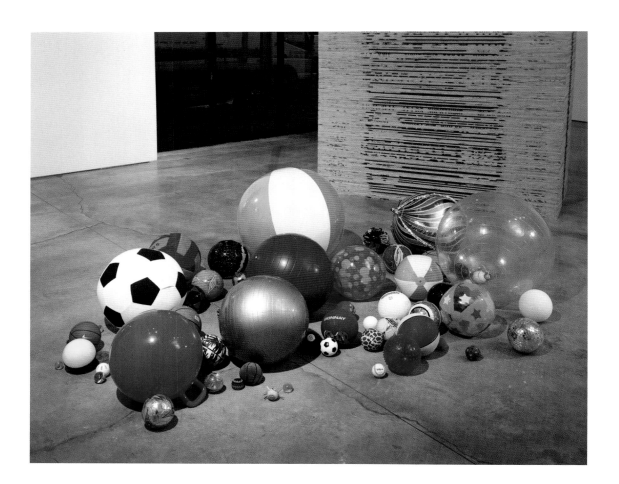

Work No. 406
Balls, 2005
Balls
Dimensions variable
Installation at Gavin Brown's enterprise, New York, USA, 2005

Work No. 407
2005
Marker pen on paper
11.7 × 8.2 in / 29.7 × 21 cm

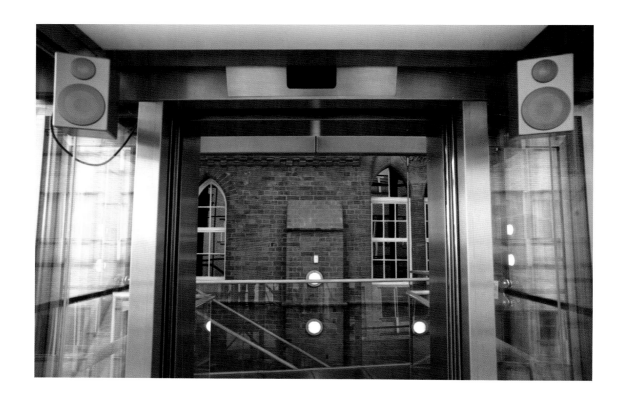

Work No. 409
2005
Piece for choir and elevator
Dimensions variable
Edition of 3 + 1 AP
Installation at Ikon Gallery, Birmingham, UK, 2005

Work No. 412
Laughing, 2005
Audio recording, speaker
Dimensions variable
Edition of 3 + 1 AP

Work No. 415
2005
Biro on paper
11.7 × 8.2 in / 29.7 × 21 cm

Work No. 418
2005
Paper
11.7 × 8.2 in / 29.7 × 21 cm

Work No. 419
2005
Highlighter pen on paper
11.7 × 8.2 in / 29.7 × 21 cm

If You're Lonely

If
If you're
If you're
If you're low
If you're low
If you're low
If you're lonely
If you're lonely
If you're lonely
If you're lonely

Don't be
Don't be, please
Don't be, please don't be
Don't be
Don't be, please
Don't be, please don't be

If
If you're
If you're
If you're low
If you're low
If you're low
If you're lonely
If you're lonely
If you're lonely
If you're lonely
Then this is for you

Work No. 421
If you're lonely, 2004–2006
Piece for voices, guitar, bass and drums
(Lyrics shown)

Work No. 422
2005
Marker pen on paper
11.7 × 8.2 in / 29.7 × 21 cm

Work No. 423
2005
Marker pen on paper
11.7 × 8.2 in / 29.7 × 21 cm

Work No. 425
2005
Marker pen on paper
11.7 × 8.2 in / 29.7 × 21 cm

Work No. 426
2005
Marker pen on paper
11.7 × 8.2 in / 29.7 × 21 cm

Work No. 427
2005
Pen on paper
11.7 × 8.2 in / 29.7 × 21 cm

Work No. 428
2005
Pencil on paper
11.7 × 8.2 in / 29.7 × 21 cm

Work No. 429
A sheet of paper folded up and unfolded, 2005
Paper
11.7 × 8.2 in / 29.7 × 21 cm

Work No. 430
A sheet of paper crumpled up and flattened out, 2005
Paper
11.7 × 8.2 in / 29.7 × 21 cm

Thinking / Not Thinking

I was thinking
And then I wasn't thinking
And then I was thinking

Thinking
Not thinking

Work No. 431
Thinking / Not thinking, 2004–2005
Piece for voice, guitar, bass and drums
(Lyrics shown)

Die

D d d d d d d d die
Die
Die
Lie down and die
Die
Die
Die
Lie down and die

I wanna lie down and die
I wanna something something
something
Something
Something

I wanna get underneath something
I wanna stay there and lie down
and curl up and die

Die
Die
Lie down and die

D d d d
D d d d
D d d d d d d
D d d d d d d d die
Die
Die

Give me something
For the p p p p p p p p p p p
p p p p p p p p pain, please die,
Lie down and die

I wanna lie down and die

I wanna get underneath something
I wanna stay there and lie down
and curl up and die

Die
Die
Lie down and die

Work No. 432
Die, 2004–2005
Piece for voices, guitar, bass and drums
(Lyrics shown)

Work No. 433
2005
Pencil on paper
11.7 × 8.2 in / 29.7 × 21 cm

Work No. 436
2005
Highlighter pen on paper
5 parts, each 11.7 × 8.2 in / 29.7 × 21 cm

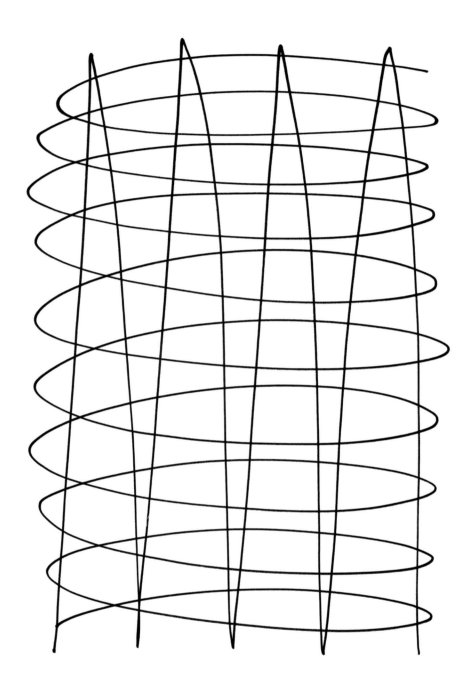

Work No. 438
2005
Marker pen on paper
11.7 × 8.2 in / 29.7 × 21 cm

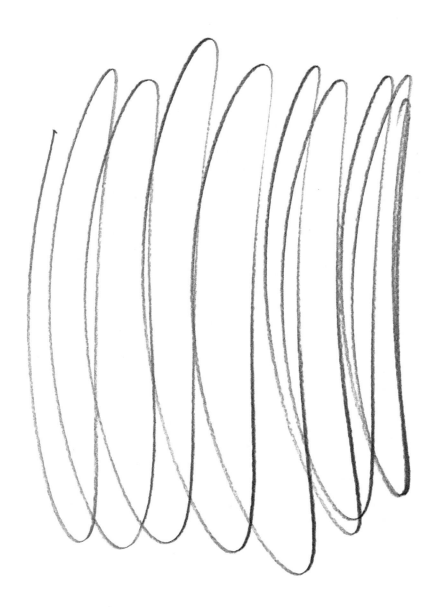

Work No. 439
2005
Pencil on paper
11.7 × 8.2 in / 29.7 × 21 cm

Work No. 441
2005
Paper
11.7 × 8.2 in / 29.7 × 21 cm

Work No. 443
2005
Pencil on paper
11.7 × 8.2 in / 29.7 × 21 cm

Work No. 447
2005
Marker pen on paper
11.7 × 8.2 in / 29.7 × 21 cm

Work No. 449
2005
Paper
11.7 × 8.2 in / 29.7 × 21 cm

Work No. 452
2005
Marker pen on paper
3 parts, each 11.7 × 8.2 in / 29.7 × 21 cm

Work No. 453
2005
Highlighter pen on paper
5 parts, each 11.7 × 8.2 in / 29.7 × 21 cm

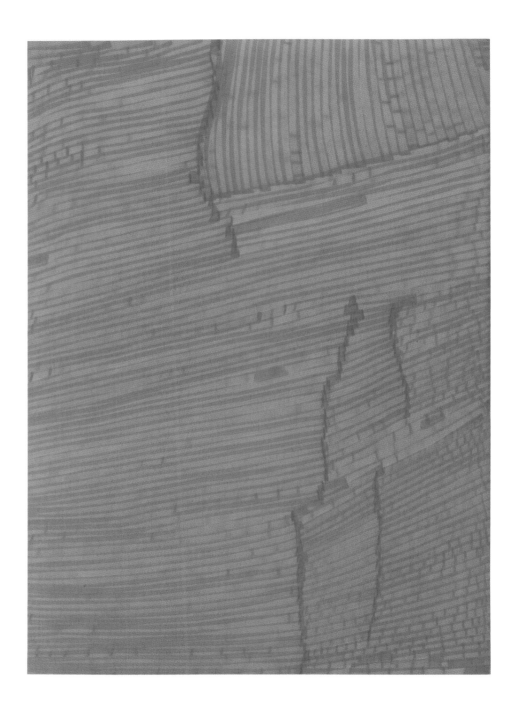

Work No. 454
2005
Marker pen on paper
11.7 × 8.2 in / 29.7 × 21 cm

Work No. 455
2005
Marker pen on paper
11.7 × 8.2 in / 29.7 × 21 cm

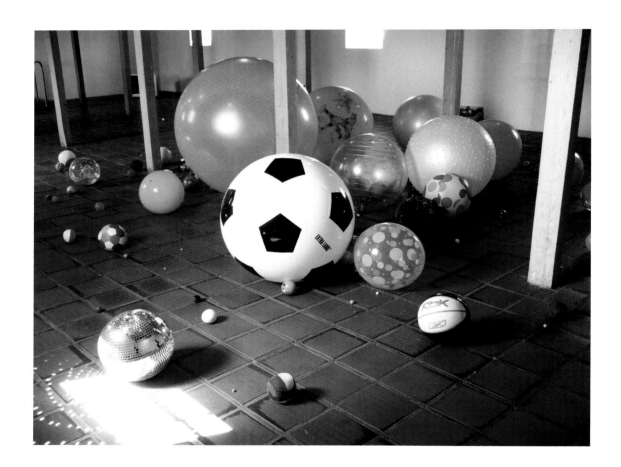

Work No. 457
2005
Balls
Dimensions variable
Installation at Hå gamle prestegard, Stavanger, Norway

Work No. 458
2005
Marker pen on paper
11.7 × 8.2 in / 29.7 × 21 cm

459

Work No. 459
2005
Highlighter pen on paper
11.7 × 8.2 in / 29.7 × 21 cm

Work No. 460
2005
Highlighter pen on paper
11.7 × 8.2 in / 29.7 × 21 cm

Work No. 461
2005
Marker pen on paper
11.7 × 8.2 in / 29.7 × 21 cm

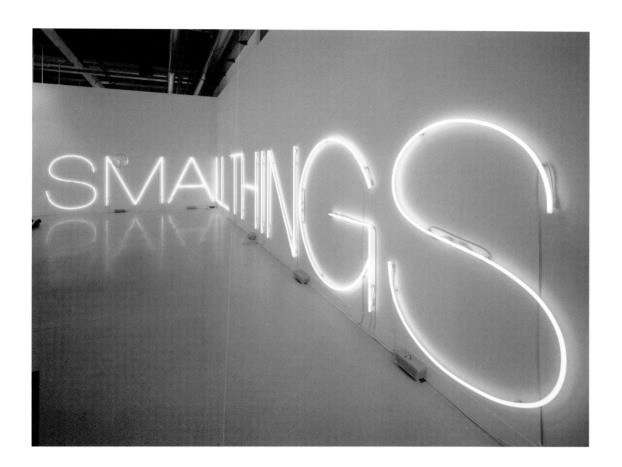

Work No. 467
SMALL THINGS, 2005
White neon
4.6 × 49 ft / 1.4 × 15 m
Installation at Basel Art Fair, Basel, Switzerland, 2005

Work No. 469
2005
Pen on paper
12 parts, each 11.7 × 8.2 in / 29.7 × 21 cm

Work... this is work. This is hard work. Talking about work is work. Thinking is work. Words are work. Words are things, shapes. It's hard to compose them, to put them in any kind of order. Words don't add up. Numbers add up! Things are everywhere. Everything is something, everything has something, but not everyone has someone. It's hard to distinguish between things, to separate things. I'm in a soup of thoughts, feelings and things, and words. Actually, it's more like a purée... or thick and stiff, like a paté. I'm in a paté and it's hard to move. It needs a lot of work to get out of it — or to separate it and find something in it. Thoughts, thoughts, sometimes I want to stop them, but it's hard to stop them. It's work. Dealing with thoughts, that's work. Thoughts, thoughts, don't come! Stop! Please! When you're going to sleep and you can't stop thinking, thoughts queueing up, that's when you need drugs — or a notebook.

I want something to ease the pain. I want to get out of my head.

Smoking used to help. For a long time smoking made my life bearable. I gave up smoking because I couldn't do it enough. I couldn't smoke enough. It was never enough. I wanted to smoke all the time, to breathe in all the time, but I couldn't, not in the shower, not when I was talking, not when I was eating. I wanted something I could do all the time. Not smoking, that was something I could do all the time. I am an addict in search of drugs.

Maybe working is trying, and work — the result of work — is everything that one tries to do. Trying... looking for excitement, or trying to handle it and use it to get out of the paté. Trying to do things; talking. Or maybe testing is a good way of putting it: testing things out. Testing things out by putting things about, and all the time trying, hoping to be excited, wanting. Wanting is what makes me work: excitement, desire for something.

Sometimes people say: 'What the fuck do you think you're doing? That's not art.'

I say: 'Fuck off, assholes!'

Assholes... they are something to get excited about, something to work for.

Work is a fight against loneliness, against low self esteem, against depression, and against staying in bed. Sometimes my self esteem is so low that I cannot reach it even when I'm feeling down.

I want to be on my own, but I don't want to be alone.

Work is everything, I think. Everything is work. Everything that involves energy, mental or physical. So... everything, apart from being dead. Living...

I don't know how anyone can do it.
How can anyone get through it
I can see why people hide.
I can see why people commit suicide.

If you're lonely,
If you're sad,
If you're lovely,
If you're mad,

Then this is for you.

Work No. 470

If you're lonely, 2005

Text

A version of this piece was first published in *The Independent* newspaper, 1 July 2005

471

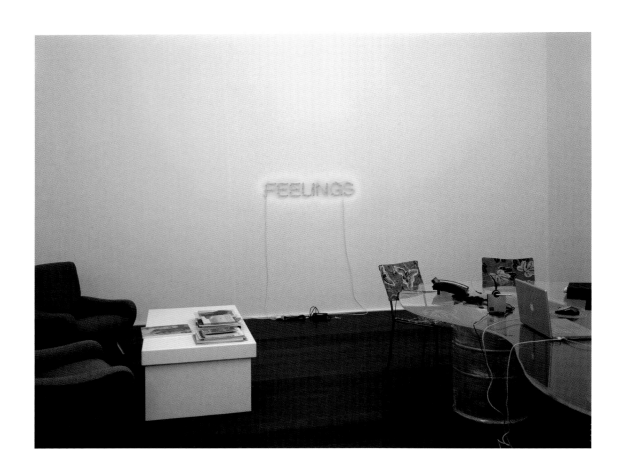

Work No. 471
FEELINGS, 2005
Red neon
6 in / 15.2 cm high
Edition of 3 + 1 AP
Installation at Hauser & Wirth Zurich, Zurich, Switzerland, 2007

Work No. 472
2005
Marker pen on paper
11.7 × 8.2 in / 29.7 × 21 cm

Work No. 473
2005
Pen on paper
12 parts, each 11.7 × 8.2 in / 29.7 × 21 cm

Work No. 474
2005
Paper
11.7 × 8.2 in / 29.7 × 21 cm

Work No. 476
2005
Highlighter pen on paper
11.7 × 8.2 in / 29.7 × 21 cm

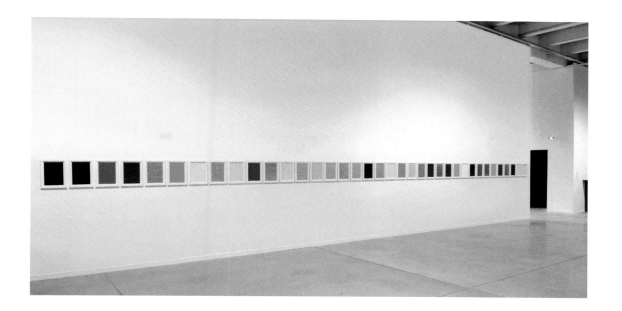

Work No. 478
2005
Pen on paper
37 parts, each 11.7 × 8.2 in / 29.7 × 21 cm
Installation at Lyon Biennale, Lyon, France, 2005

Work No. 480
2005
Pen on paper
5 parts, each 11.7 × 8.2 in / 29.7 × 21 cm

Work No. 481
2005
Pen on paper
6 parts, each 11.7 × 8.2 in / 29.7 × 21 cm

Work No. 485
2005
Pen on paper
4 parts, each 11.7 × 8.2 in / 29.7 × 21 cm

Work No. 487
2005
Pen on paper
7 parts, each 11.7 × 8.2 in / 29.7 × 21 cm

Work No. 491
2005
Pencil on paper
11.7 × 8.2 in / 29.7 × 21 cm

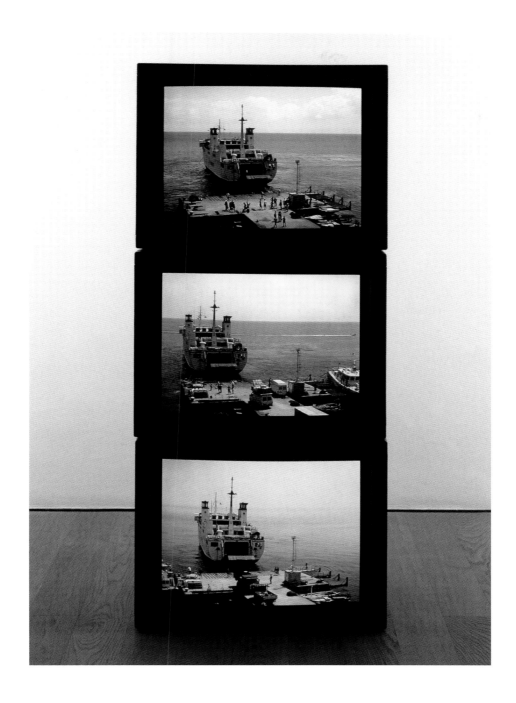

Work No. 492
Ships coming in, 2005
3 synchronized videos; Mini DV, colour, sound
8 minutes 30 seconds
Dimensions variable
Edition of 1 + 1 AP

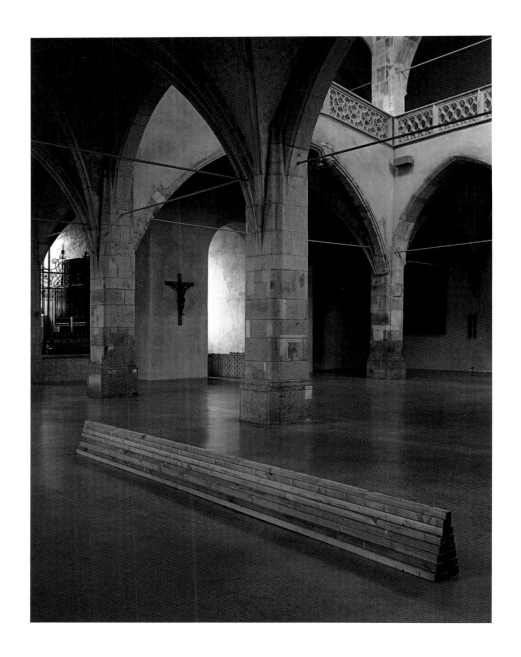

Work No. 493
2005
Planks of wood
189 in / 480 cm
Installation at St Peter's Church, Cologne, Germany, 2005

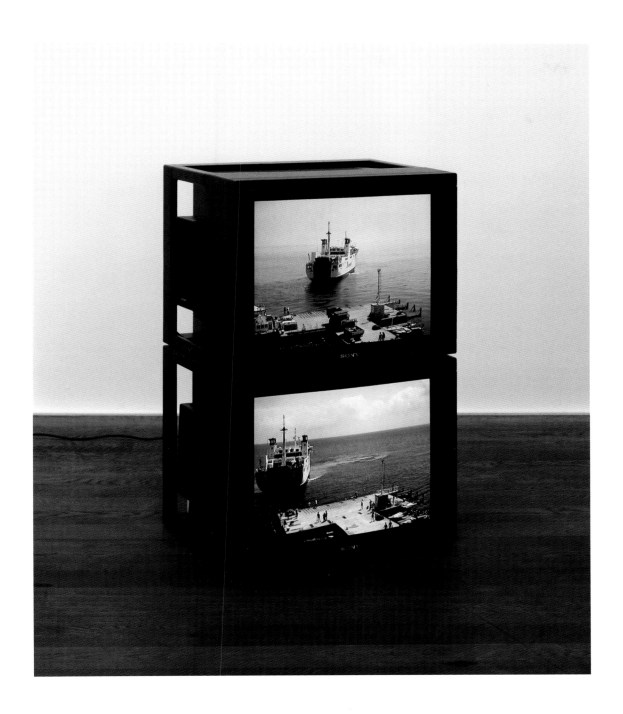

Work No. 494
Ships coming in, 2005
2 synchronized videos; Mini DV, colour, sound
8 minutes 30 seconds
Dimensions variable
Edition of 1 + 1 AP

Work No. 495
2005
Pen on paper
7 parts, each 11.7 × 8.2 in / 29.7 × 21 cm

Work No. 496
2005
Pen on paper
7 parts, each 11.7 × 8.2 in / 29.7 × 21 cm

Work No. 498
2005
Pen on paper
8 parts, each 11.7 × 8.2 in / 29.7 × 21 cm

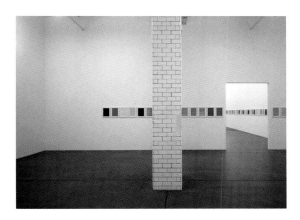
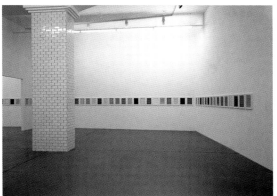
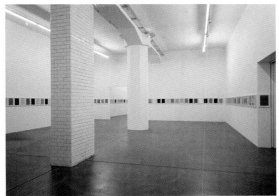
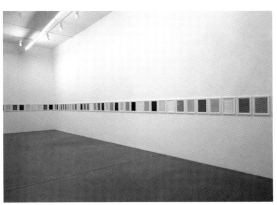
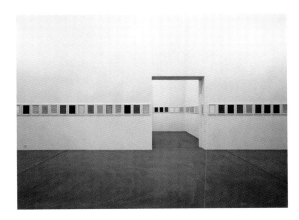
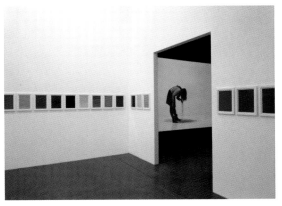

Work No. 502
2006
Pen on paper
220 parts, each 11.7 × 8.2 in / 29.7 × 21 cm
Installation at Hauser & Wirth Zurich, Zurich, Switzerland, 2006

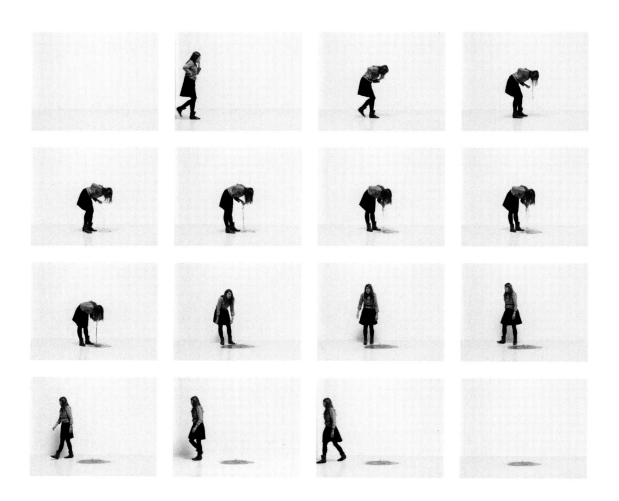

Work. No. 503
2006
35 mm film, colour, sound
1 minute 6 seconds
Edition of 1 + 1 AP

Work No. 506
2006
Pencil on paper
5 parts, each 11.7 × 8.2 in / 29.7 × 21 cm

Work No. 508
Black painting, 2006
Acrylic on canvas
24.2 × 17.9 in / 61.5 × 45.5 cm

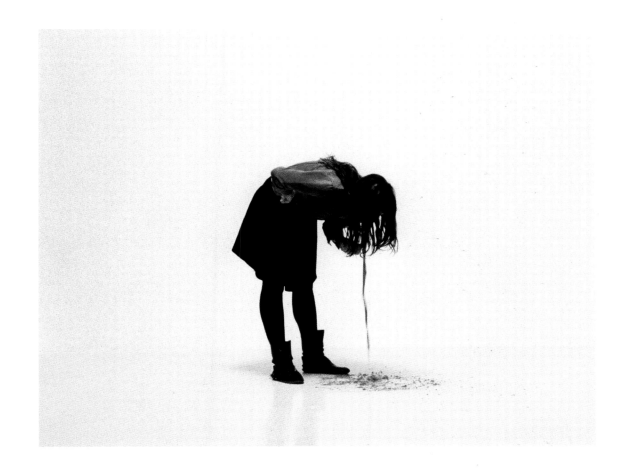

Work No. 509
2006
Photographic print
29.5 × 39.3 in / 75 × 100 cm
Edition of 1 + 1 AP

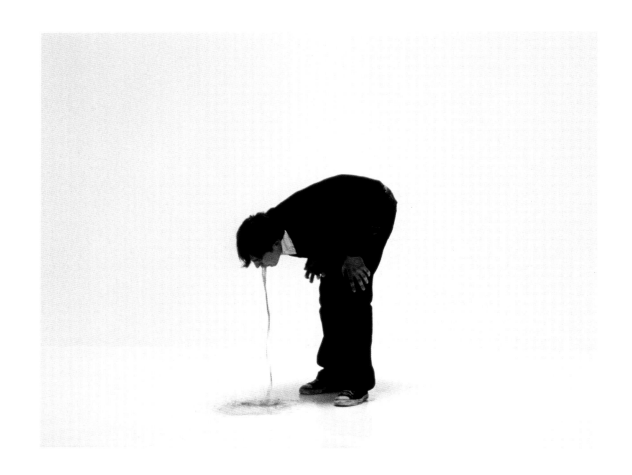

Work No. 510
2006
Photographic print
29.5 × 39.3 in / 75 × 100 cm
Edition of 1 + 1 AP

Work No. 512
2006
Biro on paper
3 parts, each 11.7 × 8.2 in / 29.7 × 21 cm

Work No. 516
2006
Marker pen on paper
11.7 × 8.2 in / 29.7 × 21 cm

Work No. 517
2006
Pen on paper
3 parts, each 11.7 × 8.2 in / 29.7 × 21 cm

Work No. 518
2006
Pencil on paper
11.7 × 8.2 in / 29.7 × 21 cm

Work No. 520
2006
Pencil on paper
11.7 × 8.2 in / 29.7 × 21 cm

Work No. 521
2006
Biro on paper
11.7 × 8.2 in / 29.7 × 21 cm

Work No. 522
2006
Marker pen on paper
11.7 × 8.2 in / 29.7 × 21 cm

Work No. 523
2006
Marker pen on paper
11.7 × 8.2 in / 29.7 × 21 cm

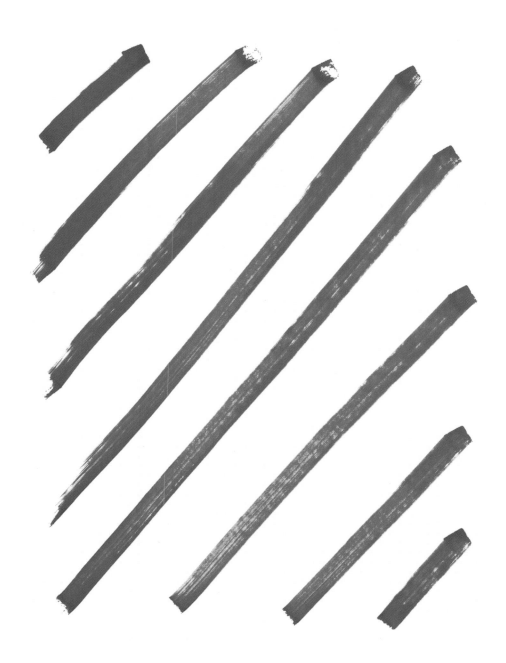

Work No. 524
2006
Marker pen on paper
11.7 × 8.2 in / 29.7 × 21 cm

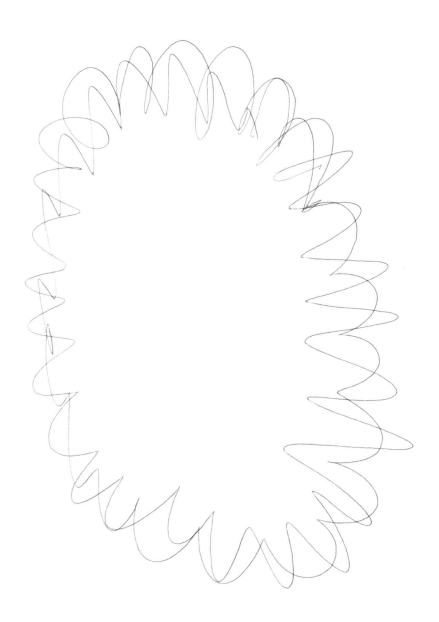

Work No. 525
2006
Biro on paper
11.7 × 8.2 in / 29.7 × 21 cm

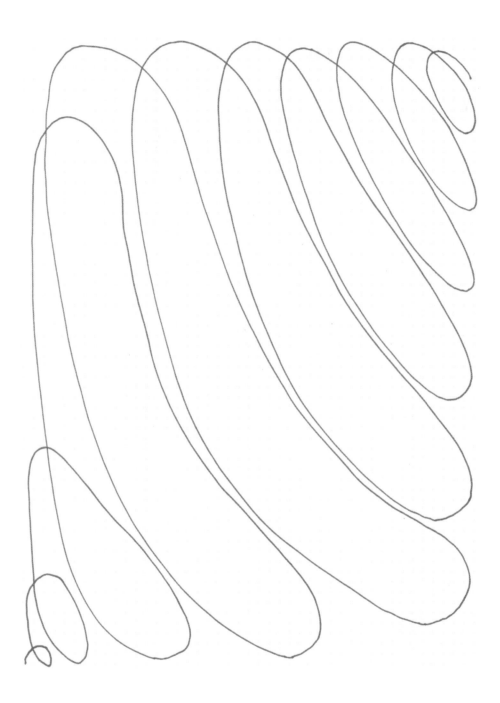

Work No. 526
2006
Marker pen on paper
11.7 × 8.2 in / 29.7 × 21 cm

Work No. 528
2006
Biro on paper
11.7 × 8.2 in / 29.7 × 21 cm

Work No. 529
2006
Biro on paper
11.7 × 8.2 in / 29.7 × 21 cm

Work No. 532
2006
Marker pen on paper
11.7 × 8.2 in / 29.7 × 21 cm

Work No. 536
2006
Biro on paper
11.7 × 8.2 in / 29.7 × 21 cm

Work No. 537
2006
Marker pen on paper
11.7 × 8.2 in / 29.7 × 21 cm

Work No. 538
2006
Pencil on paper
11.7 × 8.2 in / 29.7 × 21 cm

Work No. 539
2006
Biro on paper
11.7 × 8.2 in / 29.7 × 21 cm

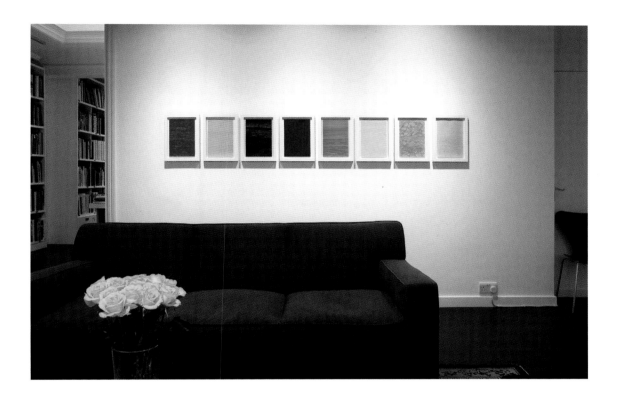

Work No. 541
2006
Pen on paper
8 parts, each 11.7 × 8.2 in / 29.7 × 21 cm
Installation at Hauser & Wirth London, London, UK, 2007

546

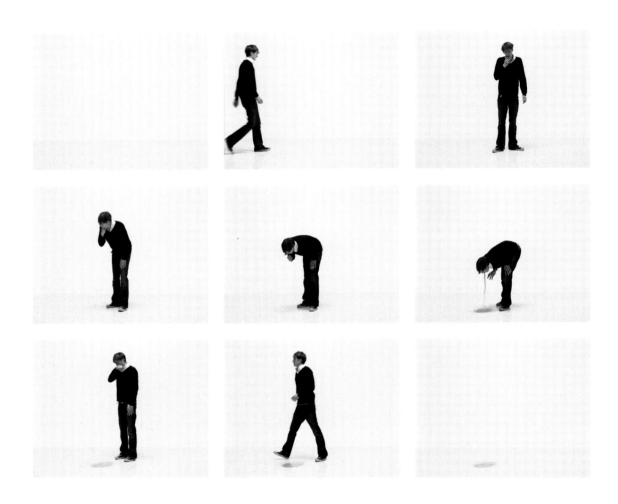

Work No. 546
2006
35 mm film, colour, sound
2 minutes 25 seconds
Edition of 1 + 1 AP

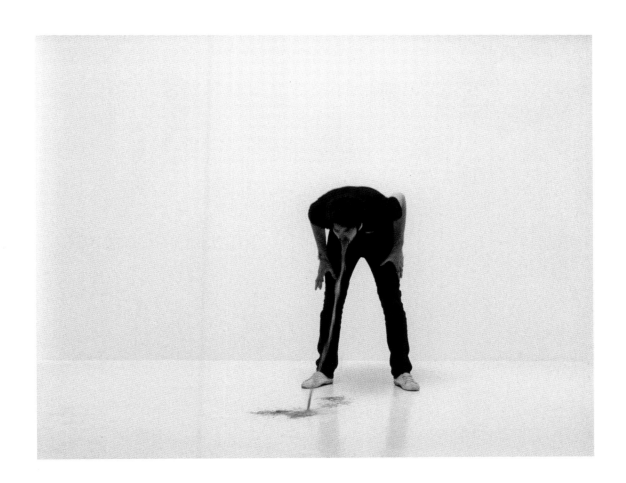

Work No. 547
2006
35 mm film, colour, sound
47 seconds
Edition of 1 + 1 AP

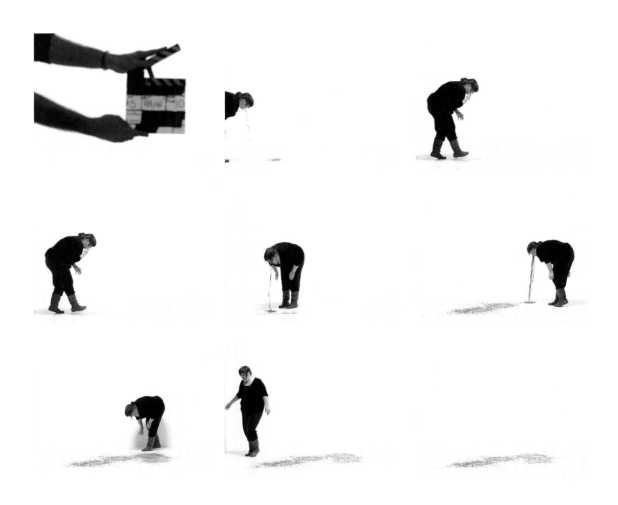

548

Work No. 548
2006
35 mm film, colour, sound
1 minute 30 seconds
Edition of 1 + 1 AP

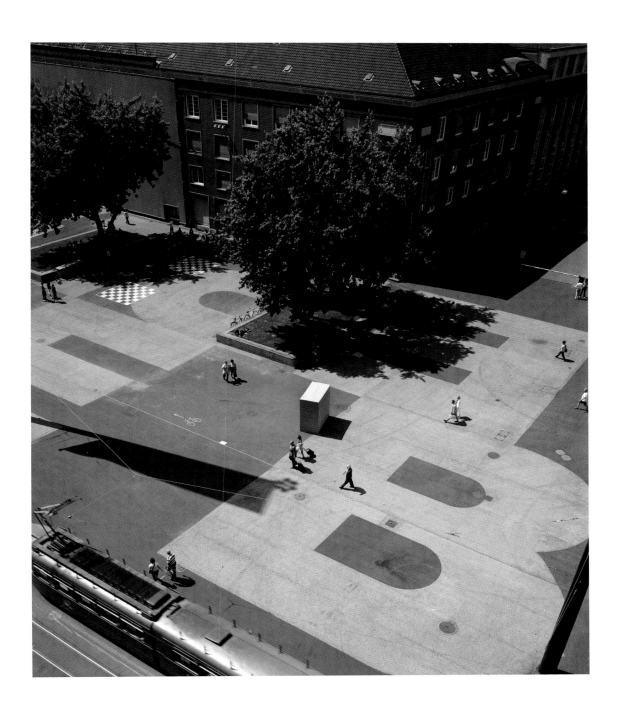

Work No. 549
2006
15 mm plywood
95.6 × 95.6 × 47.8 in / 243 × 243 × 121.5 cm
Installation at Basel Art Fair, Basel, Switzerland, 2006

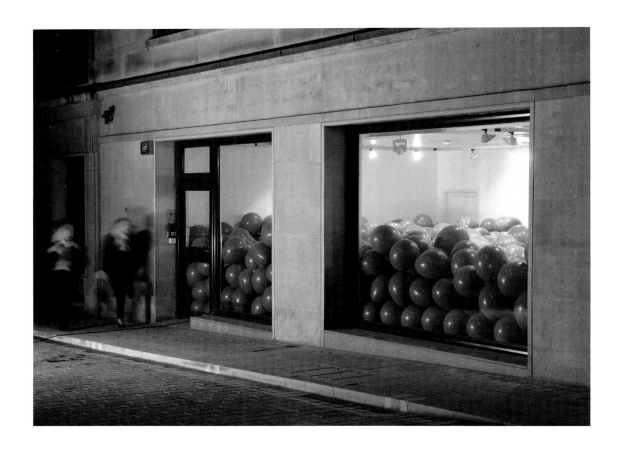

Work No. 551
2006
Brown balloons
Multiple parts, each balloon 16 in / 40.6 cm diameter; overall dimensions variable
Installation at Hauser & Wirth London, London, UK, 2008

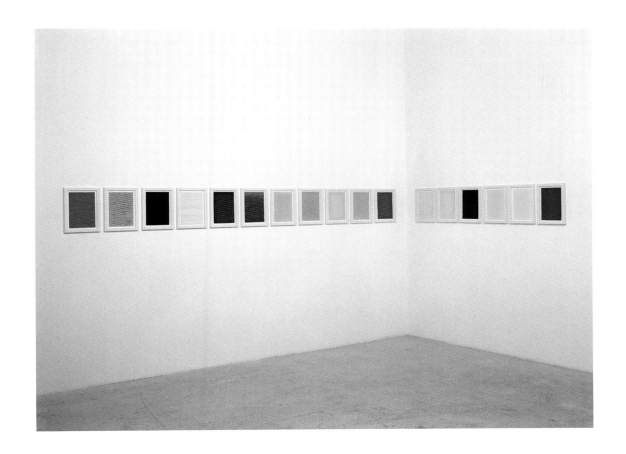

Work No. 552
2006
Pen on paper
17 parts, each 11.7 × 8.2 in / 29.7 × 21 cm

Work No. 553
2006
Pen on paper
5 parts, each 11.7 × 8.2 in / 29.7 × 21 cm

Work No. 557
2006
Marker pen on paper
6 parts, each 11.7 × 8.2 in / 29.7 × 21 cm

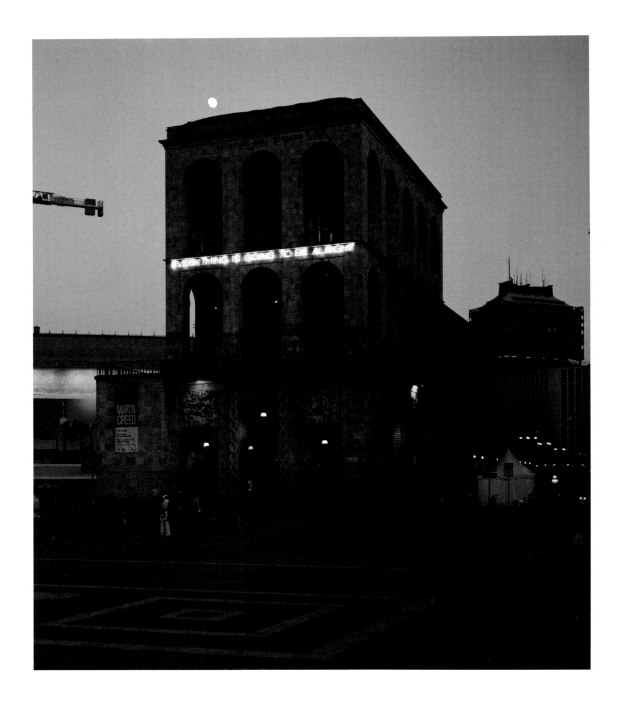

Work No. 560
EVERYTHING IS GOING TO BE ALRIGHT, 2006
White neon
1.6 × 54.6 ft / 0.5 × 14.3 m
Installation at Palazzo dell'Arengario, Milan, Italy, 2006
Commissioned by Fondazione Nicola Trussardi, Milan

Work No. 561
2006
Marker pen on paper
11.7 × 8.2 in / 29.7 × 21 cm

Work No. 562
2006
Pen on paper
12 parts, each 11.7 × 8.2 in / 29.7 × 21 cm

Work No. 563
2006
Marker pen on paper
11.7 × 8.2 in / 29.7 × 21 cm

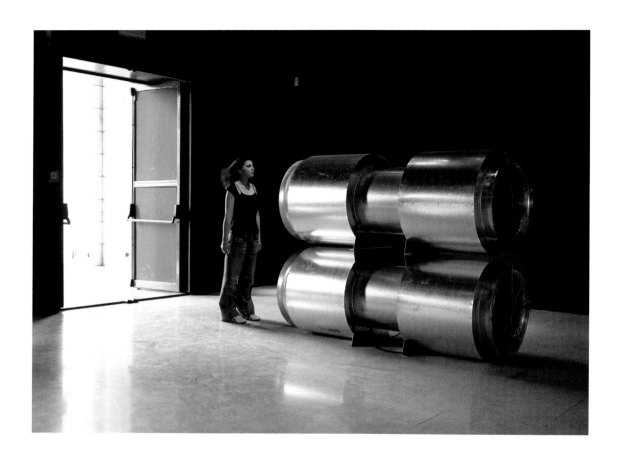

Work No. 564
Wind machines, 2006
2 wind machines
5.4 × 6.4 × 2.6 ft / 1.6 × 2 × 0.8 m
Installation at Palazzo dell'Arengario, Milan, Italy, 2006
Edition of 1 + 1 AP
Commissioned by Fondazione Nicola Trussardi, Milan

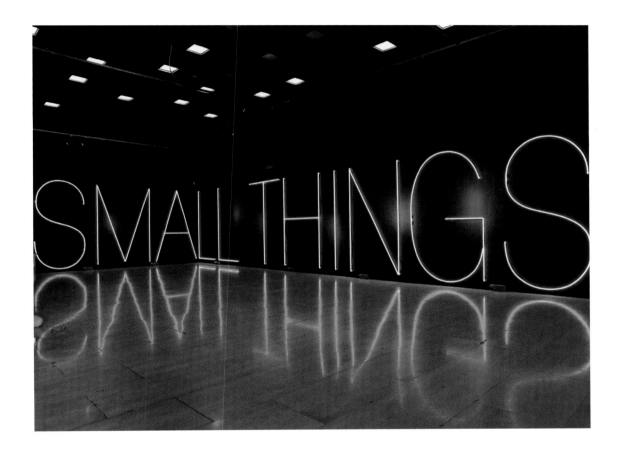

Work No. 567
SMALL THINGS, 2006
Blue neon
10 × 60 ft / 3 × 18.2 m
Installation at Palazzo dell'Arengario, Milan, Italy, 2006
Commissioned by Fondazione Nicola Trussardi, Milan

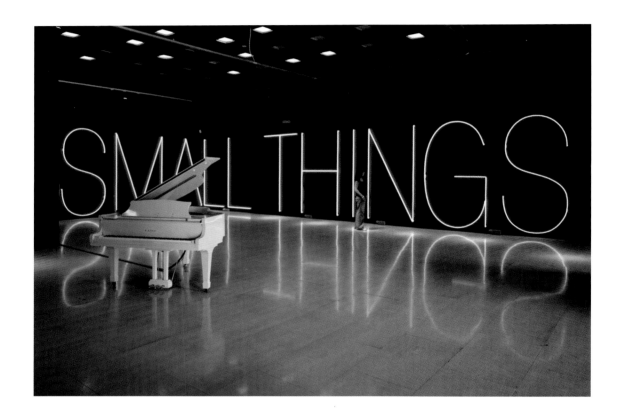

Work No. 569
Piano, 2006
Slamming piano
5 × 1.8 × 6.5 ft / 1.5 × 0.5 × 2 m
Installation at Palazzo dell'Arengario, Milan, Italy, 2006
Commissioned by Fondazione Nicola Trussardi, Milan

Work No. 570
2006
Runners
Dimensions variable
Edition of 1 + 1 AP
Installation at Palazzo dell'Arengario, Milan, Italy, 2006
Commissioned by Fondazione Nicola Trussardi, Milan

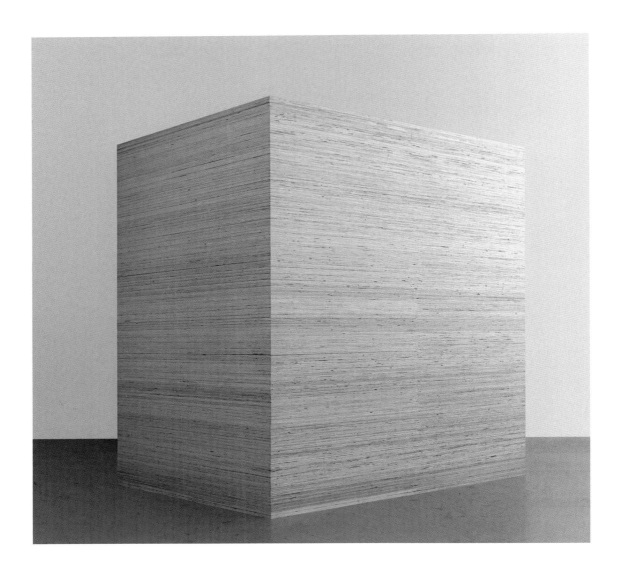

Work No. 571
2006
19 mm plywood
99.2 x 72.9 x 99.2 in / 252 x 185 x 252 cm

Work No. 572
2006
Marker pen on paper
4 parts, each 11.7 × 8.2 in / 29.7 × 21 cm

Work No. 573
2006
Marker pen on paper
11.7 × 8.2 in / 29.7 × 21 cm

Work No. 575
2006
Pen on paper
7 parts, each 11.7 × 8.2 in / 29.7 × 21 cm

I was watching 'Dear Diary' — the film by Nanni Moretti — with a person different from me called Paola Pivi in Italy or England in a year gone by.

In the film Nanni and his friend are looking for peace and quiet and eventually hit it, after many misses, on the island of Alicudi off Sicily. The extreme peace and quiet, however, once found become too much, and they miss their favourite soap opera. They run away from Alicudi shouting "Television! Give us television!" Years later I watched a lot of television in Alicudi, where you can get a good, clear picture with SKY at a very reasonable price.

Watching the film, Paola said, or I said — joined together as we were it's hard to say who said — maybe it's best to say WE said; we said "Let's go to Alicudi! Let's go there! Let's go there to that place those guys just ran away from!"

Like a cartoon island, a rock sticking out of the sea, like a drawing of an island by a child, or like a planet they land on in Star Trek which looks as if it obviously can't be real, that it must be made out cardboard; looking so zingy, bright, shiny and contrasty that it looks fake, done in Photoshop — Alicudi is I think the most beautiful place I have ever been in my life. But it's made of rock, not cardboard. I know that because if you don't wear shoes to go swimming you cut your feet. And also, if Alicudi really was made out of cardboard it would have dissolved into the sea a long time ago.

On the way to Alicudi that first time we stopped for a night — on the way to Alicudi you always have to stop for a night somewhere — in Palermo and went to see the catacombs of the cappucini monks. We were very late and only had 5 minutes to see it all before closing time. To do it we had to run. I remember running at top speed with Paola and my friends Martin and Tomma through the catacombs looking desperately left and right at all of the dead people hanging on the walls in their best clothes, trying our best to see it all. It was espressi rather than cappucini. It was a good way to see it. It was that kind of delirious running which makes you laugh uncontrollably when you're doing it. I think it's good to see museums at high speed. It leaves time for other things.

You can always see Alicudi coming. Before you get there you can see it in the distance from the boat, a little blip on the horizon; and then the little blip becomes a full size blip which you can stand on. In reverse, going away from Alicudi is amazing sad and slow. It is not often that you can leave a place and watch it get smaller and smaller in the distance until it is gone. When I leave my flat in London I turn the corner after 30 metres and it has disappeared from view; leaving Alicudi takes hours, and hours later you can still see it there in the distance.

Alicudi is magnetic. Going there can feel very difficult, as if Alicudi and you are like two magnets of the same polarity pushing each other away — and that's not counting the sea and the way that can stop you. Then, if you make it, when you are there your magnetic charge changes and you become glued, stuck. It can feel incredibly difficult to leave. Alicudi can feel like both a sort of paradise and a sort of prison: it depends, I suppose, like everything, on your insides.

While living there, Paola and I experimented with all of the different ways of getting there to see if there was an easy way. Train from Rome to Milazzo, taxi, car ferry, walking. Ocean liner from Genova to Palermo, and then aliscafo and walking. Boat from Napoli to Alicudi. Flying from London via Rome or Milan to Palermo, Catania, Reggio Calabria or Lamezia Terme. Helicopter. Whichever way you go you always end up walking up steps in the end and all of the ways to get there are difficult. From London it's easier and quicker to get to Australia.

Alicudi is a great place to watch television. We had satellite TV with all of the channels. I spent a huge amount of time watching television there. Perhaps because it's so close to nature, so peaceful and quiet. It's great to watch television in nature: television is another little force of nature. It's great to watch TV on a remote mountain in the middle of the sea. When I'm in the city I don't watch television, maybe because it is too much like the city; too similar to the city in its speed and sound and movement.

After holidaying there in 2000, we rented a house there in 2001, bought a house there in 2002, and lived there in 2003. In 2004 Paola and I split up. The dates were not planned.

The people of Alicudi helped a lot in many different ways.

Work No. 577
Alicudi, 2006
Text
A version of this piece was first published in Italian in *Vanity Fair Italia*, 2006

All dimensions inches
R = radius, R' = 2, R" = 1

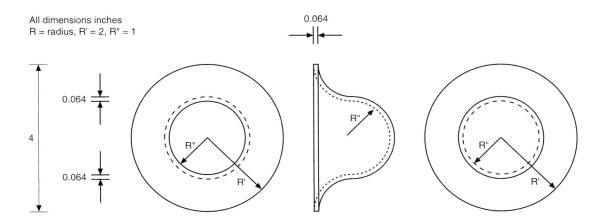

Two of the object represented in the diagram above.
Material: silver.
One polished to a mirror finish on its internal surface.
The other polished to a mirror finish on its external surface.
The objects situated as shown in the plan view below, facing each other on opposite walls.

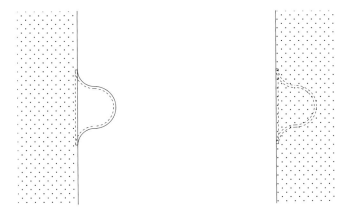

Both objects at the same height; directly opposite each other; meeting the surface of the wall steplessly, at an absolute tangent.
Recommended height: 139 cm from the floor to the middle of the objects.

Work No. 578
An intrusion and a protrusion from a wall, 2006
Silver in / silver out; opposite walls
2 parts, each 4 in / 10.1 cm diameter
Edition of 2 + 1 AP
(Drawing shown)

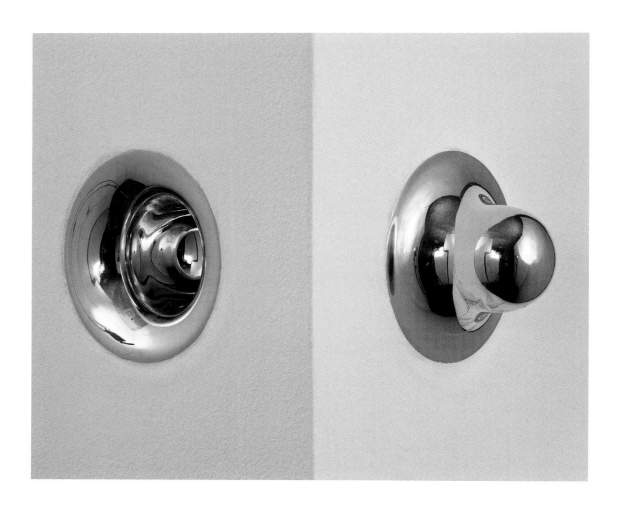

Work No. 579
An intrusion and a protrusion from a wall, 2006
Gold-plated silver in / gold-plated silver out; external corner
2 parts, each 4 in / 10.1 cm diameter
Edition of 2 + 1 AP

Work No. 581
2006
Marker pen on paper
11.7 × 8.2 in / 29.7 × 21 cm

Work No. 582
2006
Photographic prints
7 parts, each 6 × 4.5 in / 15.2 × 11.4 cm
Edition of 1 + 1 AP

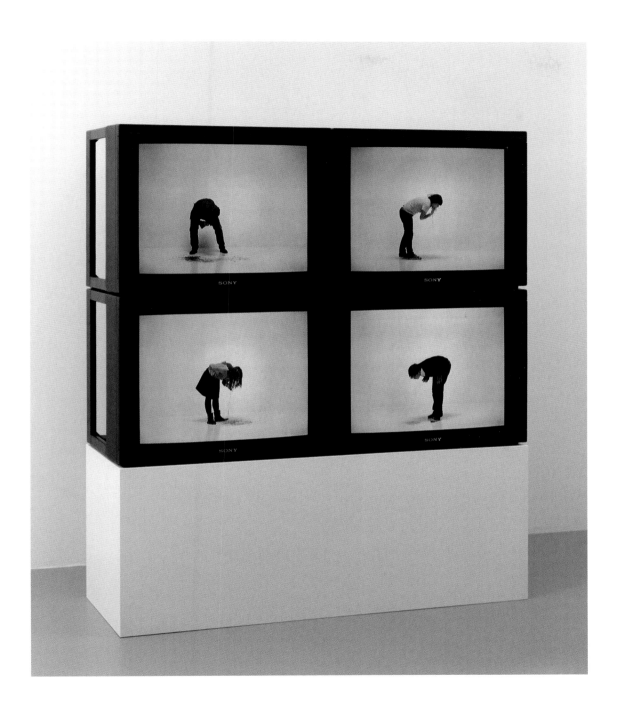

Work No. 583
2006
4 synchronized films; 35 mm film, colour, sound
4 minutes 6 seconds
Dimensions variable
Edition of 1 + 1 AP

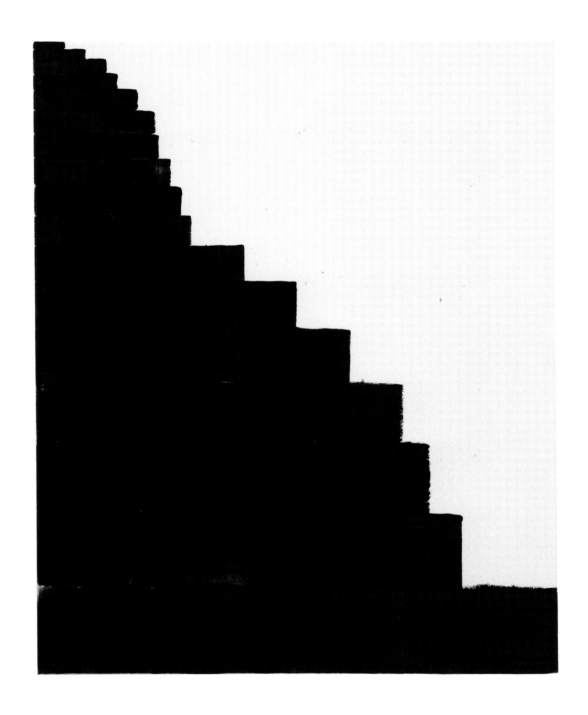

Work No. 585
2006
Acrylic on canvas
30 × 24 × 0.6 in / 76.3 × 61 × 1.5 cm

Work No. 586
Big dogs, 2007
Poster
12.5 × 12.5 in / 31.7 × 31.7 cm

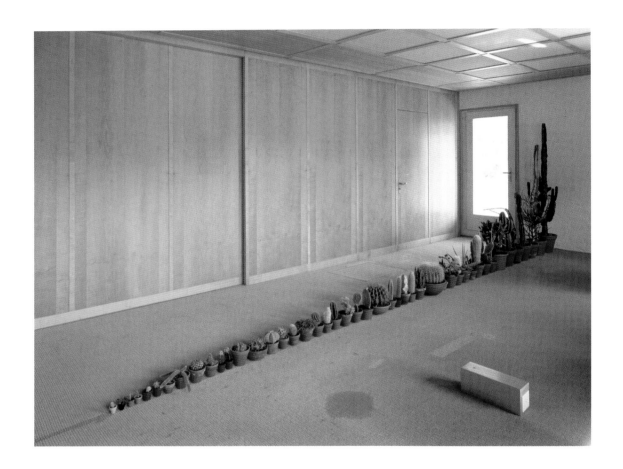

Work No. 587
2006
Cactus plants
29 parts, dimensions variable
Installation at a private residence, Switzerland, 2007

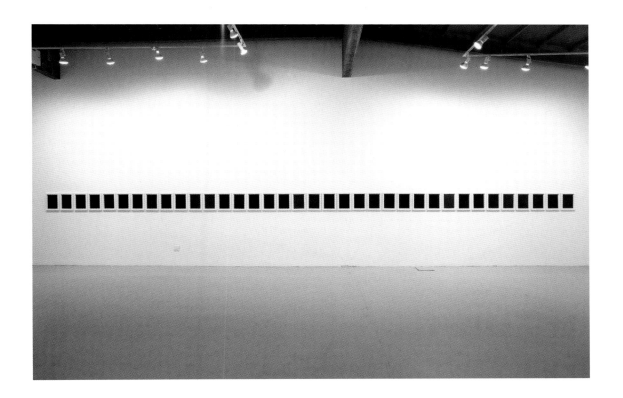

Work No. 590
2006
Marker pen on paper
36 parts, each 11.7 × 8.2 in / 29.7 × 21 cm
Installation at MC Kunst, Los Angeles, USA, 2006

Work No. 591
2006
Dogs
2 parts, dimensions variable
Edition of 3 + 1 AP
Installation at MC Kunst, Los Angeles, USA, 2006

Work No. 592
2006
Piece for harmonica and elevator
Dimensions variable
Edition of 1 + 1 AP
Installation at Museo de Arte Contemporánea de Vigo, Vigo, Spain, 2006

Work No. 593
2007
Photographic print
11.7 × 16.5 in / 29.7 × 42 cm
Edition of 1 + 1 AP

Work No. 594
2006
Emulsion on wall
Dimensions variable
Installation at Bethlehem Peace Center, Bethlehem, Palestine, 2006

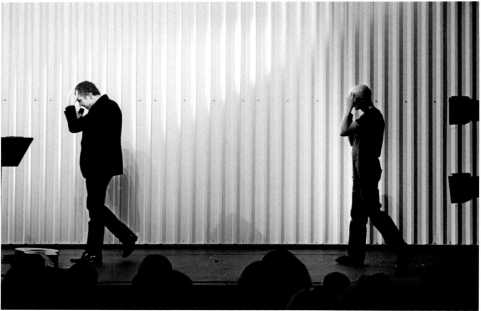

Work No. 595
2006
Choreographed dance for a talk
Top Shown in performance at Old Boy's Theatre, Christ's College, Christchurch, New Zealand, 2006
Bottom Shown in performance at The New Athenaeum Theatre, Royal Scottish Academy of Music and Drama, Glasgow, UK, 2007

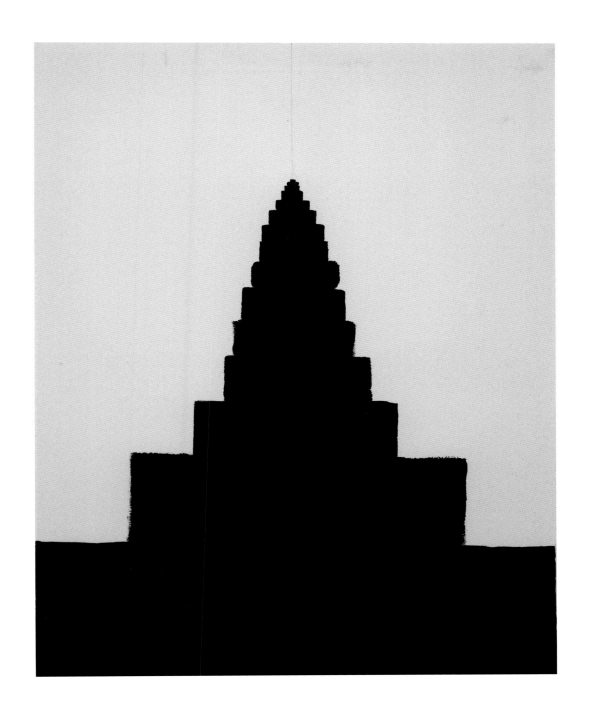

Work No. 596
2006
Acrylic on canvas
30 × 24 in / 76.2 × 61 cm

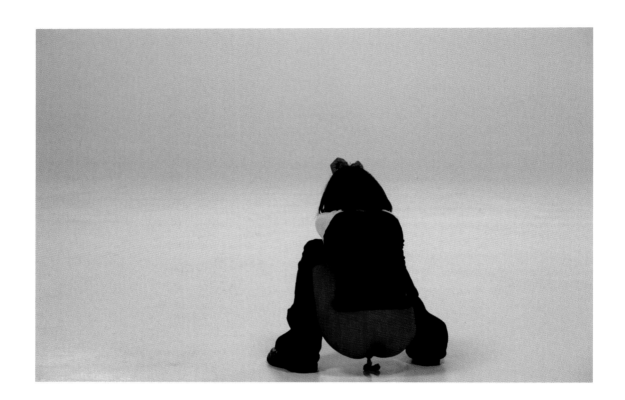

Work No. 600
2006
35 mm film, colour, sound
1 minute 18 seconds
Edition of 1 + 1 AP

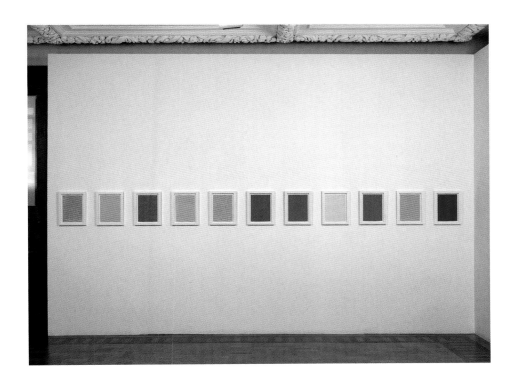

Work No. 604
2006
Pen on paper
11 parts, each 11.7 × 8.2 in / 29.7 × 21 cm

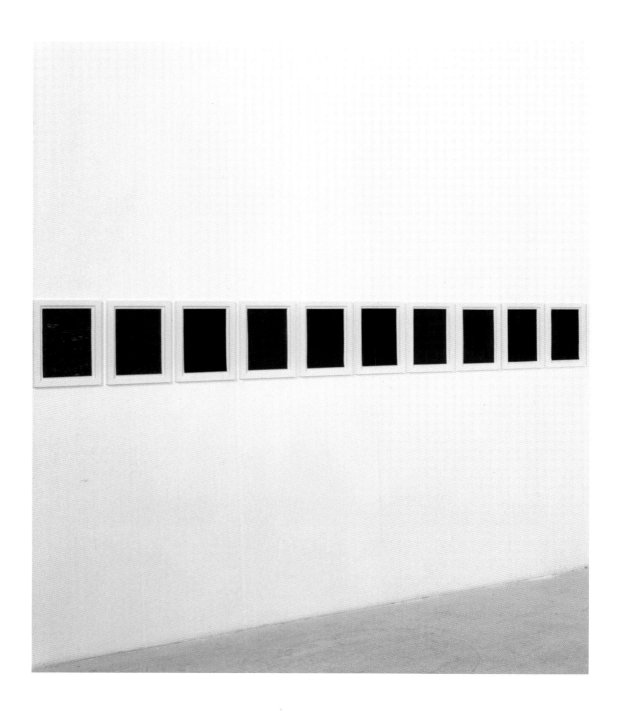

Work No. 605
2006
Marker pen on paper
88 parts, each 11.7 × 8.2 in / 29.7 × 21 cm
(Detail)

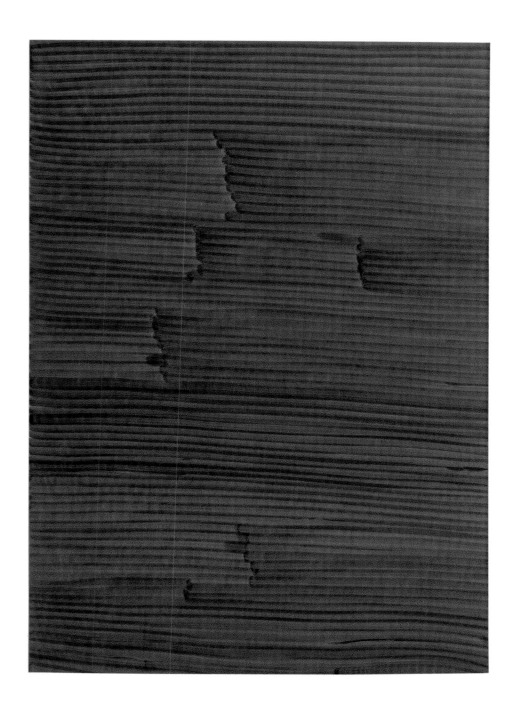

Work No. 607
2006
Marker pen on paper
11.7 × 8.2 in / 29.7 × 21 cm

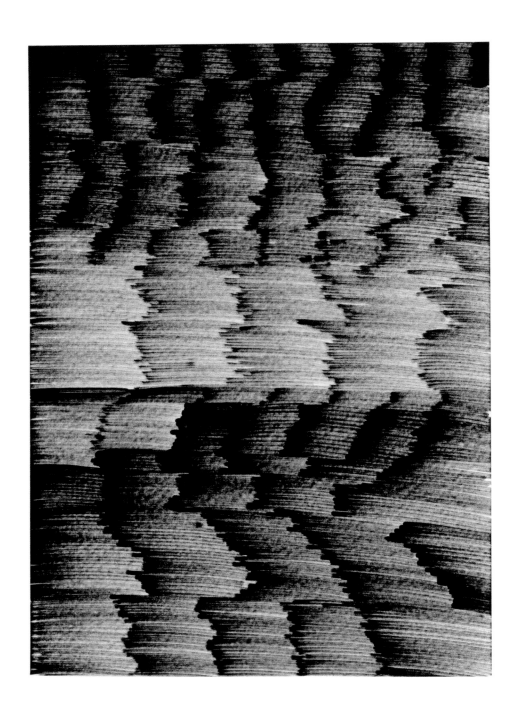

Work No. 608
2006
Marker pen on paper
11.7 × 8.2 in / 29.7 × 21 cm

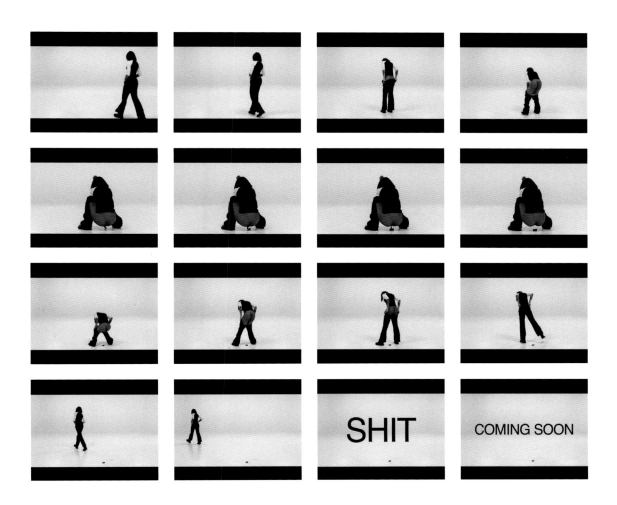

Work No. 609
Shit film trailer, 2006
35 mm film, colour, sound, 1:185 aspect ratio
1 minute 33 seconds

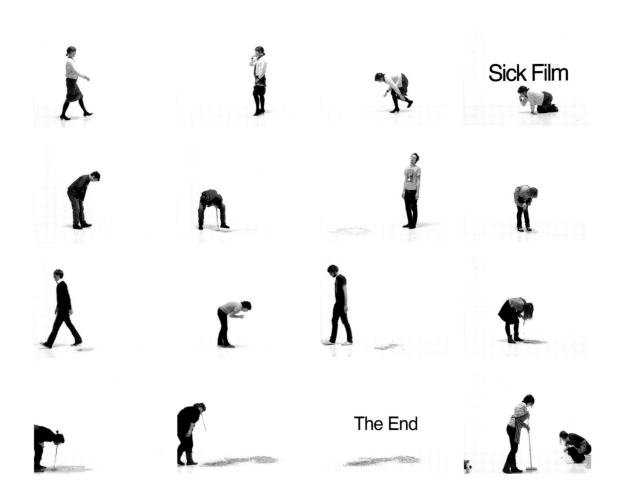

Work No. 610
Sick Film, 2006
35 mm film, colour, sound, 1:133 aspect ratio
21 minutes

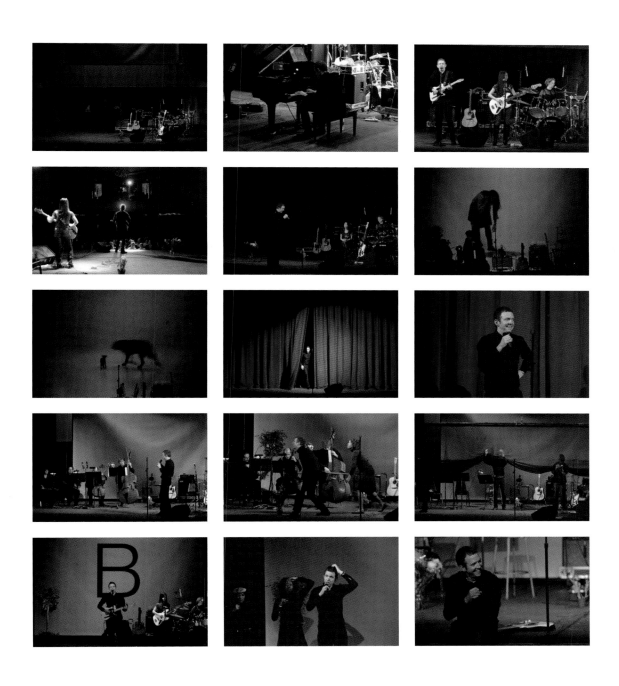

Work No. 612
2006–2007
Theatre show
Shown in performance at Harry De Jur Playhouse, New York, USA, 2007
Commissioned by Public Art Fund, New York

Pass Them On

If you're feeling bad and your thoughts are sad, pass them on to someone else...

Pass them on, pass them on, pass them on, pass them
Pass them on, pass your bad feelings on, pass them
Pass them on, pass them on, pass them on, pass them
Pass them on, pass them on

Pass them on, pass your bad feelings on, pass them,
Pass them on, pass them on, pass them on, pass them
Pass them on, pass them on, pass them on, pass them
Pass them on, pass them on

Pass your bad feelings on to a friend or a relative, or someone else that you know

Work No. 614
2006
Pass them on
Piece for voices, guitar, bass and drums
(Lyrics shown)

Work No. 615
2006
Plants
41 parts, dimensions variable
Installation in Christchurch, New Zealand, 2006
(Detail)

Work No. 617
2006
Pen on paper
30 parts, each 11.7 × 8.2 in / 29.7 × 21 cm
Installation at Scott's restaurant, London, UK, 2007

Work No. 622
2006
Postcard
4 × 6 in / 10.1 × 15.2 cm

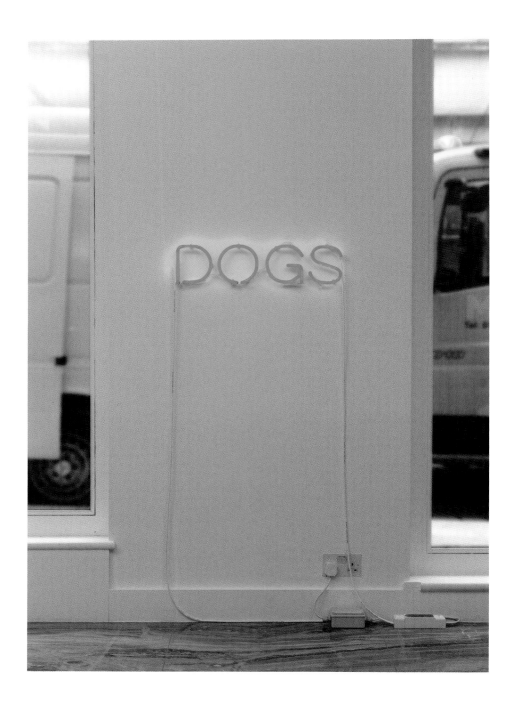

Work No. 623
DOGS, 2006
Green neon
6 in / 15.2 cm high; 3 seconds on / 3 seconds off
Edition of 3 + 1 AP

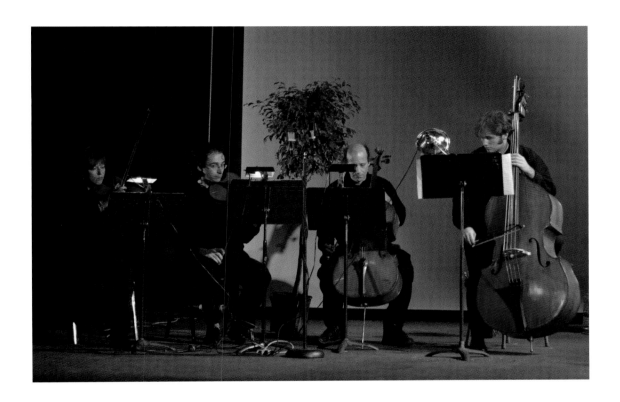

Work No. 625
Variations for string quartet, 2006
Piece for double-bass, cello, viola and violin
Shown in performance at Harry De Jur Playhouse, New York, USA, 2007

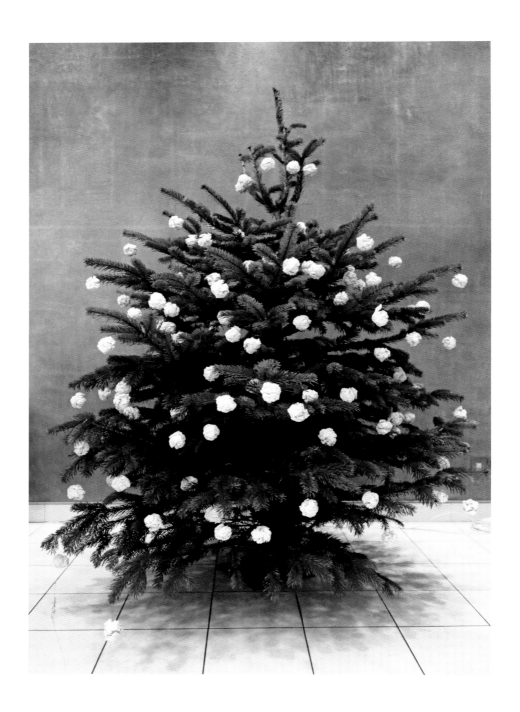

Work No. 626
2006
Christmas-tree decoration for *The Guardian* newspaper
Dimensions variable
(Photograph from *The Guardian*, 20 December 2006 shown)

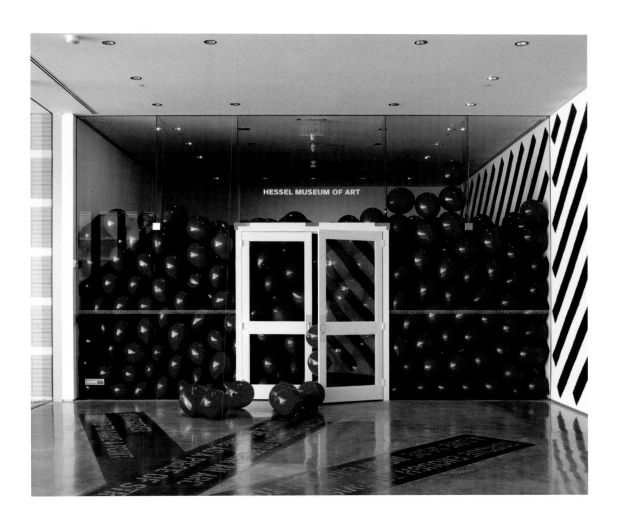

Work No. 628
2007
Dark-blue balloons
Multiple parts, each balloon 16 in / 40.6 cm diameter; overall dimensions variable
Installation at CCS Bard Hessel Museum, Annandale-on-Hudson, USA, 2007

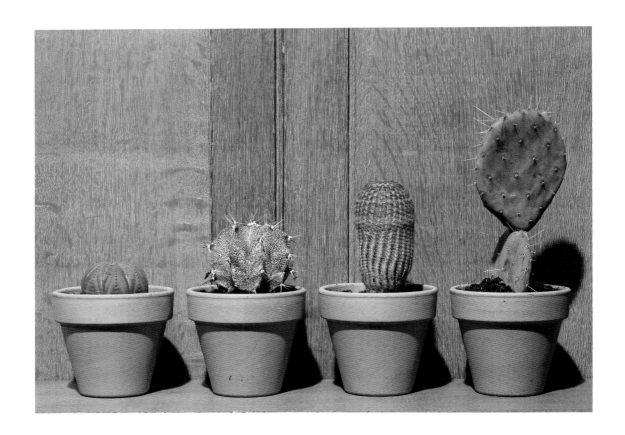

Work No. 629
2007
Cactus plants
4 parts, dimensions variable

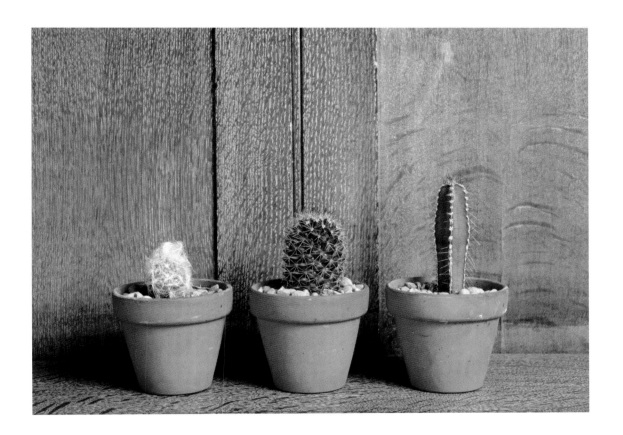

Work No. 630
2007
Cactus plants
3 parts, dimensions variable

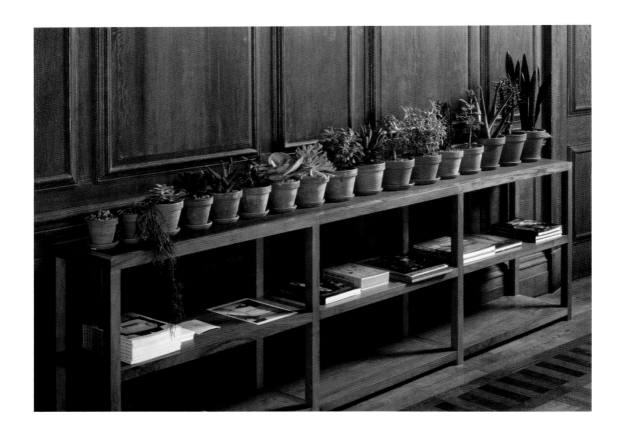

Work No. 631
2007
Succulent plants
17 parts, dimensions variable
Installation at Hauser & Wirth London, London, UK, 2007

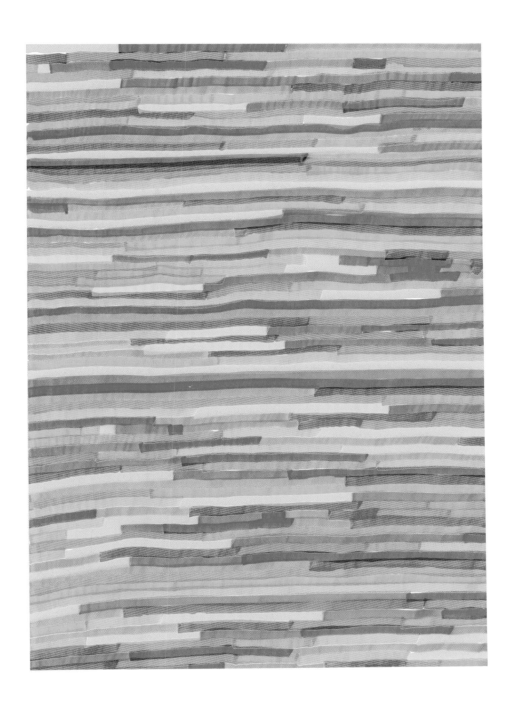

Work No. 632
2007
Highlighter pen on paper
11.7 × 8.2 in / 29.7 × 21 cm

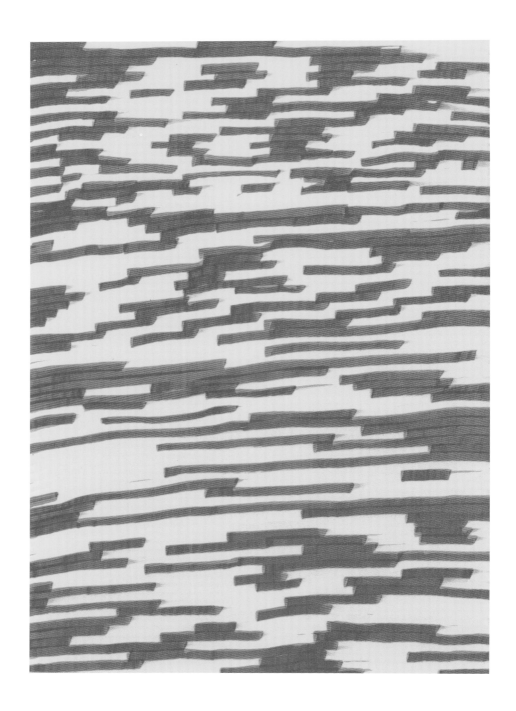

Work No. 633
2007
Highlighter pen on paper
11.7 × 8.2 in / 29.7 × 21 cm

Work No. 634
2007
Highlighter pen on paper
11.7 × 8.2 in / 29.7 × 21 cm

Work No. 635
2007
Card
11.7 × 8.2 in / 29.7 × 21 cm; inner hole 5.8 × 4.1 in / 14.8 × 10.5 cm

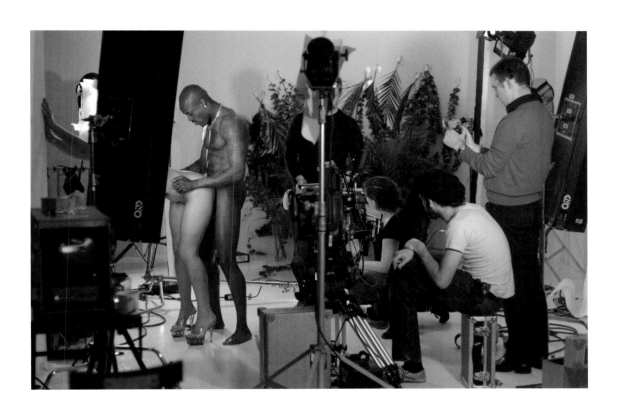

Work No. 636
2007
Announcement card
8.6 × 5.7 in / 22.2 × 14.6 cm

Work No. 638
2007
Highlighter pen and pencil on paper
11.7 × 8.2 in / 29.7 × 21 cm

Work No. 639
2007
Pencil on card
11.7 × 8.2 in / 29.7 × 21 cm

Work No. 640
2007
Biro on paper
11.7 × 8.2 in / 29.7 × 21 cm

Work No. 641
2007
Marker pen on paper
11.7 × 8.2 in / 29.7 × 21 cm

Work No. 642
2007
Paper
11.7 × 8.2 in / 29.7 × 21 cm

Work No. 643
2007
Marker pen on paper
11.7 × 8.2 in / 29.7 × 21 cm

Work No. 644
2007
Paper
11.7 × 8.2 in / 29.7 × 21 cm

Work No. 645
2007
Pen on paper
11.7 × 8.2 in / 29.7 × 21 cm

Work No. 646
2007
Paper
11.7 × 8.2 in / 29.7 × 21 cm

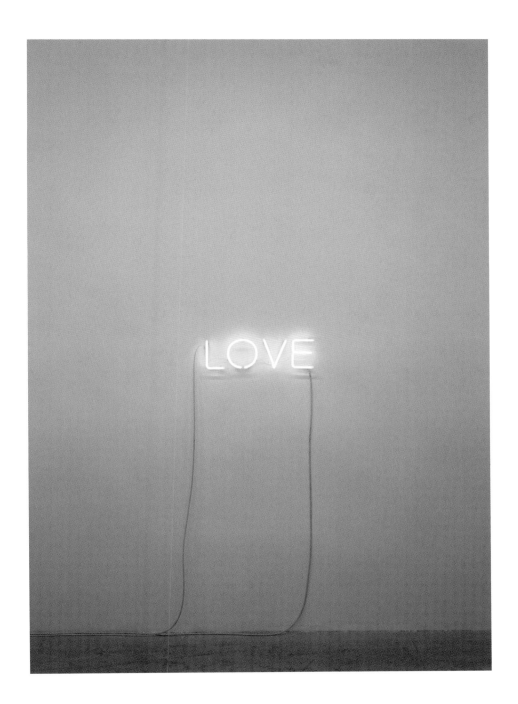

Work No. 651
LOVE, 2007
Pink neon
6 in / 15.2 cm high
Edition of 3 + 1 AP

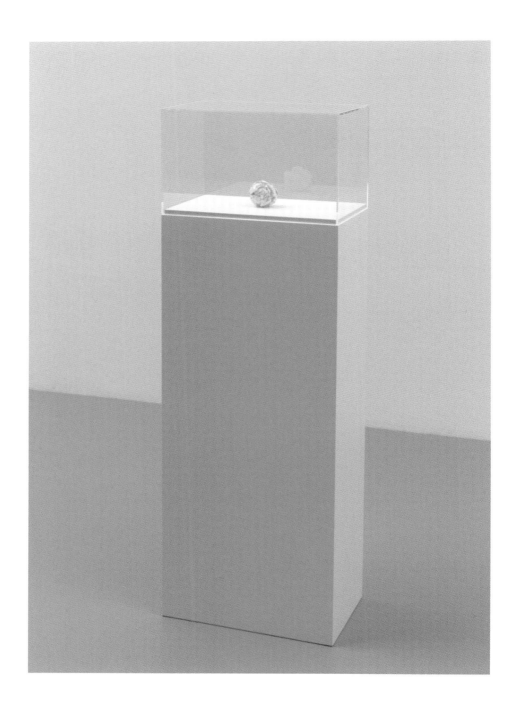

Work No. 652
A sheet of paper crumpled into a ball, 2007
US legal paper, lid, plinth
Lid 14 × 8.5 × 8.5 in / 35.6 × 21.6 × 21.6 cm; plinth height variable
Edition of 3 + 1 AP

Work No. 654
2007
Masking tape on paper, window-mount, frame
2 parts, each window 5.5 × 5.5 in / 14 × 14 cm

Work No. 656
A sheet of paper folded up and unfolded, 2007
Paper
11.7 × 8.2 in / 29.7 × 21 cm

Work No. 657
Smiling Woman, 2007
Pen, pencil, correction fluid, acrylic on paper
11.7 × 8.2 in / 29.7 × 21 cm

Work No. 660
2007
35 mm film, colour, sound
5 minutes
Edition of 1 + 1 AP

HAUSER & WIRTH COPPERMILL

REQUESTS THE PLEASURE OF YOUR COMPANY
AT A PARTY IN HONOUR OF

Martin Creed

THE REBEL, EUGENE KELLY, MEMEME,
DAVID CUNNINGHAM, SEKGURA,
TROUBLE RECORDS AND VICTORIA SPONGE WILL BE
PERFORMING AT BETHNAL GREEN WORKINGMEN'S CLUB
42 POLLARD ROW, LONDON E2 6NB
THURSDAY, 3 MAY AT 8.30 PM

PRIVATE VIEW, THURSDAY, 3 MAY 2007, 6 — 8 PM
HAUSER & WIRTH COPPERMILL, 92 — 108 CHESHIRE STREET, LONDON E2 6EJ
RSVP AMY LONG, TELEPHONE +44 (0)207 478 1780, AMY@HAUSERWIRTH.COM

WORK NO. 668

Work No. 668
2007
Announcement card
6 × 4 in / 15.2 × 10.1 cm

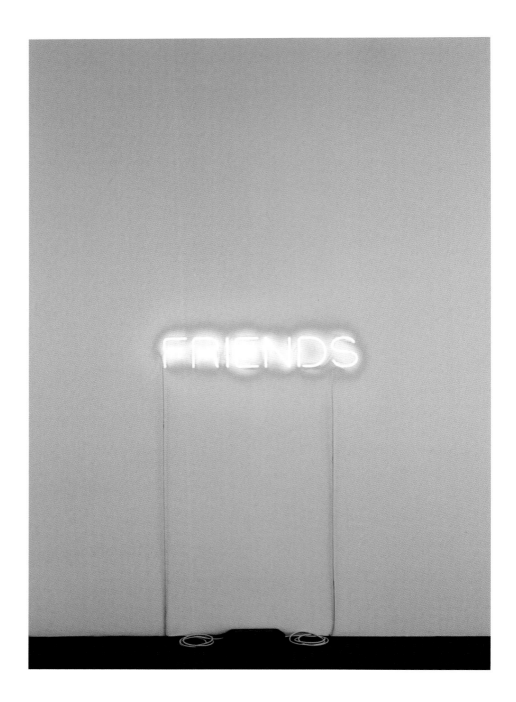

Work No. 669
FRIENDS, 2007
White neon
6 in / 15.2 cm high; 7 seconds on / 7 seconds off
Edition of 3 + 1 AP

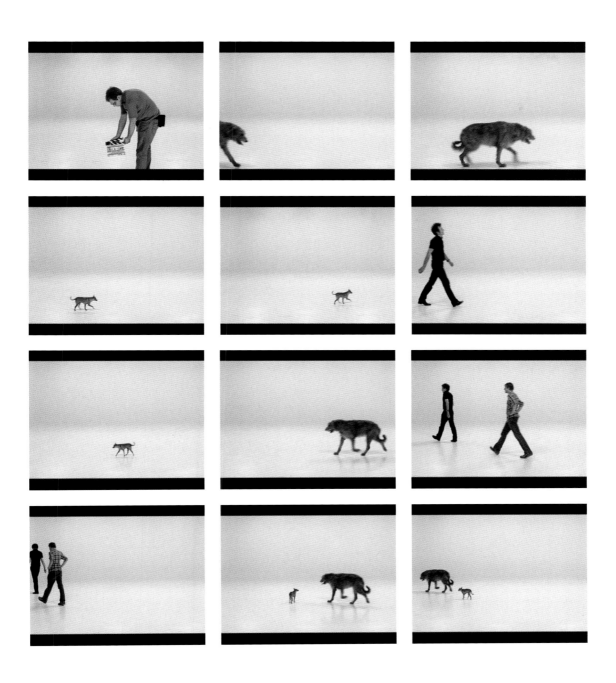

Work No. 670
Orson & Sparky, 2007
35 mm film, colour, sound
4 minutes 16 seconds
Edition of 3 + 1 AP

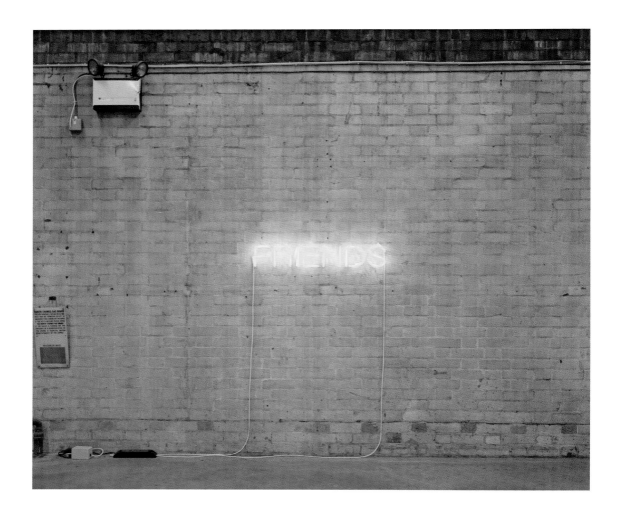

Work No. 671
FRIENDS, 2007
Yellow neon
6 in / 15.2 cm high
Edition of 3 + 1 AP
Installation at Hauser & Wirth London, London, UK, 2007

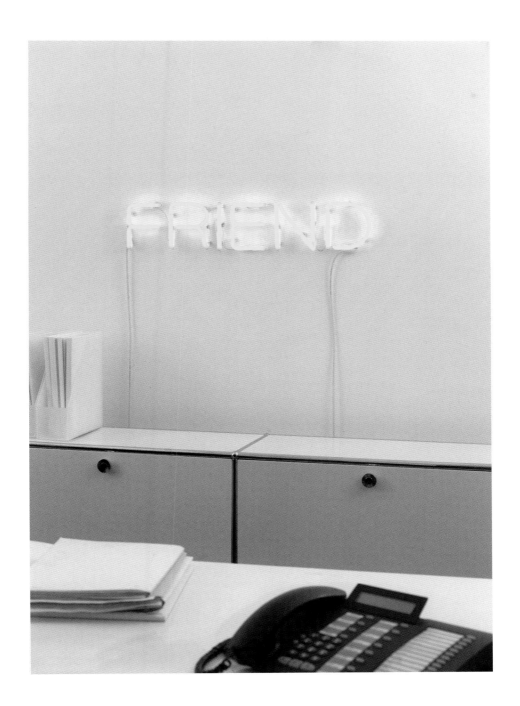

Work No. 672
FRIEND, 2007
Yellow neon
6 in / 15.2 cm high
Edition of 3 + 1 AP
Installation at Hauser & Wirth Zurich, Zurich, Switzerland, 2008

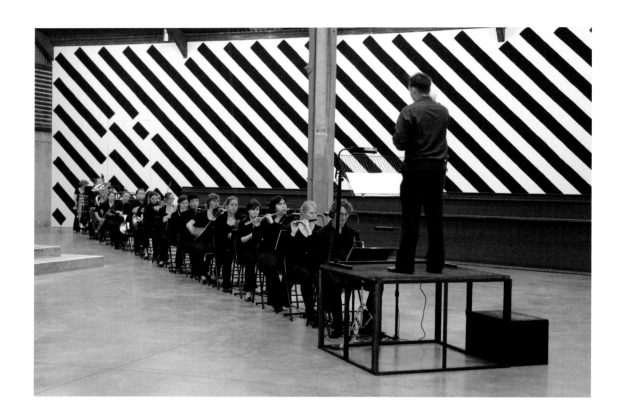

Work No. 673
2007
Piece for 18 musicians
Shown in performance at Hauser & Wirth Coppermill, London, UK, 2007

Work No. 674
2007
Pencil on paper
3.9 × 5.9 in / 10 × 15 cm

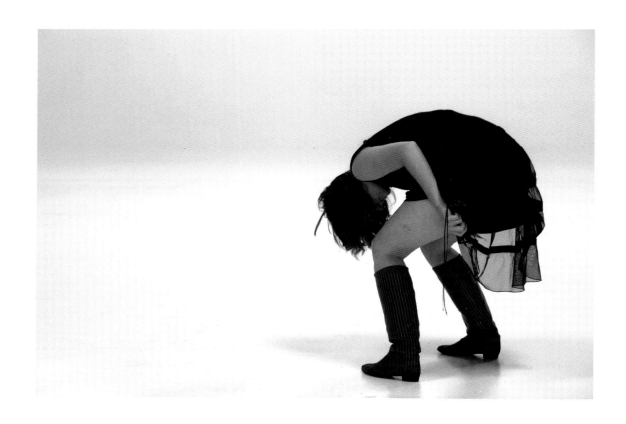

Work No. 675
2006
35 mm film, colour, sound
1 minute 0.5 seconds
Edition of 3 + 1 AP

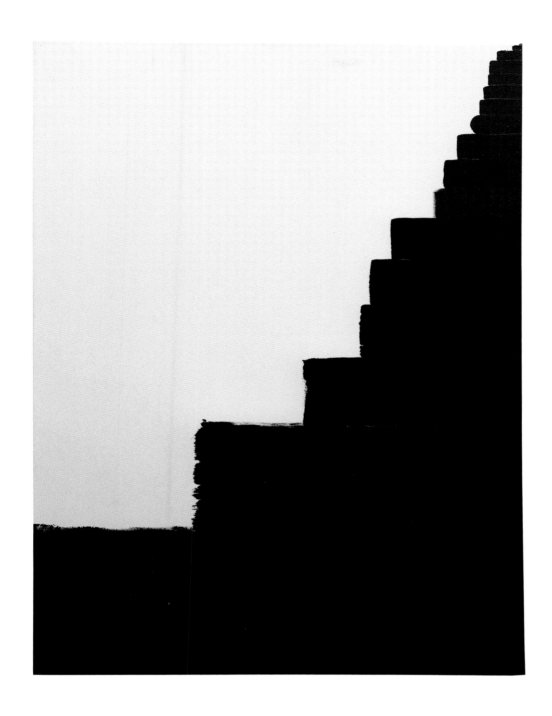

Work No. 679
2006
Acrylic on canvas
40 × 30 in / 101 × 76 cm

Width of Tape = 1·9 cm.

Work No. 680
c. 1986
Pencil, acrylic and masking tape on paper
11.7 × 8.2 in / 29.7 × 21 cm

Work No. 681
c. 1986
Pencil, acrylic and masking tape on paper
8.2 × 11.7 in / 21 × 29.7 cm

Work No. 682
c. 1986
Pencil and acrylic on paper
8.2 × 11.7 in / 21 × 29.7 cm

Work No. 683
c. 1986
Pencil, acrylic and masking tape on paper
8.2 × 11.7 in / 21 × 29.7 cm

Work No. 684
c. 1986
Pencil, acrylic and masking tape on paper
8.2 × 11.7 in / 21 × 29.7 cm

Work No. 685
c. 1986
Pencil and acrylic on paper
8.2 × 11.7 in / 21 × 29.7 cm

Work No. 686
c. 1986
Pencil, acrylic and masking tape on paper
8.2 × 11.7 in / 21 × 29.7 cm

Work No. 687
c. 1986
Pencil, acrylic and masking tape on paper
8.2 × 11.7 in / 21 × 29.7 cm

Work No. 688
c. 1986
Pencil and acrylic on paper
8.2 × 11.7 in / 21 × 29.7 cm

Work No. 689
c. 1986
Pencil, acrylic and masking tape on paper
8.2 × 11.7 in / 21 × 29.7 cm

Work No. 690
c. 1986
Pencil, acrylic and masking tape on paper
8.2 × 11.7 in / 21 × 29.7 cm

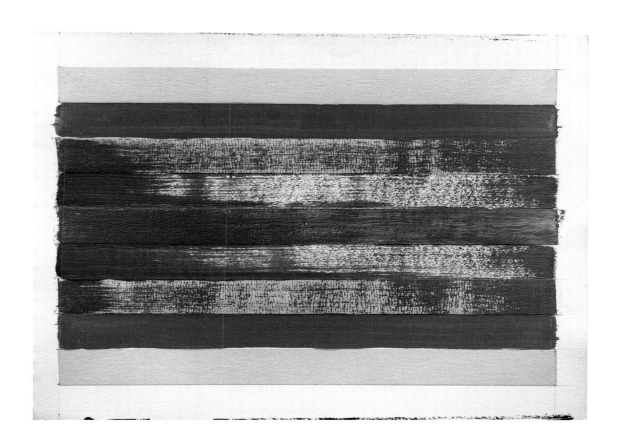

Work No. 691
c. 1986
Pencil, acrylic and masking tape on paper
8.2 × 11.7 in / 21 × 29.7 cm

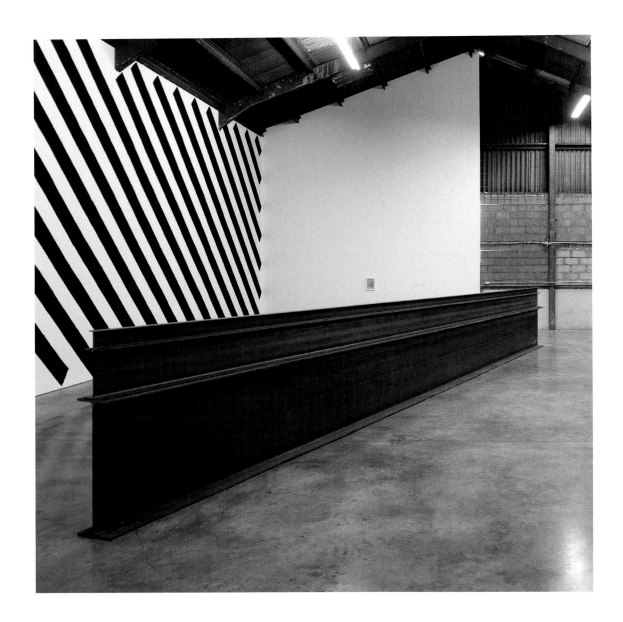

Work No. 700
2007
Steel I-beams
5 × 40 × 1 ft / 1.5 × 12 × 0.25 m
Installation at Hauser & Wirth Coppermill, London, UK, 2007

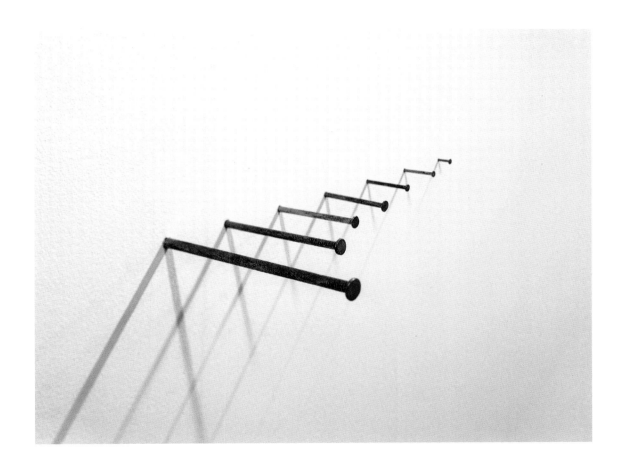

Work No. 701
2007
Nails
7 parts; dimensions variable
Edition of 3 + 1 AP

Work No. 702
2007
Acrylic and pen on canvas
13.5 × 5.9 in / 34.5 × 15 cm

Work No. 714
2006
Marker pen on paper
11.7 × 8.2 in / 29.7 × 21 cm

Work No. 721
1988
Brass
4.2 × 2 in / 10.8 × 5 cm

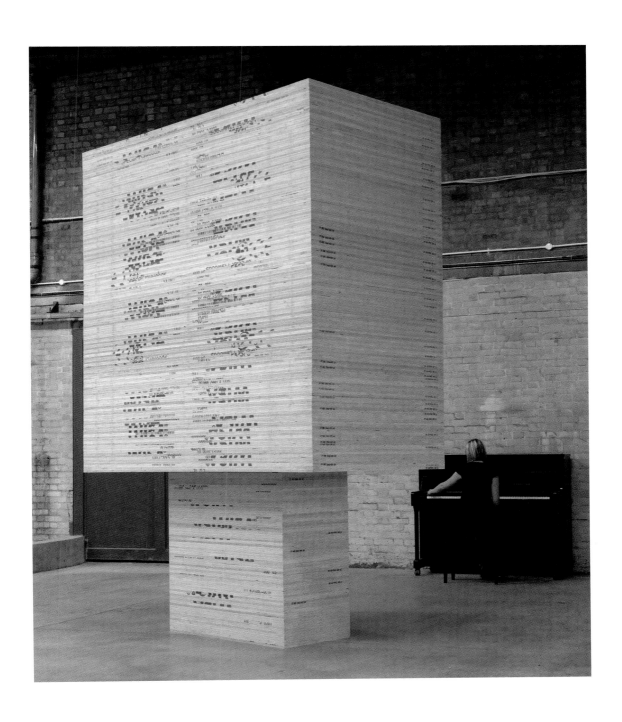

Work No. 725
2007
18 mm plywood
11.5 × 8 × 4 ft / 3.5 × 2.4 × 1.2 m
Installation at Hauser & Wirth Coppermill, London, UK, 2007

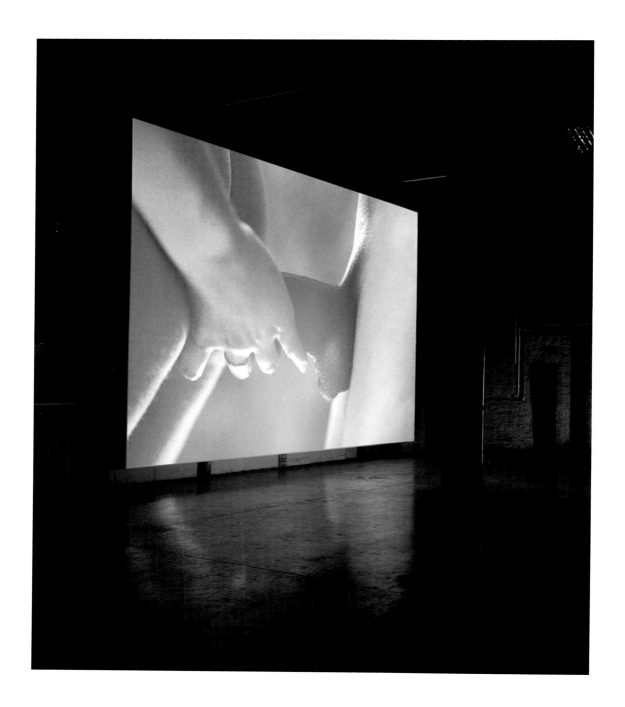

Work No. 730
2007
35 mm film, black and white, silent
4 minutes 10 seconds
Edition of 3 + 1 AP
Installation at Hauser & Wirth Coppermill, London, UK, 2007

Work No. 732
2007
35 mm film, colour, silent
2 minutes 23 seconds
Edition of 3 + 1 AP

Piano Accompaniment

Play all of the notes on the keyboard —
the full chromatic scale — going up from
bottom to top.

Rest for the same amount of time as it
just took to play all the notes

Play all of the notes — the full chromatic
scale — going down from top to bottom.

Rest again, as above.

Repeat endlessly

Pedal

Alternate playing with mute (left) pedal
pressed for one whole up and down cycle,
then the next time with no pedal, then the
next time with the sustain (right) pedal
pressed down for a whole up and down
cycle. Repeat this pedal pattern, so that
the pedalling repeats on every third cycle.

Play softly, quietly (piano / pianissimo) at
a moderate / slow speed: 90—100 beats per
minute.

Play soft staccato.

Work No. 736
Piano accompaniment, 2007
Piece for piano
Edition of 3 + 1 AP
Top Installation at the Armory Show, New York, USA, 2008
Bottom Instructions shown

Work No. 739
2007
Design for London Library lavatories
Tiles, fixtures, fittings
Dimensions variable
Installation at The London Library, London, UK
Commissioned by The London Library, London

Work No. 740
2007
Emulsion on wall
Stripes 12 in / 30.5 cm wide; overall dimensions variable
Installation at Hauser & Wirth Coppermill, London, UK, 2007

Work No. 742
2007
Paper
8.2 × 11.7 in / 21 × 29.7 cm

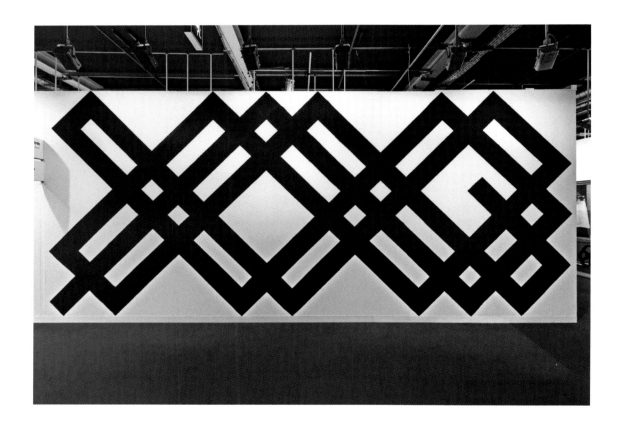

Work No. 743
2007
Emulsion on wall
Stripes 12 in / 30.5 cm wide; overall dimensions variable
Installation at Basel Art Fair, Basel, Switzerland, 2007

Work No. 744
2007
Marker pen on paper
5 parts, each 11.7 × 8.2 in / 29.7 × 21 cm

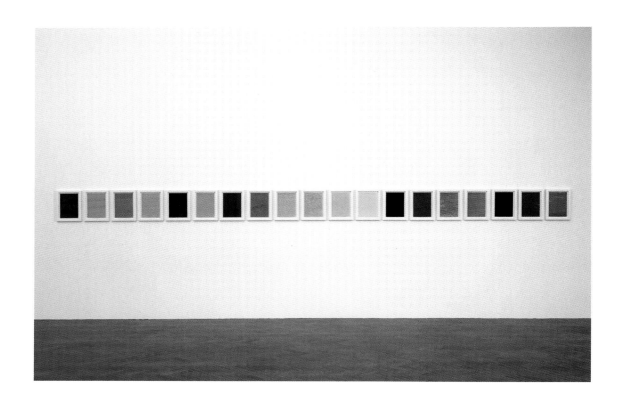

Work No. 745
2007
Marker pen on paper
19 parts, each 11.7 × 8.2 in / 29.7 × 21 cm

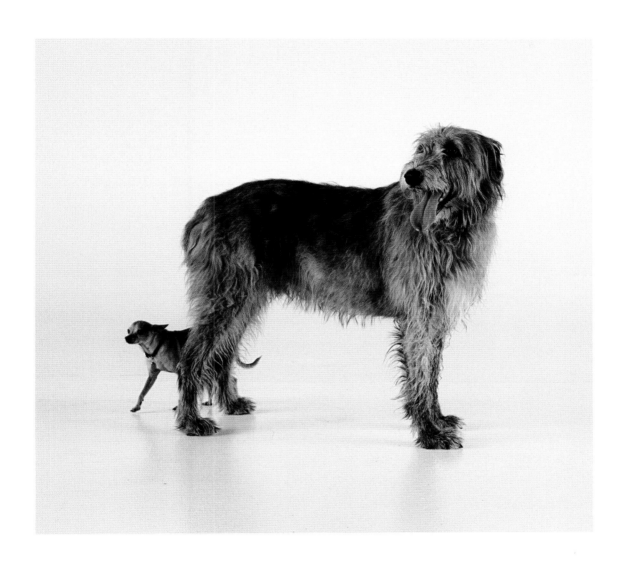

Work No. 748
2007
Photographic print
14 × 15 in / 35.5 × 38 cm
Edition of 3 + 1 AP

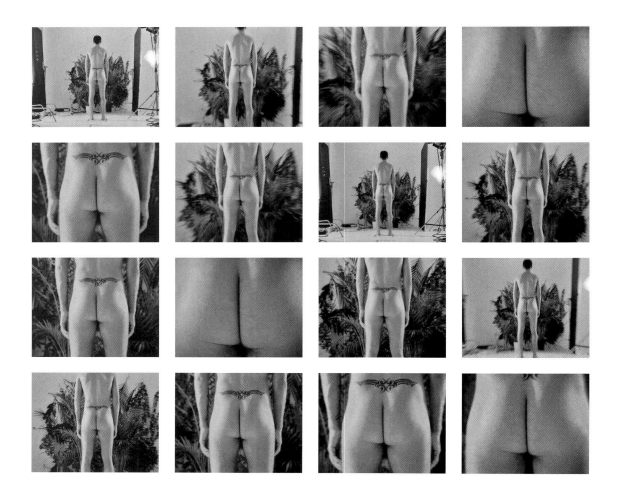

Work No. 751
2007
35 mm film, black and white, silent
37 seconds
Edition of 3 + 1 AP

Work No. 752
Holly, 2007
Pencil on paper
11.7 × 8.2 in / 29.7 × 21 cm

Work No. 753
Holly, 2007
Pencil, crayon, ink, pastel and acrylic on paper
11.7 × 8.2 in / 29.7 × 21 cm

Work No. 754
2007
Marker pen on paper
3 parts, each 11.7 × 8.2 in / 29.7 × 21 cm

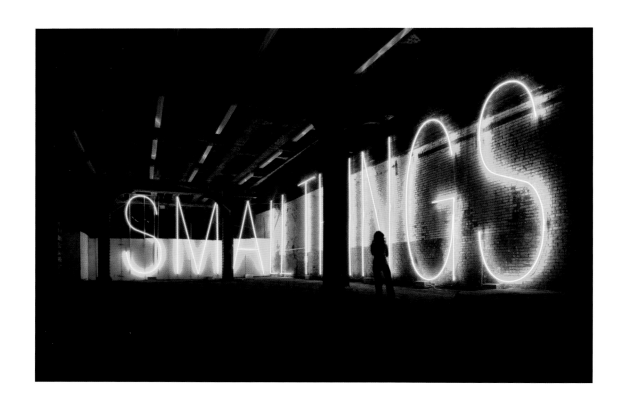

Work No. 755
SMALL THINGS, 2007
Yellow neon
15 × 100 ft / 4.5 × 31 m
Installation at 508 West 25th Street, New York, USA, 2007

Work No. 756
2006
Paper
11.7 × 8.2 in / 29.7 × 21 cm
Edition of 10 + 1 AP

Work No. 760
Hannah smiling with Starbucks cup, 2007
35 mm slide

Work No. 761
2007
Marker pen on paper
18.4 × 18.4 in / 46.7 × 46.7 cm

Work No. 764
2007
Postcard
6 × 4 in / 15.2 × 10.1 cm

Work No. 765
2007
Postcard
6 × 4 in / 15.2 × 10.1 cm

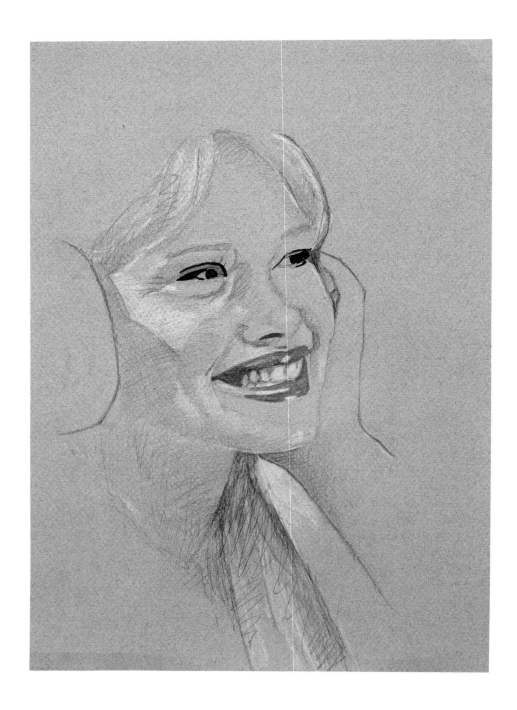

Work No. 766
Smiling woman with headphones, 2007
Ink, pastel and pencil on paper
11.7 × 8.2 in / 29.7 × 21 cm

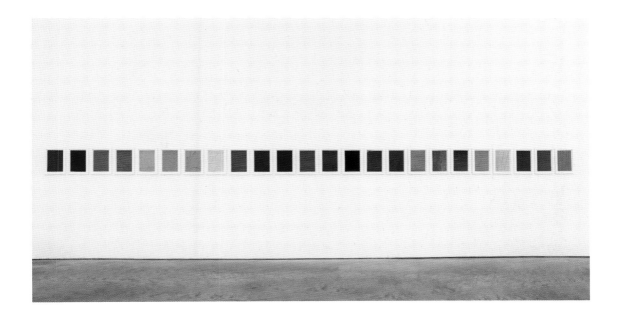

Work No. 768
2007
Marker pen on paper
24 parts, each 11.7 × 8.2 in / 29.7 × 21 cm

Work No. 769
2007
Marker pen on paper
5 parts, each 11.7 × 8.2 in / 29.7 × 21 cm

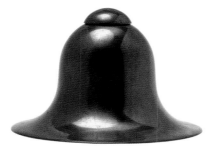
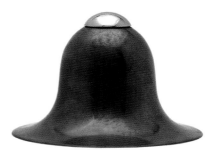

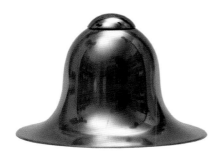
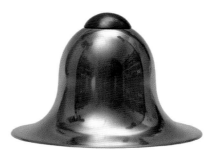

Work No. 776
2007
Brass, aluminium and chrome-plated brass
4 parts, each 2 in / 5.1 cm diameter
(Shown actual size)

Work No. 782
2007
Marker pen on paper
11.7 × 16.5 in / 29.7 × 42 cm

Work No. 784
2007
Marker pen on paper
6 parts, each 11.7 × 8.2 in / 29.7 × 21 cm

Work No. 785
2007
Trees
5 parts; dimensions variable
Installation at CCS Bard Hessel Museum, Annandale-on-Hudson, USA, 2007

Work No. 788
Paola and me reading, 2007
Pencil on paper
11.7 × 8.2 in / 29.7 × 21 cm

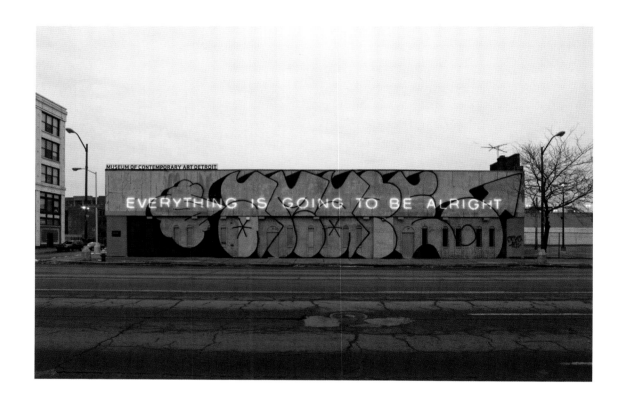

Work No. 790
EVERYTHING IS GOING TO BE ALRIGHT, 2007
White neon
2.6 × 99 ft / 0.8 × 30 m
Installation at Museum of Contemporary Art, Detroit, USA, 2007

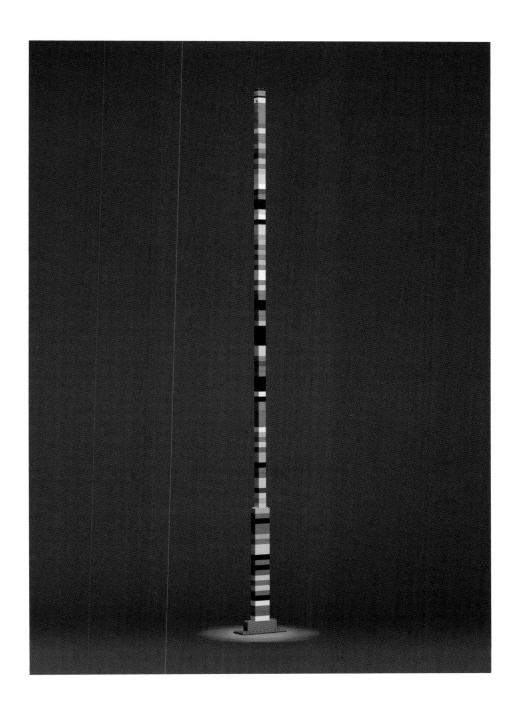

Work No. 792
2007
Lego
40.6 × 3.7 × 1.3 in / 103 × 9.5 × 3.2 cm

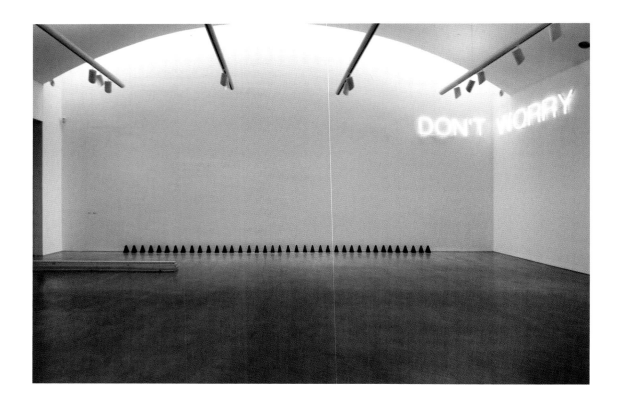

Work No. 794
DON'T WORRY, 2007
White neon
20 in / 50.8 cm high
Installation at CCS Bard Hessel Museum, Annandale-on-Hudson, USA, 2007

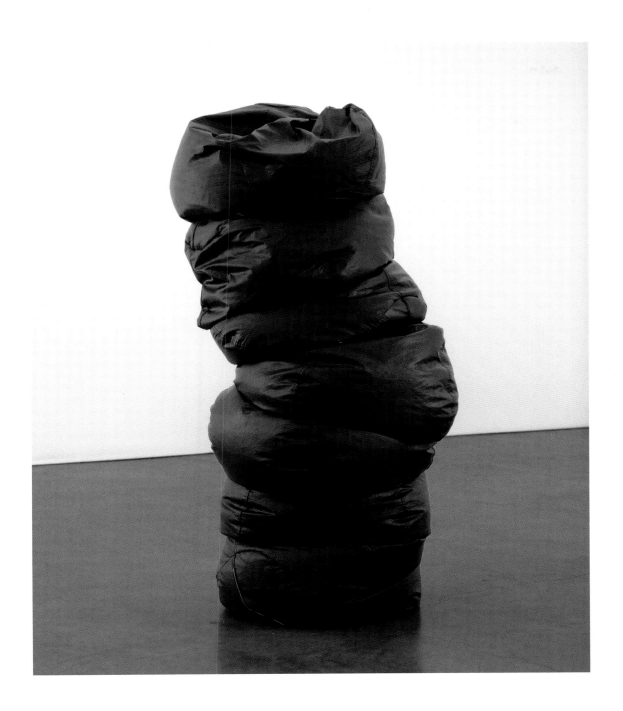

Work No. 796
2007
Bean bags
7 parts, dimensions variable
Edition of 3 + 1 AP
Installation at CCS Bard Hessel Museum, Annandale-on-Hudson, USA, 2007

798

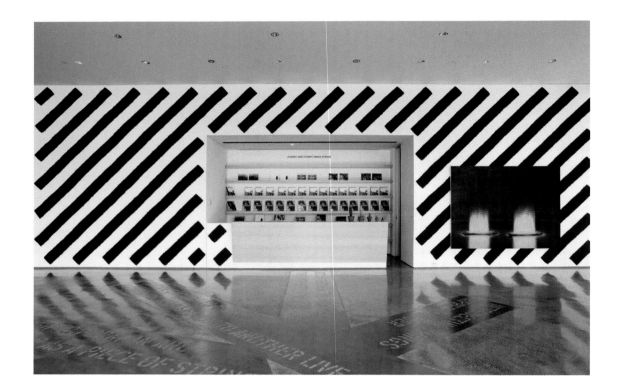

Work No. 798
2007
Emulsion on wall
Stripes 9 in / 23 cm wide; overall dimensions variable
Installation at CCS Bard Hessel Museum, Annandale-on-Hudson, USA, 2007

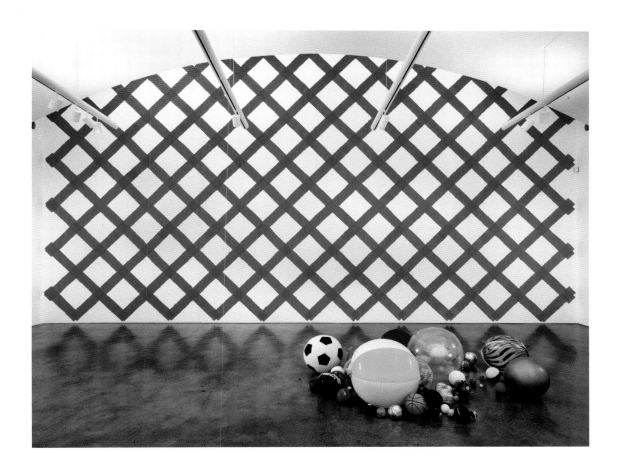

Work No. 800
2007
Emulsion on wall
Stripes 9 in / 23 cm wide; overall dimensions variable
Installation at CCS Bard Hessel Museum, Annandale-on-Hudson, USA, 2007

Work No. 801
2008
A sheet of paper torn up, 2008
US legal paper, lid, plinth
Paper dimensions variable; Lid 14 × 8.5 × 8.5 in / 35.6 × 21.6 × 21.6 cm; plinth height variable
Edition of 3 + 1 AP

Work No. 802
2007
Cactus plants
Dimensions variable
Installation at CCS Bard Hessel Museum, Annandale-on-Hudson, USA, 2007

Work No. 805
2007
Steel I-beams
5 × 40 × 1 ft / 1.5 × 12 × 0.25 m
Installation at 508 West 25th Street, New York, USA, 2007

Ooh

Ooh
Ooh
Ooh
Ooh
Ooh
Ooh
Ooh
Ooh
Ooh
Ooh
Ooh
Ooh
Ooh
Ooh
Ooh
Ooh
Ooh
Ooh

Work No. 810
Ooh, 2007
Piece for bass, tenor, alto and soprano voices
(Lyrics shown)

Work No. 812
2007
Marker pen on paper
11.7 × 8.2 in / 29.7 × 21 cm

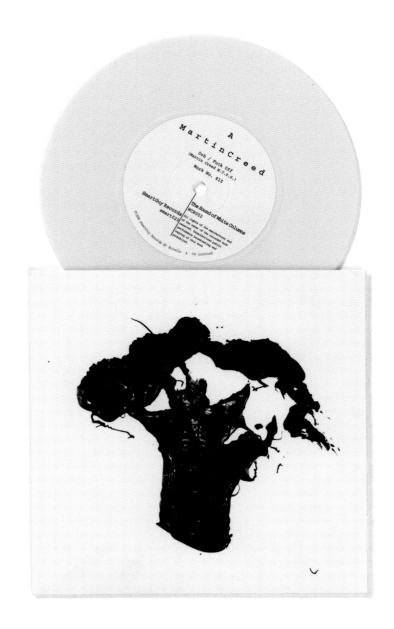

Work No. 815
Ooh / Fuck off / Words, 2007
7-inch single
Released by Smart Guy Records, San Francisco, USA / The Sound of White Columns, New York, USA

Work No. 822
2007
Masking tape on paper, window-mount, frame
2 parts, each window 5.5 × 5.5 in / 14 × 14 cm

Work No. 823
2007
Masking tape on paper, window-mount, frame
2 parts, each window 5.5 × 5.5 in / 14 × 14 cm

Work No. 832
2007
Masking tape on paper, window-mount, frame
2 parts, each window 5.5 × 5.5 in / 14 × 14 cm

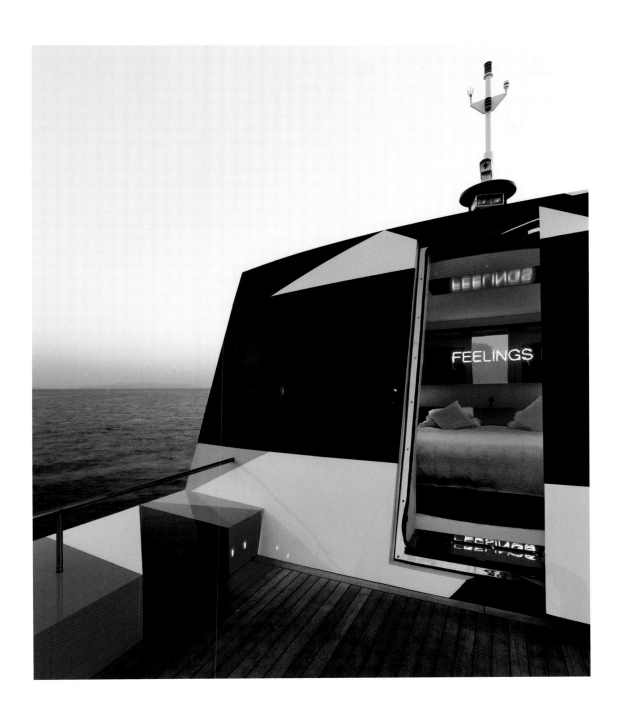

Work No. 836
FEELINGS, 2007
Purple neon
6 in / 15.2 cm high
Edition of 3 + 1 AP
Installation on a private yacht, 2008

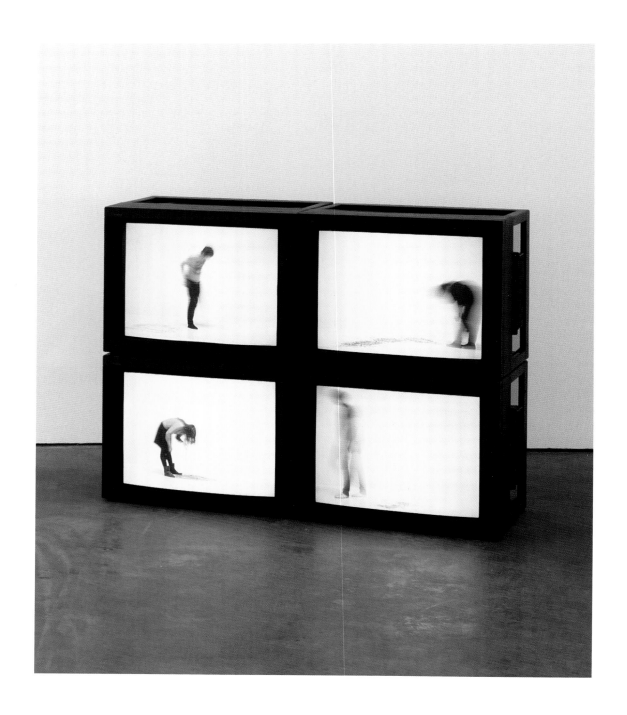

Work No. 837
2008
4 synchronized videos; 35 mm film, colour, sound
1 minute 53 seconds, looped
Dimensions variable
Edition of 1 + 1 AP

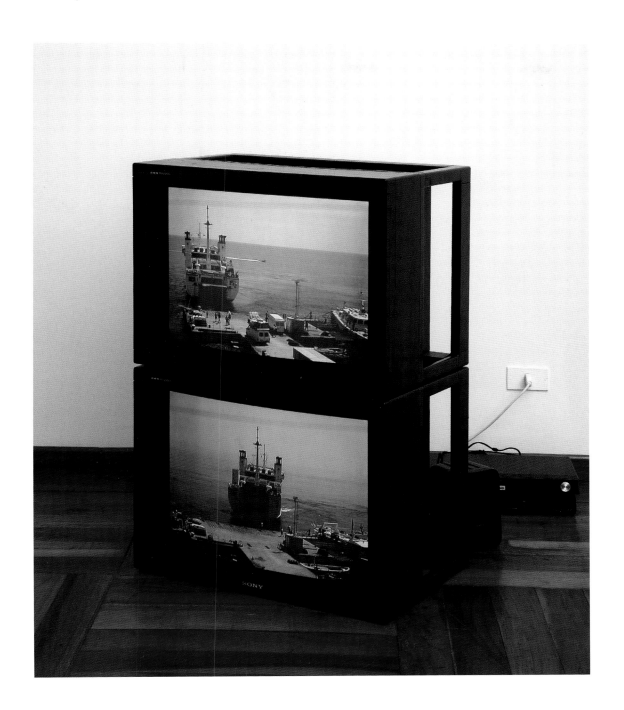

Work No. 839
Ships coming in, 2007
2 synchronized videos; Mini DV, colour, sound
7 minutes 51 seconds, looped
Dimensions variable
Edition of 1 + 1 AP

Work No. 840
2007
Emulsion on wall
Stripes 9 in / 23 cm wide; overall dimensions variable
Installation at The Douglas Hyde Gallery, Dublin, Ireland, 2007

841

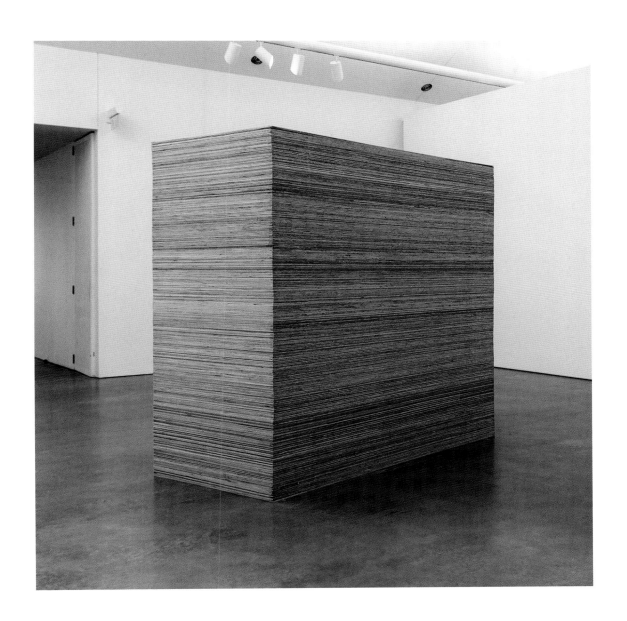

Work No. 841
2007
1/4 in plywood
8 × 4 × 8 ft / 2.4 × 1.2 × 2.4 m
Installation at CCS Bard Hessel Museum, Annandale-on-Hudson, USA, 2007

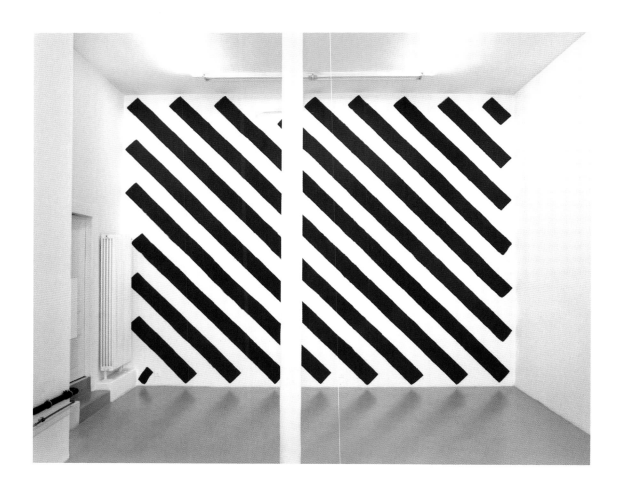

Work No. 843
2007
Emulsion on wall
Stripes 9 in / 23 cm wide; overall dimensions variable
Installation at Galerie Analix B & L Polla, Geneva, Switzerland, 2008

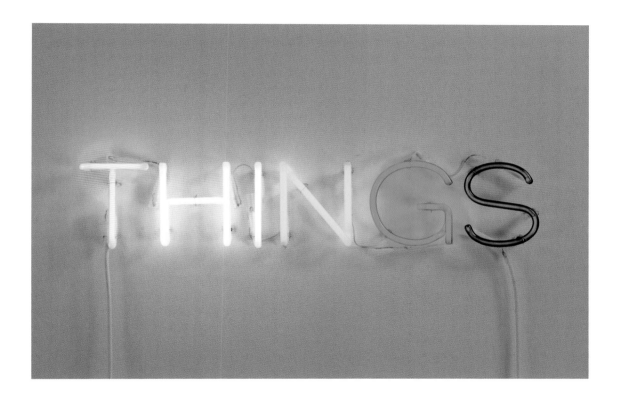

Work No. 845
THINGS, 2007
Multicoloured neon
6 in / 15.2 cm high

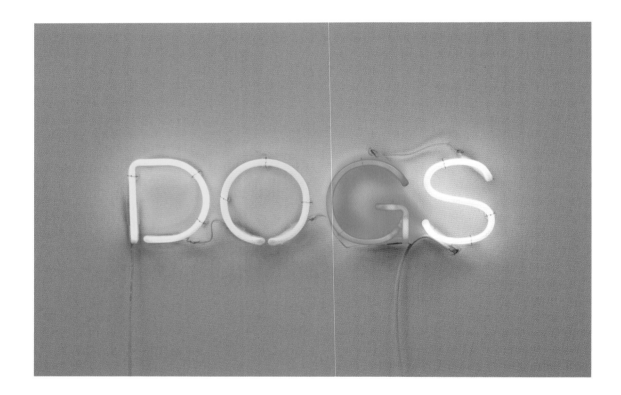

Work No. 846
DOGS, 2007
Multicoloured neon
6 in / 15.2 cm high

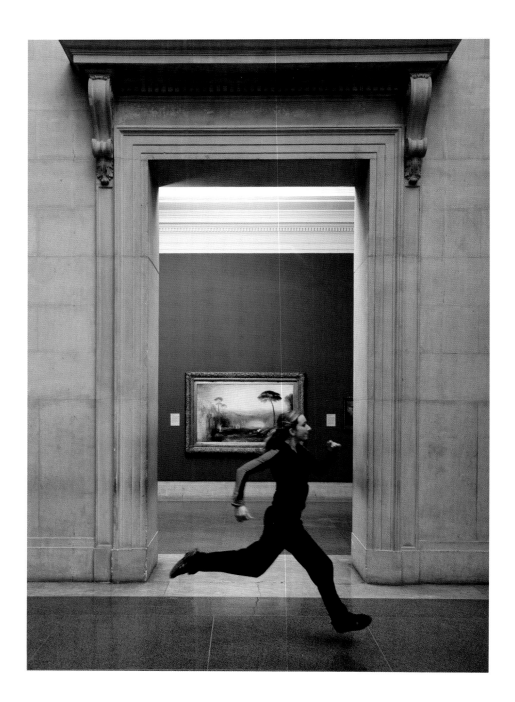

Work No. 850
2008
Runners
Dimensions variable
Edition of 1 + 1 AP
Installation at Tate Britain, London, UK, 2008

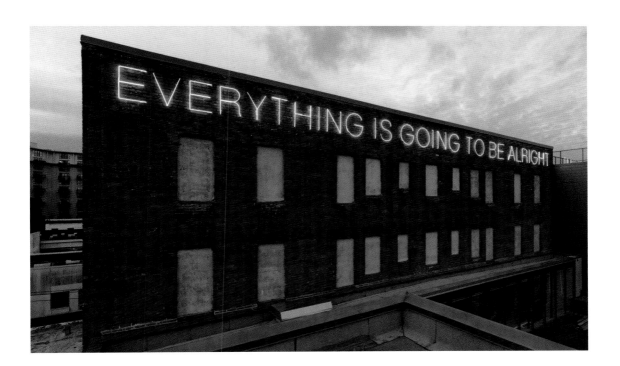

Work No. 851
EVERYTHING IS GOING TO BE ALRIGHT, 2008
White neon
29.4 × 861.4 in / 74.7 × 2188 cm
Installation at Rennie Collection, Vancouver, Canada, 2009

Hello. It's nice to be here. It's fantastic for me to have the chance to put on a show like this on such a great stage. This work is something to look at. It's nice to watch people run. Running is good to look at. It's a spectator sport just like art.

Running moves on and lets you go. But paintings just sit there: they don't let you go. So I thought it might be good to present running for people to see. I was thinking about what I could talk about tonight, and I was thinking about running — and I was thinking that you can't really talk when you're running. It's difficult to talk when you're running. So I can't make my work if I am talking about my work. I'm standing, which should make it easier to talk. But when you're running, talking is a bad and wasteful use of energy.

Sometimes when I look at things I can't stop — beautiful things, like art or beautiful people. I can't bear to stop. I get fixated and can't let go. So I thought it might be good to make it easier, by making a work that runs past you, leaving you free to move on.

I am afraid of standing still. I want to keep moving. I don't want my work to stand still. I want to keep trying.

Life is scary — it's constantly changing and you don't know what is going to happen. This work is an attempt to make something which is constantly changing, but which you can rely on. With this work you can feel safe. You can feel sure that someone will run through every 30 seconds.

It makes me happy to see people run. It's good to watch. It looks good. It's looks like freedom or escape.

This work is made of people. Running makes you notice people — unless everyone is running, in which case walking makes you notice them. But running is tiring, so most people walk.

If something keeps moving, it makes life easier. If something stays still, I get fixated on it — I can't stop looking at it. You can't have art without people. Without people this gallery would be an empty shell — so it's lucky we are here. In my life and in my work, I don't want to stand still. I want to keep moving. Life's always the same but different. The runners are like guides showing you the gallery. Showing you how to keep moving.

It can be hard work to look at things — laboriously trudging around museums looking at static objects, things that stay still. Deciding how long to look. It can be tiring — this work does the work for you. How long should you look at a painting? I don't know. Maybe instead of moving around in front of a work it's nice to have it move for you.

The world is a mess. Doing things in the world is a messy business. Working is honing things down from the mess — trying to be precise or exact, pointing things out or picking things out.

For this work to be able to be enjoyed, I think it has to be quite precise or exact — it needs the runners to come through reliably every 30 seconds. I remember being taught at my strict severe Scottish school that the word 'nice' was often used wrongly by people — that it didn't mean pleasant or friendly, but meant precise or exact. Working is trying to make something precise, or exact. So that means working is trying to be nice. An art gallery is quite a small building to find in a big city, and so you have to aim quite precisely to find it. So everyone here had to be nice to be here.

Work No. 852

2008

Speech written for opening dinner of Work No. 850, Duveen Galleries, Tate Britain, London, UK, 29 June 2008

Work No. 853
2008
Biro on paper
11.7 × 8.2 in / 29.7 × 21 cm

Work No. 857
2008
Pencil on paper
11.7 × 8.2 in / 29.7 × 21 cm

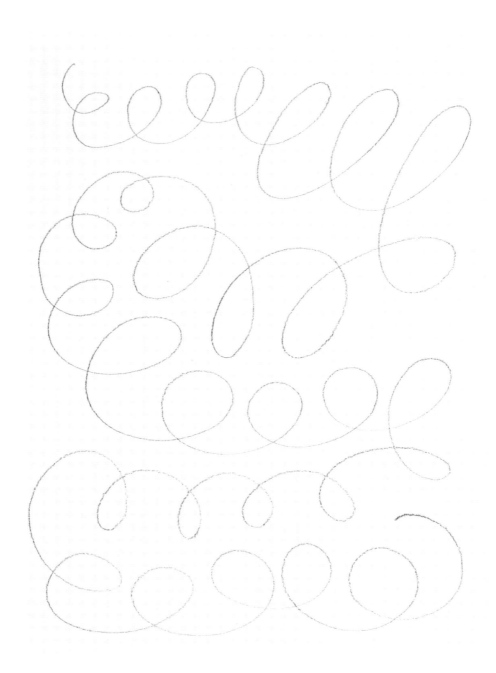

Work No. 858
2008
Pencil on paper
11.7 × 8.2 in / 29.7 × 21 cm

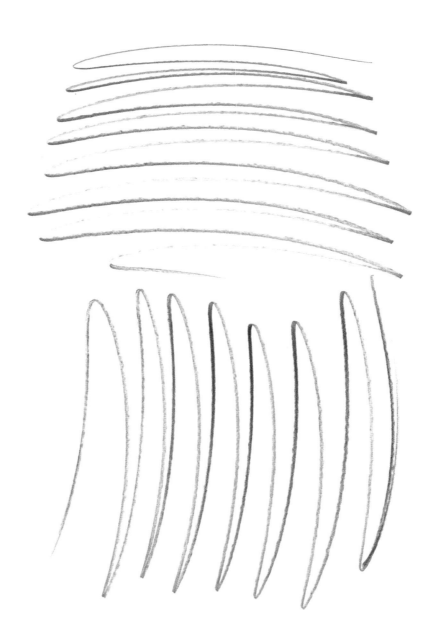

Work No. 859
2008
Pencil on paper
11.7 × 8.2 in / 29.7 × 21 cm

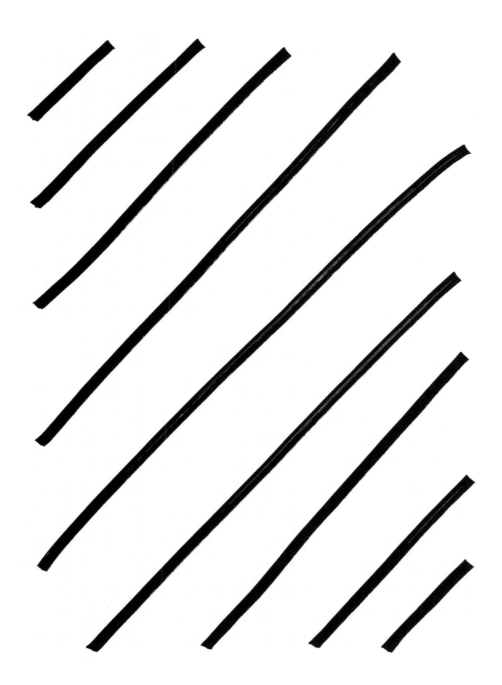

Work No. 862
2008
Marker pen on paper
11.7 × 8.2 in / 29.7 × 21 cm

863

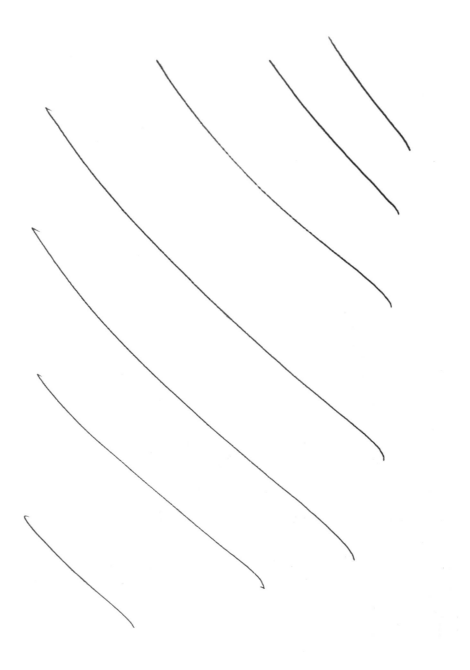

Work No. 863
2008
Pencil on paper
11.7 × 8.2 in / 29.7 × 21 cm

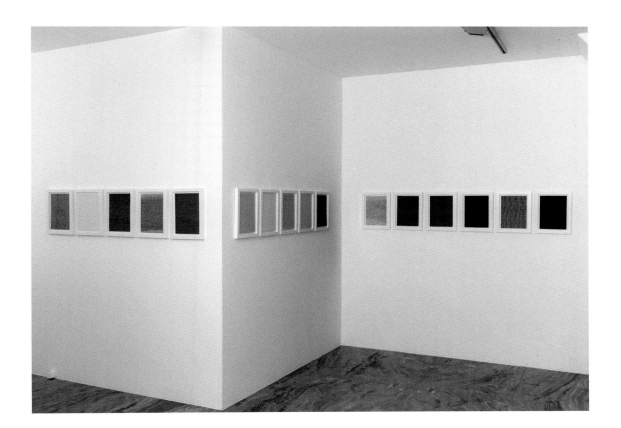

Work No. 865
2008
Marker pen on paper
16 parts, each 11.7 × 8.2 in / 29.7 × 21 cm

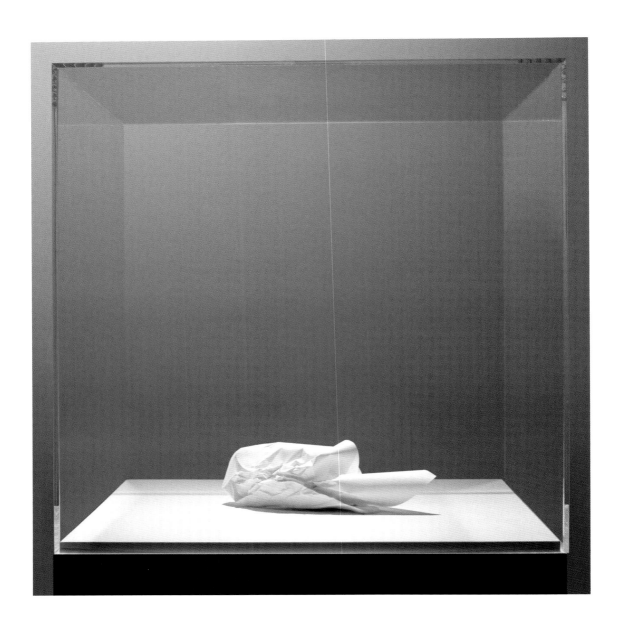

Work No. 867
2008
Paper
2.3 × 8.6 × 5.1 in / 6 × 22 × 13 cm

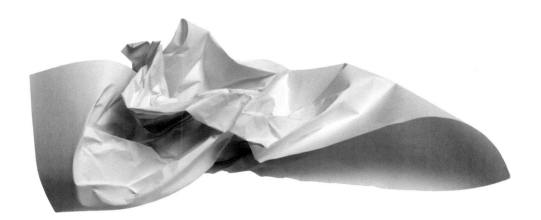

Work No. 868
2008
Paper
2.3 × 8.2 × 3.9 in / 6 × 21 × 10 cm

Work No. 870
2008
Boxes
17 × 11 × 10 in / 43 × 28 × 25 cm

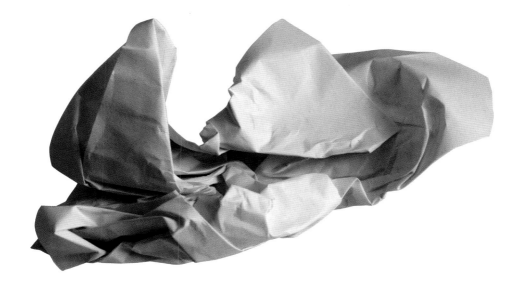

Work No. 871
2008
Paper
2.3 × 6.2 × 3.5 in / 6 × 16 × 9 cm

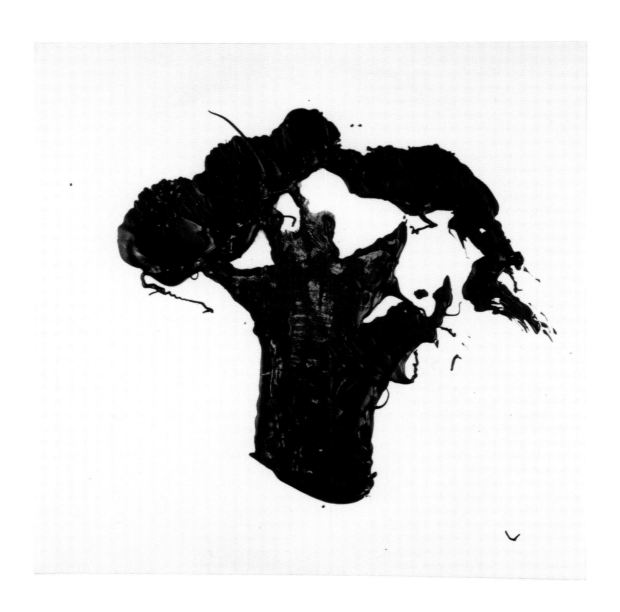

Work No. 874
2008
Acrylic on card
7.1 × 7.1 in / 18 × 18 cm

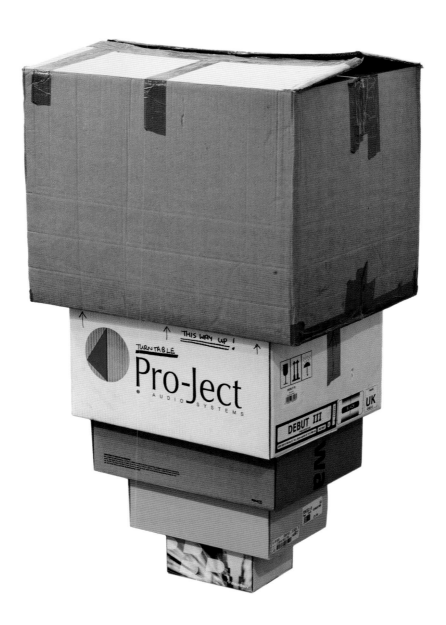

Work No. 876
2008
Boxes
345 × 24 × 18.5 in / 876.3 × 61 × 47 cm

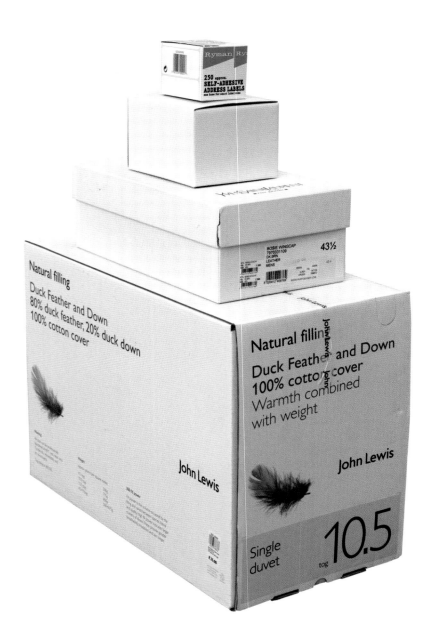

Work No. 878
2008
Boxes
27 × 21 × 10.5 in / 68 × 53 × 26 cm

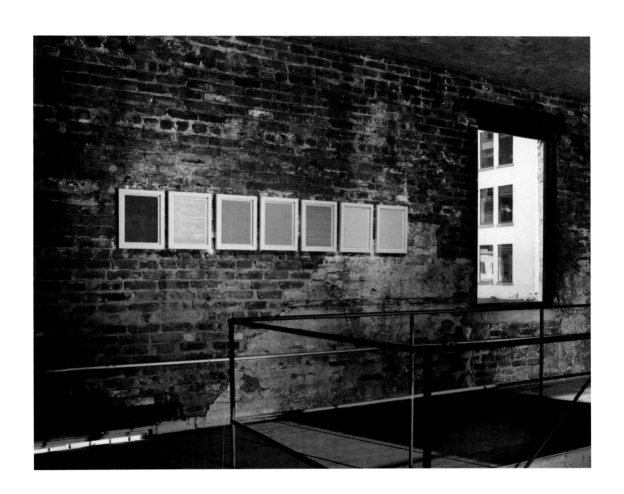

Work No. 883
2008
Marker pen on paper
7 parts, each 11.7 × 8.2 in / 29.7 × 21 cm
Installation at Gavin Brown's enterprise, New York, USA, 2008

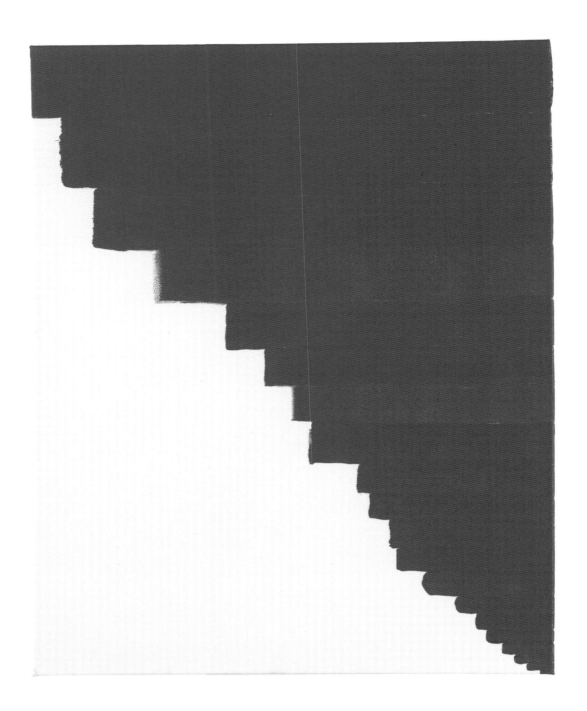

Work No. 885
2008
Acrylic on canvas
30 × 24 in / 76 × 61 cm

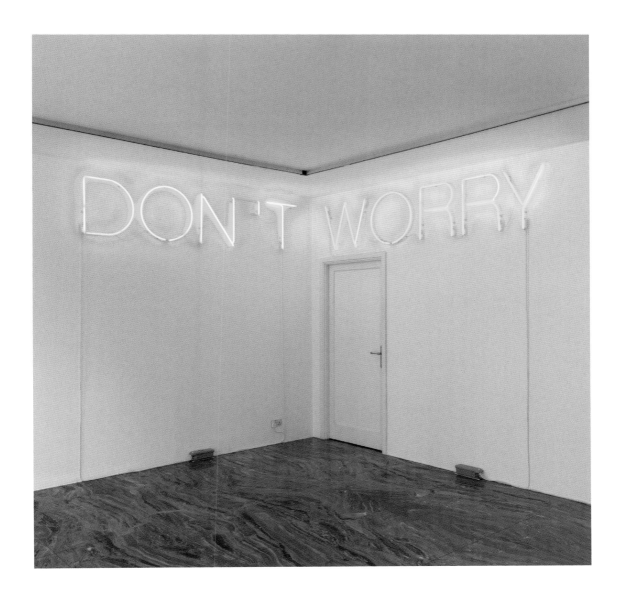

Work No. 890
DON'T WORRY, 2008
Yellow neon
20 in / 50.8 cm high
Installation at Hauser & Wirth London, London, UK, 2009

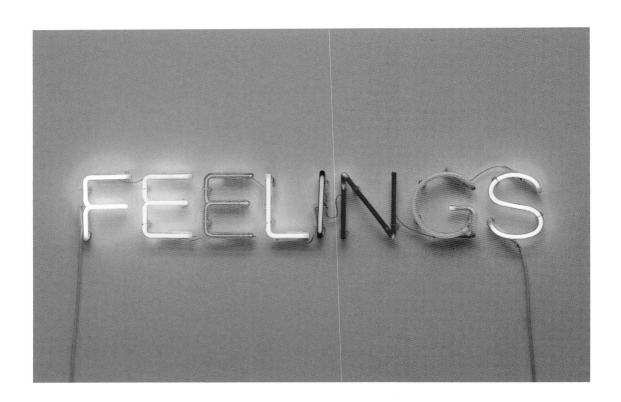

Work No. 895
FEELINGS, 2008
Multicoloured neon
6 in / 15.2 cm high
Edition 1 + 1 AP

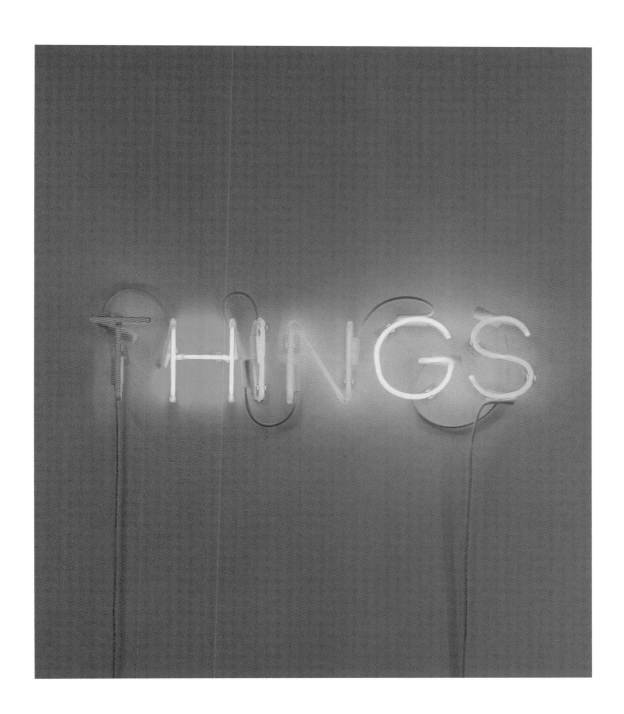

Work No. 896
THINGS, 2008
Multicoloured neon
6 in / 15.2 cm high

Work No. 897
2008
Marker pen and pencil on card
5.8 × 8.2 in / 14.8 × 21 cm

Work No. 898
2008
Pencil on paper
5.8 × 8.2 in / 14.8 × 21 cm

Work No. 903
2008
Acrylic on canvas
12 × 10 in / 30.5 × 25.4 cm

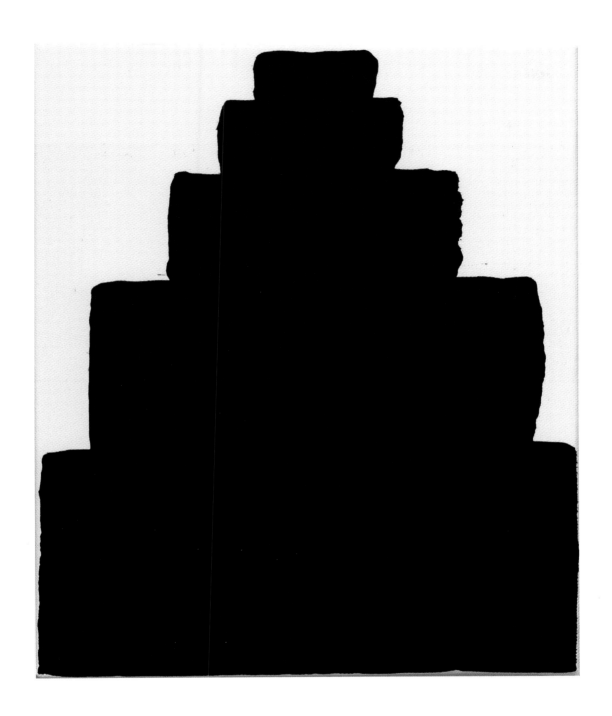

Work No. 904
2008
Acrylic on canvas
12 × 10 in / 30.5 × 25.4 cm

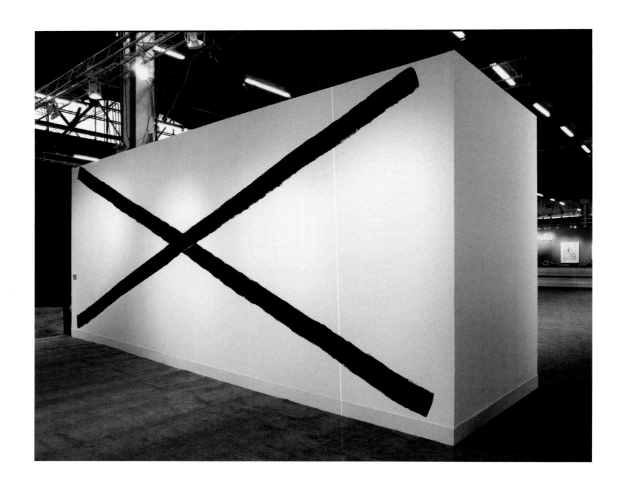

Work No. 905
2008
Emulsion on wall
Stripes 9 in / 23 cm wide; overall dimensions variable
Installation at the Armory Show, New York, USA, 2008

Work No. 906
2008
Masking tape and ink on paper, window-mount, frame
2 parts, each window 5.5 × 5.5 in / 14 × 14 cm

Work No. 907
2008, 2008
Masking tape and ink on paper, window-mount, frame
2 parts, each window 5.5 × 5.5 in / 14 × 14 cm

Work No. 912
2008
Acrylic on canvas
7.9 × 7.9 in / 20 × 20 cm

Work No. 914
2008
Marker pen on paper
5 parts, each 11.7 × 8.2 in / 29.7 × 21 cm; overall dimensions variable

Work No. 915
2008
Marker pen on paper
5 parts, each 11.7 × 8.2 in / 29.7 × 21 cm; overall dimensions variable

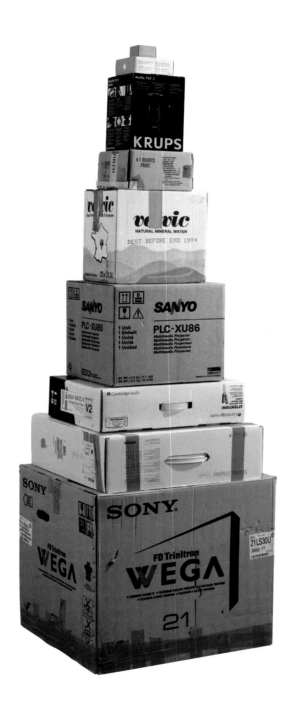

Work No. 916
2008
Boxes
78.7 × 24 × 24 in / 200 × 61 × 61 cm

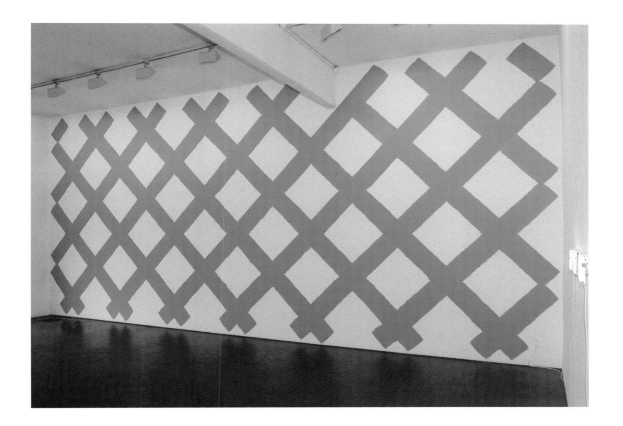

Work No. 920
2008
Emulsion on wall
Stripes 9.8 in / 25 cm wide; overall dimensions variable
Installation at Galleria Lorcan O'Neill, Rome, Italy, 2008

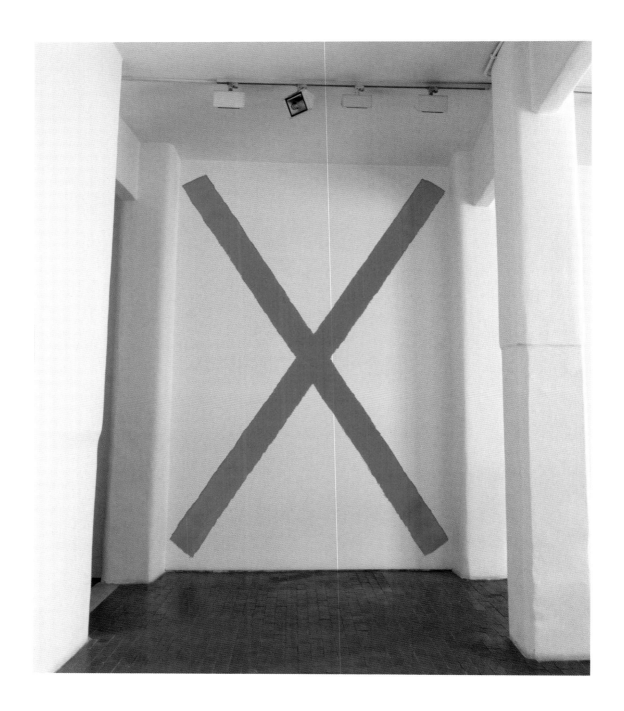

Work No. 921
2008
Emulsion on wall
Stripes 9.8 in / 25 cm wide; overall dimensions variable
Installation at Galleria Lorcan O'Neill, Rome, Italy, 2008

Work No. 923
2008
Emulsion on wall
Dimensions variable
Installation at Galleria Lorcan O'Neill, Rome, Italy, 2008

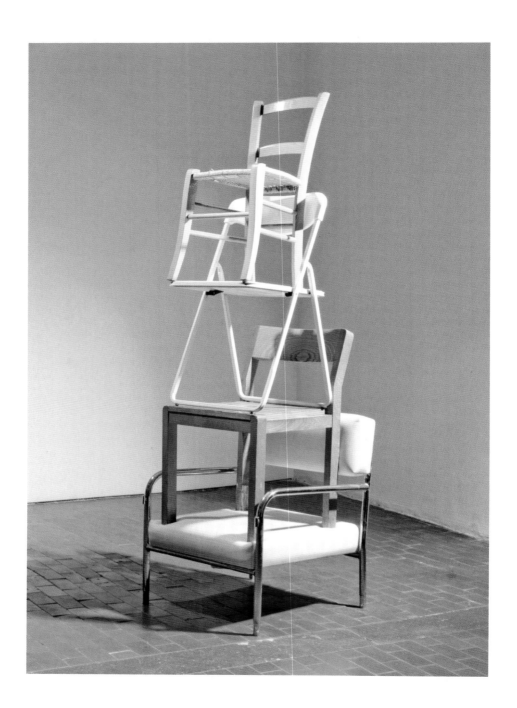

Work No. 925
2008
Chairs
74 × 21.6 × 23.6 in / 188 × 55 × 60 cm
Installation at Galleria Lorcan O'Neill, Rome, Italy, 2008

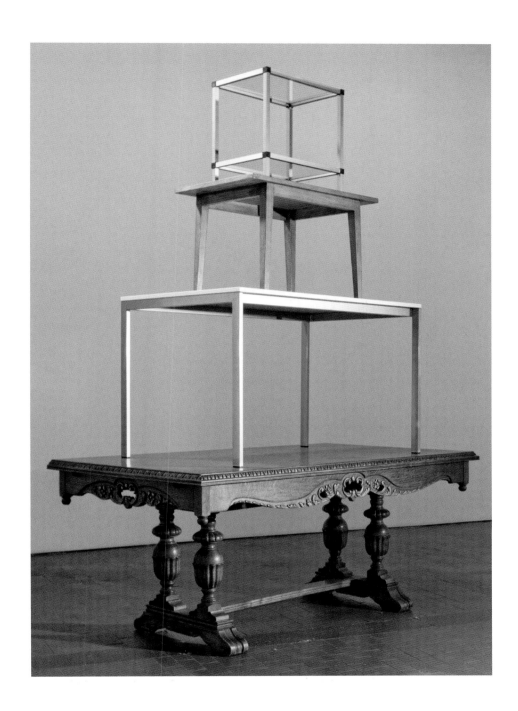

Work No. 928
2008
Tables
18.9 × 65.7 × 37.8 in / 48 × 167 × 96 cm
Installation at Galleria Lorcan O'Neill, Rome, Italy, 2008

Work No. 930
2008
Acrylic on canvas
12 × 10 in / 30.5 × 25.4 cm

Work No. 931
2008
Acrylic on canvas
12 × 10 in / 30.5 × 25.4 cm

Work No. 932
2008
Acrylic on canvas
12 × 10 in / 30.5 × 25.4 cm

Work No. 933
2008
Acrylic on canvas
12 × 10 in / 30.5 × 25.4 cm

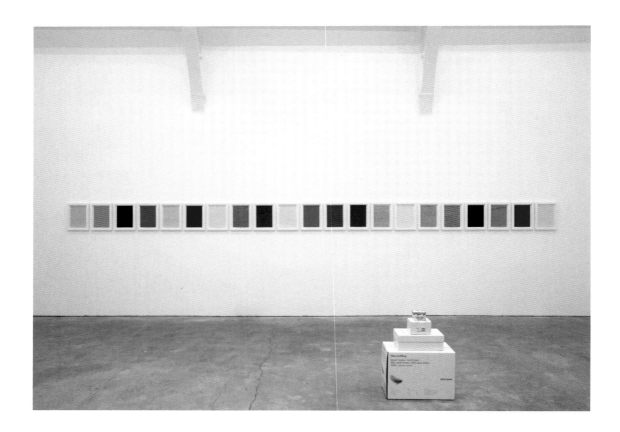

Work No. 944
2008
Pen on paper
21 parts, each 11.7 × 8.2 in / 29.7 × 21 cm; overall dimensions variable
Installation at Ikon Gallery, Birmingham, UK, 2008

Work No. 955

Martin Creed

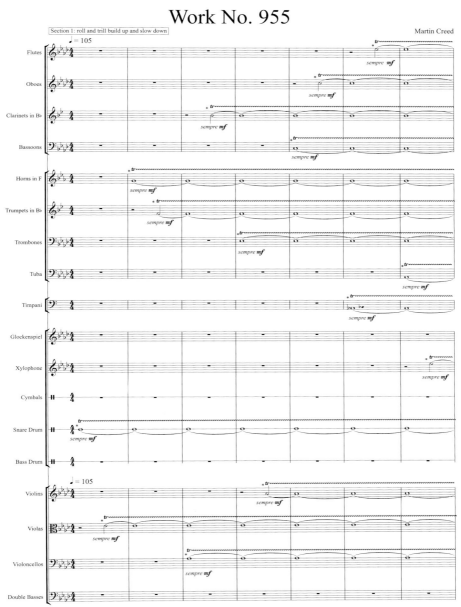

* Each instrumental voice must be of equal loudness

Work No. 955
2008
Piece for symphony orchestra
(Excerpt of score shown)

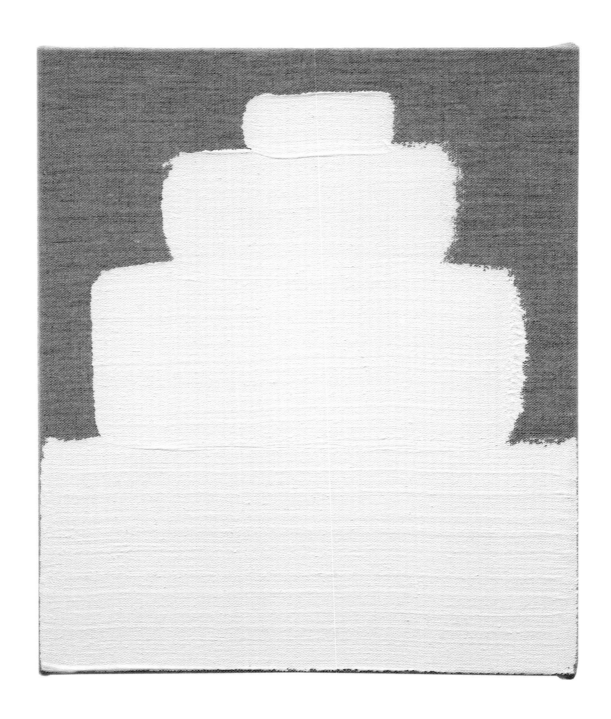

Work No. 956
2008
Acrylic on linen
30 × 24 in / 76.2 × 61 cm

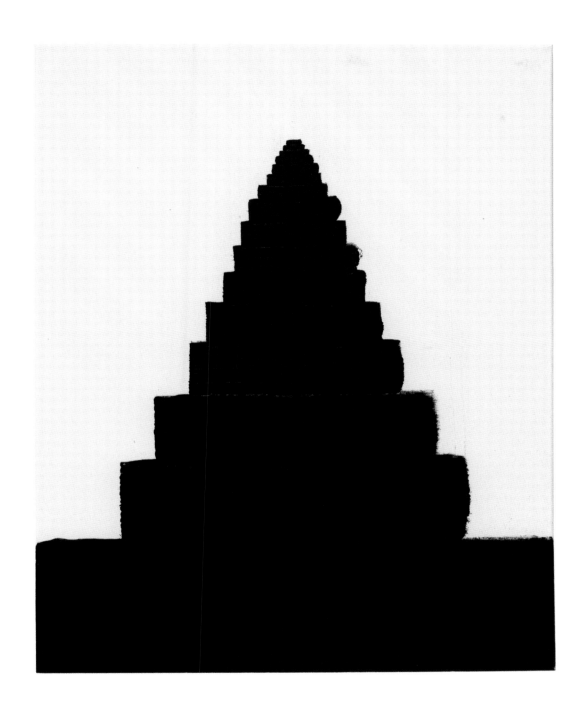

Work No. 958
2008
Acrylic on linen
12 × 10 in / 30.5 × 25.4 cm

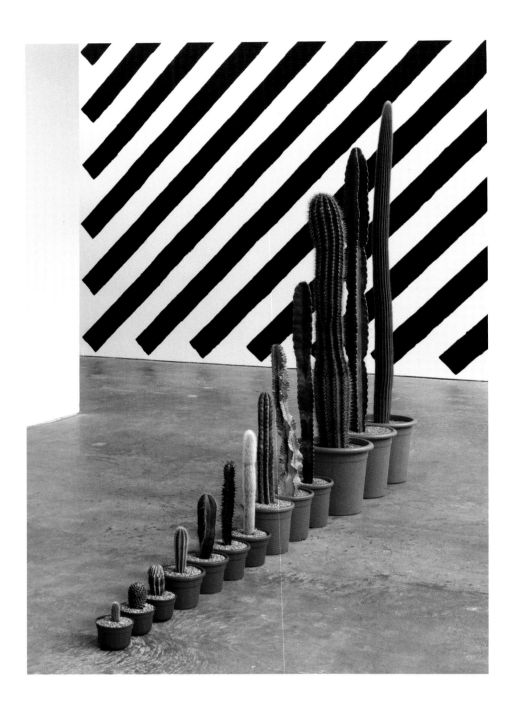

Work No. 960
2008
Cactus plants
13 parts, dimensions variable
Installation at Ikon Gallery, Birmingham, UK, 2008

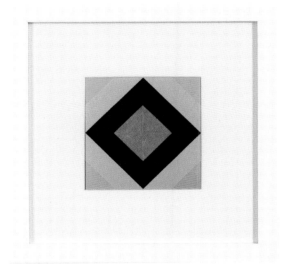 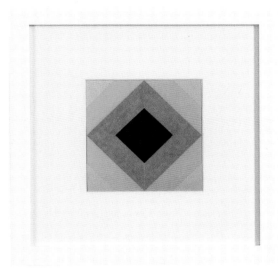

Work No. 961
2008
Masking tape and ink on paper, window-mount, frame
2 parts, each window 5.5 × 5.5 in / 14 × 14 cm

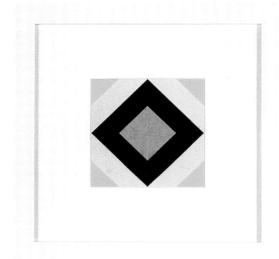 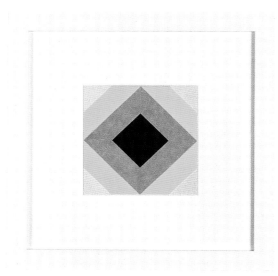

Work No. 963
2008
Masking tape and ink on paper, window-mount, frame
2 parts, each window 5.5 × 5.5 in / 14 × 14 cm

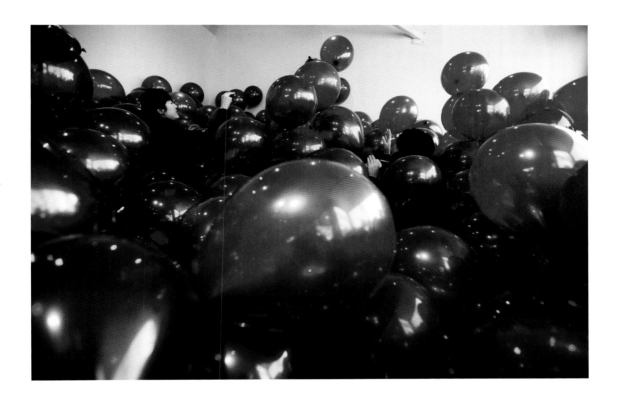

Work No. 965
2008
Purple balloons
Multiple parts, each balloon 11 in / 28 cm diameter; overall dimensions variable
Installation at Gallery SUN, Seoul, Republic of Korea, 2008

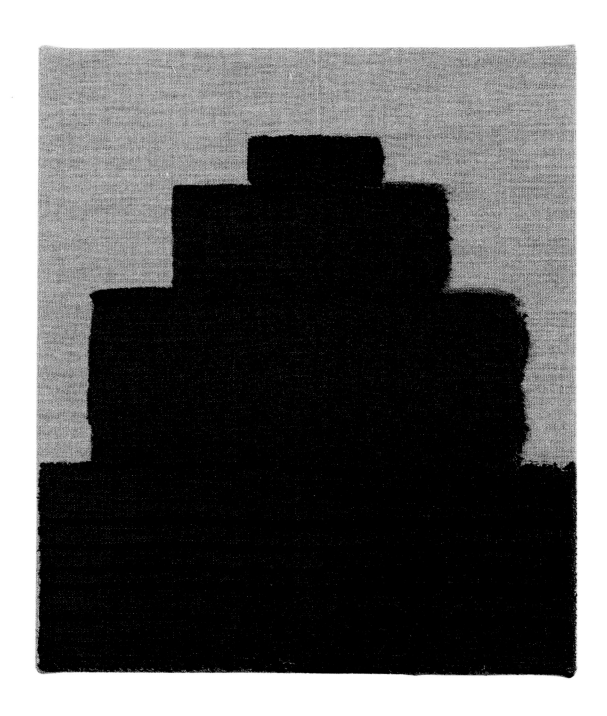

Work No. 968
2008
Acrylic on linen
12 × 10 in / 30.5 × 25.4 cm

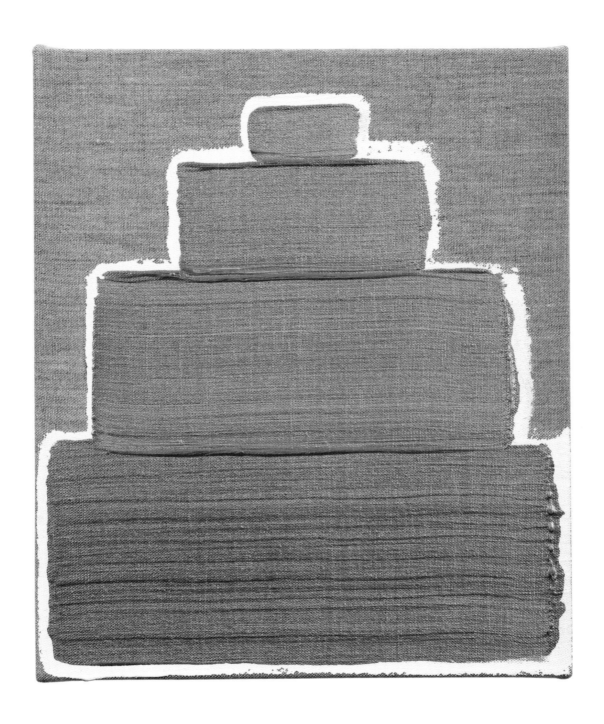

Work No. 974
2008
Primer and acrylic on linen
12 × 10 in / 30.5 × 25.4 cm

975

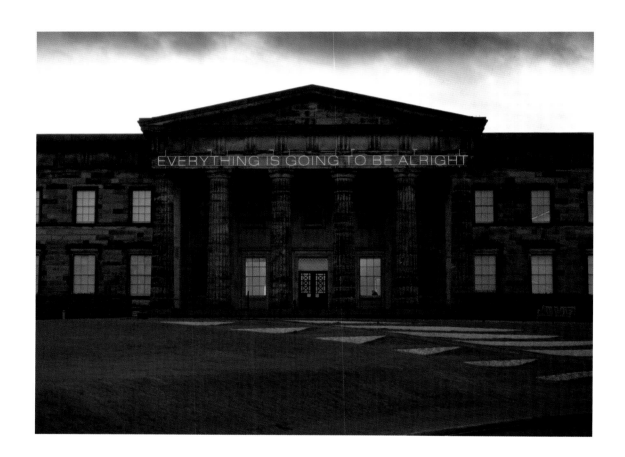

Work No. 975
EVERYTHING IS GOING TO BE ALRIGHT, 2008
Blue neon
24.4 × 606.7 in / 62 × 1541 cm
Installation at The Scottish National Gallery of Modern Art, Edinburgh, UK, 2009

Work No. 977
2008
Acrylic on canvas
12 × 10 in / 30.5 × 25.4 cm

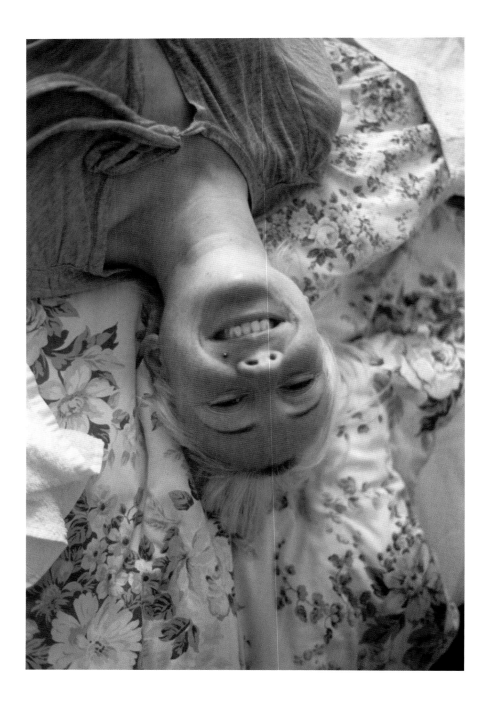

Work No. 978
Anouchka, 2009
35 mm slide

Work No. 980
2009
Acrylic on cardboard
7.1 × 7.1 in / 18 × 18 cm

Work No. 983
2008
Acrylic on cardboard
7.1 × 7.1 in / 18 × 18 cm

Work No. 984
2008
Marker pen on paper
10 parts, each 11.7 × 8.2 in / 29.7 × 21 cm

Work No. 985
2008
Acrylic and primer on linen
30 × 24 in / 76.2 × 61 cm

Work No. 986
2008
Acrylic on canvas
24 × 18.1 in / 61 × 46 cm

Work No. 987
2009
Acrylic on canvas
12 × 10 in / 30.5 × 25.4 cm

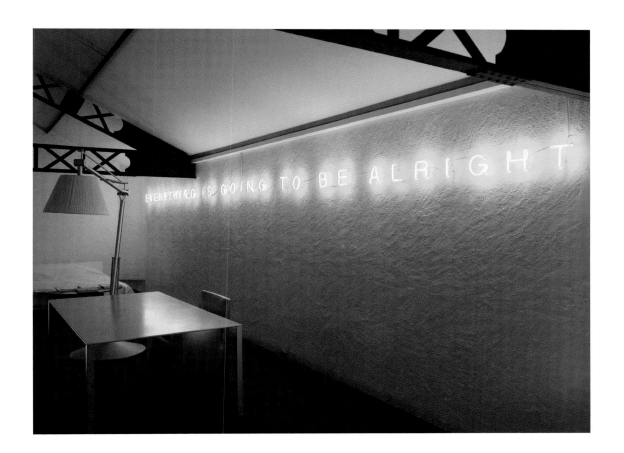

Work No. 988
EVERYTHING IS GOING TO BE ALRIGHT, 2009
Yellow neon
6 in / 15.2 cm high
Installation at La Calmeleterie, Nazelles-Négron, France, 2009

Someone recently asked me: what are you trying to achieve? It was a difficult question. Art does not have a clearly defined goal or aim. It is not like football or comedy. I could not think of an answer at the time, but it played on my mind, and later I thought: I am just trying to make my life better. I work to feel better. I produce things to help me to live, to divert myself. But nearly every day, whether I like it or not, and sometimes twice a day, I make shit. It comes from a part of me I cannot see. It is the sculpture which everybody makes. Shit happens, and you cannot ignore it.

You cannot have dark without light

And you can't have day without shite

Living and working is a matter of trying to come to terms with, to face up to, what comes out of you.

I made some films of people shitting. It was difficult to do because people have to be relaxed. You can't fake it. They were filmed on a closed set with remote control cameras to try to make it easier for the players. It was a long shoot. We prepared the set and cameras and waited until the people were ready to go. I have been putting up an exhibition in Zürich which contains one of the Shit Films (Work No. 660), a suite of paintings, and a new work which consists of a pair of curtains opening and closing in front of one of the gallery windows. The film and paintings and sculpture are all exhibited in the same room. I like putting things together all in one room and trying not to separate them. They have to be social and live together.

It was a bit of a rest to spend time in Zürich. Things feel slower and steadier there than in London. I had a feeling I could concentrate on one thing. In London I feel like I'm always doing a lot of things at the same time, and fighting my way through the day.

Doing an exhibition is quite different from making the things which are in the exhibition. It is doing your best with what you've got to make a diverting and entertaining spectacle, to put on a show which a person might visit for just one minute. An exhibition is made up of things to look at. It is a demand for attention. A picture may work well as something to live with, a little diversion in a hallway or a pattern of colours on a bedroom wall. It may form a nice background, but that does not mean it will look good at the centre of attention in an exhibition. In an exhibition it needs to work in the foreground, though it might spend the rest of it's life in the background.

An art exhibition is like a very long, slow theatrical event — a live show which lasts for perhaps six weeks instead of two hours — in which the audience can come and go as they please and move freely amongst the work. The work sits there in one place and the people move around. It is like a reversed theatre show, with the lights on. A painting might stay still, but people are always moving, and so the experience of looking at a painting is always a live, dynamic one.

Not to have to sit through things, to come and go as you please, is a great freedom. That's what I like about art galleries.

I like music because it tells the story of its own making. When you listen to a song it's like you are hearing it being made, the singer is guiding you through it, whereas when you look at a painting or sculpture you are seeing the end result, after the artist has gone away, and you have to decide the beginning or end of looking.

Looking at things is perhaps more self-conscious, much more directed, than listening to things. You can listen to something which is behind you, but you can't look at something behind you. Sound always escapes you, you can't catch it, but it feels like you can have and keep a static object. I get stuck on things. Sometimes I cannot stop looking. The problem of looking is looking away. The problem of freedom is stopping.

The more you look the more you find

That's why it's better to work blind

The more I write to make things clear, the more difficult it becomes to see. The words form a net curtain obscuring my view.

I have been working on a book, a collection of all the works I have ever made, or rather of everything that has been exhibited or sold or put into public. It is difficult to finish. It has been like trying to refold a map after a long journey. Since starting work on the book I have bought a Sat—Nav.

I was walking along on a beach years ago and I threw a stone in the water. It made a bit of a splash, a nice noise, and it looked good. It was exciting, but do I have to dive in now and trawl through the mud to try to find that stone, drag it up on the beach, clean it and show it to people? I feel like a cat having its nose rubbed in its own shit to housetrain it.

It's easy to start, but it's hard to go on, and it's very difficult to finish.

I hate endings. That is a start.

Work No. 989
2009
Text
A version of this piece was published in *The Times* newspaper, 31 January 2009

Work No. 990
2009
Curtains opening and closing
Dimensions variable
Edition of 3 + 1 AP
Installation at Artsonje Center, Seoul, Republic of Korea, 2009

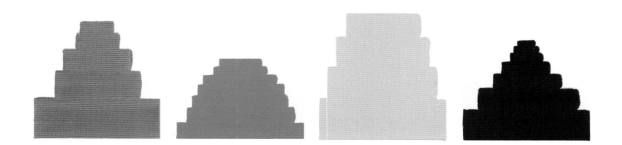

Work No. 991
2009
Acrylic on canvas
4 parts, each 24 × 18.1 in / 61 × 46 cm

Work No. 992
2009
Acrylic on canvas
12 × 10 in / 30.5 × 25.4 cm

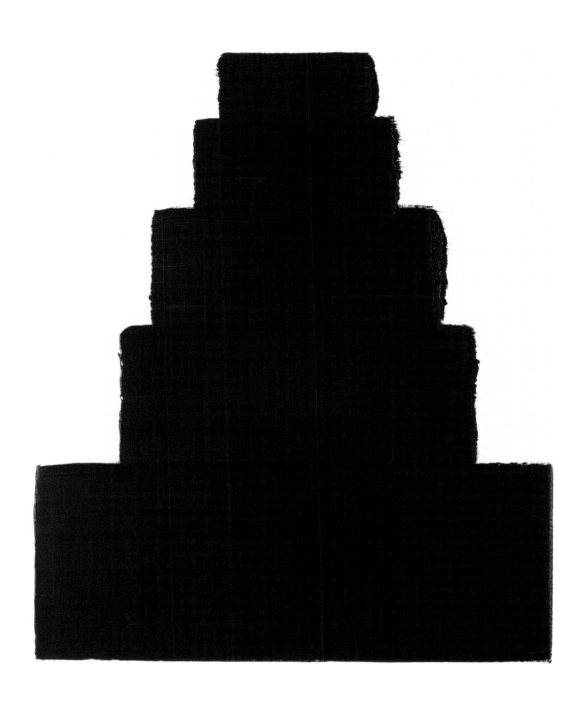

Work No. 993
2009
Acrylic on canvas
19.3 × 15.4 in / 49 × 39 cm

Work No. 994
Piece for symphony orchestra, 2009
Shown in performance by Hiroshima Symphony Orchestra at Wel City Hiroshima Concert Hall, Hiroshima, Japan,
29 May 2009

996

Work No. 996
2009
Acrylic on cardboard
7.1 × 7.1 in / 18 × 18 cm

Work No. 997
2009
Chairs
83.5 × 30 × 28.3 in / 212 × 76 × 72 cm

Work No. 998
2009
Chairs
73.6 × 27.6 × 24.4 in / 187 × 70 × 62 cm

Work No. 1000
Broccoli prints, 2009–2010
Various paints on card
1,000 parts, each 7.1 × 7.1 in / 18 × 18 cm
(Details shown)

My First Work

The more I work the more I think I don't know what I am doing or what I have done. I don't know what my first work was. I have been doing things and making things since I was born. Everything is work. It's hard work to get through the day. Who am I to say what my work is, let alone what my first work was? It is more for others to say than for me.

The things you make are like stains of sweat. You choose what to wear and perhaps put on deodorant, but you cannot control the shape and size of the sweat stains on your clothes. You make your marks without really knowing what you're doing, or as a by-product of what you are doing, or of what you think you are doing.

This has been worrying me a lot because I have been working on a book of all my work, coming out next year. The first work featured is a yellow painting made in 1986, when I was at art school. It is Work No. 3, because it felt wrong to have a Work No. 1 and 2. It is a single swirly brushmark made with a big brush on a small canvas. I was trying to simplify things: I wanted to make a painting with just one brushmark, one wave of the arm. I would like to make work that is direct and not thought-out, like a convulsion or a natural event. That painting was a bit like that. I didn't know what I was doing when I did it.

I was sitting on an aeroplane writing something recently when suddenly the man in front turned around and slapped my leg, swatting it like a fly. Without realizing it I had been shaking my leg against the back of his chair. I didn't know I was doing it. I thought I was writing something, but to him I was shaking my leg.

Work No. 1015
2009
Text
A version of this piece was first published in *The Independent* newspaper, 23 October 2009

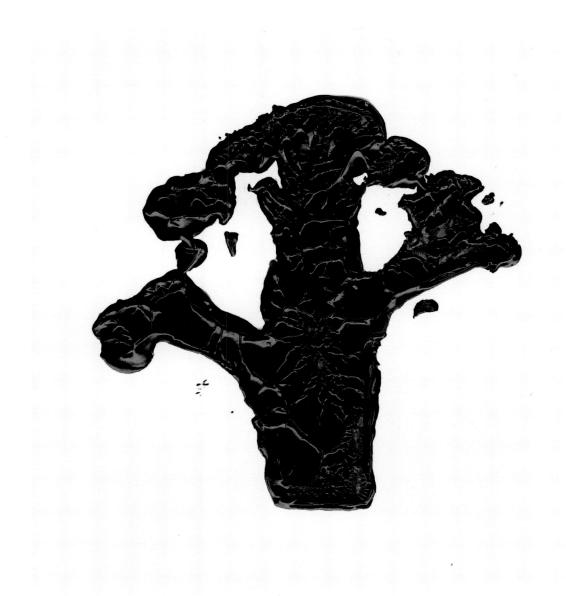

Work No. 1016
2009
Acrylic on card
7.1 × 7.1 in / 18 × 18 cm

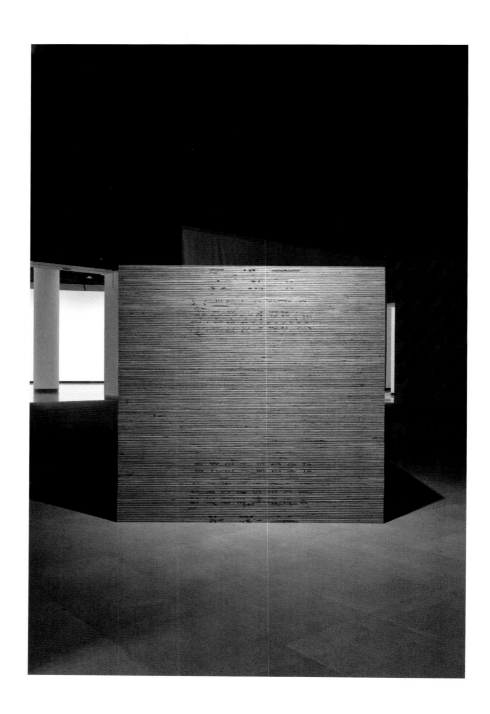

Work No. 1017
2009
5.5 mm plywood
71.7 × 35.8 × 71.7 in / 182 × 91 × 182 cm
Installation at Hiroshima City Museum of Contemporary Art, Hiroshima, Japan, 2009

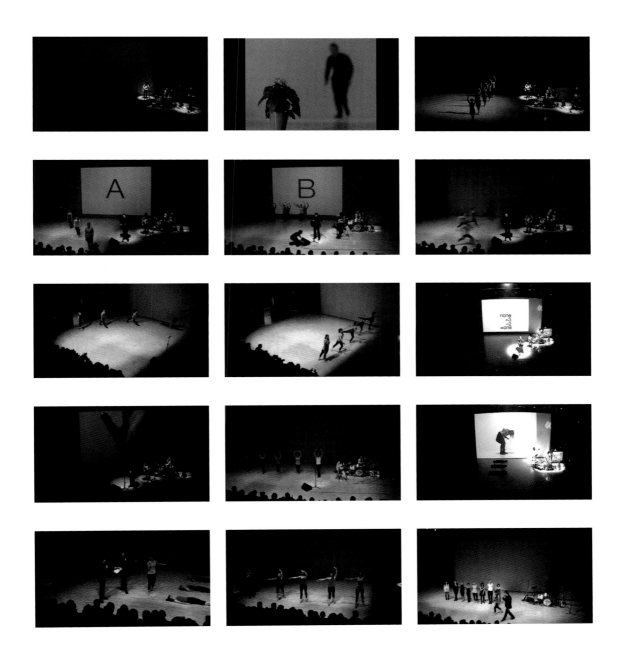

Work No. 1020
2009
Theatre show including ballet, talk, and music
Shown in performance at Lilian Baylis Studio, Sadler's Wells Theatre, London, UK, 2009

Interview
Tom Eccles and Martin Creed

Tom Eccles: In nearly every press release or museum announcement for your exhibitions you are described as a 'conceptual artist'. In fact, whenever your work is presented on television, the announcer makes a point of stressing 'conceptual artist Martin Creed'. You have a difficult relationship with that term.

Martin Creed: Yeah, well, I think … I think … I don't believe in conceptual art (sighs/laughs). I don't know what it is. I can't separate ideas from feelings. I am inside me. I cannot separate what is inside me … It's all a big soup. I can't tell the difference between the head and the heart. I've never seen an idea in my life (laughs). I've had one, but I've never seen one! I don't think I know what an idea is, at least not separate from a feeling. You can't have ideas without feelings.

TE: It's interesting you introduce feelings because I've always thought of your work as having a very high emotional register, and of course feelings are antithetical to how we would normally conceive of conceptual art, at least historically. We think of conceptual art as being devoid of emotion.

MC: I want to feel better. I work because of feelings. Ideas might help me to get through bad feelings or to reach better feelings. But feelings are at the top and the bottom. Ideas are employed in the service of feelings. Maybe ideas are a way of dealing with feelings, coping with them, or hiding from them. But it feels like feelings come first, I think. Work comes from feelings and goes towards feelings. It is a feeling sandwich, with ideas in the middle. Feelings come up, thoughts go down, and somewhere in the middle they meet each other. The thoughts and ideas often try to stop the feelings coming up, and they fight with each other, but thoughts always lose. Feelings rise like steam, and you can't stop them without getting burned!

TE: On the other hand you do share some ways of thinking with bona fide conceptualists: an insistence on numerical order, precise structure and spatial relationships. There is a distillation in your work that strives for a certain essence or essentialism. What I find surprising is that, even as early as your days at art school, there is a certain consistency to your work. Many young art students are full of emotion and expression, but you were taping lines on small canvases and painting across them in systematic ways. Did the idea of expressive work ever interest you? The early work I have seen seems pointedly devoid of self-expression and that is why I think many people categorize you as conceptual.

MC: (Laughs) Yeah.

TE: What kind of artist are you?

MC: I think if I had to use one of those words I would call myself an 'expressionist'. I think everyone is an expressionist. You give yourself away in everything you do.

TE: I think you're asking basic questions in your work. It reminds me to some extent of John Baldessari's painting *What is painting* [1966–68].

MC: But I wouldn't call that conceptual art. It's decorative art. All art is decorative!

MC and TE: (Both laugh)

MC: It's something to say! Everything is a background to people. The world is made of colours and shapes, which form background patterns. People are always in the foreground.

TE: What about going back to your earlier work, to Work No. 52, *Two paintings*. It is quite hard to understand exactly how they function and what they are. You once described them to me as finding the essence of a wall work. What does a wall work need in order to …

MC: To be on a wall.

TE: To be on the wall?

MC: Yeah. Never mind the composition or what might be in the picture, it needs to not fall off the wall. It needs to defy gravity. That is its function … if it does that it works. So I was trying to make a painting in which the way it was attached was an integral part of the work – it was a little experiment in seeing how I could make something in which the bracket, the way in which it attaches to the wall, is the main thing about it. The attachment is always part of the work. How it joins to everything else is always part of it. Nothing is separate.

TE: You've done a number of works, like the 'Blu-Tack' and the protrusions, that seem to tease out the possibilities of how an artist deals with a wall, almost trying to find the essence of that; what can actually function successfully as an artistic work on a wall.

MC: I remember thinking when I was doing those paintings, like Work No. 52, why do I have to use canvas – just because canvas is usually used for paintings? Just because I am in a painting department at art school? And why put something on the wall? The answer I came up with was: if something's on the wall you can look at it. It is easy to look at something on the wall because of the way people's eyes face

out of their heads: walls lend themselves to the exhibition of things to look at. And I thought, OK, that's good, I will try and make something on a wall. Not a painting, just a thing. I thought, yeah, OK, I'll try … but what can I do, what kind of a thing can I make? And I thought, why does it have to stick out from the wall, why can't it go in to the wall as well? … and studying that as a problem led to works in which a shape goes in and a shape comes out from the wall. I used a kind of bell shape. It was designed by gradually coming up at a tangent from the wall, going round and coming back to the wall, all using the same curve. It was a simple way of trying to make something happen on a wall – smoothly, and in all directions.

TE: So rather than a conceptually-based practice, you actually employ minimally-based strategies, using the minimal means by saying, 'OK, let's try this rule and where is that going to take us?'

MC: Yeah, in a way … and everything is kind of a little experiment in trying to make enough decisions to be able to come up with something I am happy with.

TE: Were you interested in science in school? You are obviously good at mathematics. Where does this drive come from?

MC: I wasn't particularly into science at school. I was into maths: I remember especially liking algebra and geometry. I liked doing long algebra equations. I thought it was great, you know, to work out what 'x' equalled. And I remembered liking angles, especially acute ones.

TE: And did that carry through to art school? I think that is kind of pretty fundamental to your practice now, certainly in a sense of working through a formula.

MC: Aye.

TE: And how do these formulae work artistically? I know that you often start with a rule from which a work originates. Sometimes the rules are quite complex. What rules do you choose to follow?

MC: If you can fix a rule or boundary then you can rest easy, because if it's a good rule or a good formula, it will work in any given situation. It'll help you see the mess better. And by keeping a strict boundary the differences between things can maybe become more clear. That's probably why the traffic all drives on the same side of the road: because it's a rule that helps – helps everyone to feel confident about driving along the road. And that's the way I think about the rules that are followed in some works. In the *Sick film* [Work No. 610] keeping a fixed camera and frame size meant that all of the people were treated equally, and you could see the differences between them.

TE: You once said to me 'I'm going to Sicily to do some work', and I wondered what exactly it was that you were going to do (laughs).

MC: (Laughs)

TE: What do you think you are about to do when you say 'I've got to get away to make some work'? What is it you do?

MC: I don't know what I do! I always want to get away! I hate feeling trapped. I think I say that because I have a feeling I need to try to clear my mind. Sometimes I get confused from meeting people: I don't know where I end and they begin, and so I feel I have to get away to work alone. And try and make something starting again from the beginning.

TE: I think you have real breakthroughs in your work. You have a real belief in works that you have made in the past which came through to me when we did the survey exhibition at Bard College in 2007. Certain concepts offer multiple opportunities to make very different kinds of works using the same, or a similar, strategy, or even the same material. You have the crumpled piece of paper [Work No. 88], and you seem to say, 'So OK, I'm going to work with a piece of paper and see what I'm going to do with that'. And then you develop the ripped piece of paper [Work No. 140]. And then you say to yourself, 'So OK, now I'm going to start stacking paper' [Work No. 391], and then you start stacking other things like plywood [Work No. 387], or stacking one note after another [Work Nos 107, 963, 955], or singing one number after another, and so on. How would you describe those breakthroughs? Because they are real breakthroughs, which you obviously believe in, and they are important to you because they become consistent parts of your work after that.

MC: I like what Michelangelo is supposed to have said, that the sculpture was inside the marble and it was just a matter of finding it. I think it's a nice way to think about working – finding it, not making it.

It's helpful to have a starting point, like a wall. And to feel OK about the starting point, because otherwise I'll be thinking, ah, maybe I shouldn't be doing this! Maybe it's wrong! I mean, I think that a lot of the time anyway! So maybe I need to have a place to start. Then I can try to get my head around it and feel alright about it. If I start with a wall, I can say 'OK, I'm going to try and make something for a wall. That's what I'm trying to do. And that seems good, because people can see things there.' Or, to try to write a piece of music, the instruments guitar, bass and drums, seem like a good starting point because one's treble, one's bass and one's rhythm – in a way they cover everything – and so they seem like a good place to start. And if I can live with it it's OK.

TE: I asked you about mathematics, but did music – particularly the rigours of musical composition – influence you? Were you a musician as a child?

MC: Yeah, a bit, I learned violin and piano. I think I've often consciously tried to make my work more like music. *The lights going on and off* was an attempt at trying to do that.

TE: You also use repetition in both your art and your music. You can play the same piece of music over and over again and it will never be the same.

MC: Yeah, exactly.

TE: Just like crumpling a piece of paper – you have certain dictates as to how a work *shall* be made.

MC: Yeah, exactly, you are talking about rules.

TE: Rules.

MC: Yeah, I think that's very much how I try to I think of it. It's like music in the sense that there is a score or there are instructions, which enable you to make the work wherever you like, but means that it will always be different according to the circumstances and the way it is done. Everything is always different.

TE: And also, music is an emotional register of who we are and the world around us, right?

MC: Yeah … I also like music because it's in the air, everywhere … it's all around – it doesn't have to stay in one place … I think that is also something like what I mean about decorative art. I don't mean decorative in a derogatory way. I think that art is literally a background to people. People are more important than the things they make. You can't have them without people. You always have to put the things behind the people. It's a background to people, so it's decoration. It's a pattern that you walk past, like a curtain … or whatever, you know? You can also think of decoration as a relief, because you don't have to look at it. Some nice colours in the background. The thing about looking at things like pictures is

that you have to look at them! If I want you to look at something, I've got to try and point your head towards it. But with music you don't have to do that. It's all around you, and that gives you some freedom.

People often say that they like listening to the radio because they can do something else while they're listening to it. I like that. I would like to make visual work like that. That's the way I would like to think about a lot of my work. It feels like a relief to go into *The lights going on and off*, for example. When I see that work I just think, yeah, what a relief! I don't even have to look anywhere in particular; I can look where I like – the floor or the wall – and it's over quickly before repeating, so you can see it quickly and get out of there.

I have often felt very self-conscious when I've gone to an art gallery and found the painting I've come to see and walked up to it and thought, okay, NOW this is the experience of looking at this painting. THIS is the ART (laughs). You look away and look back and think, aah, the painting is still there … now I've got to stop looking at it. But maybe the overall experience of looking at things is quite a funny, difficult-to-pin-down, fleeting thing, kind of where you take something away with you, some kind of inspiration or something, or a memory of it. I think that's why I like to carry my works around in my head a bit. If I can carry my work around with me – like *The lights going on and off* – then it can be of real use to me in my life, not just when I am standing in front of it looking at it. Maybe that is why words help. If a work can be described in words, or made of words, then you can carry it around perfectly with you. That's great, because it's like having a nice experience and then being able to take it away with you.

TE: I see your work as really quite a direct attempt to find an art that really connects to people. In a very direct way, you know? It manifests itself in different ways and I think

this is why many people read it as provocative. Sometimes it manifests itself in work like *Smiling people* [Work no. 295]. Or *Don't worry* or *Everything is going to be alright*. How do you view this kind of contradiction between what is in a sense quite generous and very humanistic work, but that sometimes seems to solicit quite a vitriolic response on the part of the audience? Or am I reading the work wrong in the first place?

MC: (Laughs) I don't know … I would see it as trying to be as direct as possible, you know? I think: I've got to try to clear away the shit and try and make something that is simple and direct, and not at all complicated. And that's what I mean by something being a relief, or like a relief. Like a solid thing or just one little action … Many works are almost like a single thing happening. Drawings or sculptures are often like a blip or a single 'woop', but there are also ones in multiple parts that are kind of rhythmic: they're like collections of single parts, or similar single bits repeated.

I used to have a kind of self-imposed rule that I would only exhibit one work at a time. It was to try to concentrate on making works that communicated or did something directly, and to not have works relying on each other, or propping each other up. Each work was made on its own as one thing, and was supposed to work as one thing, so why exhibit it with other works? I thought maybe that was a bad idea. I wanted to make things that could survive on their own in the world, and which could be open to people who wanted to use them. If there was just one work on show, or just one event in the work, I thought there was more chance for a direct relationship between the audience and the work. If there are two or more works on show, there start to be relations between the works, you start to see variations on a theme, and they can have too many inter-relationships, and that can get in the way – and it can feel wanky and interfering and sidetracky, like a self-congratulatory, smug

band playing across the stage to each other rather than playing out to the crowd.

TE: Your use of events is actually quite prevalent and used across very different media. From light/darkness in *The lights going on and off* to, obviously, balloons in *Half the air in a given space*, but then also in the video of the two boats arriving [Work No. 405]. There is a certain agony and ecstasy in the work.

MC: (Laughs) I think vomiting is also very much a single event.

TE: Probably your best-known work is *The lights going on and off*. How did you come to that piece? What was the intention behind that work, and do you think it has been read properly?

MC: I don't think there is a correct way of reading it but –

TE: Well, it's astonishing to me that so playful a work is often read by many viewers as an incredibly aggressive act on your part.

MC: Aye, yeah (laughs).

TE: Incredibly aggressive!

MC: *The lights going on and off* (laughs)?

TE: Furious.

MC: I know. Someone threw eggs at it once (laughs). I don't think they knew where to throw the eggs, so they threw them at the wall.

TE: (Laughs)

MC: I wanted to try to strip things down. I didn't know whether to have the lights on or off. I didn't feel sure about things. I didn't know what I wanted. But it was kind of an experiment in trying to make something that you don't have to look at … or don't have to

look at directly. You can look where you like … it doesn't matter, you'll see it, you can catch it in the corner of your eye … Yeah, that was part of it … but probably before that I was trying to make something that used the whole room and that wasn't made of any materials. It came from thinking there is no one material or shape that I believe in enough to put it together and point to and say 'look at this' … That work is made only of materials that are in the room that you are looking at, which includes you and everything that is being cast in light and then taken out of the light. I would get upset sometimes when works like paintings and objects got damaged. It would break my heart – I hated it, and I wanted to try to make something you couldn't break or damage. In the case of *The lights going on and off*, there is nothing to store and nothing to get damaged. To make it you can do it manually or by using technology to make it happen automatically – but that is a detail of the performance of the work – the work itself is a light effect, or something like a little piece of theatre.

TE: Was *Half the air in a given space* part of that series of experiments?

MC: Aye, I think the balloon works came out of a similar working process a bit later. It's difficult because I'm looking back now and maybe I'm guessing a bit or making up what I was thinking at the time. *The lights going on and off* was an attempt to try to make something that makes itself in front of you as you watch it – just like a piece of music makes itself before you as you listen to it. I was trying to make a sculpture more like a piece of music. The first one I made was the 30-second one. It was a minute split in half.

TE: You introduce a similar idea with the door opening and closing [Work No. 129]. Why this repetitive urge?

MC: I find it comforting – it's reliable. It's a scary, crazy, ever-changing, unpredictable

world, and you don't know what is going to happen. And so a rhythm, whether musical or visual, is a comfort. It's like putting up a ruler, or a grid, against the world, so that the changing world, as messy as it is, can be made into a pattern – like looking at a garden through a fence. Dancing makes you feel good. A rhythm is a helping hand, something to hold on to, like a handrail on the edge of the world … I don't know if comfort is exactly the right word, but it's something like that. In a work like No. 850, I thought of it more like a natural event, so that the runners were like waves lapping up on the beach, with the audience like people walking along the beach.

TE: It's interesting that you use the word 'comfort'. I find many of your works quite irritating.

MC: (Laughs)

TE: You know?

MC: Yeah, right (still laughing). Aye.

TE: Certainly the composition you did for an orchestra playing one note at a time in a sequence from high to low notes [Work No. 673] is very irritating.

MC: I don't think it is. (Both laugh)

TE: Many other people found it annoying. Many people find *The lights going on and off* highly irritating. The piano piece [Work Nos 372, 569] seems to be a deliberate shock to the quiet of the space in which we normally look at art.

MC: Aye.

TE: It's as though you are insisting, 'OK, now, we will repeat that'.

MC: Yeah, yeah.

TE: You *will* listen to this!

MC: (Laughs)

TE: You *will* see this!

MC: Yeah –

TE: You *will* remember this!!

MC: No, no, but that's wrong, because you don't have to watch it. You are free not to look at those works. It is very important to me that the audience is freely moving. They can come and go as they please. Those works are not presented in a concert-hall for people to sit through. They are more in the background, like decoration: a rhythmic, repeated pattern.

TE: I saw the banging piano as kind of a sound version of *The lights going on and off* with noise and then silence, each attenuated.

MC: Yeah, right, exactly.

TE: Do you possibly aim to lessen the visitor's enjoyment?

MC: (Laughs) No, absolutely not. It is like a ride in a fun fair. It makes a loud crash, but you don't have to go on it. But maybe working is also a matter of trying to provoke, like throwing stones into a pond to make ripples, or hurting yourself to see if you can feel something … or like stamping your feet or having a tantrum.

TE: Or breaking with the normal or breaking the continuum in a sense? Or forcing you to actually engage with the thing you came to do?

MC: Aye, yeah (laughs).

TE: And do it in a timely manner?

MC: Aye.

TE: Are you going through the door or not going through the door? Are you looking at this painting or are you not looking at this painting?

MC: Yeah. I think that part of the point of those works is that they are trying to make a work out of kind of little limbo moments. I have often had the best time when I've left and I haven't got there yet. I love being in airports and motorway service stations or on the tube in London, and just day-dreaming or looking at people. But I don't just go on the tube and go round and round. It seems to work better when you have somewhere to go.

The experience of looking at things is always a kinetic one because you're alive, your heart's beating, you're moving around, you're not static, which means that a painting is a kinetic work because it is moving because you are moving. If I think about it like that then there is no difference between a painting and, say, a work made of balloons or a person running through the gallery or a banging piano. For me they're all the same. When you look at something you hear things and when you listen to something you see things. Sounds are always involved too.

TE: LeWitt, Judd, Andre and others of that generation always accompanied their work with extensive statements and writings. It seems to be me that you do have statements, but they are all in your songs.

MC: Aye, aye. Maybe they are.

TE: When I see one of your performances, I say, 'Alright, I get it now. It's real.'

MC: Alright (laughs).

TE: It's real. It's not just a send-up of rather absurd ideas. It in fact means something very real to this man.

MC: Yeah, yeah.

TE: So, do you see the songs as statements?

MC: Yeah, absolutely, yeah! Totally, yeah. Everything is a statement! I have to live with everything I do for the rest of my life! The songs and the works using words as well. One song that I think is very important to me is 'I Don't Know What I Want'. That is a statement that means something to me.

TE: Why?

MC: Well, because I don't know what I want. Or, to put it another way, I want everything! I want to do everything, so I often feel torn.

TE: Torn between what?

MC: Between, well, between one thing and another. Or torn every which way (laughs).

TE: Well, let's go to something else then. (Both laugh)

MC: Yeah.

TE: In recent years you've started making films.

MC: Yeah, *Sick*, *Shit*, and the *Sex* film.

TE: And again we come back to these essential bodily functions.

MC: Aye, yeah, right.

TE: How did the decision come about to make the first film?

MC: It came directly from doing talks. I was doing a talk and I was thinking that what I was trying to describe – the process of working – is a process of trying to get from the inside out. Being sick is a good example of that. And it's a good example of someone making something.

It puts your insides out. You don't really know what's going to come out, it's painful, but you feel better afterwards. The films are like portraits of people expressing themselves.

TE: So it's about looking at people making the same gesture, rather like the series of photographs of people smiling: a mother, a father, a friend …

MC: Exactly, yes, something uncontrolled. I am sick and tired of thinking. I want my work to be more like a vomit than a rumination. I just want to go 'Blah!' or 'Woosh!'.

TE: The *Sick film* might be considered to be about painting – it certainly suggests the figure of Jackson Pollock in those famous Hans Namuth photographs – and if so, then the *Shit film* is about sculpture. What's the *Sex film* about?

MC: I don't know, because in the *Sex film* nothing is actually made. It was very clear in the *Sick* and *Shit* films that someone comes on, makes something, and goes off. But in the *Sex* film there is not really a beginning or an end. I just wanted to film two bodies coming together and apart in close up. I thought it would be nice.

TE: Well, it certainly fits with the binary aspect of your work.

MC: I didn't make those works with a set goal in mind – I didn't know what to expect.

Tom Eccles is the Executive Director of the Center for Curatorial Studies at Bard College in Annandale-on-Hudson, New York. This conversation took place on 27 March 2008 in New York City.

Questionnaire

The Full Score and Martin Creed

An exercise in synaesthesia: what colours, textures, smells, tastes provoke some kind of musical response in you? I don't know. I don't think I know what a musical response is. In my experience everything provokes everything: it's all one big soup of feelings, thoughts, noises, tastes, smells, emotions which are difficult to separate … Music is like art: I think it is hard to know what it is or how it works. It's in the heart and mind of the listener. I suppose a piece of music is something like ordered or tidied noise, or sounds pointed to for a time. But I don't find it helpful to think about music or art too much when I work. It's a matter of trying to put sounds and shapes together to see if they are exciting, and to see if I can live with them.

Your favourite instrument? If I had to choose, the voice I suppose. It's the first instrument, and it's one which everybody owns.

What is your earliest musical memory? When I was a kid I always wanted my mum to put on a record when I went to sleep. The two albums I liked were 'Cabaret', the soundtrack album with Liza Minnelli, and 'Jeff Love and his Orchestra Play Big Bond Movie Themes'.

When and why did you realise that you wanted to be a composer?
Just after art school I started trying to compose some pieces for a 3-piece band. I was a bit frustrated with some of the sculptures I was making. I felt my sculptures did not represent the excitement of the process of working. They were the things left over after I had finished working, like the sediment at the bottom of a glass, and didn't really tell the story of how they came about. I find the process of working, of trying to make something, interesting and exciting, and I thought that maybe in a piece of music I could show the process, tell the story, better than in a sculpture. The music makes itself in front of people. Since then I have been trying to make my sculptures more like music.

What do you do in your spare time? I work, it helps to pass the time. It helps me to get by. I am scared of emptiness.

What is your favourite moment in any piece of music? The start. Everything sounds good at the start. It's exciting. It's like a relationship: it's easy at the start, but it's hard to go on, and it's very difficult to finish.

Which performance (of your own or another composer's music) brings back the most vivid memories, and why? Seeing The Jam and The Smiths live in Glasgow when I was a teenager. I remember the whoosh, the wave of excitement, the feeling of being close and together with many people and having one big experience in one big room, as if the air was solid matter and everyone was joined together.

What is your favourite recipe? Any unusual ingredients? You can never use enough lemons. I love lemons, but I don't want to be one.

How do you deal with composer's block? I try to let it wash over me. When working I think it is good to always remember: I don't have to do this – perhaps I should do something else. I think if you can accept the possibility that you might fail it makes it easier to work.

Where do you compose? I work a lot in private, but in the end I think only when pieces are played live can I find out about them, find out what they are really like. In private you can get comfortable and kid yourself. I also work often when I am travelling and on the move. I think it's helpful also to work in other countries, to test your work out in other countries, see what it feels like in a place different from your own. I am slow: I think I often need to live with things for quite a long time.

What is your favourite joke? Velcro: what a rip-off.

OR

My aunt has a map of Britain tattooed on her back. She's a tough, uncompromising woman, but at least you always know where you are with her.

Where in the world would you most like to visit? Africa.

Originally published as 'Composing Myself' in *The Full Score*, Winter 2008.

The System of Objects

Massimiliano Gioni

3.0 All numbers are equal.*

3.1 The works of Martin Creed can be executed endlessly, like musical scores. He's not interested in the shock factor, even in the apparently more radical works, like *The lights going on and off*. Creed doesn't believe in originality, the unique, the eccentric. Instead, he is fascinated by quantity and repetition. The system is more important than its individual parts.

3.2 Creed's art is intrinsically egalitarian, profoundly democratic. Paradoxically, he seems to be bent on eliminating talent, erasing the exceptional, imposing a series of basic rules that can be applied in any situation. Creed works on the fundamentals.

3.2.1 I believe that Creed accepts any invitation to take part in any exhibition, as a form of self-discipline and extreme democracy. All exhibitions are equal.

4.0 Creed's art is substantially binary.

4.1 Creed's art lives in the interval between the event and its negation, between its violent bursting forth, immediate suspension and subsequent repetition. The metronome is the fundamental metaphor for Creed's work: sound, negation of sound, repetition of sound. Sound, silence, sound, silence … This is the grammar that sustains many of Creed's works – the tension between the expectation of an event, its occurrence and its symmetrical negation.

4.1.2 Though sustained by binary opposites, the work of Martin Creed prefers inclusion to exclusion. Sound and silence are equally important, and both are incorporated in the work. As one of Creed's texts indicates, the whole world + the work = the whole world.

5.1.1 If we consider the question of rhythm, Creed's art seems as reassuring as a mantra, a familiar refrain, a structure to cling to, suspended over the abyss of chaos. The rhythm counters the unpredictable multiplicity of life. Art as order and security. Art as a choreography of life.

6.1.2 If we consider the sudden apparition of an event and its immediate negation – the piano that suddenly opens and bangs shut, the light that turns on and off, the door that swings open and closes – Creed's art appears quite menacing, merciless: it snaps like a mousetrap, incessantly repeating the guillotine's rhythm.

7.0 Is Creed's art concerned with death?

7.1 In Creed's art the body is often represented as a machine, regulated by mechanical pulsations. Even when it resorts to the most elementary biological explosions – as in the *Sick* or *Shit* films – the human body is trapped in an infinite repetition of gestures. Even the expression of the *Smiling people* has something doltish about it: their good humour is suspect, prolonged *ad libitum*. There's something suffocating in this vision.

7.1.1 *Half the air in a given space* is a work that literally takes the air, and therefore also the breath, away.

7.2 Yet we might argue that the representation of the body, in Creed's work, is also a celebration of the infinite resources of our being. It is the basic gesture of liberation, the zero degree of sculpture and painting – the precise point at which expression and expulsion become synonyms. It is the basic awareness of being alive.

7.2.1 As I write I nervously chew gum. My body expresses itself in a form of primordial violence – the bite – whose rhythmical structure is, after all, not that different from a metronome or a guillotine.

7.2.2 As monks and smokers know very well, the repetition of gestures is serotoninergic, it generates a sense of wellbeing. Rhythm and pleasure are closely connected.

7.2.2.1 Risking the banal, we might say that Creed's art is also fascinated by the so-called little death, as the French put it, or namely the orgasm: sex rarely appears, but it is there in the deeper structure, the eternal repetitions, the percussive rhythm of the work. Manifestation of climax, however, is rare.

7.2.2.2 Creed's art is also tragically onanistic – a closed circuit.

7.2.2.2.1 Is boredom the desire for happiness left in its pure state?

7.3 Further proof of the bodily obsession in Creed's work: the complementary forms that protrude from walls and encyst themselves in corners, like strange genital excrescences.

7.4 For Creed the body is often little more than an orifice, a point of inside-outside passage. A membrane. Breath, the raspberry that also sounds like flatulence, the gasp evoked by the balloons, the vomit, the shit, but also the word – repeated, chewed, pursued, extracted, sung, often flayed by the Scottish accent that makes it more guttural and physical – are all emissions that exit the body through an orifice.

7.4.1 When he sings, plays, works or acts on stage, it is as if Creed were trying to empty himself.

7.4.2 Referring to autism might be obvious and even, perhaps, out of place, but Creed's work seems to stage a dramatic relationship between inside and outside very similar to the one described in the infamous text by Bruno Bettelheim, *The Empty Fortress*, on the meaning of the confines of the bodies of autistic children.

8.0 I like things. A lot.*

8.1 Creed's work is immersed in the sea of objectivity.

8.2 In Creed's oeuvre there is an excited passivity, an almost child-like acceptance of the multiplicity of the things of the world. Creed's art welcomes the widest range of objects – preferably the least precious – but always things that have a natural readiness for play. Some of his favourite objects are round.

8.3 Creed's art is celebration of the superfluous, but reduced to the essential.

8.4 Creed's art often involves a form of direct, physical engagement of viewers, who must avoid obstacles, stumble over sounds, embrace balloons, climb over furniture. Creed is fascinated by the thin line that separates hospitality and violence.

8.5 Creed likes to mention Carl Andre's name when talking about art. Walking on Andre's floor pieces is a particularly perverse process: a form of vandalism that is not only expected, but even encouraged by the artist. A gesture of subtle violence.

8.5.1 Andre's floors are pedestals that transform any viewer into sculpture.

8.5.2 Creed is also interested in the rhythmical structure of Andre's floors, sculptures and poems.

8.5.2.1 Creed and Andre share a profound fascination with words – written, in the case of the latter, spoken, emitted, perforated, in the case of the former. See, for example, Creed's recent theatrical experiments.

8.5.3 Andre's work was also the last form of abstract sculpture to generate furious reactions on the part of the audience. *The lights going on and off* strikes a similar balance between uncompromising refusal to please the audience and extreme acceptance of the role of that same audience in shaping and transforming the work. In a certain sense, *The lights going on and off* is the three-dimensional equivalent of a Carl Andre floor piece.

8.5.4 The influence of other artists should always be underestimated or, at least, carefully assessed, never reduced to mere transmission or appropriation. This said, a succinct list of the references that have impacted and transformed Creed's work should include the names of: Carl Andre, Samuel Beckett, Lenny Bruce, John Cage, Johnny Cash, Devo, Donald Judd, Bobby Fischer, Sol LeWitt, Piero Manzoni, Bruce Naumann, Sex Pistols, Frank Stella, Talking Heads, Andy Warhol, Lawrence Weiner, Ludwig Wittgenstein.

8.5.4.1 In a formula, we might define Martin Creed's work as a sort of rock 'n' roll minimalism. But unlike its musical models, Creed's work contains a rigour that pushes in a completely different direction.

9.0 Creed's work is dramatically split between amusement and punishment.

9.1 The protestant heritage of minimalism and the religious background of Creed, who was brought up in a Quaker family, have undoubtedly contributed to the ethical thrust that seems to permeate all of his work. (The biographical details of family background should not be overlooked, but neither should they be attributed too much value.)

9.2 At times Creed's work seems to be crushed under an excess of rules. Therefore the birth of each new work is always infused with a surplus of energy and often prompts a smile of relief: the new surprises us, in Creed, because it indicates the possibility of escape from the system of rules the artist has imposed on himself and his work. Or, vice versa, it confirms the efficacy of the rules, and therefore reasserts their validity and vitality.

10.0 The word 'work' is a fundamental concept of Creed's universe, but it is above all a fundamental concept of occidental culture. Work and labour are a divine sentence, a punishment after the banishment

from Eden. In Creed's oeuvre everything is work.

10.1 The birth of contemporary art corresponds to a process of emancipation from the concepts of work and labour. Contemporary art is based on the conviction that the value of the artwork is separate from – or inversely proportional to – the quantity of labour required to produce it.

10.1.1 In an old English tabloid masons ironically aped the work of Andre, constructing abstract sculptures with bricks, a degraded version of minimalist purity. The most radical abstract art irritates the public precisely because it ignores the equation 'work = labour = effort = retribution'. In Martin Creed's world, the obsession with the idea of work is thus also tinged by a love-hate relationship with respect to the British working class.

10.2 The hypertrophic notion of work in Creed's output becomes an attempt – which may seem a desperate one at times – to give everything a value: in his interviews Creed also tries to transcribe pauses and coughs, just as in his theatrical performances the interjections, the unfinished phrases, the digressions represent the real plot. In other words even the simplest gesture is considered labour and work, and as such it deserves respect and appreciation, even if this means being overwhelmed by the excess of equally fundamental and therefore equally useless details.

10.2.1 The care Creed puts into the most insignificant details of every work not only reveals an obsessive, almost maniacal, even disturbed attention, but it also opens up a set of infinite possibilities: if anything is work, then potentially everything can be incorporated into the realm of art. The whole world – if we just know certain fundamental rules – can be transformed into a symphony of artworks.

11.0 Martin Creed's work has an intimate, personal, even melancholy sphere that all too often gets overlooked. On and off, up and down, open and closed are all expressions that could just as easily be applied to moods, happiness and depression, euphoria and dysphoria.

11.1 The insistence with which Creed repeats 'everything is going to be alright' reminds us of a magic spell, an entreaty that actually betrays a widespread sense of anxiety: if it were true that everything is alright, then we wouldn't need any sign of reassurance.

12.0 Creed's work has always seemed tragic in its premises, joyful in its results. And vice versa.

* Martin Creed's words

Massimiliano Gioni is the Director of Special Exhibitions at the New Museum in New York, and the Artistic Director of the Nicola Trussardi Foundation in Milan.

When Nothing is More than Enough

Germaine Greer

If nothing is enough, why have any more? The difficulty is that nothing cannot be achieved. We might well be satisfied with nothing, but we can't get hold of it. Everything is something. Every gesture, however we strive to empty it, is loaded. The aim of minimalism in a universe of loaded gestures is to arrive at the emptiest possible gesture. A minimalist masterpiece is a gesture that successfully resists being loaded. Though hoohah and hullabaloo may greet its appearance in public, the minimalist masterpiece will retain its utter purity. The truly successful minimalist work is one that can be neither bought nor sold. *The lights going on and off* is the ultimate uncollectable. It can't even be photographed, let alone reproduced. You can't stick a poster of it on your wall to show how hip you are. All of which is obvious, like the blueness of the sky, but, like the blueness of the sky, not understood.

Minimalism is not new. As a movement, though it may not always have been called such, minimalism has already lived a whole century, longer than impressionism, post-impressionism, cubism, expressionism, modernism, futurism, or surrealism. Malevich is still a hugely relevant artist, though most of his admirers could not tell you why, which is as it should be. *The lights going on and off* is a lineal descendant of Alighiero Boetti's *Yearly lamp* (1966), a light bulb that would be illuminated only for a random eleven seconds in any year, hidden in a box. What we should probably infer from the longevity of minimalism is that its possibilities are far from exhausted. If Kant is right to define the object of aesthetic judgment as an object with no ulterior purpose, use or function, all art strives towards minimalism but is usually deflected by the conditions in which the work exists, by patronage, politics, established religion or the artist's personal ambition. Art that invokes moral values, that tells a story, that engages with actual events, that has become a trade object, has already compromised its art-ness. When a minimalist work becomes so embedded in its own reputation that it is treated as a symbol denoting a mass of notions that are essentially nothing to do with it, it is no longer minimalist. The gesture is then overloaded with purport and overwhelmed, its playfulness extinguished.

Art being a part of life, the threat of such extinction is ever-present. Nature, as distinguished from art, abhors a vacuum. The beholder, having decided to experience *The lights going on and off* is not about to confess to experiencing nothing as she stands within its space. The artist's gesture will be filled with something, even if it is only the beholder's awareness of her pupils' expanding and contracting out of sync, or her disappointment, outrage, or delight. As one who was delighted when Creed won the Turner Prize in 2001, I have to admit thinking very hard

all the time I spent in the room at Tate Britain, as the lights went on and off, about the unnecessary lengths artists go to to dramatise spatial relationships, about light as their true medium, about the space being one living cell pulsating within the art establishment mausoleum, but also that I didn't need to be thinking about such things at all, or thinking at all, the sheer gratuitousness of the gesture, the luminosity of its total pointlessness was as near to perfection as human achievement ever gets. The blue of the sky is the blue of utter emptiness.

Most of the male American minimalists with whom the movement is usually identified have packed too much ego into their work for it to survive as minimalist. It is when we consider the work of women like Agnes Martin and Eva Hesse that we draw closer to the still centre where ego has been eclipsed, and to Creed. Martin's humility, all of whose ways 'are empty', is close kin to Creed's egolessness; both are rare in any artist since the Renaissance. Creed's response to Martin's soft grids can be seen in works like Nos 461, 472 and 557. Martin was influenced by Indian tribal art, and it is a curious coincidence that Creed's haptic approach to filling his A4 picture space with contiguous lines arrives at a minimalist version of the classic Pintupi images of the straightening of spears. In Work No. 175: *Two drawings*, Creed's homage to Hesse is touching and transparent, but her spirit can be sensed more subtly elsewhere, in Works Nos 83, 263, 264, 340 and 384, for example.

Like Hesse and Martin, Creed avoids the regimentation and machine-made regularity usually associated with minimalism; when his felt-pen tracks across the page it obeys the pressure of his hand and arm. The result is organic rather than geometric. As for self-glorification, Creed has evaded it even more successfully, because he has made works that have no signature and do not even require his agency. Given his meticulous instructions, anyone could install a version of *Half the air in a given space* (Works Nos 200, 202, 268, 360). Whenever and wherever *Half the air in a given space* is installed it is a different work; Creed does not insist on controlling every aspect of it. Neither the balloons nor the people among them behave in predictable ways. When for once Creed capitulated to the pressure to show that he could draw, he drew a doodle with a marker pen (Work No. 438), as Hesse might have done, but it is a perfect doodle, a super-doodle that he must have practised a thousand times. The marker pen travels six or seven feet with unvarying pressure on point and paper as it swiftly describes a spiral of nine coils and the four pinnacles within the spiral. Easy, when you know how. Making it look easy is part of the minimalist project; the fun part is what Creed has most strikingly in common with Eva Hesse.

Creed's struggle for emptiness never ends. He strives for utterances that will not yield an ulterior meaning to even the most dogged (mis)interpreter. How difficult this can be became apparent from Creed's 2006 project for the Fondazione Nicola Trussardi in Milan, which was called simply 'I like things'. On the face of it, the Palazzo dell'Arengario was a perfect site for the installation; the smooth blankness of its pared-

down neo-classicism is justified by the same Platonic authority that underpins Creed's formalism. However the values projected by the Palazzo dell'Arengario, which was designed by a committee of Mussolini's favourite architects in the late thirties, are not so much formalist as Fascist. The building brought its own tragic personality to the event, and the work was inevitably corrupted by it. *The lights going on and off* was installed in the Sala delle Colonne; this time instead of remaining on for five seconds and then off for five seconds, the lights were on for a second and then off a second. People entering the space were buffeted by a wind machine; members of the Road Runners Club of Milan occasionally dashed past them. When 'one of Martin Creed's iconic works', the slogan 'Everything is going to be alright', which had been mounted in Times Square in 1999 (Work No. 225) and dozens of places since, was replicated in white neon across the façade of a Fascist building that was damaged by Allied bombs and never officially opened (Work No. 560), its insouciance was penetrated with so much painful irony that, like the whole show, it turned conceptual. Conceptualism is the obverse of minimalism; it deals in proliferating meaning. It projects information and it harvests information shared with the viewer. 'I like things' inspired thousands of words of interpretation: the show was a critique of consumerism, post 9/11 paranoia, godlessness, fundamentalism, and so forth. 'I like things' was the first time the public saw *Sick film* (Work No. 610), which seems to enact emptying out, as if it were a work of revulsion, a sudden violent discontinuity with the tenor of Creed's frolicsome creativity.

Its no wonder then that Martin Creed is on record as saying that he is sick of thinking – he doesn't say whose. The Italian media have grown up with Arte Povera and were not about to complain that what he does is not art, but in the discussion of 'I like things' in the Italian media Creed must have found himself identified with causes to which he was not in the least committed. Closest to the spirit of the artist was probably the *Gazzetta dello Sport*, which not only reported the show without sneering but also pointed out that art and sport have many things in common. This Creed would not deny. He differs from the great exponents of Arte Povera in his utter lack of self-importance; he does not roll a two-metre ball of crumpled newspaper through city streets but crumples a single sheet of blank paper into a sphere and leaves one in every room in a house. He didn't throw a neon tube about the wall of the room in the Tate Gallery to dramatise the space, he simply turned the lights on and off, a process rather less simple that it was made to seem.

The ultimate irony is that, if I should now write that I think Creed is a great artist, I shall have proved him a failure. He would rather I said I love what he does, which would be the truth.

Germaine Greer's latest publication is *On Rage* for Melbourne University Press. She writes a fortnightly column on art for *The Guardian* newspaper.

Martin Creed 20 Questions

Matthew Higgs

The *Collins Dictionary of Art Terms & Techniques* defines 'realism' as, amongst other things, 'the depiction of real objects without distortion or stylization'. By this – admittedly selective – definition alone it is possible to confirm that Martin Creed is a realist. His development of real objects – doorstops, masking tape, metronomes, ceramic tiles, Blu-Tack, Elastoplast, pieces of furniture, neon signs and balloons – into what might be termed 'object situations' provides us with (Collins again) 'a frank picture of everyday life'. Creed's fundamentalism as both an artist and a citizen extends to acknowledge not only his own limitations as an artist ('What can I actually achieve?') but also signals the limitations of art itself. Work No. 143, Creed's 1996 reductive mission statement – a manifesto of sorts – goes some way to clarifying his position. It deduces that:

the whole world + the work = the whole world

Creed's lower-case conundrum ultimately leaves 'the work' nursing a bruised ego – its (numerical) 'value' reduced to zero. In doing so he begs the question: if art has no value – then why make art? Short of an answer, Creed carries on regardless, pursuing a contradictory impulse – a paradoxical desire to produce both something and nothing.

Sensing no conflict of interests with his practice as an artist, Creed formed the band Owada in 1994. Fairly accurately described as sounding 'like something between Steve Reich and the Ramones' Owada acts out an aural equivalence to his often tragic-comic artworks. The first CD – the self-deprecatingly titled Nothing – released last year on David Cunningham's Piano label (PIANO 508) further reinforces the decidedly informal brand of formalism that is at the heart of Creed's project. A project whose very matter-of-factness prevents it – to quote the artist – from 'going up its own arse'.

20 QUESTIONS

The standard one-to-one format of an interview invariably reveals as much about the subjectivity of the interviewer as it does about its subject. In an attempt to both democratize the role of the interrogator and to hopefully broaden the scope of the interview's actual remit 20 individuals – all of whom have had either a professional or personal relationship with Martin Creed – were each invited to pose him a single question. Creed's subsequent responses are reproduced here verbatim.

1. Peter Doig: How Scottish is your art?
Martin Creed: (Laughs) … I think it is probably quite Scottish in … in … in … in … in some ways … in the way that I think of Scottish as being … kind of careful … and sort of … erm … it has tendencies towards … erm … it can sometimes be a little … anal! … Scottish like … like … erm … aye … careful … and … quite slow as well … I think that is quite Scottish …

2. Martin McGeown: If you could ask one question of any artist, living or dead, what would it be and to whom would you ask it?
MC: … I dunno … (Coughs) … I don't think I would … and that's … erm … well because I don't really think it's about art necessarily … all this … but … erm … living or dead? …

I find that difficult to answer … because I can't … I'd like to … it wouldn't really matter to me who it was … erm … (Coughs) … (Sighs) … I mean I think I would … (Laughs) … no … when I think about that question my head just clouds over with … there isn't one thing I would like to ask … I'd like to ask … you know … everything … of … you know it's not … I wouldn't … there isn't … there isn't … my head clouds over with questions and artists … people … and things …

3. Keiko Owada: What is your idea of ultimate happiness?

MC: … erm … I suppose to make … to make work that I feel happy with … that I feel I can live with … that I like … and to be with people … who I like … and … who I can live with … and … who I feel happy with …

4. Iwona Blazwick: If you could own five works of art from the 20th Century what would they be?

MC: … erm … (Sighs) … erm … a 'black' painting by Frank Stella … erm … shit … (Laughs) … it's difficult to say … 20th Century did she say? … dunno … can't choose five … maybe I'm thinking more about things that are considered to be art … erm … aye … my mind goes blank to questions like this … and I think the reason that I said a 'black' painting … is that I love Frank Stella's work … erm … from what I remember at that time when I looked at his work … and I liked it a lot … I felt like I'd sort of learned a lot … at that time I did think that there were works of art … but I don't really think about it like that anymore … you know … so it's just all a blur … you know … five … there's lots of beautiful things … and nice things … but they … it's all just a blur … it all merges in … art … life … you know … people … nice times … you know … so to pick five would be misleading … to pick five … five works of art … because it would … you know I think … I think there is easily … (Laughs) … erm … there are just so many things … I can't choose five … I find this a difficult question … because she's asking about works of art … and erm … and not only is she asking about works of art she's asking me to pin down five of them … I'd rather … I'd rather just answer the question … about … erm … could I … could I … is there some stuff … (Laughs) … from the 20th century that I would like to own? … and erm … there isn't really that much … no … I like … er … tools … for trying to make things … you know … a cooker is good … coffee machine … you know … record player … erm … I don't feel able to say five things that … it panics me that question … because there aren't really five … I wouldn't say that there are five things that I would like to own … aye … I suppose I feel uncomfortable about ownership … one of the things that I like about recorded music is that it's a little more widely … you know … more people can own it than … let's say a sort of … unique … erm … sculpture … you know the more the better … I'd say … I don't like to choose one thing above another … I feel very … very … uncomfortable about sort of judging or choosing because I don't feel I've got any basis to say that something is better than something else … erm … and I think that that leads to a discomfort with uniqueness and preciousness … and … er … also a discomfort with owning and coveting … to me it's something to do

with trying to feel free … with feeling free … for my 21st birthday I was given an espresso machine … erm … and … er … and … er … and at that time I was trying to make work … and kind of felt … I dunno … frustrated … or something … anyway … I'm not very good at owning things … this coffee machine … you know I kept in a box for about two years … (Laughs) … so that I couldn't see it … it was just such a weight on my mind having this brilliant coffee machine that I would make coffee with in the morning … it was just too … kind of … it didn't make me feel free … it made me feel … erm … erm … erm … un-free! … (Laughs) … I mean I keep a lot of things in boxes … because I feel like it's a weight on my mind if I have them … displayed around … erm …

5. Lesley Smailes: What is your inside leg measurement?
MC: 32.

6. Adam McEwen: Where do you get that funky sense of rhythm?
MC: (Laughs) … I dunno if I have one really … (Laughs) … (Laughs) … erm … (Laughs) … er... to me it's all about rhythm … aye … to me … erm … well trying to write a piece of music … is … erm … trying to … erm … to fill in some time … and to do that rhythm is very useful … to make you aware that time is passing … like a ticking clock … I don't know about 'funky' though …

7. David Cunningham: Why do you make work and what aspect of the activity do you enjoy?
MC: I make work because I … erm … because I want to express myself and because I want to try and communicate with people and because I want to be loved … erm … I enjoy all of it … (Pause) … well I make … erm … well I make work because I … I … want to … (Sniffs) … express myself … I think I've said this before … (Laughs) … because I want to communicate with people and because I want to be loved I want to … I want to … I want …

yeah … I want to try to communicate with people … I want to … erm … you know … I want to say 'Hello!' … I want to … erm … I've thought about this a lot... but I can't … I can't … I can't … I can't think about it in any other way except that I want to express myself … I want to communicate somehow … try to communicate with people … with other people … that's very important … that there are other people involved in it … erm … yeah and I want to be loved … erm … I suppose it's in making work … that … erm … it's possible … or I feel that it's more possible to try and sort of pin it down … to try to say … to try and communicate in a way that … erm … try to do it in a clear way … or rather it's in trying to make work that maybe there is a chance … that I … I … can sort of find out about what it is that I do … want … perhaps … erm … I think what I enjoy most is the beginning and the end … yeah … the … er … erm … the first workings and then the conclusion … it's the middle bit that is a pain …

8. Andrew Wheatley: What would you be if you weren't an artist?
MC: (Laughs) … erm … dunno … but I don't really say that I am an artist … I mean … I wouldn't say "I am an artist" … I wouldn't really say I am anything … you know I want to make things … I want to make things that I can live with … you know … I don't want to make 'art' necessarily … (MH: So you wouldn't define what you do as 'art'?) … Not necessarily no … No! … No! … it's just stuff … extra stuff in the world … it can be good stuff or bad stuff … but I don't call it 'art' because I don't find that useful … I don't find it useful to think about art … I mean whether it is art or not … you know? … I don't find it useful to define myself as an artist … no … not at all … you know I don't think that I am trying to make art … you know I think the 'art world' … if there is such a thing … (Laughs) … is a place … you know I think it's a fact that … erm … that … er … art galleries are places that … are places that I have been able

to do what I do … but that doesn't make what I do 'art' … it doesn't … there's no … when I say it's not 'art' … I'm not … I'm … erm … erm … I'm trying to take art out of the … out of the … equation … because when I say that I don't think of myself as an artist … I don't say that in relation to some idea of what an artist is … I just don't find it useful to think about it …

9. Jeremy Deller: What makes you laugh?
MC: (Laughs) … erm … oh God! … lots of things … (Laughs) … er … och! … it's too difficult a question … erm … I dunno … it's difficult to say … you know … lots of things … I've laughed quite a lot today … (Laughs) …

10. Gilda Williams: Apart from your own music what would your five Desert Island Discs be?
MC: (Laughs) … Oh God! … something by Mozart … erm … erm … erm … you see my mind … (Laughs) … it's like that other question … I dunno … something by the Talking Heads … what's that one? … 'Pick me up'? … 'Pull me up'? … 'Pulled Up'! … (Laughs) … something by Elvis … something by The Beatles … erm … and … 'Waiting For The Man' by Lou Reed … but I don't know about that … not about that … I don't know about those five … (Laughs) … you see having to answer questions like this … like pick five works of art … or five records … it just makes me panic … you know … that's something that I find difficult about making decisions … it's this idea that you are trying to … sort of … pin … that you are trying to … that in order to decide something … that you have to pin it down … and … erm … you know I think it's possible to decide something without pinning everything down … these questions … you know they panic me … because they make me think … but … er … they panic me … I do go blank … I'm not just sort of making it up … (Laughs) … you know 'Choose five records'? … I love lots of … there's loads of music I like … you know if you asked me … to choose five

things that you like … now that's a question! … (MH: Okay, choose five things that you like) … (Laughs) … Okay! … I like music by Mozart … I like espresso machines … I like doughnuts … erm … I like sort of being with people … kind of at parties … you know … I also don't like that sometimes … I like coffee … did I say that? (MH: No) … did I say espresso machines? … (MH: Yes) … well it's coffee that I like more than the machine that makes it! … (Laughs) … I like flying in aeroplanes … I love taking off and I love landing … you know the bit where it speeds up on the runway and it takes off … I like loud music … I love playing … I love … I like … playing live … playing music really loud especially in front of a great drummer like Adam McEwen … when the drums are amplified … all miked up … I love that … I like dancing … (Laughs) … I like other people dancing … I like dancing with other people … I like sex … I like kissing … I like … er … travelling on trains … I like reading on trains … more than … reading … on … unmoving … land … (Laughs) … I like you … I like all of the people who have asked these questions … I'm not just trying to suck up to them … I like … erm … I like … I like talking to people …

11. Giorgio Sadotti: If you were a number and not a name, what would it be and why?
MC: (Laughs) … erm … aye … I'd have to say zero … because … er … you know it's exactly half way between positive and negative … and since I'd find it very difficult to choose a number … zero would be the least of … zero would be the number that would cause me the least worry … and that's … yeah … important to me … aye … I'd probably feel happiest with that …

12. Alison Jacques: Can objects hide?
MC: I wonder what she means? … (Laughs) … (Laughs) … No! … (Laughs) … of course they can't… no they can't … (Laughs) … erm … they … I think it is possible to make an object

... erm ... that ... er ... fits in with its surroundings to the extent that it ... it ... becomes invisible ... but ... er ... I've never tried to do that ... I mean objects can't hide ... they can't hide ... I mean ... to say that they can hide implies that they have a will of their own ... (Laughs) ... which I don't think is true ... I don't think that they can hide ... they can appear more or less ... less or more ... apparent ... obvious erm... but they can't hide ... no ...

13. John O'Reilly: Imagine you were on Play School. Which window would you choose to look through: the round window, the square window or the arched window – and why?
MC: (Laughs) ... well if I couldn't stand back and look through all of them ... erm ... I'd have to ... er ... och ... I'd think it would have to be the square one ... because it's the most ... normal ... square ... rectangular ... it's more normal than round or arched ... (MH: Is normal a good thing?) ... to me often ... aye ... when I'm making decisions ... you know ... erm ... because that's the most difficult thing that I find ... is making decisions ... given that I want to make things ... you know trying to decide what to make ... how to make it ... how to decide ... like writing some of the first pieces of music ... to use the sort of normal band set up of bass, guitar, and drums ... it seemed to me like a kind of ... it got me out of deciding ... it was a sort of ready made ... a normal situation that I could try and use ... that I felt okay with ...

14. Gareth Jones: How long is a piece of string?
MC: (Laughs) ... It can be ... there's lots of different lengths it can be ... (Laughs) ... the real answer to that is that it is between zero and infinity ... that just about covers it all ...

15. Thomas Frangenberg: Between duty and play where would you situate your work?
MC: ... erm ... I don't think ... erm ...

(Laughs) ... I don't think I would situate it in relation to duty ... you see duty ... it seems like 'duty' in that question seems to imply ... morals ... (Laughs) ... (MH: Keep going) ... I don't think ... (MH: Does morality or ethics come into it?) ... well aye ... I mean ... well definitely ... personal ethics ... not a world view on ... on ... er ... things ... aye it does come into it ... because I want to make things I can live with ... and I don't think that I could live with them if I thought that they were ... if I felt that they were unethical in some way ... but it's not something that I think about ... you know? ... I wouldn't find it any more useful to think about ethics than I would about art ... I think play comes into it definitely ... (Laughs) ... (Coughs) ... erm ...well it's all kind of just playing around ... it's like you know ... I think a lot of work to me ... is about playing around with ... ways of doing things and ways of coming up with things ... and erm ... of ways of trying to say things ... or ways of trying not to say things ... and I think that is all kind of play ... and with a bit of luck it's good fun ... you know? ...

16. Dean Hughes: If you had to choose between two lines, one straight and one squiggly, which one would you choose – and why?
MC: ... erm ... I wouldn't choose ... but if I had to choose ... (Laughs) ... then ... maybe the squiggly one because there are more different directions with a squiggly line ... er ... No! ... Straight! ... because it's simpler and more direct.

17. Cornelia Grassi: How come you say 'aye' so much?
MC: (Laughs) ... because I learned to speak in Scotland and 'aye' is Scottish for 'yes' ... and I say 'yes' quite a lot ... so I say 'aye' quite a lot ...

18. Simon Martin didn't have a question for you, would you like to respond?
MC: (Laughs) ... No!

19. Ingrid Swenson: Are you sure that everything is going to be alright?

MC: No! … (Laughs) … I'm not sure … I think the reason Ingrid is asking that is because … because I've been working on this sort of … public sculpture … erm … erm … which is a sign saying 'everything is going to be alright' … a sort of … neon sign … erm … no I'm not sure … erm …

20. Matthew Higgs: Finally, what question would you like to ask yourself?

MC: (Pause) … erm … what would I ask myself? … 'Is it okay?' … 'Is it okay?' … 'How is it possible?' … they're not very specific questions …

'Martin Creed 20 Questions' was first published in Issue 18 of *Untitled*, London, Spring 1999.

Glossary of names:

Peter Doig is an artist. Martin McGeown is a Director of Cabinet. Keiko Owada is a script writer and plays the bass for Owada. Iwona Blazwick is Director of the Whitechapel Gallery and was formerly Director of Exhibitions at Tate Modern. Lesley Smailes is a film maker. Adam McEwen is an artist who used to play the drums for Owada. David Cunningham is a musician. Andrew Wheatley is a Director of Cabinet. Jeremy Deller is an artist. Gilda Williams is a writer and was formerly a commissioning editor at Phaidon. Giorgio Sadotti is an artist. Alison Jacques is Director of Alison Jacques Gallery. John O'Reilly is a writer. Gareth Jones is an artist. Thomas Frangenberg is an art historian. Dean Hughes is an artist. Cornelia Grassi is Director of greengrassi. Simon Martin is an artist. Ingrid Swenson is Director of PEER and formerly the Curatorial Director of The Pier Trust. Matthew Higgs is an artist and curator.

The Lights Off

Barry Humphries

Martin Creed is faithful to the tradition of Melbourne Dada inaugurated by me over half a century ago. His latest work will surely be acclaimed as his masterpiece and art lovers will probably stampede to acquire it. The question on everyone's lips will be 'what next?' Perhaps a similar exhibit in a locked gallery or even in some other space not advertised to the public so that art lovers will be obliged to imagine not merely Mr Creed's latest concept but its very location, if anywhere. Thus the artist will achieve complete detachment not only from his creation but from his audience. Mr Creed may indeed choose to repudiate authorship of the work and pursue a profession so far removed from the world of art (such as tram driving) that the art loving public may begin to feel they *imagined* he was an artist, thus imparting a mythical quality to his seminal creation *The lights off* (Melbourne, 2005).

Barry Humphries is a successful character actor in Europe and Australia, whose most famous and enduring creation is Melbourne housewife Dame Edna Everage.

Somethings

Tess Jaray

Temporality, waiting, longing, desire. These may not be the subjects of Martin Creed's work, but they are part of its content. So, also, perhaps more clearly, is the joy in small things, the delight in intrusion, the celebration of overlooked banalities, the mischief in the unexpected obstruction, the irritation factor, and the sheer surprise and celebration of things, the spaces between them, and sometimes both together.

Nevertheless, his protestations, both clever and believable – 'they are just things', even set to music, as in his *I like things* – may be a touch disingenuous. There is nothing casual in these casual works. On the contrary, there is a fierce formality holding them together. His ability to *place* has nothing to do with an aesthetically pleasing *placement*, but with a precise revealing of the exact place for an exact thing.

The effect of the doorstop piece, or the handle that won't turn, is infuriating; *A large piece of furniture partially obstructing a door* (Work No. 142) must resonate universally. The disfigurement of an entire wall by a small extrusion reminds us of the power of the smallest blemish. In these pieces light is cast on the unexpected, the overlooked, the spaces in between. We are amused at our own discomfiture. But there is something quite other in the fixed wall pieces. Forever there, frustrated, alone, unable to escape their fate, pining for freedom. His piece – or rather his two in one piece – titled, somewhat prosaically, to prove his point – *An intrusion and a protrusion from a wall* (Work No. 21) – is fixed in eternal, frustrated desire on the walls of my living room, its positive and negative held in perfect, formalized equilibrium. In spite of his protestations 'they are just things', he has

charged and animated 'things' by some strange transfer of electricity into presences, sometimes utterly celebratory, sometimes benign, often baleful, animosity hidden under a veneer of charm and delight and good manners. Appearance is all, he seems to be saying: the act of disguise reminiscent of the Victorians covering their piano legs, a fabulist's believable paean to hypocrisy. His Work No. 850, a person running every thirty seconds through the Duveen Galleries at the Tate, is both an exquisite presentation of a body in motion, and an endless, repetitive chasing, an act of nihilistic frustration, never to catch anyone, never to reach catharsis. And the vomit pieces – as if in counter-point – *insisting* on catharsis; forcing it, spewing it out again and again, until it denies itself in the very act of performing.

There is great complexity here, wrapped in many coverings of apparent simplicity. There is real understanding of how scale may be manipulated to amuse, and thereby disarm. There is no 'spoofing', no 'conning of the public', as the tabloids would have us believe. (This is rarely the case with real artists.) Rather, Creed presents essay after essay in meaning in meaninglessness, and draws serious, focussed attention to the absurdity of our tiny and solipsistic concerns on this planet.

But, and it is a crucial but, turning nothing into something is surely the essential alchemy of art. And the works are not just *things*: they are *somethings*, and he makes them matter.

Tess Jaray is a painter living in London.

Forms of Attachment

Darian Leader

Many of Martin Creed's early works consisted of bell-like protrusions, spun or cast in brass, aluminium or plaster. These could be found fixed to the bar in a pub, to the walls of art galleries or private homes, or simply as freestanding objects. At first glance, they resemble salt-and-pepper shakers or draught taps. The larger plaster protrusions have fewer contours, bulging cheekily and mysteriously from walls and surfaces.

Creed explains the birth of these works from his experiences as a house painter. Painting people's houses meant continually removing artworks from walls, painting, then reinstating the works. Why, Creed wondered, couldn't one just make a work that could be painted over with a roller? And hence the plaster protrusions, which were designed as a part of the wall itself rather than something that could be fixed onto it.

These works exemplify the logic central to Creed's endeavours: to make work that isn't work and to reduce the structure of attachment to its bare minimum. Both of these threads are condensed in his well-known neon equation: 'The whole world + the work = the whole world.'[1] The work here seems to add nothing to the world and at the same time the '+' sign indicates both an addition and the most basic fact of an attachment, a join, a link. The metal and plaster protrusions are just that: pure additions that seem to have little purpose beyond adding something to the world.

In the same period that these protrusions were being made, Creed also began working with metal brackets and tape. 'The minimum a work needs to do is hang on a wall,' Creed observed, and so to access this minimal structure, one should focus precisely on the attachment, not the work. So Creed began to work with the materials of attachment: brackets, sticky tape, Blu-Tack and the other adhesives used to connect, mount and join. These were no longer invisible accessories to a more significant composition, but became the determining element in the composition itself. These forms of attachment became the stuff of Creed's works, as he explored the elementary space in which one thing was joined to another.

Creed was building a unique grammar. If many conventional artworks were like words, his works were the connectives and punctuation marks between them, the adhesives that made everything else possible. Work No. 96 (1994), indeed, is an instruction for design or typography: *Every 'and' set in bold type.* This minimal connective, Creed says, 'is the joining word', and his work has continually found new ways of depicting, questioning and revealing joins. Journalists

are often amazed by how, during a press conference, Creed manages to answer all questions with different intonations of the single word 'Aye', without realising that this is simply an extension of the artist's project: to exaggerate the minimal element, the feature that sticks, glues, connects and joins.

Units of construction and attachment are not a background prop here, but actually form what is being constructed and attached. In one work,[2] we can see tape or sticking plaster layered countless times over itself, and in another we see two synchronized videos of a boat docking in a harbour, replayed over and over again.[3] Both works are exploring how things meet, how they join, how they become attached. Even in Creed's sex film, in which we see a penis repeatedly entering a woman's body, the rhythm is entirely neutral and devoid of passion, as if the sexual act is reduced to its minimal logic, an intrusion then withdrawal: the simple binary of attachment.[4] As Creed says, the film is about a man and a woman 'coming together then coming apart'.

Creed is interested in what joins one thing to another, and the attachment works gave a new inflection to the earlier protrusion pieces. Surveying the hundreds of metal and plaster efflorescences, it is difficult not to think of the earliest form of attachment between two human beings – the nipple – or, perhaps more precisely, between a human being and an object – the dummy or pacifier. The bells, taps and shakers all share this simple structure, as if Creed were creating work that embodied this archaic minimal form of human attachment itself. What interests him, he says, is 'the point at which two things meet'.

This interest in reducing attachment to its minimum structure has a vital counterpoint in Creed's work. If the bond between two things is being reduced to its formal, minimal level, Creed is also constantly striving to undo attachment. Links and joins imply investments: emotional and libidinal. Yet when he makes an arrangement of cactuses or nails or metronomes or colours, he is resolute that they should all have equal status. Choosing a colour, for example, would privilege it, give it a special value. It would constitute, in other words, an investment. So Creed chooses all colours, making a work from each colour in a packet of pens or a palette of paints. The same goes for objects and musical notes: unable to choose one particular cactus or note, Creed juxtaposes all of them, creating miniature universes of objects.

In Work No. 105 (1994), for example, Creed couldn't decide which note to play on a piano, so produced a work in which all the notes are

played, with one second of sound followed by one second of silence. Each note, Creed says, is treated equally, not only in relation to the other notes but to silence itself. In Work No. 107: *Up and down* (1994), the notes go up and down the scale and then back again, but now played on drums and guitars. The aim once again is to write music that treats all notes equally, and one could cite Creed's decision to number as opposed to title his works as yet another example of this: 'All numbers', he says, 'are equal'. And so status is evenly distributed throughout the series of works.

This passion for equality works against a certain conception of art and its place in the world. Art, we are often told, is about making something special, separating it off from the rest of the world and giving it a new dignity and status. Museums and galleries then house these objects, reinforcing the sense of privilege and inequality. Yet the internal principle of Creed's work does exactly the opposite: it is committed, most of the time, to doing away with choice, to reducing privilege and to making things equal. This strange democracy has the effect of making audiences uneasy as they search for a hidden meaning or some exception in the array of monochrome felt-pen drawings, metronomes or sound pieces.

Creed's strategy not only contests the traditional aesthetics of uniqueness and privilege, but is at the same time a masterful resolution of the dilemma of choice. Social theorists remind us how today's society offers too much: whatever we may wish for, we have to choose between dozens of varieties – of food, of drink, of clothes, and even of electricity- or water-suppliers. This new freedom comes at a price, as we become paralysed with choice, spending even more time trying to decide what to choose. Similarly, one of the most common symptoms of modernity is obsession, where the subject remains caught in an interminable procrastination. Unable to make a choice, the obsessive ends up doing nothing, submerged in rituals of decision making.

One of Freud's patients worried that a stone he had knocked his foot against in the road might cause an accident when his loved-one's carriage travelled along it later that day. He put it by the side of the road, only to then worry that this was absurd and return to place it back in the middle of the road. The repetition of this obsessive ritual trapped him in a painful and fruitless economy of choice. In another example, a man waits for his beloved's phone call, yet worries that perhaps his phone isn't working. He lifts the receiver to check that the dial tone is indeed present, only to be tortured by the thought that perhaps she had tried to phone at that moment. He waits, then has to check the dial tone again …

Where modern psychiatry might prescribe a pill or a course in cognitive self-management, Creed offers an alternative solution: turn the inability to choose into the dynamic of creating work. Unable to choose which way the lines should run, the artist makes them go both ways, generating a series of crisscross works. Unable to decide which beat a drum machine should play, he has it play all available beats.

Unable to choose which paintbrush to use, he uses all available brushes. These pieces are both testimony and solution to indecision.

This strategy applies not only to the scope of materials but also to the location of the works themselves. Unable to choose between left and right, Creed is often meticulous in situating his work in the exact centre of a wall. 'It's a way', he says, 'of not having to decide'. Work No. 159 (1996–2001) consists of just the sentence 'something in the middle of a wall', as if the principle of equality had precedence over the object itself. It is as if the grammar of objects has overridden the question of semantics: the formal features of arrangement have become the very thing to be arranged.

This tension between choice and non-choice is echoed in an analogous tension in Creed's work between separation and non-separation. Creed explores, as we have seen, the forms of attachment, but these forms are themselves ambiguous. Attachment supposes that two things are separate but at the same time joins them. This is not an abstract intellectual puzzle, as anyone who has been in love knows. The wish for proximity or identity with one's object can bring with it not just the familiar anxiety of separation, but a real terror of immersion and of losing oneself. How can one make sense of this apparent paradox?

Creed takes this question very seriously. As he says, he aims to 'not have lines between things', but at the same time experiences 'an anxiety about making something totally separate from anything else'. Things must be separated and not separated. The plaster protrusions, for example, seem continuous with the surface from which they have emerged, with no visible break or cut. This is work that is not separate from the world, again illustrating Creed's formula 'the whole world + the work = the whole world'. 'If something is joined to the world seamlessly', he says, 'then there's no line between it and the world: it's all part of the same thing, not separable'.

And yet total non-separation is problematic. The tension here is brought out beautifully in Creed's shit and vomit films.[5] Shot crisply and with the highest production values, these short films depict a variety of characters shitting and vomiting on a white soundstage. They continue Creed's study of protrusions, this time focusing on the body, and show a material that is internal to the body becoming external. The very process by which something becomes separated is the subject of these works: shit and vomit embody the boundary or edge between what is separate and what is non-separate.

The paradoxical quality of this relation is brought out in what we could call Creed's signature 'set' theory. Where the set of metronomes is not itself a metronome, the set of sets is certainly also a set, and hence the question of whether it is in fact a member of itself. Isn't this the logic of 'the whole world + the work = the whole world'? What is added is already contained within the initial set, so work can be created while at the same time nothing is added. It is separated but at the same time contained.

This interest in set-theoretical problems is reflected in a work like the neon *THINGS*[6] – which both names what there is in the world and adds to it – and Work No. 228 (2000), in which all the sculpture in a collection of the Southampton City Art Gallery was placed by Creed in one room. One could see this as yet another example of the inability to decide – if you can't choose one, choose all – and of the artist's equality principle, but it is also the creation of a set, in much the same way that Creed has produced sets of balloons, of balls, of plants and of other miniature worlds. 'There's the thing you make', he says, 'and then everything else apart from that thing'.

Creating these sets adds to the world, yet since the artist is only using what's there, nothing is added. In a similar way, the works that involve filling a gallery space with balloons or folding the corner of an A4 piece of paper or scrunching paper into a ball are part of the same project. They add while not changing anything, and yet at the same time they obviously change something. It's the set-theoretical question of inclusion and containment. In a way, the shit and vomit films perpetuate this in the sense that they encompass – that is, include – the things that the body has excluded. Shit and vomit might be ejected and hence separated, but the work includes them back in again.

The same logic organizes Creed's on-off works, the most celebrated of which consisted of the lights going on and off at Tate Britain.[7] At one level, the work resolved the artist's inability to decide whether to have the light on or off: they now did both and simultaneously denied privilege to any one part of the room. At another level, he was aiming 'to make something without adding anything'. The room was left as it was and the oscillation of lights meant that, as Creed put it, 'there's no line between the work and the world here, between the work and everything in it. You can't say the work begin or ends here'. Other binary works such as Work No. 129: *A door opening and closing* (1995) illustrate the same principle, creating work without adding any new object to the world.

Binaries, for Creed, are the building blocks of any structure. Take what the artist calls 'the blobby world' and add a binary sequence such as on/off or black/white. Through this process, the world becomes minimally ordered, and this creation of a structure is, for Creed, also the basic dynamic in artistic creation. Introducing a binary creates what Creed calls a 'drawing'. Hence a work such as the runners sprinting through the Duveen Galleries at Tate Britain[8] should be seen as structurally akin to the lights going on and off. They incarnate the minimal presence of a viewer in a space – the runners are instructed to run as fast as they possibly can through a gallery – as well as the minimal presence of a work in a space. The runners are both us – the viewers – and the works themselves, in the sense of what we are there looking at. This logic suggests that the running piece is actually a drawing or painting, an idea that is not impeached by the experience of watching these odd figures dart through the halls on Millbank.

This question of addition is perhaps identical to that of separation and non-separation that is so central for Creed. Strange as it may seem, the parsimony of the lights going on and off at the Tate has a formal equivalence with the apparent excess of Creed's films of people shitting and vomiting. Both deal with what is added and potentially subtracted and separated, what is '+' and what isn't. To put it another way, Creed not only reduces certain experiences to their minimal, formal structure, but also explores the effect of structures and binaries on the world. This equivalence establishes a particular coherence to his work, one that follows the logic of the creation of sets that are always part of the initial set.

Creed's numbered work is now approaching the 1,000 mark. But curiously, there's no work number 1. If the work is always including itself, this might come as no surprise, but it is difficult not to accord that status to Work No. 143: *the whole world + the work = the whole world* (1996). Like a mathematical formula that gives the structure of some aspect of the physical world, Creed's equation offers the logic of a work without determining what the work will actually be. This coherence is almost mathematical in itself, creating works that are funny and beautiful and always totally serious.

Notes

1 Work No. 143.
2 Work Nos 67, 74, 77, 78, 81, 86.
3 Work Nos 405, 492, 494, 839.
4 Work No. 730.
5 Work Nos 503, 546, 547, 548, 583, 600, 660, 675, 837.
6 Work Nos 221, 231, 251, 260, 261, 285, 331, 845, 896.
7 Work Nos 127, 160, 227, 225, 276, 312.
8 Work No. 850.

Darian Leader is a psychoanalyst practising in London. His books include *Stealing the Mona Lisa: What Art Stops Us From Seeing* and *The New Black: Mourning, Melancholia and Depression*.

The Title + The Text =

John O'Reilly

How big is small? In Flann O'Brien's exotic world of *The Third Policeman* the character Sergeant McCruiskeen is an artist, a sculptor. He spent years making minute boxes like Russian dolls, each opening into another. Number twelve took three years to make. It was so small it took him another year to convince himself that he had made it. From number thirty onwards the boxes had become invisible.

Martin Creed is one such artist. His small is enormous. In comparison the minimalism of John Cage is baroque, flamboyant and gaudy. Tom Waits once sang 'the big print giveth, the small print taketh away'. Martin Creed works in the small print.

The immense rigour with which he avoids making aesthetic decisions in creating his pieces is reminiscent of the American artist Sol LeWitt, who wrote 'when an artist uses a conceptual form of art, it means that all of the planning and decisions are made beforehand and the execution is a perfunctory affair. The idea becomes the machine that makes the art … [the art] is purposeless.'[1] What, in the words of Sol LeWitt, is Martin Creed's idea?

Nothing.

How do you communicate nothing? How many different ways can you communicate nothing? For someone working with such limited data, he has tapped a rich vein of nothing. Work No. 81 for the Starkmann Building in London—nothing as interior design. Work No. 88 for a London Imprint series – nothing posted and sent through the mail. The titles themselves give nothing away. He has a handy formula of disappearance: the whole world + the work = the whole world

In this equation the work is both something and nothing. It adds and subtracts. Art degree zero. Consider the artist's instructions for Work No. 105:

'Audio cassette: recorded piece for Piano.

The ascending and descending chromatic scales played over the whole piano keyboard, each note being played for one second and being followed by a one second rest. Side A of the cassette contains the ascending scale, and Side B the descending.'

One admiring critic judged Martin Creed's work to be transcendentally pointless. In our accelerated culture of the *more* (the more real, the more true) the *extra*, the *hyper*, of information, this is Art in the pursuit of lessness. An ascetic art which yields a desert of meaning.

Perhaps it is what French philosopher Paul Virilio calls the art of disappearance. Martin Creed's seductive subtraction opens a window of opportunity. Creed is an artworld Houdini, whose work enables his audience to experience the magic of disappearance. It's a gift allowing us to wonder at the passing of time. The art's there? The art's gone? It is likely by the time he gets to Work No. 1050 the work itself will have completely disappeared.

Notes

1 *Artforum*, vol. 5, no. 10, Summer 1967, pp. 79–83

A version of this essay was first included as liner notes accompanying Work No. 117, a cassette published by Paolo Vitolo Gallery, Milan, in 1995.

John O'Reilly is an author, editor, copywriter and, in his spare time, a Doctor of Philosophy.

What Are You Looking At?

Colm Tóibín

Each night Malik was woken once or twice by a sound. It could be anything: the noise of a motorbike on the street below and then the noise fading into the distance, or one of the others who shared the room groaning in his sleep or saying a few words which made little sense, or someone talking or shouting below the window, or the men who came to hose down the streets or the truck which came to collect the garbage.

He lay there loving this time alone, time when he was still and warm, when no one could see him, and when anything, any thought at all, could come into his mind and he could let it linger and allow it to lead to another thought, or let it fade of its own accord as he decided or did not. And then he would easily fall back asleep and wake again in the afterglow of this easy time in the night when he controlled the world or the world controlled him, or both happened, as two figures might dance and then stop, or a door might open and then close, or lights go on and then off, or something might be itself in the same instant as it became its own shadow.

And then the morning broke in Barcelona and the eight of them in Malik's room, and the three in the room at the back, had to use the single bathroom. They never queued, and there was never a rule about who went first or who waited until the end. If someone was in a hurry or late, however, he could make that clear to the others and he would be let go next. No one ever stayed too long in the bathroom, just time enough to use the toilet and the shower and maybe shave and then dry off and come back and dress. Each of them slept in the underpants they wore during the day, and none of them ever removed their underpants in the presence of the others. They each carried a fresh pair of underpants with their towel into the bathroom and returned wearing that, with yesterday's underpants in a ball in their hand to be put in with the other clothes for the laundry.

Sometimes, in the morning as he waited for his turn for the bathroom, Malik thought about what was covered by the underpants and supposed it was hidden because it was private and unpredictable. He approved of the idea of keeping part of himself private. It was like how his mind wandered and amused itself, or conclusions he drew, or things he remembered. It was more important than anything for him that no one could ever know enough to blame him for what was going on in his mind. Once or twice, when he looked at one of the others – especially Nadeem who was the biggest of them all, the tallest, the hairiest, the one whose underpants almost did not cover his private parts – he would have been interested to know what was going on in their minds, what they really thought if they woke in the night, or when they were walking alone in the street.

Thoughts were strange, it occurred to him now as he went into the bathroom and looked in the mirror; thoughts could take you through a night and day and then another night, but they could be nothing to anyone else; then they could fade and inhabit a place for lost or dead or finished thoughts not even the size of a piece of paper rolled into a ball or the place where the tiniest amount of dead stale air lingered and then was blown away. If you added a thought to the world, it struck him, the result would be the world.

In the bathroom each of them was careful to lock the door; you waited until the sound came of the lock being pulled back if you were next, and then you moved towards the door; you never stood directly outside waiting. Once, when he came back in the evening, however, he found that Salim had not locked the door and he caught him sitting on the toilet bowl. It was just one or two seconds, but it was something Malik had not forgotten. Salim must have been shitting at that very moment he barged in and maybe the sudden opening of the door, the surprise and shock of it, might have caused the piece of shit to come quicker, harder. But whatever it was, Malik vividly remembered the look on Salim's face, the wince, the grimace, the wrinkled brow, the puzzled, almost rigid scowl with an edge of something approaching intense pleasure or physical satisfaction. A look so private it made that second and the image of Salim's face more memorable than all the other times he had seen Salim eating or laughing or walking around or talking or watching television.

In the mornings, before he started work at the Four Corners, even if just for five minutes, Malik liked to sit beside Super at the cash register of the supermarket down the street. If there was any news in the street, such as a new shop opening, or someone arriving or going home, or a price which had gone up, then Super would tell him and he would try to nod sagely and wisely as though he were experienced at considering the implications of such things.

And then he would spend the day making sure that the floor of the Four Corners was swept, that there were clean sheets to put over the customers who were having hair-cuts and clean towels for those being shaved, that there were not too many old magazines and newspapers on the bench where customers sat and waited, that the mirrors were clean and shiny and that he himself got in no one's way and didn't cause too much of a nuisance.

Some days were busy, others slack. There was usually a strange empty hour in the morning when there were no customers at all and they all had to watch out in case Baldy pounced on the place, insisting that there were no customers only because the barbers looked lazy or surly or completely incompetent. Baldy would demand that the barbers stand behind their chairs as though waiting for the arrival at that very moment of a customer. But mostly Baldy was too busy to pounce, too busy, they all said, selling mobile phones at the cheapest price, or at least no more expensive than the very cheapest.

Malik usually kept his eyes on the door and the window. Even when he

had to go to get towels or sheets or empty the tray of the freshly cut hair which he had swept up, he never stayed in the back room for too long in case he might miss something. Although he knew some of the people who passed because they were customers at the Four Corners or they came to buy groceries at the supermarket, he was careful never to greet them with anything more than a nod of recognition. He did not want to be seen not working even though he had nothing to do most of the time.

They had given up trying to teach him to cut hair; he was hopeless, they said. The fun of watching him make a mess of someone's hair and the pleasure of laughing at him as he grew more nervous and agitated had lost its initial charm. One or two of the barbers treated him now with blunt indifference or mild irritation and soon, even Super agreed, his utter uselessness would come to Baldy's attention and no one knew what might happen then.

There was one thing that took place every day that made them all excited. It never occurred at the same time so there was no point in looking out for it. A sprinter came down the street at a pace that Malik did not know anyone could manage. They all knew to rush to the window or open the door when they heard the shouting and excitement in the street which heralded the sprinter. Everyone moved out of the way for him to pass. Malik had often seen people jogging and, once, he and Super had watched a man being chased by the police, who could not really run as they had to make sure that their pistols did not fall out of the holsters.

But this was different, this was like something from television or the race track, this guy had to be a champion of some sort, or a professional. He moved with a fierce intensity and astonishing speed, and if you missed him you would have to wait until the following day.

Even Super, who had a theory about most things, could not understand why a sprinter would run down a busy street; he could be easily injured or knock someone over. Super agreed that the sprinter was brilliant, one of the best, and soon, he said, he expected that there would be something in the newspapers or on television, or someone would come into the supermarket and explain what the man was training for, or if it was a stunt, or who the man was, or if he lived nearby.

Although Super had warned Malik not to go too far beyond this street, to stay close to where there were other Pakistanis, he slowly worked out that it was safe to wander one block on each side. He moved carefully, often doubling back and stopping, noting the number of stores selling mobile phones, hoping not to bump into Baldy and ready to move into the shadows if he did. He wished he had a phone of his own because no one minded you standing on the street staring at them or their store as long as you were talking on a mobile phone. Malik wondered if some of the people he saw talking on their phones as they stood on the sidewalk had no actual person on the other end and they were just holding their phones to their ears and talking when possibly their phones had even run out of money or needed the battery re-charged. It was just an excuse to stare.

In one of the side streets there was an old carpenter's workshop where

the double doors were always open. They were usually busy inside and they did not seem to mind him looking. Perhaps, he thought, they did not even notice him. There was something in particular that he found himself staring at; he had no idea why it interested him so much. It was not something he could mention to anyone else, even to Super, but he found himself looking forward to it, just gazing at it for a minute, stopping as he passed on his way to the Four Corners or to the supermarket, or even on his break, or on his way home if the place was still open.

It was nothing really, just a pile of plywood, maybe a hundred sheets. It was hard to say because they were packed densely on top of each other. No one seemed to touch the pile, or maybe they did, but not enough to make any difference to the patterns down the side of the pile. He knew that he should be thinking about money, or worrying about Baldy, or even thinking about food or something Super said, or the customers who came for haircuts or shaves at the Four Corners, or even something on television, but he found the strange waves and edges of the plywood kept his mind busy as he stared at them, and even afterwards. It looked like something more than just a whole lot of sheets piled up, but not like a block of wood or anything exact. He did not know what it was like, and he knew that anyone he told would think he was a fool for saying that he loved looking at it, it was as simple as that, even though it reminded him of nothing. It was just itself.

On one of those days he must have lingered for too long in the side streets. When he arrived back at the Four Corners, Baldy was there.

Baldy came right up to him.

'What are you looking at?' Baldy asked him.

'I'm not looking at anything,' he said.

'Well, don't. Don't look at anything, you little maggot. Get on with your work! What do you do anyway?'

Malik did not reply.

'What do you do anyway?' Baldy repeated. 'I don't know why we have you here. We'll have to deal with you one of these days. Do you hear me?'

Malik did not reply.

Later, when he told Super what had happened, Super said that he thought it sounded serious. He would try and talk to Baldy, he said, but he was not sure what the result would be.

Malik concentrated on small things so that he would not worry too much about Baldy. He made sure as well that he did not linger in the streets any more in case Baldy spotted him. He found a piece of Blu-Tack, which he had kept in his pocket for a while, and then decided to mould it in his hand and roll it into a ball and stick it against the wall in the entrance hall to the apartment. Someone might see it, he thought, and wonder who had left it there. Or even better maybe, no one might really notice it, people passing might see it and glance for a second and it would not register as anything new or unusual or worth considering.

But it would be there, he thought, at least until someone removed it or it fell off, and then there would be nothing. For others maybe it

would be no big deal, or no deal at all, that it had ever been there, but for Malik now it would be something to consider if he woke in the night, or if he looked out of the window of the Four Corners with the sweeping brush in his hand.

He had made something; he had put something somewhere, something blue and sticky and easy to mould because it was soft. And it was there. It had been there for two days now. He loved looking at it as he passed.

One day Baldy came into the Four Corners looking for him.

'Where are you?' he asked.

'I am here,' he said.

'I know where you are,' Baldy replied.

Baldy went over and checked the ledger and the cash box.

'Super says you are intelligent,' Baldy said. 'But I have never seen any sign of it.'

If Baldy had called him stupid or lazy he would not have minded. Stupid would just be a term of abuse, and he might seem lazy because he usually had nothing much to do. But he did not want Baldy to say that he was not intelligent.

'I don't see the slightest sign of intelligence,' Baldy said as everyone in the Four Corners watched.

Malik moved closer to Baldy and looked at him steadily, evenly.

'I am intelligent,' he said.

'Can you count?'

'Yes.'

'How many pockets do you have?'

'In my trousers I have two at the front and two at the back.'

'Right. So I am going to give you phone cards to sell. You put the cards in your left pocket at the front and you put them nowhere else. And you put the money in the right pocket at the front. And these cards only work for mobile phones and they are the cheapest anyone will get. Five hours talking for ten euro.'

He handed Malik a bunch of phone cards. Malik immediately put them in the left-hand front pocket of his trousers.

'If I find you cheating, you won't have any trousers,' Baldy said. 'I'll use your trousers to wring your neck.'

Malik did not reply.

'Do you understand?'

Malik nodded.

'And be here every evening when I come, to give me the day's returns.'

Malik was going to ask how anyone would know he had the cards and what his own cut would be for selling them but he decided to say nothing.

Baldy left the Four Corners as though in a bad humour.

Nadeem came over and slapped Malik on the back.

'You're in business,' he said and smiled. One of the customers smiled as well.

Later when Malik went to the supermarket, Super said that he would

work out the terms with Baldy, but he thought that Malik would be on a percentage of the money he took in if the sale of the cards went over a certain figure. By the time he said this Malik had only sold two or three cards, and these to the actual barbers in the shop. One or two, he thought, might have even bought them because they felt sorry for him. But in the days that followed, people began to stop by the Four Corners asking for Malik, and by the end of a week he was able to inform Super that he had sold more than thirty phone cards at ten euro each.

'Did Baldy take all the money from you?' Super asked.

Malik nodded.

'I'll talk to him,' Super said.

A few days later as Baldy was collecting the money, he spoke to him as though he was angry.

'Keep an account of how many you sell every week. And you're on ten per cent. You get it every Friday.'

Malik understood that this was business so he knew it was important not to smile or say anything in reply. He nodded his head gruffly in a way he thought Baldy might appreciate.

It was clear to him then that even if the sales of the cards did not go very high, Baldy might realize that he was both intelligent and honest. And he had something more to do than sweep the floor and keep things clean and get sheets and towels. Men came looking for him by name, and a few women too, and they recognized him on the street and they saluted him if they saw him.

Sometimes when he woke in the night he no longer worried about the possibility of being sent home, or of being given even more menial work. He liked selling phone cards. And he lay in bed in the dark in the great strange city, his hands behind his head, and the thought came into his mind and he loved the thought and held it there for as long as he could. The thought came in words and he was tempted to whisper the words into the rank air of the room: everything is going to be alright.

On Fridays and Saturdays he usually went to the supermarket after the Four Corners had closed and sat listening to Super or helping him if he needed help or having some food with him. And then when the supermarket closed he walked alone home. Even as the summer came and there were more tourists, old Gomez, who had hair sprouting from his ears, and who came into the supermarket to buy milk, still closed his bar at midnight.

As Malik passed he watched Gomez stacking up the chairs in the bar so he could sweep the floor properly and then wash the floor. No two chairs in Gomez's bar were the same and, stacked on top of each other, they looked like a leaning tower of chairs. Some were old-fashioned in carved wood, others were made of steel; some looked almost cheeky and proud as they sat at the top of Gomez's pile, others seemed slouched and surly as they appeared to resent the other chairs that rested on them, sticking their sharp legs into the most vulnerable parts of the chairs below them.

The chairs were all different sizes as though Gomez had collected

them over years, chosen deliberately to match the various people who came into his bar. Malik wondered if they might all topple over some night but he knew that Gomez had been stacking them for years, and supposed the old man knew which chair should go at the bottom and which at the top as he swept the floor and then mopped it and then waited for the floor to dry before going home.

On one of those nights as he passed Gomez's bar he noticed three girls with blonde hair and red faces wearing high heels and short skirts walking along. The two on either side seemed to be holding up the girl in the middle who did not look happy. Suddenly, the girl in the middle began to vomit. A stream of mushy liquid, some of it yellow and green, came gushing violently out of her mouth even before she had time to put her head down or her hand to her mouth. Some of the vomit landed on her shoes and some on the street in front of her but some of it also rolled down her chin and then down her dress. Her friends held her, the expressions on their faces full of concern, as the girl almost doubled up now to vomit some thick watery stuff. Then she stood up straight and put her head back with her eyes closed as though she needed desperately to think about something other than what she had just done.

The girl and her friends were so wrapped up in what was happening that they did not seem to mind, or even notice, that people, including Malik, stood around observing the scene closely. When it seemed that the girl had finished and there was nothing more left in her to vomit, a sudden further jet of puke came out of her mouth as she let out a cry of nausea and pain and then she doubled up again as some further whitish fluid came in quick bursts out of her mouth. Her friends were busy now finding tissues as the girl herself stood up straight once more.

Her face was unprotected, Malik thought. It was as though nothing about her was private now. She could be seen as she really was, as she intimately was; there were no guards or screens between her and those who watched her. Malik believed he had probably seen her as no one who knew her had seen her unless they had seen her vomiting as well.

Now for a second as she seemed to be tasting the vomit in her own mouth and trying to swallow it, the girl tried to smile as her friends helped her to wipe the stuff from her dress and her shoes and neck and her hands. And then the three girls walked on. The vomit, Malik knew, would be cleaned away during the night when the street was hosed down and all sign of it would be gone in the morning as he passed here again on his way to the Four Corners.

He shook his head in wonder at the image of the vomit being hosed away, disappearing under the city. And then he let another image – sharper, unforgettable – of the girl herself who had done the vomiting come to play in his mind like a tree on a windy day might play with its shadow. And then he continued walking home.

Colm Tóibín is a novelist.

Biography

Martin Creed was born in 1968 in Wakefield, England, and was raised in Glasgow, Scotland. Between 1986 and 1990 he studied at the Slade School of Fine Art, London. After art school Creed lived and worked in London until 2001, when he moved to Alicudi, Italy. In 2001 he won the Turner Prize.

He currently lives and works in London and Alicudi.

Exhibition History

SOLO EXHIBITIONS AND PROJECTS

2010
Fruitmarket Gallery, Edinburgh, UK
Museo de Arte de Lima, Lima, Peru
'Things', The Common Guild, Glasgow, UK
Gavin Brown's enterprise, New York, USA

2009
Artsonje Center, Seoul, Republic of Korea
Hiroshima City Museum of Contemporary Art,
 Hiroshima, Japan
Hauser & Wirth Zurich, Zurich, Switzerland
Hiromi Yoshii Gallery, Tokyo, Japan
'Work No. 203', Tate Britain, London, UK
'Work No. 975', Scottish National Gallery
 of Modern Art, Edinburgh, UK

2008
Ikon Gallery, Birmingham, UK
Gavin Brown's enterprise, New York, USA
'Duveens Commission', Tate Britain, London, UK
Galleria Lorcan O'Neill, Rome, Italy

2007
The Douglas Hyde Gallery, Trinity College Dublin,
 Dublin, Ireland
Galleria Alberto Peola, Turin, Italy
'The Lights Going On and Off', Mills Gallery,
 Boston Center for the Arts, Boston, USA
'Small Things', 508 West 25th Street, New York, USA
Hauser & Wirth Coppermill, London, UK
'Feelings', Hessel Museum of Art and Center for
 Curatorial Studies, Bard College, Annandale-on-
 Hudson, NY, USA
'Dogs', Sorry, We're closed, Rue de la Régence, Brussels,
 Belgium
'Martin Creed's Variety Show', Abrons Arts Center,
 New York, USA

2006
'Martin Creed's Variety Show', Old Boy's Theatre,
 Christchurch, New Zealand

'Martin Creed's Variety Show', Tate Modern, London, UK
Michael Lett Gallery, Auckland, New Zealand
'Big Dogs', MC, Los Angeles, USA
The Wrong Gallery @ Tate Modern, London, UK
'Work No. 547', Johnen Galerie, Berlin, Germany
'I Like Things', Fondazione Nicola Trussardi, Milan, Italy
'The Lights Off', Haubrokshows, private apartment,
 Berlin, Germany
Hauser & Wirth Zurich, Zurich, Switzerland
'Sick Film', Curzon Mayfair, London, UK
'All the Bells in a City or Town Rung as Quickly and
 as Loudly as Possible for Three Minutes', San Juan,
 Puerto Rico

2005
Graves Art Gallery, Sheffield, UK
'Work No. 409', Ikon Gallery, Birmingham, UK
Van Abbemuseum, Eindhoven, the Netherlands
'Lachen', Kunst-Station Sankt Peter, Cologne, Germany
'The Lights Off', Australian Centre for Contemporary Art,
 Melbourne, Australia
Galerie Rüdiger Schöttle, Munich, Germany
'The Lights Going On and Off', Comptoir de Nylon,
 Brussels, Belgium
Gavin Brown's enterprise, New York, USA

2004
'Work No. 360', Johnen Galerie, Berlin, Germany
Hauser & Wirth London, London, UK
'Work No. 330', Galerie Emmanuel Perrotin, Paris, France
'the whole world + the work = the whole world', Centre for
 Contemporary Art, Ujazdowski Castle, Warsaw, Poland
'TWG @ CCA', Centre for Contemporary Art,
 Kitakyushu, Japan

2003
'Martin Creed', Kunsthalle Bern, Bern, Switzerland
'Beaucoup de Bruit pour Rien' (with Marylene Negro),
 FRAC Languedoc-Roussillon, Montpellier, France
'Work No. 300', Gavin Brown's enterprise, New York, USA
'Work No. 289', The British School at Rome, Rome, Italy
'Small Things', Galerie Analix Forever, Geneva,
 Switzerland

2002
'A Large Piece of Furniture Partially Obstructing a Door',
 Alberto Peola Arte Contemporanea, Turin, Italy
The Wrong Gallery, New York, USA

2001
'The Lights Off', Johnen & Schöttle, Cologne, Germany
Galerie Rüdiger Schöttle, Munich, Germany
 (with Anri Sala)
Hamilton Art Gallery, Hamilton, Canada
'Work No. 265', Micromuseum for Contemporary Art,
 Palermo, Italy

2000
'Martin Creed Works', Camden Arts Centre, London, UK
'Work No. 252', Kunst-Station Sankt Peter, Cologne,
 Germany
'Arte all'Arte', Arte Continua, San Gimignano, Italy
'Art Now: Martin Creed', Tate Britain, London, UK
'The Lights Going On and Off', Gavin Brown's

enterprise, New York, USA
'Work No. 225', Times Square, New York, USA
 (Project of the Public Art Fund)
'Martin Creed Works', Southampton City Art Gallery,
 Southampton, UK (travelled to Leeds City Art Gallery,
 Leeds, UK, Bluecoat Gallery, Liverpool, UK, and
 Camden Arts Centre, London, UK)
'Work No. 232: the whole world + the work = the whole
 world', Tate Britain, London, UK

1999
Marc Foxx Gallery, Los Angeles, USA
Art Metropole, Toronto, Canada
Galerie Praz-Delavallade, Paris, France
Cabinet Gallery, London, UK
'Work No. 203', The Portico, London, UK
'Work No. 160', Space 1999, London, UK
Alberto Peola Arte Contemporanea, Turin, Italy

1998
Galerie Analix B & L Polla, Geneva, Switzerland

1997
Galleria Paolo Vitolo, Milan, Italy
Victoria Miro Gallery, London, UK
The British School at Rome, Rome, Italy

1995
Galerie Analix B & L Polla, Geneva, Switzerland
Galleria Paolo Vitolo, Milan, Italy
Camden Arts Centre, London, UK
Javier Lopez Gallery, London, UK

1994
Cubitt Gallery, London, UK
Marc Jancou Gallery, London, UK

1993
'Work No. 78', Starkmann Limited, London, UK

SELECTED GROUP EXHIBITIONS

2010
Heidelberger Kunstverein, Heidelberg, Germany
'Auto-Kino!', Temporäre Kunsthalle Berlin, Berlin,
 Germany
'Party!', The New Art Gallery Walsall, Walsall, UK

2009
'Pourquoi Attendre! Une exposition autour du Fonds
 André Iten', Centre d'art contemporain, Geneva,
 Switzerland
'Tonite', The Modern Institute, Glasgow, UK
'A House is not a Home', La Calmeleterie
 (private residence), Nazelles-Négron, France
'Compass in Hand: Selections from the Judith Rothschild
 Collection', Museum of Modern Art, New York, USA
'Passages through Sicily', Palazzo Riso, Palermo, Italy
'Classified: Contemporary Art at Tate Britain',
 Tate Britain, London, UK
'Passports: Great Early Buys from the British Council

Collection', Whitechapel Gallery, London, UK
'Paper: Pressed, Stained, Slashed, Folded', The Museum
 of Modern Art, New York, USA
'English Lounge', Tang Contemporary Art Centre,
 Beijing, China
'London Calling', The Total Museum of Contemporary
 Art, Seoul, Republic of Korea
'Kaleidoscopic Revolver', Hanjiyun Contemporary Space,
 Beijing, China
'N'importe quoi', Musée d'art contemporain de Lyon,
 Lyon, France
'All That Is Solid Melts Into Air', Museum van
 Hedendaagse Kunst, Antwerp, Belgium
'In A Room Anything Can Happen', Center for Curatorial
 Studies, Bard College, Annandale-on-Hudson,
 NY, USA
'Work No. 245', Centre Pompidou-Metz, Metz, France

2008
'Contact', 79a Brick Lane, London, UK
'21:100:100', Gertrude Contemporary Art Space, Fitzroy,
 Australia
'The ICA Auction', Institute of Contemporary Arts,
 London, UK
'Peintures, entre autres', Analix Forever, Geneva,
 Switzerland
'Platform Seoul', Sun Contemporary, Seoul, Republic
 of Korea
'History in the Making: A Retrospective of the Turner
 Prize', Mori Art Museum, Tokyo, Japan
'...same as it ever was', The Arts Gallery, University of the
 Arts London, London, UK
'Standard Sizes', Andrew Kreps, New York, USA
'Delusive Orders', Museum Sztuki, Lodz, Poland
'So ist es und anders', Museum Abteiberg,
 Mönchengladbach, Germany
'This is Not A Void', Galeria Luisa Strina, Sao Paulo,
 Brazil
'Sphères', Le Moulin, Boissy-Le-Châtel, France
'No Leftovers', Kunsthalle Bern, Bern, Switzerland
'Geo/Metric: Prints and Drawings from the Collection',
 Museum of Modern Art, New York, USA

2007
'Presque Rien I', Laure Genillard, London, UK
'4' 33"', Magazin4 – Bregenzer Kunstverein, Bregenz,
 Austria
'Silence: Listen to the Show', Fondazione Sandretto
 Re Rebaudengo, Turin, Italy
'Mouth Open, Teeth Showing: Major Works from the True
 Collection', Henry Art Gallery, University of
 Washington, Seattle, USA
'Lines, Grids, Stains, Words', Museum of Modern Art,
 New York, USA
'The Lath Picture Show', Friedrich Petzel Gallery,
 New York, USA
'Deaf 2: From the Audible to the Visible', Galerie Frank
 Elbaz, Paris, France
'Words Fail Me', Museum of Contemporary Art Detroit,
 Detroit, USA
'The Future of Futurism', Galleria d'Arte Moderna e
 Contemporanea, Bergamo, Italy
'The Turner Prize: A Retrospective', Tate Britain,
 London, UK

'Ensemble', ICA Philadelphia, Philadelphia, USA
'Insubstantial Pageant Faded', Western Bridge Gallery,
 Seattle, USA
'Shallow', I-20 Gallery, New York, USA
'Love Chief', Auckland Art Gallery, Auckland,
 New Zealand
'How to Improve the World', Gas Hall, Birmingham, UK
'Hot for Teacher', Nog Gallery, London, UK
'The Invisible Show', Centro Jose Guerrero, Granada,
 Spain
'Quality Street', Art Frankfurt, Frankfurt, Germany
'Disforie 007', Palafukas, Turin, Italy
'Critical Mass', Kunsthalle Bern, Bern, Switzerland
'Half Square, Half Crazy', Villa Arson, Nice, France
'Maximinimalist', Inova, Peck School of the Arts,
 Milwaukee, WI, USA

2006

'Martin Creed, Vincent Lamouroux, Christian Robert-
 Tissot', Le Spot, Le Havre, France
'Out of Time: Contemporary Art from the Collection',
 Museum of Modern Art, New York, USA
Mexico Arte Contemporaneo, Mexico City, Mexico
'Galerie Patrick Seguin invites Hauser & Wirth', Galerie
 Patrick Seguin, Paris, France
'Off the Wall', Scottish National Gallery of Modern Art,
 Edinburgh, UK
'Into Me/Out of Me', P. S. 1/MoMA, Long Island City,
 NY, USA (travelled to KW Institute for Contemporary
 Art, Berlin, Germany and MARCO, Rome, Italy)
'Strange, I've Seen that Face Before', Städtisches Museum
 Abteiberg, Mönchengladbach, Germany
'I (Ich) Performative Ontology', Secession, Vienna, Austria
'Wrestle', Hessel Museum of Art and Center for Curatorial
 Studies, Bard College, Annandale-on-Hudson, NY, USA
'I. Act Two', Wiener Secession, Vienna, Austria
'The Invisible Show: Audio Works from the 20th Century',
 MARCO Museum of Contemporary Art Vigo, Vigo,
 Spain (travelled to Centro José Guerrero, Granada, Spain)
'Word', Deborah Colton Gallery, Houston, TX, USA
'Concrete Language', Contemporary Art Gallery,
 Vancouver, Canada
'How to Improve the World', Hayward Gallery, London, UK
'SCAPE 2006 Biennial of Art in Public Space',
 Christchurch Art Gallery, Christchurch, New Zealand
'Out of Place', The New Art Gallery Walsall, Walsall, UK
'Surprise, Surprise', Institute of Contemporary Arts,
 London, UK
'Coincidence', Gallery Vianuova Art Contemporanea,
 Florence, Italy
'Nichts', Schirn Kunsthalle, Frankfurt, Germany
'I: Act One', Futura, Prague, Czech Republic
'Yes Bruce Nauman', Zwirner & Wirth, New York, USA
'Other Rooms, Other Voices: Contemporary Art from the
 FRAC Collections', The Israel Museum, Jerusalem, Israel
'Collection Rehang', Tate Modern, London, UK
Public Art Project, Art Basel, Basel, Switzerland
'Of Mice and Men', 4th Berlin Biennial for Contemporary
 Art, Berlin, Germany
'Disposition', Lukas Feichtner Galerie, Vienna, Austria
'Good Vibrations', Palazzo delle Papesse, Sienna, Italy
'Free Play', Hå gamle prestegard, Stavanger, Norway
'Reality, Odense 10'55', Kunsthallen Brandts, Odense,
 Denmark

'Big Bang: Destruction and Creation in 20th Century Art',
 Centre Georges Pompidou, Paris, France
'Haubrokshows: Sounds of Silence', Galerie Gisela
 Capitain, Berlin, Germany
'Infinity Etc.', Mercer Union, Toronto, Canada
'The Sublime is Now! Das Erhabene in der
 Zeitgenössischen Kunst', Museum Franz Gertsch,
 Burgdorf, Switzerland
'Draw a Straight Line and Follow It', Center for Curatorial
 Studies, Bard College, New York, USA
'As If By Magic', Bethlehem Peace Center, Bethlehem,
 Palestine
'The Summer Show', The Royal Academy, London, UK
'Art and Buildings', The New Art Gallery Walsall, Walsall,
 UK
'Crème Anglaise', Lieu d'Art et d'Action contemporaine,
 Dunkirk, France

2005

'Ambiance – Des Deux Côtes du Rhin', K20
 Kunstsammlung, Düsseldorf, Germany
'Narrow Focus', Tranzit, Bratislava, Slovakia
'Joy', Casino Luxembourg Forum d'Art Contemporain,
 Luxembourg
'L'humanité mise à nu et l'art en frac, même', Casino
 Luxembourg Forum d'Art Contemporain, Luxembourg
'Light Art from Artificial Light', ZKM Zentrum für
 Kunst und Medientechnologie, Karlsruhe, Germany
'The Art of White', The Lowry, Salford, UK
'Encore', Büyük Londra Oteli, Istanbul, Turkey
'Extra Ordinary', Kulturhuset, Stockholm, Sweden
'General Ideas: Rethinking Conceptual Art 1987–2005',
 CCA Wattis Institute for Contemporary Arts,
 San Francisco, USA
'Remagine: Oeuvres du Fonds National d'Art
 Contemporain', Musée d'Art Contemporain, Lyon,
 France
'Fragile', Galerie Analix Forever, Geneva, Switzerland
'Expérience de la Durée', Biennale d'Art Contemporain
 de Lyon, Lyon, France
'Drunk vs. Stoned 2', Gavin Brown's enterprise, New York,
 USA
'Narrow Focus', Tranzit, Bratislava, Slovakia
Printemps de Septembre, Toulouse, France
'Monuments for the USA', White Columns, CCA Wattis
 Institute for Contemporary Arts, San Francisco, USA
'Size Matters: Exploring Scale in the Arts Council
 Collection', Yorkshire Sculpture Park/Longside
 Gallery, Wakefield, UK
'Feeling Strangely Fine', Galeria Estrany – de la Mota,
 Barcelona, Spain
'Angekommen – Die Sammlung im eigenen Haus',
 Kunstmuseum Stuttgart, Stuttgart, Germany
'Popisme: Episode IV', Ecole des Beaux-Arts, Tours, France

2004

'Sur la Terre Comme au Ciel', Espace Paul Riquet,
 Béziers, France
'Art News', Three Colts Gallery, London, UK
'None of the Above', Swiss Institute, New York, USA
'From Moore to Hirst: Sixty Years of British Sculpture',
 National Museum of Art, Bucharest, Romania
'Challenge', Synagogue – Centre of Contemporary Art,
 Trnava, Slovakia

'Il vento ci porterà via', Associazione Culturale Pneuma, Castel San Pietro Terme, Italy
'Nothingness', Galerie Eugen Lendel, Graz, Austria
'Live', Palais de Tokyo, Paris, France
'Strategies of Desire', Kunsthaus Baselland, Muttenz/Basel, Switzerland
'State of Play', Serpentine Gallery, London, UK
'Russian Doll', MOT, London, UK
'Art & Architettura, 1900–2000', Museo d'Arte Contemporanea di Villa Croce, Genoa, Italy
'Live', Palais de Tokyo, Paris, France
'Artists' Favourites: Act I', Institute of Contemporary Arts, London, UK
'Artists' Favourites: Act II', Institute of Contemporary Arts, London, UK
'Bad Behaviour: from the Arts Council Collection', Longside Gallery, Yorkshire, UK
'Genesis Sculpture, Experience Pommery #1', Domaine Pommery, Reims, France
'Café in Mito', Art Tower Mito, Mito, Japan
'Optimo: Manifestations of Optimism in Contemporary Art', Ballroom Marfa, Marfa, TX, USA

2003
'Adorno', Kunstverein Frankfurt, Frankfurt, Germany
'Skulptur 03', Galerie Thaddaeus Ropac, Salzburg, Austria
'Soundsystem', Kunstverein Salzburg, Salzburg, Austria
'Shine', Museum Boijmans van Beuningen, Rotterdam, the Netherlands
'Bodzianowski–Boyce–Bujnowski–Creed–Elsner–Hablützel–Höfer–Lulic–Ruff–Sasnal', Galerie Johnen & Schöttle, Cologne, Germany
'Thatcher', The Blue Gallery, London, UK

2002
'Boyce–Creed–Sala–Sasnal', Galerie Johnen & Schöttle, Cologne, Germany
'The Young and the Hung', Galerie Thaddaeus Ropac, Salzburg, Austria
'No Return', Collection Haubrok, Mönchengladbach, Germany
'Rock my World: Recent Art and the Memory of Rock'n'Roll', CCA Wattis Institute for Contemporary Arts, San Francisco, USA
'Strike', Wolverhampton Art Gallery, Wolverhampton, UK
'On/Off', Vistamare Associazione Culturale, Pescara, Italy
'My Head is on Fire but my Heart is Full of Love', Charlottenborg, Copenhagen, Denmark
'Tempo', Museum of Modern Art, New York, USA
'To Actuality', AR/GE Kunst Galerie Museum, Bozen, Italy
'Through a Sequence of Space', Galerie Nordenhake, Berlin, Germany

2001
'Turner Prize 2001', Tate Britain, London, UK
'Space-Jack!', Yokohama Museum, Yokohama, Japan
'White Light/White Noise', Mexico City, Mexico
'Art/Music: Rock, Pop, Techno', Museum of Contemporary Art, Sydney, Australia
'Makeshift', Brighton University Art Gallery, Brighton, UK
'Nothing in the Main Hall', Rooseum Center for Contemporary Art, Malmö, Sweden
'Nothing', Contemporary Art Centre, Vilnius, Lithuania

'Works on Paper from Acconci to Zittel', Victoria Miro Gallery, London, UK
'Under Pressure', Swiss Institute, New York, USA (travelled to Museum of Contemporary Art, Tucson, AZ, USA)
'Hotel Sub Rosa', Cabinet Gallery, London, UK
'Rooseum Provisorium', Rooseum Center for Contemporary Art, Malmö, Sweden

2000
'Protest and Survive', Whitechapel Art Gallery, London, UK
'A casa di... ', Fondazione Pistoletto, Biella, Italy
'Intelligence: New British Art 2000', Tate Britain, London, UK
'...Sabotage...', Shed im Eisenwerk, Frauenfeld, Switzerland
'Collector's Coice', Exit Art, New York, USA
'The British Art Show 5', Edinburgh, UK
'Don't Worry', Chelsea & Westminster Hospital, London, UK
'The Invisible Touch', Kunstraum Innsbruck, Innsbruck, Austria
'Proper (Vilnius Date)', Contemporary Art Centre, Vilnius, Lithuania
'Perfidy: Surviving Modernism', Kettle's Yard, Cambridge, UK (travelled to La Tourette, Eveux-sur-Arbresle, France)

1999
'Limit Less: Aktuelle Britische Kunst', Galerie Krinzinger, Vienna, Austria
'54 x 54 x 54', Museum of Contemporary Art, London, UK
'Porcupines/Arthinking', 291 Gallery, London, UK
'Searchlight: Consciousness at the Millennium', California College of Arts and Crafts, San Francisco, USA
'Getting the Corners', Or Gallery, Vancouver, Canada
'Nerve', Institute of Contemporary Arts, London, UK
Anthony Wilkinson Gallery, London, UK
'Serendipity', Poëziezomers Watou, Watou, Belgium
'Ainsi de suite 3 (deuxième partie)', Centre regional d'art contemporain, Sète, France
'Dimensions Variable – Contemporary British Art', Contemporary Art Centre, Vilnius, Lithuania

1998
'Lovecraft', Spacex Gallery, Exeter, UK (travelled to South London Gallery, UK)
'Not Today', Gavin Brown's enterprise, New York, USA
'Imitating Christmas', Wiensowski & Harbord, Berlin, Germany
'Every Day', 11th Biennale of Sydney, Sydney, Australia
'Proper: Blind Date 1', Titanik, Turku, Finland
'Speed', Whitechapel Art Gallery, London, UK
'Crossings: Kunst zum Hören und Sehen', Kunsthalle, Vienna, Austria
'Camouflage 2000', Galerie Praz-Delavallade, Paris, France
'Sunday', Cabinet Gallery, London, UK
'An Idea of Art/Art and Life', Galleria Paolo Vitolo, Milan, Italy
Delfina, London, UK
'Not Nothing', Todd Gallery, London, UK

1997

'Dimensions Variable – Contemporary British Art',
Helsinki City Art Museum, Helsinki, Finland (travelled
to Stockholm, Sweden and Contemporary Art Centre,
Vilnius, Lithuania)

'Laure Genillard – Une selection et une collection', Galerie
de l'Ancien College, Chatellerault, France

'Lovecraft', Centre for Contemporary Arts, Glasgow, UK

Cairn Gallery, Nailsworth, Gloucestershire, UK

'Thoughts', City Racing, London, UK

'Supastore de Luxe No.1', Up & Co., New York, USA

'Answer Affirmative or Negative', Art Metropole, Toronto,
Canada

Galerie Mot & Van den Boogaard, Brussels, Belgium

'Snowflakes Falling on the International Dateline',
CASCO, Utrecht, the Netherlands

'Imprint 93 (and other related ephemera)', Norwich
Gallery, Norwich, UK

1996

'Life/Live', Musee d'Art Moderne, Paris, France

'Against', Anthony d'Offay Gallery, London, UK

'The Speed of Light, The Speed of Sound', Design
Institute, Amsterdam, the Netherlands

'Ace!', Arts Council Collection, Hayward Gallery, London,
UK

'A Century of Sculptors' Drawings', Karsten Schubert,
London, UK

'East International', Sainsbury Centre for Visual Arts,
Norwich, UK

'Trace 1995–96', Galleria Paolo Vitolo, Milan, Italy

'Weil Morgen', Eisfabrik, Hannover, Germany

'Affinata', Castello di Rivara, Turin, Italy

'Try', Royal College of Art, London, UK

'Kiss This', Focal Point Gallery, Southend-on-Sea, UK

'Some Drawings: From London', The Rooms, London,
UK

'A4 Favours', Three Month Gallery, Liverpool, UK

'Banana Republic', Bund, London, UK

1995

'Just Do It', Cubitt Gallery, London, UK

Laure Genillard Gallery, London, UK

'Imprint 93/City Racing', City Racing, London, UK

'Zombie Golf', Bank, London, UK

'Unpop', Anthony Wilkinson Fine Art, London, UK

'The Fall of Man', Three Rooms and a Kitchen, Pori,
Finland

'In Search of the Miraculous', Starkmann Limited,
London, UK

'Fuori Fase', Viafarini, Milan, Italy

'Multiple Choice', Jibby Beane, London, UK

'Snow Job', Forde, Geneva, Switzerland

'My Darling Cicciolina...', Last order(s), London, UK

1994

'Conceptual Living', Rhizome, Amsterdam,
the Netherlands

'The Little House on the Prairie', Marc Jancou Gallery,
London, UK

'Modern Art', Transmission Gallery, Glasgow, UK

'Imprint 93/Cabinet Gallery', Cabinet Gallery, London,
UK

'Domestic Violence', Gio' Marconi, Milan, Italy

'Art Unlimited: Multiples of the 1960s and 1990s', CCA,
Glasgow, UK, (travelled to Todd Gallery, London, UK)

'Sarah Staton's Supastore Boutique', Laure Genillard
Gallery, London, UK

'Potato', IAS, London, UK

1993

'Wonderful Life', Lisson Gallery, London, UK

1992

'Inside a Microcosm', Laure Genillard Gallery, London,
UK

'Outta Here', Transmission Gallery, Glasgow, UK

Angel Row Gallery, Nottingham, UK

1991

Laure Genillard Gallery, London, UK

Angel Row Gallery Touring Show, Nottingham, UK

1989

The Black Bull, London, UK

Public Collections

Arts Council Collection, London, UK

British Council Collection, London, UK

Collezione La Gaia, Busca, Italy

Contemporary Art Society, London, UK

FNAC Fonds national d'art contemporain, Puteaux,
France

FRAC Languedoc-Roussillon, Montpellier, France

FRAC Nord Pas-de-Calais, Dunkirk, France

Galleria d'Arte Moderna e Contemporanea, Turin, Italy

Kunsthalle Bern, Bern, Switzerland

Kunstmuseum Stuttgart, Stuttgart, Germany

Musée d'Art moderne et contemporain Strasbourg,
Strasbourg, France

Museum Abteiberg, Mönchengladbach, Germany

Museum Kurhaus Kleve/Ewald Mataré Sammlung,
Kleve, Germany

Scottish National Gallery of Modern Art, Edinburgh, UK

Southampton City Art Gallery, Southampton, UK

Tate Collection, London, UK

The Government Art Collection, London, UK

The Museum of Modern Art, New York, USA

The New Art Gallery Walsall, Walsall, UK

Centre for Contemporary Art, Ujazdowski Castle,
Warsaw, Poland

Van Abbemuseum, Eindhoven, the Netherlands

Victoria & Albert Museum, London, UK

Selected Bibliography

PUBLICATIONS

2009

Hiroshima City Museum of Contemporary Art, *Martin Creed*, Hiroshima: Hiroshima City Museum of Contemporary Art (exh. cat.)

Omori, Toshikatsu (ed.), *Basic Action*, Tokyo: Hiromi Yoshii Gallery (exh. cat.)

2008

Guglielmino, Giorgio (ed.), *How to Look at Contemporary Art (...and Like It)*, London: Umberto Allemandi, pp. 253–255, ill.

Holzwarth, Hans Werner (ed.), *Art Now, Vol. 3*, Cologne: Taschen, pp. 101–103, ill.

Ikon Gallery, *Martin Creed*, Birmingham: Ikon Gallery (exh. cat.). Published to accompany an exhibition held at Ikon Gallery, Birmingham, 24 September–16 November 2008; Hiroshima City Museum of Contemporary Art, Japan, 23 May–20 July 2009 and Artsonje, Seoul, South Korea, 12 November 2009–12 February 2010.

Mori Art Museum, *History in the Making: A Retrospective of the Turner Prize*, Tokyo: Mori Art Museum, pp. 40–41, 106, 108, ill.

Tate Britain, *Martin Creed. Work No. 850. 2008*, London: Tate Publishing (exh. brochure), ill.

2007

Biesenbach, Klaus (ed.), *Into Me / Out of Me*, Ostfildern: Hatje Cantz (exh. cat.), pp. 177–179, ill.

Montagu, Jemima (ed.), *Open Space: Art in the Public Realm in London 1995–2005*, London: Arts Council England, pp. 36–39

2006

Bjørheim, Jan Kjetil, *Free Play*, Prestegard, Norway: Hå gamle prestegard (exh. cat.), ill.

Burkard, Lene and Liv Camilla Skjodt (eds), *Reality, 10'55 Odense*, Odense, Denmark: Kunsthallen Brandts (exh. brochure), pp. 24–25, ill.

Casino Luxembourg – Forum d'art contemporain, *joy*, Luxembourg: Édition Casino Luxembourg (exh. cat), pp. 24–25, ill.

Cattelan, Maurizio, Massimiliano Gioni and Ali Subotnick (eds), *Of Mice and Men: 4th Berlin Biennial for Contemporary Art*, Ostfildern: Hatje Cantz (exh. cat.), pp. 142–143, ill.

Eccles, Tom (ed.), *Wrestle. Marieluise Hessel Collection*, Annandale-on-Hudson, NY: Bard Center for Curatorial Studies (exh. cat.), pp. 24–25

Kania, Elke and Reinhard Spieler (eds), *The Sublime is Now! Das Erhabene in der zeitgenössischen Kunst*, Berne: Benteli (exh. cat.), p. 80

Sardo, Delfim (curator), *The Invisible Show*, Vigo, Spain: Museo de Arte Contemporanea de Vigo (exh. cat.), p. 97

British Council Switzerland, *Talking Art*, Berne: British Council Switzerland (brochure)

Städtisches Museum Abteiberg, *Strange, I've Seen that Face Before: Objekt, Gestalt, Phantom*, Mönchengladbach/ Cologne: Städtisches Museum Abteiberg /Dumont (exh. cat.), p. 63, ill.

2005

Ackermann, Marion (ed.), *Kunstmuseum Stuttgart*, Ostfildern: Hatje Cantz, pp. 288–289, ill.

Adams, Clive and Edwin Bowes (eds), *The Art of White: Painting, Photography, Installation*, Salford, UK: Lowry Press (exh. cat.), p. 90

Arts Council England, *Size Matters: Exploring Scale in the Arts Council Collection*, London: Hayward Gallery (exh. cat.), p. 30

Australian Centre for Contemporary Art, *The Lights Off*, Melbourne: Australian Centre for Contemporary Art (exh. cat.)

Biennale d'Art Contemporain de Lyon 2005, *Expérience de la durée*, Paris: Paris musées (exh. cat.), pp. 106–109, ill.

D'Ailly, Stella, Lisa Olausson and Maya Sten, *Extra Ordinary*, Stockholm: Printfabriken (exh. cat.), pp. 50–51, ill.

Galerija Gregor Podnar, *Nothingness*, Frankfurt: Revolver (exh. cat.), pp. 38–39, ill.

'Martin Creed', in: *Art Unlimited*, Basel: MCH Messe Schweiz, pp. 58–59, ill.

Rugoff, Ralph (curator), *Monuments for the USA*, San Francisco: CCA Wattis Institute for Contemporary Arts (exh. cat.)

2004

Brüggemann, Stefan (ed.), *Capitalism and Schizophrenia*, Nashville: Turner (exh. cat.)

Centre for Contemporary Art Ujazdowski Castle, *Martin Creed: the whole world + the work = the whole world*, Warsaw: Centre for Contemporary Art Ujazdowski Castle (exh. cat.)

Domaine Pommery, *Genesis Sculpture, Experience Pommery #1*, Reims: Domaine Pommery (exh. cat.)

Eccles, Tom (ed.), *Plop: Recent Projects of the Public Art Fund*, London: Merrell

Institute of Contemporary Arts, London, *Artists' Favourites: Act I & II*, Frankfurt: Revolver (exh. cat.), pp. 8–9

Kunsthalle Bern, *Martin Creed*, Berne: Kunsthalle Bern (exh. cat.)

Palais de Tokyo, *Live*, Paris: Palais de Tokyo (exh. cat.)

Serpentine Gallery, *State of Play*, London: Serpentine Gallery (exh. cat.), pp. 16–19, ill.

2003

Longside Gallery, *Bad Behaviour: From the Arts Council Collection*, London: Hayward Gallery (exh. cat.), pp. 56–57, ill.

Museum Boijmans Van Beuningen, *Shine: Wishful Fantasies and Visions of the Future in Contemporary Art*, Rotterdam: Museum Boijmans Van Beuningen (exh. cat.)

2002

Bradley, Will, Henriette Bretton-Meyer and Toby Webster, *My Head is on Fire but my Heart is Full of Love*, Copenhagen/Glasgow: Charlottenborg Udstillingsbygning/The Modern Institute (exh. cat.)

CCA Wattis Institute for Contemporary Arts, *Rock My World: Recent Art and the Memory of Rock 'n' Roll*, San Francisco: CCA Wattis Institute for Contemporary Arts (exh. cat.)

Herkenhoff, Paolo, Roxana Marcoci and Miriam Basilio, *Tempo*, New York: The Museum of Modern Art (exh. cat.)

Sammlung Haubrok, *No Return*, Mönchengladbach, Germany: Sammlung Haubrok (exh. cat.)

2001

Kamiya, Yukie (curator), *Space-Jack!*, Yokohama, JP: Yokohama Museum of Art (exh. cat.)

Pinto, Roberto and Gilda Williams (eds), *Arte All'Arte – V edizione 2000*, Rome/San Gimignano: Gli Ori/Arte Continua (exh. cat.)

2000

Button, Virginia and Charles Esche (eds), *Intelligence: New British Art 2000*, London: Tate Publishing (exh. cat.), pp. 49–51, ill.

Chelsea & Westminster Hospital, *DON'T WORRY*, London: Chelsea & Westminster Hospital (exh. cat.)

Shed im Eisenwerk, *...sabotage...* , Frauenfeld, Switzerland: Shed im Eisenwerk (exh. cat.)

Southampton City Art Gallery, *Martin Creed Works*, Southampton: Southampton City Art Gallery (exh. cat.)

Whitechapel Art Gallery, *Protest And Survive*, London: Whitechapel Art Gallery (exh. cat.)

1999

Collings, Matthew (ed.), *This is Modern Art*, London: Weidenfeld & Nicolson

Di Pietrantonio, Giacinto and Gwy Mandelinck, *Serendipity*, Watou, Belgium: Poëziezomers

Patrizio, Andrew (ed.), *Contemporary Sculpture in Scotland*, St. Petersburg, FL: Craftsman House (exh. cat.)

Rindler, Lawrence (ed.), *Searchlight: Consciousness at the Millennium*, London: Thames & Hudson

1998

Bingham, Juliet, Jonathan Watkins and Joe Spark, *every day*, Sydney: Biennale of Sydney

Cathrin, Pichler, *Crossings. Kunst zum Hören und Sehen*, Vienna/Ostfildern: Kunsthalle Wien/Hatje Cantz (exh. cat.)

Groos, Ulrike and Markus Müller, *Make it Funky: Crossover zwischen Musik, Pop, Avantgarde und Kunst*, Cologne: Oktagon

Obrist, Basualdo, Bonami, Cameron [et al.], *Cream: Contemporary Art in Culture*, London: Phaidon

Whitechapel Art Gallery, *Speed*, London: Whitechapel Art Gallery (exh. cat.)

Toppila, Paula, *Proper (blind date) 1–3*, Helsinki: Frame Finnish Fund for Art Exchange (exh. cat.)

1997

Collings, Matthew, *Blimey! From Bohemia to Britpop*, London: 21

Gallagher, Ann, *Dimensions Variable: New Works for the British Council Collection*, London: The British Council

1996

Arts Council of England, *Ace!*, London: Arts Council of England

Bosse, Laurence and Hans Ulrich Obrist (eds), *Life/Live*, Paris: Paris musées (exh. cat.)

Creed, Martin, *Martin Creed: the whole world + the work = the whole world*, Geneva/London: Galerie Analix B & L

Polla/Karsten Schubert Gallery

Frith Street Gallery and Karsten Schubert Gallery, *From Figure to Object: A Century of Sculptors' Drawings*, London: Frith Street Gallery/Karsten Schubert Gallery (exh. cat.)

Norwich Gallery and Sainsbury Centre for Visual Arts, *EAST International*, Norwich: Norwich Gallery/ Sainsbury Centre for Visual Arts (exh. cat.)

Rolo, Jane and Ian Hunt (eds), *Book Works: A Partial History and Sourcebook*, London: Book Works

1994

Arts Council of England, *Art Unlimited: Multiples of the 1960s and 1990s*, London: Arts Council of England

ARTICLES

2010

Angeletti, Marie, 'Field Guide – Martin Creed', *Modern Painters*, March, pp.16–17, ill.

Barnett, Laura, 'Portrait of the artist: Martin Creed', *The Guardian* online, 22 February

Miller, Phil, 'Restless Native', *The Herald Magazine*, 20 February, pp. 6–11, ill.

Wade, Mike, 'And now for my next trick – artist answers his critics with another simple slice of life', *The Times*, 20 February, p. 15, ill.

2009

Anderson, Zoë, 'A brand new Creed', *The Independent*, 15 October, p. 14, ill.

Anderson, Zoë, 'Martin Creed Work No. 1020', *The Independent*, 21 October, p. 17, ill.

Bonami, Francesco, 'Now is For Ever, Again', *Tate Etc.*, Issue 15/Spring, pp.30–36, ill.

Coles, Alex, 'Work No. 1020', *Financial Times* online, 28 October

Craine, Debra, 'Martin Creed at the Lilian Baylis', *The Times*, 19 October, p. 13, ill.

Creed, Martin, 'If you could live with only one piece of art what would it be?', *Frieze*, Issue 122, April, p. 128, ill.

Creed, Martin, 'The week: Diary', *The Times*, 31 January

Desment, Natalie, 'L'invisibilité pour ne pas disparaître / Invisibility So As Not To Disappear', *esse arts + opinions*, Spring/Summer, pp. 9–11, ill.

Dillon, Brian, 'The Gallery as Brain', *Modern Painters*, Summer, pp. 26–27

Godfrey, Mark, 'Divided Interests', *Artforum*, May, pp. 205–213, ill.

Higgins, Charlotte, 'Five positions and a chess move: Turner winner turns to ballet', *The Guardian*, 22 August

Tóibín, Colm, 'Ordinary World', *Esquire*, February, p. 55, ill.

2008

Blincoe, Nicholas, 'Fast Forward', *The Guardian*, 27 September, ill.

Campbell-Johnston, Rachel, 'Is Martin Creed a genius?', *The Times*, 16 January, ill.

Demir, Anaid, 'Being Martin Creed', *bc Magazine*, issue 3, Summer, ill.

Higgins, Charlotte, 'Martin Creed's new piece for Tate

Britain. A show that will run and run', *The Guardian*, 1 July, p. 11, ill.

Jones, Jonathan, 'Reviewing Martin Creed with the benefit of reflection', *The Guardian*, 30 July, ill.

Luke, Ben, 'Martin Creed: Running at Life', *Art World*, Issue 5, June/July, pp. 31–36, ill.

Searle, Adrian, 'An Electrifying Gesture,' *The Guardian*, 1 July, p. 11

Trigg, David, 'Time and Motion', *Art Monthly*, vol. 321, November, pp. 1–4, ill.

'U. S. Recent Projects', *Public Art Review*, issue 38, Spring/Summer, p. 90

'Work No. 673', *.Cent*, issue 12, Autumn/Winter, p. 58, ill.

2007

Avgikos, Jan, 'Martin Creed', *Artforum*, vol. XLVI, no. 2, October, pp. 368–369, ill.

Buck, Louisa, 'Creed's sexy farewell to Coppermill', *The Art Newspaper*, no. 181, June, p. 50

Chiles, Lawrence, 'Get Me', *Wonderland*, issue 7, Feb/March, p. 98, ill.

Cooper, Emmanuel, 'Creed's credo: it's all the best possible taste', *Tribune*, 15 June, p. 24, ill.

Edgers, Geoff, 'ON and OFF', *The Boston Globe*, 13 September

Falconer, Morgan, 'The great entertainer', *Times 2*, 9 May, p. 15, ill.

Gilbert, Alan, 'From Pop to Poop', *The Village Voice* online, 14 August, ill.

Lubbock, Tom, 'Space man', *The Independent*, 11 June, p. 16, ill.

Mattioda, Mario, 'Interview', *Vogue Italia*, issue no. 679, March, p. 242, ill.

Searle, Adrian, 'Beyond the jokes', *The Guardian*, 8 May, pp. 24–26, ill.

Slyce, John, 'Martin Creed', *Flash Art*, no. 256, October, pp. 125–126, ill.

Smith, Roberta, 'The Bearable Lightness of Martin Creed', *The New York Times*, 13 July, ill.

Stott, Tim, 'Martin Creed', *Art Review*, issue 17, December, p. 143, ill.

Sutcliffe, Thomas, 'The organ that will never be art', *The Independent*, 25 May, ill.

2006

Costa, Chiara, 'Martin Creed', *Mousse*, June, pp. 6–9, ill.

Gautier, Michel, '+/- Martin Creed ou la solution Zero', *20/27*, issue no. 1, p. 107, ill.

Illuminations, 'The EYE. Martin Creed', Illuminations, 26 min (film)

'Oh Christmas Tree, Oh Christmas Tree', *The Guardian*, 20 December, front page, ill.

Ollman, Leah, 'Creed's work delivers a shock', *Los Angeles Times*, 25 August

Perra, Daniele, 'Martin Creed – I like things', *Tema Celeste*, July–August, p. 94, ill.

Vetrocq, Marcia E., 'Martin Creed, Artful Dodger', *Art in America*, no. 8, September, pp. 146–149, ill.

2005

Cattelan, Maurizio, 'Something to work for. Martin Creed interviewed by Maurizio Cattelan', *Flash Art*, vol. 38, no. 242, May/June, pp. 110–111, ill.

Coles, Alex, 'Martin Creed', *Frieze*, no. 89, March, pp. 130–131, ill.

Harding, Jessica, 'Portrait of a Lady with an Ermine', *Another Magazine*, Spring/Summer, p. 98, ill.

Lafuente, Pablo, 'Martin Creed. Philosophical Remarks', *Flash Art*, vol. 38, no. 242, May/June, pp. 112–115, ill.

'Work No. 392', *.Cent*, issue 3, Spring, p. 48–49

2004

Coomer, Martin, 'Martin Creed', *Time Out London*, 20 October, ill.

Roberts, Alison, 'This will put a smile on your face', *Evening Standard*, 3 August, p. 41, ill.

Cullinan, Nicholas, 'State of Play', *Frieze*, no. 82, April, pp. 93–94, ill.

Gingeras, Alison M., 'Painting without canvas or sculpting with paint', issue, pp. 22–25, ill.

O'Reilly, Sally, 'Martin Creed', *Art Monthly*, no. 281, November, pp. 34–35, ill.

2003

Berwick, Carly, 'A Right Kind of Wrong', *Artnews*, vol. 102, no. 1, January, p. 25, ill.

Higgs, Matthew, 'Martin Creed', *Work, Art in Progress*, no. 7, October/December, pp. 20–21, ill.

'Licht an', *Neue Zürcher Zeitung*, 22 November, p. 48

2002

Davies, Brian, 'Letter: Alphabet as art', *The Independent*, 7 January, p. 2

Irvine, Ian, 'A capital idea', *The Independent*, 31 January, p. 10

Reindl, Uta, 'Martin Creed. Galerie Johnen + Schöttle. Cologne', *Tema Celeste*, April, p. 92, ill.

Sans, Jerome, 'On Stage', *The Curator's Egg*, no. 3

2001

Bush, Kate, 'London Field', *Artforum*, vol. XXXIX, no. 1, September, p. 85

Campbell-Johnston, Rachel, 'Nothing ventured', *The Times*, 11 December, p. 17

Collings, Matthew, 'Where were you when the lights went out?', *Sunday Times*, 16 December, p. 2

Mullins, Charlotte, 'The tailor who created the emperor's new clothes', *The Independent*, 11 December, p. 5

Reynolds, Nigel, 'Turner Prize won by man who turns the lights off', *Daily Telegraph*, 10 December, ill.

Waser, Georges, 'Emblem für die Sterblichkeit? Der Konzeptkünstler Martin Creed gewinnt den Turner Prize', *Neue Zürcher Zeitung*, no. 288, 11 December, p. 61

2000

Buck, Louisa, 'Martin Creed', *Artforum*, vol. XXXVIII, no. 6, February, pp. 110–111, ill.

Coles, Alex, 'Martin Creed at City Art Gallery', *Art in America*, no. 11, November, p. 176, ill.

Jones, Jonathan, 'Let there be light', *The Observer*, 19 March, pp. 16–17, ill.

Searle, Adrian, 'Is this what they call pop art?', *The Guardian*, 18 January, pp. 14–15, ill.

1999

Beech, Dave, 'Martin Creed', *Art Monthly*, no. 226, May

Higgs, Matthew, 'Martin Creed: 20 Questions', *Untitled*,
no. 18, Spring
Liebmann, Lisa, Adams, Brooks, 'A Summer Place', Art in
America, New York, vol. 87, no. 6, June, pp. 100–107, ill.
Lillington, David, 'Martin Creed', *Metropolis M*, April

1998

Buck, Louisa, 'Faces, places and spaces to watch in 1998:
your cut-out and keep guide to the future of British art',
New Statesman, London, 2 January
Buck, Louisa, 'UK Artist Q&A' [interview], *The Art
Newspaper*, no. 86, November

1997

Archer, Michael, 'The Object of Art', *Art Monthly*, no. 208,
July/August
Coles, Alex, 'Martin Creed – No Entry', *Art + Text*, no. 56,
February–April
Kyriacou, Sotiris, 'Propositions', *Art Monthly*, no. 208,
July/August
Pigott, Hadrian [et al.], 'Go into a shop and ask for
nothing', *Very*, no. 2

1996

Williams, Gilda, 'Martin Creed Tabula Rasa', *Art Monthly*,
no. 195, April

1995

Lederman, Erika, 'Unlimited Works at Starkmann
Limited', *Art Monthly*, no. 185, April
Piccoli, Cloe, 'Martin Creed', *Flash Art Italia*, December–
January
'The Ruby Kelly Column', *Art Review*, vol. XLVII,
June

1994

O'Reilly, John, 'Art for Bart's sake', *The Modern Review*,
vol. 1, no. 16, August/September
Searle, Adrian, 'Martin Creed and Sam Samore',
Time Out London, July 21–July 27

1992

Collings, Matthew, 'Matthew Collings on some kind of
sculpture show at Laure Genillard', *City Limits*, January

DISCOGRAPHY

2009

Thinking/Not Thinking, Tokyo: Hiromi Yoshii

2008

Work No. 815, *Ooh/Fuck Off/Words*, San Francisco/
New York: Smart Guy Records/The Sound
of White Columns

2004

Work No. 320, *I Don't Know What I Want*, London:
Serpentine Gallery

1999

Everything is Going to be Alright, London: The Pier Trust
I Can't Move, Toronto: Art Metropole

1997

Owada, *Nothing*, London: Piano 508

1995

Work No.117, Milan: Paulo Vitolo Gallery

Picture Credits

Every possible effort has been made to locate and credit
copyright holders of the images reproduced in this book.
Any omissions or errors can be corrected in future editions.

Blaise Adilon 478; David Allison 343; Mike Bruce 152, 153, 178,
243, 259, 279, 286, 376, 472, 474, 476, 506, 541, 561, 581, 585,
604, 607, 608, 617, 629, 630, 631, 632, 635, 638, 639, 641, 642,
643, 644, 645, 646, 654, 656, 669, 672, 714, 721, 745, 756, 761,
769, 782, 788, 822, 823, 832, 865, 890, 896, 903, 904, 906, 907,
914, 915, 930, 931, 932, 933, 958, 974, 977, 991, 992;
A. Burger 183, 287, 293, 294, 312, 331, 372, 471, 480, 494, 502,
508, 512, 516, 517, 518, 520, 521, 522, 523, 524, 525, 526, 528,
529, 532, 536, 537, 538, 539, 549, 571, 572, 573, 575, 583, 587,
651, 652, 743, 801, 815, 870, 878, 885, 961, 963, 996; Camden
Arts Centre 254; Centre for Contemporary Art, Ujazdowski Castle
126, 325, 326; Martin Creed 4, 5, 6, 7, 8, 9, 11, 12, 14, 18, 19, 21,
23, 24, 33, 36, 37, 42, 43, 47, 52, 53, 58, 61, 67, 69, 74, 75, 78, 79,
81, 83, 84, 86, 88, 92, 95, 97, 99, 100, 101, 102, 106, 112, 115,
122, 127, 130, 131, 132, 143b, 152, 153, 167, 168, 170, 171, 172,
182, 200, 201, 202, 204, 205, 210, 217, 218, 245, 248, 251, 253,
254, 265, 275, 295, 299, 304, 318, 399, 760, 978; Martin Creed &
David Cunningham 399; Martin Creed & Ingrid Swenson 299,
304, 318; Colourgenics 383 ; Philippe Degobert 177;
The Douglas Hyde Gallery 840; Suzanne Eisenberg 273; Jon Etter
433, 436, 441, 443, 445, 446, 447, 449, 452, 453, 454, 455, 458,
460, 461, 553, 557; Galerie Analix Forever 843; Galerie
Emmanuel Perrotin 330; Galleria Alberto Peola 142, 204, 205,
839; Galleria Lorcan O'Neill, Roma 702, 895, 897, 898, 920, 921,
923, 925, 928, 983; Galleria Paolo Vitolo 120; Barbora Gerny 117,
180, 283, 285, 301, 309, 338, 339, 340, 389, 398, 438, 439, 459,
469, 473, 552, 562, 605, 633, 640, 984, 985, 986, 993, 997, 998;
Hiroshima City Museum of Contemporary Art 1017; Hugo
Glendinning 20, 22, 28, 29, 118, 139, 140, 157, 160, 203, 335,
370, 371, 373, 374, 386, 415, 551, 560, 564, 567, 569, 570, 586,
591, 612, 622, 623, 625, 636, 657, 671, 673, 679, 680, 681, 682,
683, 684, 685, 686, 687, 688, 689, 690, 691, 700, 701, 725, 730,
740, 752, 753, 766, 850, 853, 857, 858, 859, 862, 863; Chris
Kendall 336, 264; Achim Kukulies 252, 270, 271, 481, 493, 987;
Kallan MacLeod 329; Raymond Meier 836; Marcel Meury 382;
Gian Paolo Minelli 247; Nikolaos Oikonomeas 77; L. Ontani 265;
Myoung-Rae Park 965, 990, 994; Paola Pivi 316; A. Reeve 975;
Sebastian Schobbert 360; Goswin Schwendinger 384, 379, 344;
Site Photography 851; Andrew Smart, A.C. Cooper 968, 980,
1000; Andy Stillpass 121, 190; Tate Photography 232; D. Uldry
311, 308, 263,175; Pieter de Vries 282; Siegfried Wameser 492;
Zbigniew Wendt 485; Stuart Whipps 396, 837, 944, 956, 960;
Joshua White 487, 590, 591, 596; David Willems 281; Ellen Page
Wilson 129, 184, 226, 300, 305, 306, 321, 341, 380, 387, 391, 395,
403, 405, 406, 407, 419, 422, 423, 425, 426, 427, 428, 429, 430,
495, 496, 582, 628, 744, 754, 755, 768, 785, 794, 796, 798, 800,
802, 805, 845, 846, 867, 876, 883, 905; and Ryan Moore, Thomas
Mueller, Alex North, Tom Powell and Oren Slor.

Acknowledgments

Thanks to:

Iwan Wirth
Manuela Wirth
Ursula Hauser
André Remund
Marc Payot
Florian Berktold
Gregor Muir
Sara Harrison
Michaela Unterdörfer
Nicole Keller
Joel Yoss
Frederique Laroque
And everyone at Hauser
 & Wirth

Gavin Brown
Corinna Durland
Alex Zachary
And everyone at Gavin
 Brown's enterprise

Lorcan O'Neill
Laura Chiari
Serena Basso
Jörg Johnen
Manuel Miseur
Alberto Peola
Rüdiger Schöttle
Michael Lett
Michelle Macarone
Barbara & Luigi Polla

Rob Eagle
Emily Pulham
Maria Arusoo
Oliver Fuke
Oscar Carlson
Sam Belinfante
Nathalie Quagliotto
Bethan Lofthouse
Katie Guggenheim
Marta Angelozzi

Bob Wise
James Rushton
Gill Graham
John Boughtwood
Howard Friend
Lucy Bright
Claire Ingram
Meg Montieth
Jonas Persson
And everyone
 at Music Sales

Everyone at Thames
 & Hudson

Gerhard Steidl
Michael Mack
Catherine Lutman
Melissa Larner

Tom Eccles
Massimiliano Gioni
Germaine Greer
Matthew Higgs
Barry Humphries
Tess Jaray
Darian Leader
John O'Reilly
Colm Tóibín
Hugo Glendinning
Ellen Page Wilson
Cornelia Providoli
Andrew Crichton
Simone Sentall
Roger Tatley
Bob Rennie
Carey Fouks
Zillah Bowes
Thomas Gardner
Mike Harradine
Neon Circus
Robin Fletcher
Fletcher Gallery Services
Paolo Mina
Mintu Manvar
Hetal Pandya
Accountrust
Len Thornton
Rob Nagel
Bernhard Starkmann
Cesar & Mima Reyes
Andy & Karen Stillpass
Axel Haubrok
Marty & Rebecca
 Eisenberg
Adam Clayton
Anthony D'Offay
Simon Groom
John Hutchinson
Trevor Smith
Simona Fantinelli
Francesco Grana
Martin McGeown
Andrew Wheatley
Laure Genillard
Roger Ackling
Claudia Cargnel
Matthew Slotover
Daniel Twomey

Helen Alfille
Antony Gormley
Kirsty Bell
Thomas Frangenberg
Tim Head
Ann Gallagher
Maurizio Cattelan
Ali Subotnik
Natasha Conland
Fiona Bradley
Charles Asprey
Nicholas Serota
Graham Haworth
Susan Brades
Katrina Brown
Carolina Grau
Teresa Gleadowe
Renee Praz
Bruno Delavallade
Thaddeus Ropac
Nikolaus Ruziscka
Emmanuel Perrotin
Paolo Vitolo
Karsten Schubert
Roger Bywater
Victoria Miro
Alison Jacques
Marc Jancou
Juliana Engberg
Javier Lopez
Paolo Falcone
Gail Cochrane
Nicholas Blincoe
Giorgio Verzotti
Giacinto di Pietrantonio
Godfrey Worsdale
Nigel Walsh
Jenni Lomax
Catherine Gibson
Pawel Polit
Robert Gibson
Paolo Falcone
Marieluise Hessel
Bernhard Fibicher
Nicola Trussardi
Rochelle Steiner
Cristiana Perrella
Alistair Spalding
Emma Gladstone
Jonathan Watkins
Yukie Kamiya
Sunjung Kim
Stephen Deuchar
Judith Nesbitt
Helen Beeckmans
Katharine Stout
Ingrid Swenson

Paola Pivi
David Cunningham
Keiko Owada
Karen Hutt
Adam McEwen
Fiona Daly
Genevieve Murphy
Phillida Reid
Chiara Bersi Serlini

Jo Robertson
Aileen Corkery
James Ware
David Southard
John Creed
Gisela Creed
Nicolas Creed

and Anouchka Grose

Index

The entries in the first part of this index relate to the materials and media listed in the captions for the works, and to people mentioned in the captions or essays; the second part lists titles of the works.

acrylic
 on canvas 3, 508, 585, 596, 679, 702, 885, 903, 904, 912, 930, 931, 932, 933, 977, 986, 987, 991, 992, 993
 on card 874, 1016
 on cardboard 980, 983, 996
 on linen 956, 958, 968, 974, 985
 on paper 657, 680, 681, 682, 683, 684, 685, 686, 687, 688, 689, 690, 691, 753
adhesive 100; see also glue
aluminium 28, 29, 135, 188, 263, 264, 776
amplifier 92, 95, 97, 120, 122, 130, 182
announcement card
 see card
audio cassette 117
audio recording 401, 412

ballet 1020
balloon 200, 201, 202, 204, 210, 247, 262, 265, 268, 329, 360, 551, 628, 965
ball 370, 406, 457
bean bag 796
billboard 143b
biro see pen
Blazwick, Iwona xxix, xxxiii
Blu-Tack 79, 91
blue-print 58, 152, 153
brass 5, 6, 7, 9, 11, 12, 14, 19, 20, 21, 23, 24, 28, 29, 33, 52, 53, 61, 84, 305, 306, 721, 776

cactus see plants
canvas 6, 7, 18, 52, 53; see also acrylic, linen, and pen
card 635; see also acrylic,

ink, paint, pen and pencil
 announcement card 163, 394, 636, 668
 postcard 361, 622, 764, 765
cardboard 74, 77, 78; see also acrylic
 box 870, 876, 878, 916
catalogue 157
chair 925, 997, 998
chipboard 4
chrome-plated brass 9, 11, 12, 14, 18, 23, 33, 47, 52, 53, 69, 84, 306, 386, 776
chrome-plated copper 178
concrete 173
correction fluid 657
crayon 753
Creed, Martin 139, 337
Cunningham, David xxx, xxxiii
curtain 990

dance 595, 612, 1020
Deller, Jeremy xxxi, xxxiii
Doig, Peter xxviii, xxxiii
dog 591
doorstop 115, 131
drum machine 120, 122, 182

elevator 371, 409, 592
emulsion 594, 740, 743, 798, 800, 840, 843, 905, 920, 921, 923
enamel 6

film/video
 35 mm film 503, 546, 547, 548, 583, 600, 609, 612, 660, 670, 675, 730, 732, 751, 837, 1020
 Mini DV 405, 492, 494, 839
 synchronized film/video 405, 492, 494, 583, 837, 839
 u-matic video 42, 47
fitting/fixture 739
floppy disk 211
frame 58, 152, 153, 175, 654, 822, 823, 832, 906, 907
Frangenburg, Thomas xxxii, xxxiii

glue 22; see also adhesive
gold-plated brass 99, 386
gold-plated silver 106, 184, 282, 308, 348,

380, 381, 579
Grassi, Cornelia xxxii, xxxiii

Hughes, Dean xxxii, xxxiii
Hutt, Karen 337

ink 167, 168, 170, 171, 175; see also pen
 on card 961, 963
 on paper 43, 74, 101, 138, 141, 143, 150, 158, 159, 161, 162, 174, 224, 235, 753, 766, 906, 907, 961, 963

Jacques, Alison xxxi, xxxiii
Jones, Gareth xxxii, xxxiii

Lego® 792
lid 126, 183, 293, 294, 301, 309, 652, 801
lights see neon
linen 8

McEwen, Adam 139, xxx, xxxiii
McGeown, Martin xxviii, xxxiii
magazine spread 236, 392
Martin, Simon xxxii, xxxiii
masking tape see tape
metal polish 53
metronome 97, 112, 134, 180, 189, 223
microphone 92, 95
mixer 95
music 1020; see also song lyrics
musical score
 for instruments 105, 107, 108, 109, 110, 111, 116 , 128, 139, 592, 625, 673, 736, 849, 955, 994
 for voice 810
 for voice and instruments 118, 124, 207, 208, 209, 212, 214, 215, 216, 296, 320, 332, 337, 371, 409, 421, 431, 432, 614

nail 701
neon 203, 205, 219, 220, 221, 225, 226, 231, 232, 239, 240, 243, 251, 252, 253, 259, 260, 261, 273, 275,

277, 279, 281, 283, 285, 286, 287, 289, 291, 311, 325, 326, 331, 335, 336, 338, 374, 376, 379, 389, 398, 467, 471, 560, 567, 623, 651, 669, 671, 672, 755, 790, 794, 836, 845, 846, 851, 890, 895, 896, 975, 988
newspaper 274, 626

O'Reilly, John 96, xxxii, xxxiii
Owada, Keiko 139, 337, xxix, xxxiii

paint 4, 5, 83, 101, 135, 188, 263, 264; see also acrylic
 on card 1000
paper 77, 78, 88, 121, 126, 140, 167, 168, 170, 171, 175, 183, 190, 218, 293, 294, 301, 309, 319, 327, 339, 340, 343, 344, 383, 384, 391, 418, 429, 430, 441, 446, 449, 474, 642, 644, 646, 652, 654, 656, 742, 756, 801, 822, 823, 832, 867, 868, 870, 906, 907; see also acrylic, blue-print, ink, magazine spread, newspaper, pen, pencil and poster
pastel 753, 766
pen
 on canvas 702
 on paper 321, 341, 344, 373, 403, 427, 469, 473, 478, 480, 481, 485, 487, 495, 496, 498, 502, 517, 541, 552, 553, 562, 575, 604, 617, 645, 657, 944
 biro on paper 415, 512, 521, 525, 528, 529, 536, 539, 640, 853
 highlighter pen on paper 382, 419, 436, 453, 459, 460, 476, 632, 633, 634, 638
 marker pen on card 897
 marker pen on paper 397, 407, 422, 423, 425, 426, 438, 447, 452, 454, 455, 458, 461, 472, 516, 522,

lx INDEX

523, 524, 526, 532, 537, 557, 561, 563, 572, 573, 581, 590, 605, 607, 608, 641, 643, 714, 744, 745, 754, 761, 768, 769, 782, 784, 812, 862, 865, 883, 914, 915, 984
see also ink
pencil
 on card 639, 897
 on paper 428, 433, 439, 443, 445, 491, 506, 518, 520, 538, 638, 657, 674, 680, 681, 682, 683, 684, 685, 686, 687, 688, 689, 690, 691, 752, 753, 766, 788, 857, 858, 859, 863, 898
photographic print 36, 37, 43, 167, 168, 170, 171, 295, 299, 304, 316, 318, 399, 509, 510, 582, 593, 748
piano 372, 569
plants 587, 615, 629, 631, 630, 802, 960
plaster 83, 101, 188, 263, 264
plinth 126, 183, 293, 294, 301, 309, 652, 801
plywood 387, 549, 571, 725, 841, 1017
polystyrene 74, 77, 78
postcard *see* card
poster 248, 367, 368, 369, 586
primer 18, 52, 974, 985

runner 570, 850

Sadotti, Giorgio xxxi, xxxiii
silver 172, 177, 184, 308, 380, 381, 578
silver-plated brass 99, 386
size 7, 52
slide, 35 mm 760, 978
Smailes, Lesley xxx, xxxiii
song lyrics 148, 191, 192, 193, 194, 195, 196, 197, 207, 208, 209, 212, 214, 215, 216, 296, 320, 332, 337, 421, 431, 432, 614, 810
speaker, hi-fi 95, 120, 401, 412
steel 5
 I-beams 700, 805
Swenson, Ingrid xxxiii
synthesizer 130

tables 928
talk 595, 1020
tape
 Elastoplast tape 78, 86
 magic tape 77
 masking tape 58, 67, 74, 75, 81, 152, 153, 175, 654, 680, 681, 683, 684, 686, 687, 689, 690, 691, 822, 823, 832, 906, 907, 961, 963
 text 76, 267, 470, 577, 852, 989, 1015; *see also* song lyrics
theatre show 612, 1020
tile 100, 271, 330, 739
trees 785
typographic design 96

video *see* film/video
vinyl letter 217
vinyl record 815

wall 19, 106, 282, 578; *see also* emulsion
Wheatley, Andrew xxx, xxxiii
Williams, Gilda xxxi, xxxiii
wind machine 564
window-mount 58, 152, 153, 175, 654, 822, 823, 832, 906, 907
wood 4, 5, 22, 395, 396, 493; *see also* plywood

WORK TITLES

1–100 195
A 1" cubic stack of masking tape in the middle of every wall in a building 81
A 1" cubic stack of masking tape in the middle of every wall in a room 75
2 283
30 seconds with the lights off 128
101–200 196
1234 118
Ach nein 162
Alicudi 577
All the bells in a city or town rung as quickly and as loudly as possible for three minutes 245
All the sculpture in a collection 228
All the sounds amplified 95
All the sounds on a drum machine 117, 182
All the sounds on a drum machine played one after the other, in their given order, at a speed of one per second, in a continuous loop 120
All the sounds on a synthesizer 130
Anouchka 978
As many 1" squares as are necessary cut from 1" masking tape and piled up, adhesive sides down, to form a 1" cubic stack 67, 74
As many 2.5 cm squares as are necessary cut from 2.5 cm Elastoplast tape and piled up, adhesive sides down, to form a 2.5 cm cubic stack 78
As many 2.5 cm squares as are necessary cut from 2.5 cm Magic tape and piled up, adhesive sides down, to form a 2.5 cm cubic stack 77
ASSHOLES 398
A–Z 197, 274

BABIES 279
Balls 370, 406
Be natural 216
Big dogs 586
Big things in small rooms 224
Black painting 508
Blowing a raspberry 401
Broccoli prints 1000

Chrome and brass 42
A crumpled ball of paper in every room in a house 121, 190

Die 432
DOGS 623, 846
DON'T WORRY 220, 239, 273, 277, 291, 794, 890
A doorbell amplified 92
A door opening and closing 129
A door opening and closing and a light going on and off 132
A doorstop fixed to a floor to let a door open only 30 degrees 131, 171
A doorstop fixed to a floor to let a door open only 45 degrees 115, 167
Down over up 394
Drum machine 122

An Elastoplast cube in the middle of every empty wall in a gallery, filling the gaps in an exhibition 86
Elevator, oooh/aah up/down 371
EVERYTHING IS GOING TO BE ALRIGHT 203, 205, 219, 225, 226, 289, 560, 790, 851, 975, 988
Extra bit 174

Feeling blue 191
FEELINGS 287, 311, 336, 471, 836, 895
For pianoforte 101
Four drawings 344
Four objects 23
FRIEND 672
FRIENDS 669, 671
From one take one add one make none 141
Fuck off 211, 235, 240, 337, 815

Give me something to say 212

Half of anything multiplied by two 150
Half the air in a given space 200, 201, 202, 204, 210, 247, 360
Hannah smiling with Starbucks cup 760
HELLO 243
High 111
Holly 752, 753

I can't move 209
I don't know what I want 320
I don't know what I want to say 267
I like things 207
If you're lonely 421, 470
An intrusion and a protrusion from a wall 19, 21, 61, 84, 99, 106, 172, 177, 184, 282, 308, 348, 380, 381, 578, 579

A lamp going on and off 312

A large piece of furniture partially obstructing a door 142

Largo, larghetto, adagio, andante, moderato, allegro, presto e prestissimo 134, 180

Laughing 412

The lights going on and off 127, 160, 227

The lights in a building going on and off 254

The lights in a street going on and off 276

The lights off 270

Lights on / lights off 170, 236

LOVE 374, 379, 389, 651

A love duet 138

Low 110

LOW 286

NOLI SOLICITUS ESSE / SORGE DICH NICHT / DON'T WORRY / MH MEPIMNA 252

Nothing 194

Nothing is something / Blow and suck 208

An object on a door 36

Objects in different places 43

Oh no 161

On a tiled floor, in an awkward place, a cubic stack of tiles built on top of one of the existing tiles 100, 168

On a tiled floor, in a useful place, a cubic stack of tiles built on top of one of the existing tiles 271

One packet of Blu-Tack 91

One whole song 193

Ooh 810, 815

Orson & Sparky 670

Paola and me reading 788

Pass them on 614

PEOPLE 376

Piano 569

A protrusion from a wall 83, 101, 135, 178, 263

RZECZY 325

Salt and pepper set 33

Self portrait smiling 299, 318

Self portrait thinking 316

A sheet of A4 paper crumpled into a ball 88

A sheet of A4 paper torn up 140

A sheet of paper crumpled into a ball 126, 218, 293, 294, 301, 652

A sheet of paper crumpled up and flattened out 319, 327, 339, 430

A sheet of paper folded up and unfolded 328, 340, 343, 383, 384, 429, 656

A sheet of paper torn up 183, 309, 801

Ships coming in 405

SHIT 281

Shit film trailer 609

Short G 116

Sick film 610

SMALL THINGS 275, 467, 567, 755

Smiling people 295, 304, 399

Smiling woman 657

Smiling woman with headphones 766

Some Blu-Tack kneaded, rolled into a ball, and depressed against a wall 79

Something in the middle of a wall 159

Something on the left, just as you come in, not too high or low 158

S.O.N.G. 214

Start middle end 124

THINGS 221, 231, 251, 253, 260, 261, 285, 331, 335, 338, 845, 896

Thinking / Not thinking 431

Thirty-nine metronomes beating time, one at every speed 112, 189

Thirty thirty 192

Three metronomes beating time, one quickly, one slowly, and neither quickly nor slowly 223

Trill 849

Two drawings 58, 175

Two objects 9, 11, 14, 386

Two objects in the dishwasher 37

Two paintings 52, 53

Two protrusions from a wall 188

UCZUCIA 326

Up and down 107

The usual first one 108

Variations for string quartet 625

What's the point of it? 296

the whole world + the work = the whole world 143, 143b, 157, 217, 232, 300

Wind machines 564

Words 815

WORDS WORDS WORDS 259

X 361

Yellow painting 3

You're the one for me 215